A New American Sculpture, 1914–1945 Lachaise, Laurent, Nadelman, and Zorach

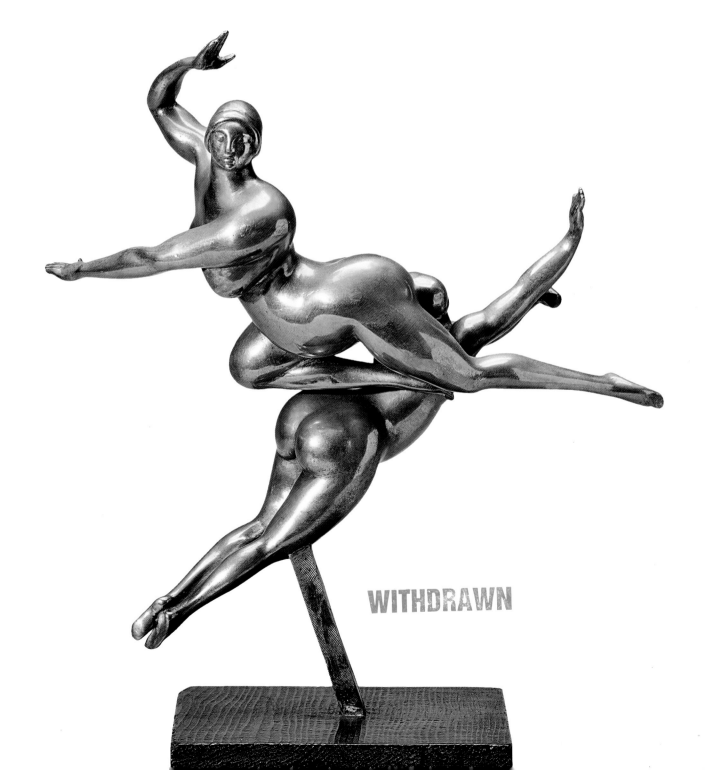

A New American Sculpture, 1914–1945

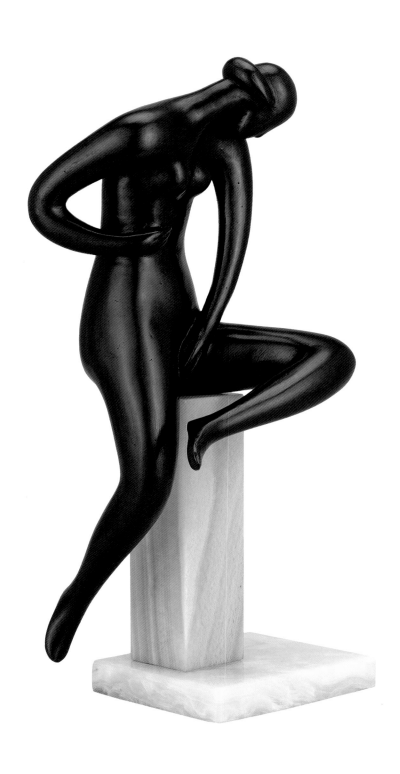

Lachaise, Laurent, Nadelman, and Zorach

Edited by

ANDREW J. ESCHELBACHER

Essays by

ANDREW J. ESCHELBACHER

MICHAELA R. HAFFNER

RONALD HARVEY

SHIRLEY REECE-HUGHES

ROBERTA K. TARBELL

Portland Museum of Art
Portland, Maine

Amon Carter Museum of American Art
Fort Worth, Texas

Distributed by Yale University Press
New Haven and London

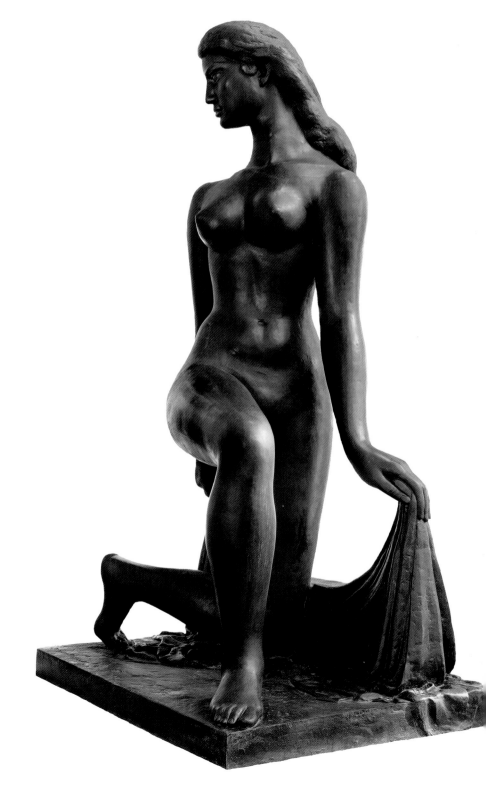

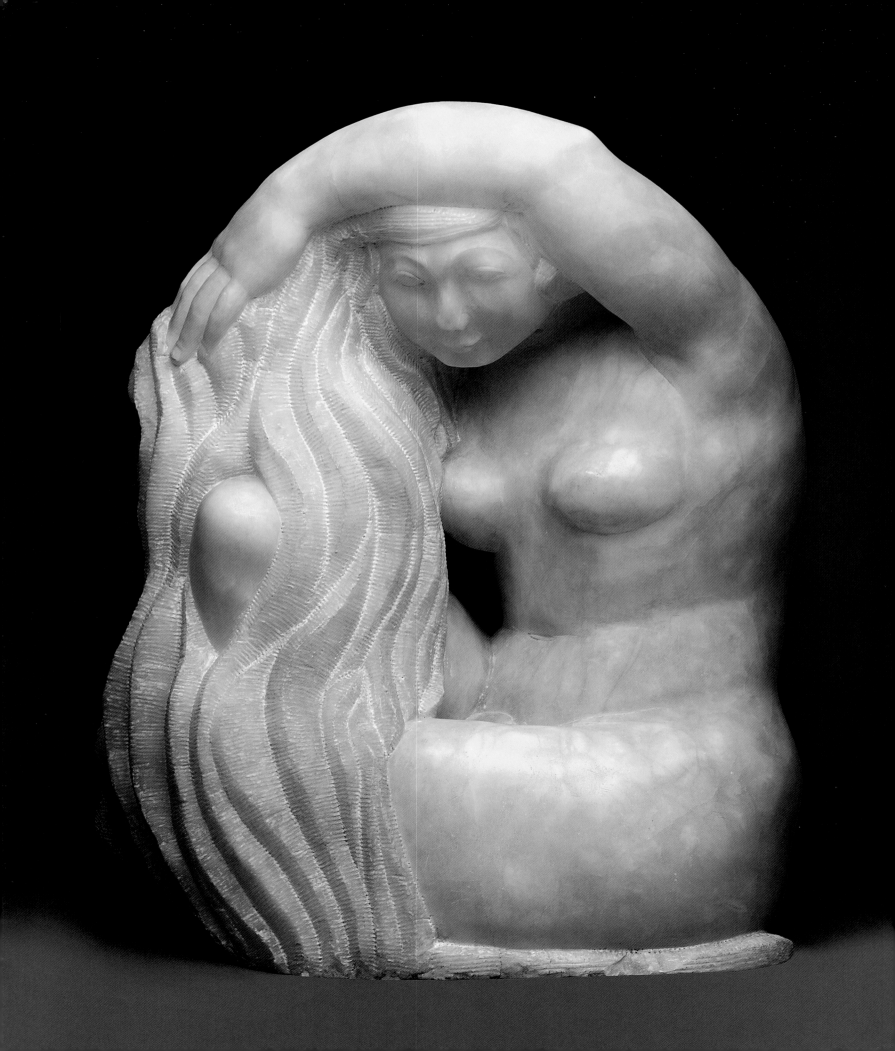

Contents

Foreword

In the first half of the twentieth century, particularly in the decades between the World Wars, modernism fundamentally altered virtually every aspect of Western culture. Enlightenment thinking—rooted in reason, rational thought, and the scientific method—had long dominated the world of ideas, fomenting its revolutions across the spectrum of civilization and setting the stage for the pervasive changes modernism would bring.

The visual arts were among the disciplines most dramatically upturned by this philosophical sea change. Though academic practice and theory remained touchstones, artists began to reimagine the past and transform their mediums as if seeing through new eyes. They moved away from conservative, traditional approaches to explore a fresh aesthetic that prioritized experimentation, ingenuity, and atypical techniques and materials. For sculpture, this shift manifested earliest in Europe, especially Paris, where in 1900 the great Auguste Rodin mounted a solo exhibition of more than 150 objects that marked the beginning of a new artistic age.

In the years immediately before and after Rodin's show at the Pavillon d'Alma, artists from across the continent and the United States descended on Paris, drawn by the creative energy that emanated from the city across borders and seas. Four sculptors in this milieu—all European-born—immersed themselves in this nexus of innovation, and then, imbued with its spirit, either returned or immigrated to the United States. There, during the turbulent interwar period, Gaston Lachaise, Robert Laurent, Elie Nadelman, and William Zorach, known to each other but working independently, would transform American figurative sculpture.

Fusing ideas from classicism, modernism, and pop and vernacular cultures, this quartet of immigrant sculptors pioneered a distinct mode of American modernism. Yet while each of them has been examined in monographic or survey exhibitions, no study to date has addressed the vibrant formal connections among them. Though celebrated in their lifetimes, and though their individual legacies are long established, their shared ideologies and related formal and thematic characteristics, which proved so important to the history of American art, have been overlooked.

A New American Sculpture, 1914–1945: Lachaise, Laurent, Nadelman, and Zorach fills this gap in the scholarship. Organized by the Amon Carter Museum of American Art and the Portland Museum of Art, Maine, this project is the first to

explore the aesthetic implications of the artists' time in Paris, how America's folk and popular cultures influenced their mature styles, and how their work was received.

The Amon Carter and Portland together house a substantial number of works by these sculptors, and both museums are dedicated to advancing the study of American modernism. This project provided an unprecedented opportunity to study in greater depth the works by these artists, who combined classical precedents and the ideas of an international avant-garde with everyday aspects of American life, pop culture, and folk art to take their medium in decidedly new directions.

It is our honor to graciously recognize here those whose help proved indispensable in bringing this project to fruition. It was a special honor to partner with the families and estates of the artists. On behalf of Robert Laurent, we thank the family of Robert Laurent. At the Lachaise Foundation, we thank Director Paula R. Hornbostel. For Elie Nadelman, our thanks go to Cynthia Nadelman and Catherine Tinker, as well as Philip and Theresa Nadelman. And for William Zorach, we thank Charlie Ipcar and Judy Barrows, Dahlov Ipcar, Robert Ipcar and Jane Landis, Jonathan and Cecile Zorach, Peggy Zorach, Peter and Julie Zorach, and Tim Zorach.

In addition to providing access to their respective archives and artworks, these descendants and friends of the artists enriched this project with their memories and stories.

In retrospect, it is entirely fitting that by the early 1920s, Lachaise, Laurent, Nadelman, and Zorach had each become active members in the Modern Artists of America, a small society of independents whose ethos—"opposed to the blind acceptance of tradition"—was recorded in their inaugural exhibition catalogue. Ever grounded in a sense of formal harmony and craftsmanship, they had broken free from academic strictures to seek out fresh inspirations and techniques; immigrants who brought the past with them, they had organized around a shared passion to shape tomorrow. "We discovered that art didn't begin and end with the Greeks," Zorach recalled in 1957. Modern art, he said, was for them "a spiritual awakening." It would prove as well an awakening for the future of American sculpture.

MARK H. C. BESSIRE
Judy and Leonard Lauder Director, Portland Museum of Art

ANDREW J. WALKER
Executive Director, Amon Carter Museum of American Art

Acknowledgments

Writing these acknowledgments is one of the most gratifying parts of this exhibition, allowing the exhibition curators the opportunity to recognize the contributions of so many people and organizations who made the exhibition and catalogue of *A New American Sculpture* possible. This exhibition results from a strong collaboration between the Portland Museum of Art and the Amon Carter Museum of American Art in a partnership led by our directors, Mark H. C. Bessire and Andrew J. Walker. In addition, the exhibition will travel to the Memphis Brooks Museum of Art. We are grateful to Emily Ballew Neff, Marina Pacini, and their colleagues for their enthusiasm in helping us to present the work of these four pioneering sculptors to the community of museumgoers and readers across the country.

First and foremost, we are grateful to the many lenders to this exhibition and their representatives. We wish to thank our colleagues at peer institutions throughout the country who have facilitated loans on our behalf: Janne Sirén at the Albright-Knox Art Gallery; Andria Derstine at the Allen Memorial Art Museum, Oberlin College; James Rondeau, Judy Barter, and Sarah Kelly Oehler at the Art Institute of Chicago; Jay McKean Fisher at the Baltimore Museum of Art; Thomas Collins and Sylvie Patry at the Barnes Foundation; Anne Pasternak and Kimberly Orcutt at the Brooklyn Museum; Peter C. Sutton at the Bruce Museum; Sharon Corwin, Beth Finch, and Shalini Le Gall at the Colby College Museum of Art; Christopher Brownawell at the Farnsworth Art Museum; Martha Tedeschi and her predecessor Thomas W. Lentz at the Harvard Art Museums / Fogg Museum; Melissa Chiu at the Hirshhorn Museum and Sculpture Garden, Smithsonian Institution; Kevin Salatino at The Huntington Library, Art Collections, and Botanical Gardens; Paula R. Hornbostel at the Lachaise Foundation; Jonathan Binstock at the Memorial Art Gallery of the University of Rochester; Thomas P. Campbell, Randall Griffey, and Thayer Tolles at the Metropolitan Museum of Art; Ellen Alvord at the Mount Holyoke College Art Museum; Glenn D. Lowry, Christophe Cherix, Kathy Curry, Leah Dickerman, and Ann Temkin at the Museum of Modern Art; Kim Sajet at the National Portrait Gallery, Smithsonian Institution; Jacqueline Z. Davis at the New York Public Library for the Performing Arts; Timothy Rub, Kathleen A. Foster, and Jennifer Thompson at the Philadelphia Museum of Art; Elizabeth Broun, Virginia Mecklenburg, and Karen Lemmey at the Smithsonian American Art Museum; Thomas J. Loughman and Erin Monroe at the Wadsworth Atheneum Museum of Art; Adam D. Weinberg, David Breslin, Jennie Goldstein, Barbara Haskell, and Scott Rothkopf at the Whitney Museum of American Art; and Matthias Waschek at the

Worcester Art Museum. We also extend sincere thanks to Susan and Herbert Adler; Marc and Ronit Arginteanu; George H. Warren; Joel Rosenkranz and Mark Ostrander at Conner · Rosenkranz LLC; Lee Findlay Potter at Findlay Galleries; Alice Levi Duncan at Gerald Peters Gallery; Bernard Goldberg and Ken Sims at Bernard Goldberg Fine Arts LLC; Taylor Acosta and Jenny Sponberg at the Myron Kunin Collection of American Art; as well as the Estate of Dr. Samuel and Adele Wolman, along with the many private collectors who chose to remain anonymous.

We are very grateful to the Henry Luce Foundation, Inc. and the National Endowment for the Arts for their support of this project. In addition, we wish to thank Furthermore: a program of the J. M. Kaplan Fund and the Wyeth Foundation for American Art for their support of this catalogue, as well as the Davidson Family Fellowship and the Terra Foundation for American Art for their support of our research.

As curators and authors we owe a great deal to the teams in Portland and Fort Worth for their extensive contributions to this project. In particular, we thank Mollie R. Armstrong and Emmeline Yen for spearheading the effort to secure reproduction rights for the images in this catalogue. In Portland, additional thanks go to Jessica May, Erin Damon, Jennifer DePrizio, Diana J. Greenwold, Elena Henry, Allyson Humphrey, Elizabeth Jones, Kris Kenow, Christi Lumiere, Christopher Patch, and Lauren Silverson, as well as former colleague Elizabeth Cartland. At the Amon Carter, we wish to thank Heather Creamer, Marci Driggers, Lori Eklund, Stacy Fuller, Will Gillham, Alessandra Guzman, Claudia Sanchez, Peggy Sell, Cliff Vanderpool, and Scott Wilcox, as well as former colleague Judy Ivey and volunteers Taylor Day and Kathleen Rice.

This publication would not have been possible without the extraordinary efforts, grace, and good cheer of Sandra M. Klimt, Jane E. Boyd, Juliet Clark, Malcolm Grear Designers, Bruce Schwarz, Martin Senn, and Frances Bowles, as well as the anonymous reviewers who commented on our initial essay drafts.

In addition, many friends and colleagues have offered invaluable support and guidance during the preparation of this exhibition and catalogue. We wish to extend our own thanks to the families and friends of Lachaise, Laurent, Nadelman, and Zorach. Our fellow authors Michaela R. Haffner, Ronald Harvey, and Roberta K. Tarbell have been generous and engaging colleagues and offer new perspectives on American modernism in their essays. Karen Lemmey led a wonderful Barnet Scholar's Weekend in Portland at an early stage of this exhibition. Barbara Buckley offered the authors great insight and access to works by Robert Laurent at the Barnes Foundation. Virginia Budny has been generous with her knowledge of Gaston Lachaise at all stages of this project. We are also exceedingly grateful for the support and tireless efforts of librarians and archivists such as Barbara Beaucar, Marisa Bourgoin, Shiva Darbandi, Heather Dawn Driscoll, Sam Duncan, Jonathan Frembling, Liza Kirwin, Amanda McKnight, Rachel Panella, Kristen Regina, and Rick Sieber. In addition, numerous colleagues, including Rachael Arauz, Robert Cozzolino, Kaywin Feldman, James Hargrove, Kevin Murphy, Thayer Tolles, and Kenneth Wayne, graciously shared their knowledge, offered crucial feedback, or otherwise facilitated the project.

And finally, our families have offered extraordinary support, care, and love as we have developed this project. To them, and the many named and anonymous colleagues, readers, and museum guests, we offer our sincerest thanks.

ANDREW J. ESCHELBACHER
SHIRLEY REECE-HUGHES

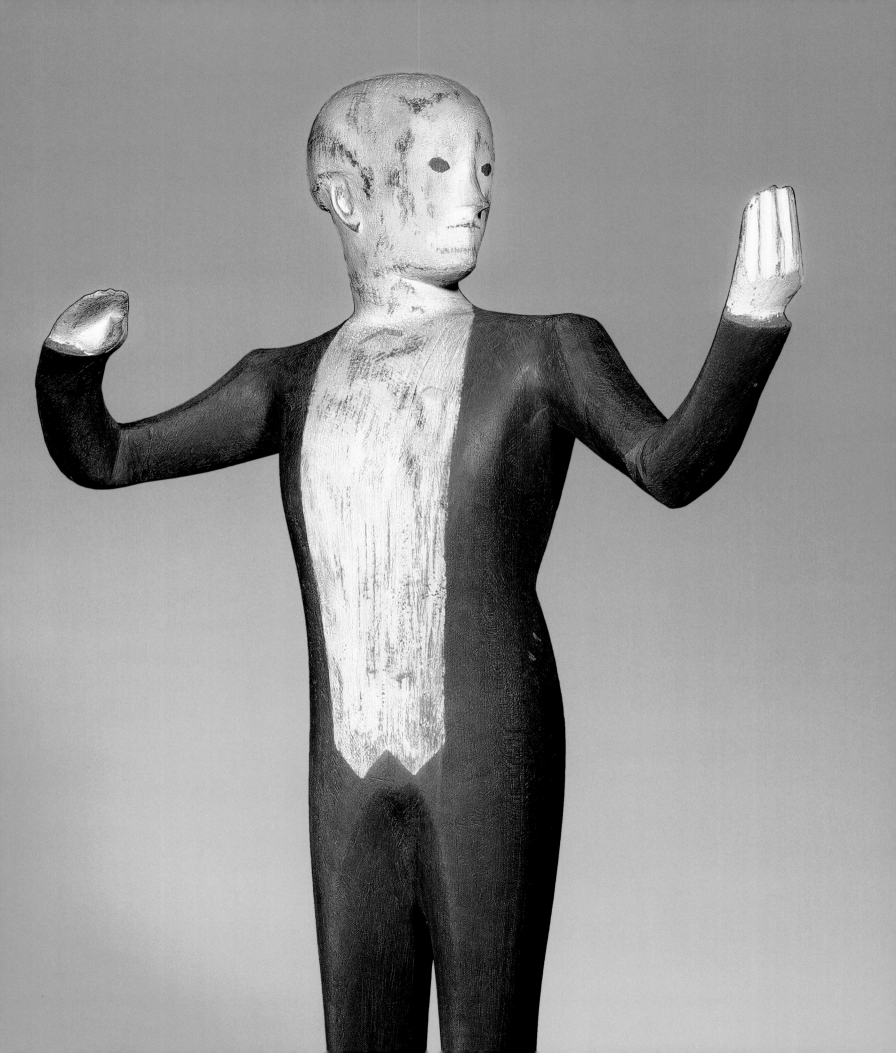

Lenders to the Exhibition

Susan and Herbert Adler Collection

Albright-Knox Art Gallery, Buffalo, New York

Allen Memorial Art Museum, Oberlin College, Ohio

Amon Carter Museum of American Art,
Fort Worth, Texas

Marc and Ronit Arginteanu

The Art Institute of Chicago

The Baltimore Museum of Art

The Barnes Foundation, Philadelphia, Pennsylvania

Bernard Goldberg Fine Arts LLC, New York

Brooklyn Museum, New York

Bruce Museum, Greenwich, Connecticut

Colby College Museum of Art, Waterville, Maine

Conner · Rosenkranz LLC, New York

Farnsworth Art Museum, Rockland, Maine

Harvard Art Museums / Fogg Museum, Cambridge,
Massachusetts

Hirshhorn Museum and Sculpture Garden,
Smithsonian Institution, Washington, D.C.

The Huntington Library, Art Collections, and
Botanical Gardens, San Marino, California

Myron Kunin Collection of American Art,
Minneapolis, Minnesota

Lachaise Foundation, New York

Memorial Art Gallery of the University of Rochester,
New York

The Metropolitan Museum of Art, New York

Mount Holyoke College Art Museum,
South Hadley, Massachusetts

The Museum of Modern Art, New York

Collection of Cynthia Nadelman

Philip and Theresa Nadelman Collection

National Portrait Gallery, Smithsonian Institution,
Washington, D.C.

The New York Public Library for the Performing Arts,
Astor, Lenox and Tilden Foundations

Philadelphia Museum of Art

Portland Museum of Art, Maine

Smithsonian American Art Museum, Washington, D.C.

Wadsworth Atheneum Museum of Art,
Hartford, Connecticut

George H. Warren, Courtesy of Findlay Galleries

Whitney Museum of American Art, New York

Worcester Art Museum, Worcester, Massachusetts

The Estate of Dr. Samuel and Adele Wolman

Private lenders

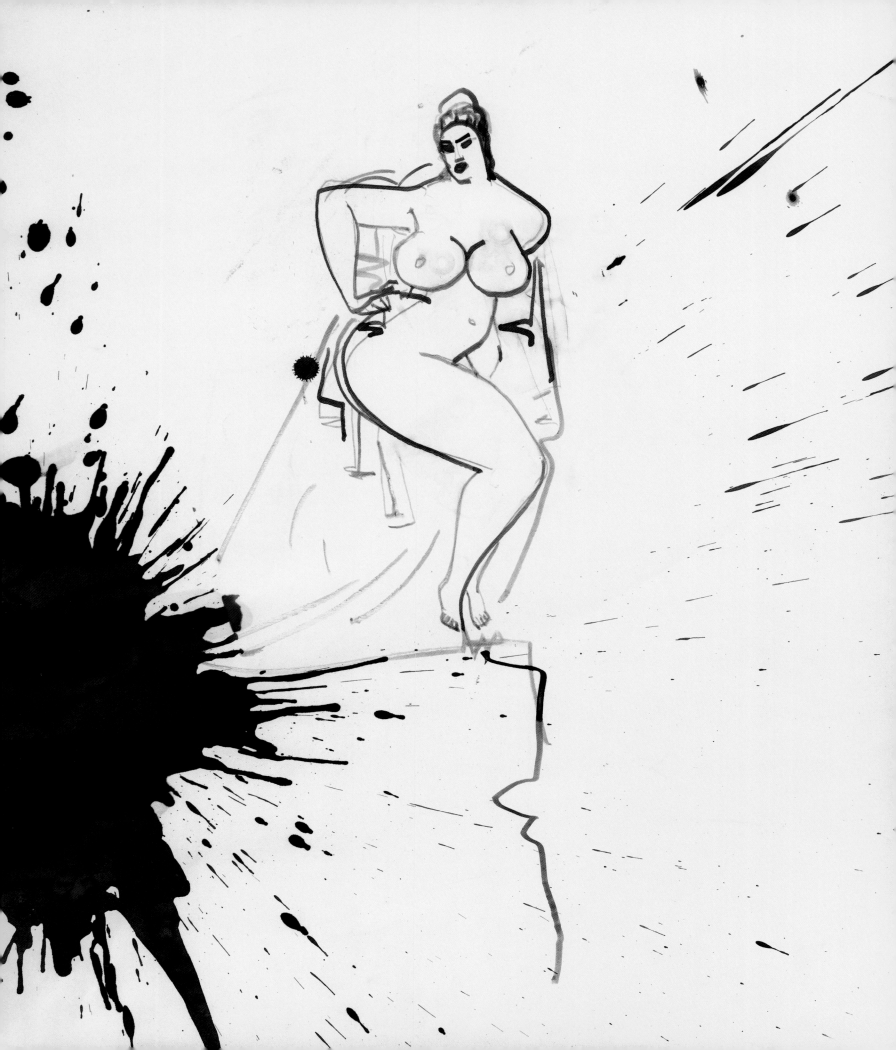

Catalogue Authors

ANDREW J. ESCHELBACHER, Ph.D.

Susan Donnell and Harry W. Konkel Assistant Curator of European Art
Portland Museum of Art, Maine

MICHAELA R. HAFFNER

Curatorial Assistant
Amon Carter Museum of American Art, Fort Worth, Texas

RONALD HARVEY, M.F.A.

Conservator and Principal
Tuckerbrook Conservation, Lincolnville, Maine

SHIRLEY REECE-HUGHES, Ph.D.

Curator of Paintings and Sculpture
Amon Carter Museum of American Art, Fort Worth, Texas

ROBERTA K. TARBELL, Ph.D.

Professor Emerita of Art History
Rutgers University, Camden, New Jersey
Visiting Scholar
Center for American Art, Philadelphia Museum of Art

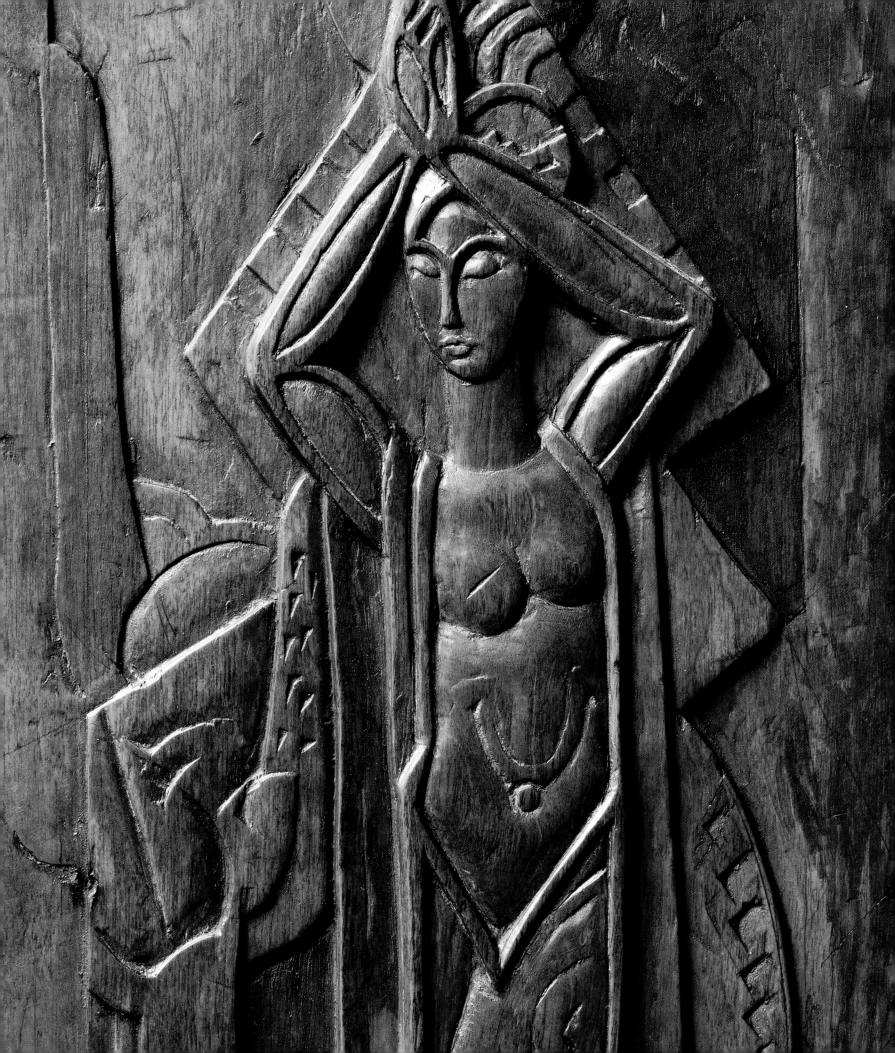

Paris and the Birth of a New American Sculpture

ANDREW J. ESCHELBACHER

Paris was the epicenter of sculptural innovation in the Western world between 1900 and World War I. Artists from across Europe and the United States descended on the French capital, seeking to develop a new style of sculpture appropriate for modernity's radically shifting social and aesthetic climate. They innovated and rebelled, exchanged ideas and challenged each other's assumptions, while breaking from established sculptural practices. During these years, the city became a cauldron of artistic innovation.[1] Among the group of young sculptors, European-born artists Gaston Lachaise, Robert Laurent, Elie Nadelman, and William Zorach took part in the vibrant artistic scene before settling definitively in the United States. In America, they went on to pioneer a distinct mode of art that probed the intersections of an international-style modernism and the local forms and popular imagery of their adopted country.

While Lachaise, Laurent, Nadelman, and Zorach became leading American modernists in the 1920s and 1930s, the lessons from their Parisian experiences in the prewar decade were foundational. In those years, Auguste Rodin existed as a towering presence to be emulated or rejected. Artists reconsidered historical sources and art from around the globe filled the city's galleries, museums, and international exhibitions. As artists navigated these diverse influences, they developed new modes of sculpture that prioritized the harmonious relationship of curve, volume, and surface. Lachaise, Laurent, Nadelman, and Zorach participated in this culture in different ways, responding uniquely to the revolutionary aesthetics that developed in those years. Nevertheless,

their American works continually recall their engagement with the artistic ingenuity they witnessed in the French capital.

The Problem of Rodin

In June of 1900, Auguste Rodin opened his first solo exhibition just outside the gates of the Exposition Universelle, the world's fair marking the start of the new century. At the Pavillon d'Alma, erected especially for Rodin's installation, the artist displayed more than 150 sculptures, drawings, and watercolors.[2] The *Monument to Balzac*, *The Burghers of Calais*, and *The Gates of Hell*, as well as countless fragments, formed the core of the exhibition, which was the apotheosis of Rodin's revolutionary departure from academic conventions and from the neo-baroque monumentality of the sculpture on the official exhibition grounds next door.[3] The extensive display seemed the perfect expression of the drama, intense psychological weight, and virility of the new age. The show proved to be the apogee of Rodin's career, affirming his role as the most dynamic and influential sculptor at the turn of the century.

The American infatuation with Rodin had begun in full the previous decade, when sculptors and critics had sought out the Frenchman's art as an alternative to the staid style of the École des Beaux-Arts and American art schools.[4] In addition to the numerous artists who visited Rodin in Paris, many others saw his work at American exhibitions, especially after the Chicago World's Fair of 1893.[5] Countless sculptors mimicked the animated surfaces and dynamic poses that communicated psychological and emotional nuances of the human condition. This style spread across the country, and by the early twentieth century American sculpture revealed a great debt to Rodin's example.[6] Indeed, adherence to the Frenchman's

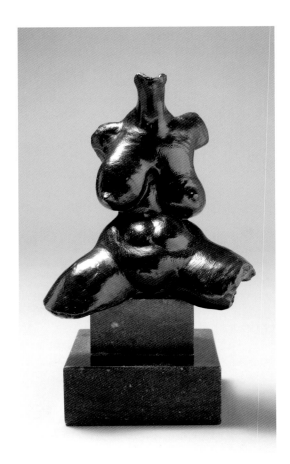

FIG. 1 **Gaston Lachaise** (United States, born France, 1882–1935), *Female Torso*, 1928, bronze, 8 1/2 x 8 x 2 1/2 inches. Harvard Art Museums / Fogg Museum, Gift of Lois Orswell, 1955.188

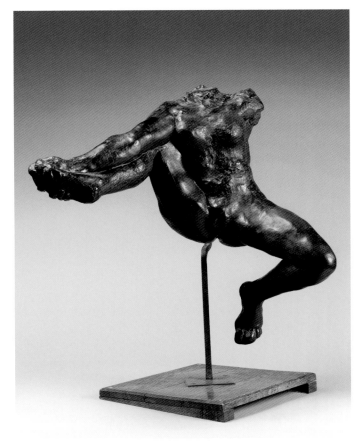

FIG. 2 **Auguste Rodin** (France, 1840–1917), *Iris, Messenger of the Gods*, circa 1895, cast prior to 1916, bronze, 32 1/2 x 27 x 24 3/4 inches. Musée Rodin, Paris, S.1068

aesthetic was widespread among American-born sculptors who sought to be modern, leading to what Ilene Fort has identified as a cult of Rodin in the United States.[7]

Lachaise, Laurent, Nadelman, and Zorach developed ambivalent relationships to Rodin's art as they came to know it in Paris.[8] Lincoln Kirstein, an influential critic, curator, and champion of Nadelman, noted:

> Rodin's influence on Nadelman is apparent in reproductions of two early plaster groups . . . as well as a fine portrait sketch of Thadée Natanson of 1909. Later, Rodin's denial of the integrity of stone as a material, the textural softness of his marble cut by his *praticiens* and *metteurs au point* oppressed Nadelman, who never failed in his admiration for [Rodin's] *The Age of Bronze* or *Balzac*.[9]

Gaston Lachaise maintained a similarly equivocal stance vis-à-vis Rodin. Lachaise had been a student at the École des Beaux-Arts at the time of Rodin's Alma exhibition and almost certainly visited the show.[10] The younger artist's tendency to repurpose models and to extract fragments of sculptures developed directly from the unique process that Rodin exhibited in 1900.[11] The frank sexuality of Lachaise's later work (for example, **FIG. 1**) specifically recalls Rodin's depictions of the female body in sculptures such as *Iris, Messenger of the Gods* (**FIG. 2**); elsewhere, Lachaise's 1933 portrait of Kirstein (**PLATE 20**) directly evokes Rodin's *Saint John the Baptist* (**FIG. 3**) and the related *Walking Man*.[12] Despite these clear influences, Lachaise was constantly in search of a simplicity of form and sculptural silhouette that distinguished his style from Rodin's.[13] The smooth surfaces and lack of visible modeling in his refined sculpture created further distinctions from his forerunner. Indeed, his friend E. E. Cummings specifically argued that the artist's "crisp and tireless searching for the truths of nature as against the facts of existence, negates Rodin."[14]

Cummings' claim about Lachaise "negating" Rodin is markedly similar to French critic André Salmon's writing about new sculpture in Paris after 1900. Salmon wrote that the young sculptors of the French school were entirely committed to their revolution, which necessitated the "demolition, the negation of Rodin."[15] Nevertheless, the artists of the new generation—with whom Lachaise, Laurent, Nadelman, and Zorach mixed—remained indebted to the elder artist, even as they broke away from the emotional weight

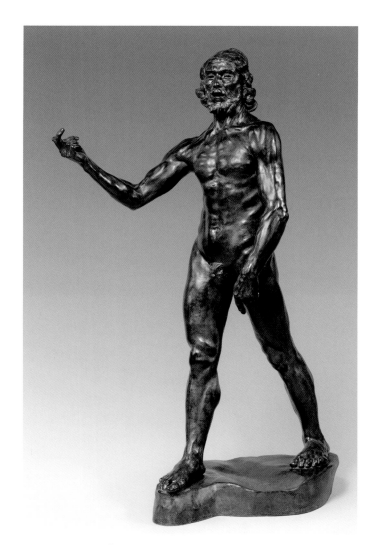

FIG. 3 **Auguste Rodin** (France, 1840–1917), *Saint John the Baptist*, 1880, cast 1915, bronze, 80 x 28 1/4 x 47 inches. Musée Rodin, Paris, S.999

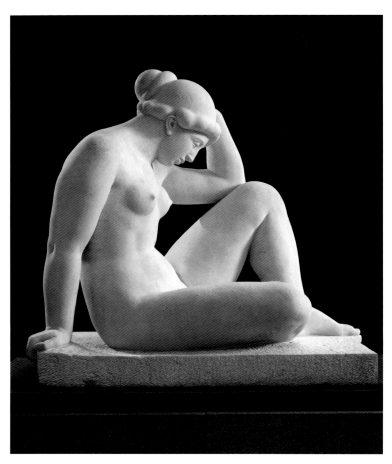

FIG. 4 **Aristide Maillol** (France, 1861–1944), *La Méditerranée*, also called *La Pensée*, 1923–29, marble, 39 1/2 x 46 1/4 x 27 inches. Musée d'Orsay, Paris, France, RF3248;AM1463

rounded forms. Critics also noted how Maillol drew on Archaic Greek precedents rather than the canonical classical ones, leading Roger Fry to write that the sculpture had "the solemn eyes and grand authority of the magnanimous spirits of the antique described by Dante."[18] The critic Jacques Tournebroche deemed the sculpture "a perfect simplicity of lines," remarking, "the powerful ease of the forms animates the marble and enlivens it. The white skin appears to turn pink through the sculpture's contained emotion."[19] The novelist and essayist André Gide also lauded Maillol, describing *La Méditerranée* as silent and beautiful, offering a sense of calm nobility.[20]

Organized through a series of carefully arranged triangular shapes, *La Méditerranée* became the most prominent expression of the forthcoming international aesthetic rooted in grace, balance, and lack of emotional drama. Yet it was not the only example of that mode in 1905. At the same Salon, Emile-Antoine Bourdelle exhibited his *Pallas Torso* and his remarkable *Hercules the Archer*. Joseph Bernard, too, began a new style of expression in 1905 with the elegant simplification of form and graceful arabesque curves of his *Dancer*.[21] François Pompon modernized the tradition of animal sculpture, capturing all manner of creatures with a new simplicity, surface unity, and formal calm. As scholar Catherine Chevillot notes, "something was in the air," and it would inform the work of Lachaise, Laurent, Nadelman, and Zorach, who matured in Paris around this moment of experimentation and innovation.[22]

Gaston Lachaise

Gaston Lachaise was born in Paris in 1882. Like Rodin and many nineteenth-century sculptors, Lachaise emerged from a working-class background and began his formal training at a school for the applied and decorative arts. While many nineteenth-century artists had studied at the École Gratuite du Dessin in Paris, Lachaise began his training at the École Bernard Palissy before gaining entrance to the prestigious École des Beaux-Arts in 1898.[23] At the nation's top art school, which had rejected Rodin three times in the late 1850s, Lachaise trained with the conservative sculptor Gabriel-Jules Thomas. He exhibited at the annual official national Salons and was seemingly on track to win the prestigious Prix de Rome. Yet after

and complex compositional strategies of his œuvre. They also turned against the romantic drama of Rodin's art and its explicit links to historic sources and literary texts. Rather than return to the traditions of the academic mode, which relied heavily on narrative and the mimetic or naturalistic representation of the human body, the younger artists developed a mode of sculpture based on formal calm, simplification, and contemplation. They wanted their art to be universally understandable and self-contained based on its shapes, surfaces, and silhouettes, not through the knowledge of complicated stories.[16]

1905 proved to be a turning point in the development of this new style. At the Salon d'Automne, the Frenchman Aristide Maillol exhibited *La Méditerranée* (**FIG. 4**) in plaster, an early example of the new mode of sculpture.[17] Depicting a French peasant woman as a classical figure, the statue impressed audiences with the elegant simplicity of its smooth surfaces and

falling in love with married Canadian-American Isabel Nagle, whom he had met in Paris in 1903, Lachaise quit his formal training and took a job in the jewelry workshop of René Lalique in order to earn enough money for his passage to the United States.

Lachaise likely met Lalique when both men teamed with sculptor Jean-Paul Aubé to erect the wood sculpture *La Reconnaissance*, which earned the Grand Prix at the Exposition Universelle of 1900.[24] Working in Lalique's studio between 1903 and December 1905, Lachaise expanded the practical knowledge of materials and techniques that he had developed at the École Bernard Palissy. The hands-on work of casting objects, making models, and carving hard materials would have a significant impact on his American career.

In addition to deepening his facility for the craft of sculpture and the decorative arts, Lachaise's time with Lalique provided a stimulating departure from the classical Greek studies the young sculptor had undertaken at the École des Beaux-Arts.[25] Lalique's art epitomized the flowing curves and natural forms of the Art Nouveau movement, which rejected academic-style applied and decorative arts.[26] The serpent was one of the jeweler's most important motifs because, as scholar Marie-Odile Briot explains, "the snake is the living abstraction of the line which Art Nouveau would see as the underlying 'biomorphic' structure of form."[27] Lachaise appears to have taken these lessons to heart, even keeping a live snake in his pocket at times in order to study its movement.[28] Lalique's vision of his objects as modern, intellectual talismans also surely informed Lachaise's later effort to concentrate his sculpture into a cosmological expression of woman.[29]

In December 1905, Lachaise set sail for America, bringing with him a strong recommendation letter from Lalique.[30] Upon his arrival, he worked as a studio assistant for artists including John Evans, Henry Hudson Kitson, and Paul Manship. He continued to develop his own art in the evenings and in his free time, while also spending time with his love Isabel Nagle. Lachaise and Nagle eventually married in 1917, after Nagle's son left for college, freeing her to divorce her first husband.[31] Even in the years before their official union—and for the rest of Lachaise's life—she was his muse and the inspiration for many of his works. Lachaise would certainly have kept her in mind as he modeled countless small studies of the female form, including *Nude with a Coat*, displayed at the Armory Show of 1913.

Lachaise seems to have used statuettes such as *Nude with a Coat* and *Woman Walking* (PLATE 2) to conceptualize the forms and movements of women, ultimately in preparation for more monumental artworks such as *Standing Woman* (also known as *Elevation*; PLATE 16).[32] This work was not just a testament to his love for Isabel, but a statement of a universal, talismanic idea of womanhood. In the transition between the studies and the finished sculpture, he simplified the figure's physical movement and reduced her skeletal and muscular details to a generalized anatomy of bodily planes and rounded curves. He also eliminated the overt signs of his modeling by smoothing the rounded surfaces, emphasizing the woman's sinuous lines. As a result, the full-figured woman seems to rise effortlessly from the ground, making contact with the earth just at the balls of her feet. Her raised arms complement the skyward energy, while the apparent weightlessness of the body is paradoxical in light of its corporeal fullness. The work expresses a composed grace in its simplified anatomical forms.

While Lachaise sculpted mainly female figures through his career, his portrait of Lincoln Kirstein (PLATE 20) reveals his adept handling of the male form. When Lachaise depicted his close friend, he used Rodin's *Saint John the Baptist* as a point of departure and augmented the pose with inspiration drawn from an Egyptian sculpture of the god Amun that he and Kirstein had seen at the Metropolitan Museum of Art in New York.[33] Despite the visible references to these precedents, Lachaise made the *Kirstein* his own, blending stylistic simplification, ethereal weightless-ness, and an animated surface.

Lachaise squared and slightly opened his subject's hips and presented him straight-backed with his head held erect. Though the critic's left foot rests firmly on the ground, the orientation of his legs, the verticality of his chest and head, and the lithe, delicate gesture of his right toes pushing off the ground make the sculpture seem buoyant. Its grace alludes to the movements of the ballet, one of Kirstein's passions. The gleaming, stippled golden surface enlivens the blend of masculine power and delicacy, while simulta-neously suggesting an attention to surface detail honed in Lalique's studio.[34] Executed at a much smaller scale than Rodin's hulking *Saint John*—and lacking

the romantic verve of distended musculature and virile modeling—the *Kirstein* becomes jewel-like and self-contained. It appears fully resolved formally and thematically; its simplified composition and sense of calm depart from Rodin's probing representation of movement in his striding figure.

Both *Standing Woman* and the Kirstein portrait demonstrate Lachaise's participation in the international style of modernism that Maillol's *La Méditerranée* typified. Rather than use distended musculature to create meaning in the style of Rodin, artists such as Maillol and Lachaise focused on reducing the animation of the anatomy to create a harmony of line, curve, and volume. In describing the principles behind these artworks, Maillol argued that his sculpture was architecture, created through a balancing of forms rooted in geometrical principles.[35] This equivalency between modern sculpture and architecture became standard in the contemporary discourse. The influential critic and artist Adolf von Hildebrand explained that architectural sculpture prioritized the overall unity of masses and shapes rather than the specific details of internal forms.[36] For Hildebrand, architectural sculpture revealed the potential of art, enabling viewers "to realize a unity of form lacking in the objects themselves as they appear in Nature."[37] Years later, Kirstein echoed these ideas when he wrote that Lachaise's art revealed his "profound knowledge of the architecture of the human body."[38]

Lachaise continued to grow as a sculptor in the United States, but the seeds of his aesthetic were planted in Paris through his training, work for Lalique, and time enjoying the artistic scene of the city and the sculptors' enclave near Montparnasse, where he lived.[39] Though he departed for America before the high point of Montparnasse's avant-garde culture of modern sculpture, the spirit of innovation was already blossoming during his final years in the neighborhood. For over a generation, it had been a sector of Paris where sculptors including Jules Dalou and Alexandre Falguière had studios. Bourdelle soon joined them, and by the turn of the century Montparnasse was a central spot for young artists to congregate. Many Eastern European Jewish immigrants to Paris arrived on the scene, including Elie Nadelman in 1904 and later William Zorach, as did the students of Henri Matisse in the years before World War I. Pioneering sculptors such as Ossip Zadkine, Chana Orloff, and

Amedeo Modigliani moved between the Café du Dôme and the neighboring Café de la Rotonde, exchanging ideas and techniques. Even the avant-garde artists who lived in Montmartre, at the other end of the city, would trek across Paris to drink and debate in these cafés.[40]

Despite his early departure, Lachaise certainly benefited from the neighborhood's innovative environment and the spirit of sculptural revolution that permeated the city. He had likely seen Maillol's *La Méditerranée* at the Salon d'Automne in 1905, but if by some chance he had not, he would at least have been aware of it through countless newspaper reviews as well as discussions with his peers. He was certainly attuned to the new modes of modernism that Maillol and his contemporaries such as Bourdelle pioneered. These artists, whom the academic American sculptor Lorado Taft described as "conspicuous insurgents," together with the culture of creativity from which they emerged, continually informed Lachaise's American œuvre.[41]

Elie Nadelman

Nadelman entered the Montparnasse circle in 1904, settling in Paris after a brief stop in Munich. The destination was natural for the Polish émigré, since an exile in Paris was "presupposed" for any Polish patriot, as Kirstein explained.[42] Once in France, Nadelman quickly became a part of the Polish art community, circulating among the Eastern European artists who spent time at the Café du Dôme and were later part of the School of Paris.[43] Over the course of the decade, Nadelman became a fixture in galleries and salons, regularly exhibiting at the Salon des Indépendants and the Salon d'Automne, as well as securing solo exhibitions at the Galerie Druet in 1909, London's Paterson Gallery in 1911, and again at Druet in 1913.

Before arriving in France, Nadelman had studied in Poland and Munich, where he likely first encountered Adolf von Hildebrand's ideas about architectural forms. As Kirstein pointed out, Nadelman's earliest Parisian sculptures recall the intensity and interconnected forms typical of Rodin's style.[44] He soon began separating himself from this mode, instead using formal references to classicism as a starting point for his new approach to modernism. Nadelman's commitment to the past went so far as to earn him

the nicknames "Phidiassohn" and "Praxitelmann," in reference to the famed Greek sculptors Phidias and Praxiteles.[45] He was even willing to fight for his beliefs about the significance of classicism for modern art, actually coming to blows with the Futurist theorist Filippo Marinetti, who advocated destroying the arts and knowledge of the past.[46] Critics such as the Franco-Polish poet Guillaume Apollinaire explained that the artist's graceful and noble style justified his efforts to align himself with the grand tradition of ancient Greek sculptors.[47]

Nadelman's *Standing Female Figure (Gertrude Stein)* (FIG. 5) is typical of his effort to renew modern sculpture through classical sources. The scholar Pick Keobandith suggests that Nadelman drew inspiration from a Greek statue of Aphrodite at the Louvre to create his form, "only made up of curved lines which give her a plastic harmony and a certain sensuality."[48] The turn to ancient precedents freed Nadelman and his peers such as Maillol, Bourdelle, and Charles Despiau from turn-of-the-century conventions of naturalism and drama and offered an opportunity to focus entirely on the formal elements of sculpture.[49]

In this way, form became Nadelman's chief subject, as he believed "it is the form itself, not resemblance to nature, which gives us pleasure in a work of art."[50] The artist declared that his subjects were "nothing but a pretext for creating significant form, relations of forms which create a new life that has nothing to do with life in nature, a life from which art is born, and from which spring style and unity."[51] He created a series of ideal heads and full-length figures, including *Standing Female Figure*, which use references to the past without the ancient context or meaning. Instead, these sculptures explore the relationship of planes and curves along with convex and concave shapes.

Entrenched in the modernist milieu of Paris, Nadelman's ideas and example intersected with the avant-garde practices of Pablo Picasso, Alexander Archipenko, Constantin Brancusi, and Amedeo Modigliani.[52] His 1909 exhibition at the Galerie Druet shocked his peers specifically because of the new forms of modernism.[53] Later, Nadelman claimed to have invented the principles of Cubism, which he said Picasso then appropriated after seeing Nadelman's drawings in the collection of Leo Stein (Gertrude's brother).[54] Others have suggested that the ovoid forms of Nadelman's ideal heads inspired Brancusi's

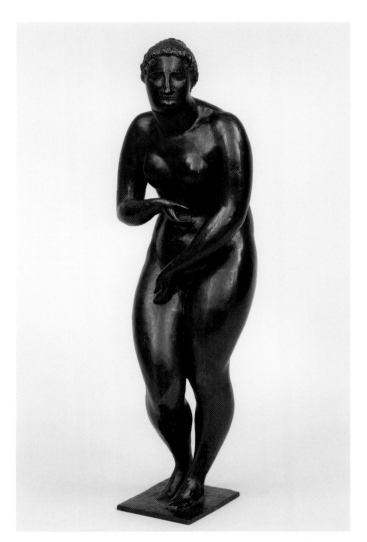

FIG. 5 **Elie Nadelman** (United States, born Poland, 1882–1946), *Standing Female Figure (Gertrude Stein)*, circa 1907, bronze, 29½ x 10½ x 9½ inches. Whitney Museum of American Art, New York; Gift of the Estate of Elie Nadelman, 97.149

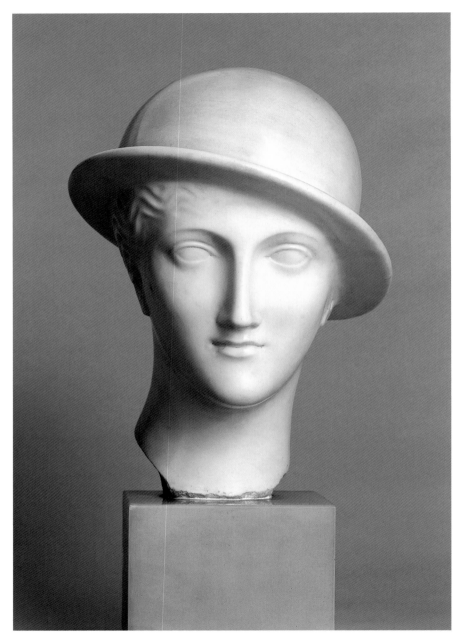

FIG. 6 **Elie Nadelman** (United States, born Poland, 1882–1946), *Mercury Petassos I*, circa 1914, marble, 16 inches (height). Collection of Diane and Robert Moss

simplification of forms and shapes in his muse busts.[55] Though Nadelman never became as abstract as Brancusi, the comparison draws attention to a shared basic premise of their art, which Nadelman continued to pursue in his late Paris years and into his time in America.

His *Seated Female Nude* (**PLATE 8**), for instance, characterizes his application of the doctrine of significant form around the start of World War I as he moved away from direct references to classicism. Without defined musculature, the limbs, head, and torso are volumetric tubes that approximate human movement. The left leg elegantly bends at the front of the composition, finding a counterbalancing gesture in the swoop of the right arm. The elongated right leg locates its own harmonious pairing in the softly arcing fall of the figure's left arm. The nude's delicate balancing act on the simple pedestal increases the sculpture's grace by separating its movement from the stabilizing marble support. The play between the body and the pedestal emphasizes the artist's search for equilibrium in the simple and refined arrangement of line, curve, and volume. The sculpture typifies Nadelman's understanding that, as André Gide explained, "every curve of the human body is accompanied by a reciprocal curve, which opposes it and corresponds to it."[56]

In the last years of his Parisian period—and in his earliest works made in the United States—Nadelman also began amplifying his classicism with more concrete allusions to popular culture. In *Mercury Petassos I* (**FIG. 6**), for instance, the artist created a marble bust of the Roman god wearing a contemporary hat. Nadelman's effort to collapse contemporary and antique fashion lends a forceful modern energy to the sculpture. The young god has been updated to the twentieth century, not just in formal style, but also in attitude and comportment. This new direction in Nadelman's art would have a lasting impact on his American œuvre, as seen in his seminal *Man in the Open Air* (**PLATE 9**), which also fuses a classical precedent with a modern, American verve.

New Classicism and Modern Forms

As Nadelman turned to classicism, he joined many artists in Paris who mined historical styles and vernacular aesthetics. Artists investigated all manner of precedents, including pre-classical Greek sculpture, folk art, Japanese art, African and Oceanic sculpture,

and even the European Gothic style, among others. Some, such as Nadelman, also looked to the classical tradition—but with new eyes and a concern for the formal potential of modernism, rather than trying to connect directly to a revered canon. As a result, a type of "new classicism" developed, which scholar Penelope Curtis notes "owed as much, if not more, to pre-classical or non-Western sources as to the Classical and Renaissance traditions."[57] As Curtis' reference to both pre-classicism and non-Western sources implies, the term "new classicism" is complicated. For example, many of the African and Oceanic artworks from which sculptors and painters culled inspiration actually dated from the very recent past. Nevertheless, artists viewed them through a historic lens because they represented societies and styles of visual culture that appeared distant from the modern bourgeois city.

Kenneth Wayne has suggested that the resurgence of seemingly classical sources forged a conceptual unity that informed the universalist, international aesthetic of modernism. He wrote, "each artist was going back to fundamentals . . . back to the long Western art tradition (to ancient art or that of the Renaissance), or to non-Western sources (African, Oceanic, or Cambodian art), as a way to create a universal and international artistic language that could be understood by a wide range of individuals."[58] While the traditional classical or Renaissance inspirations persisted in practice, these sources were often overshadowed in modernist rhetoric by styles outside of this academic canon.

Art from the Archaic Greek period, which artists could study at museums or in reproductions, took new prominence in sculptors' minds and vocabularies. Indeed, Antoine Bourdelle, in a gesture representative of the broader appreciation for pre-classical Greek sculpture, installed a plaster copy of a typical Archaic Kouros in a place of prominence on the wall in his studio (**FIG. 7**). For early twentieth-century commentators, Archaic sculpture demonstrated the calm compositions and architecturally simplified forms that resonated with new concerns about the harmony of line, curve, and volume.[59] Modernist critics, for example, were quick to relate Maillol's classical sources to these specific pre-classical Greek examples, and some also linked Nadelman's view of the ancient past to Archaic inspirations.[60] Later in the century, William Zorach proudly walked past the classical Greek installations at

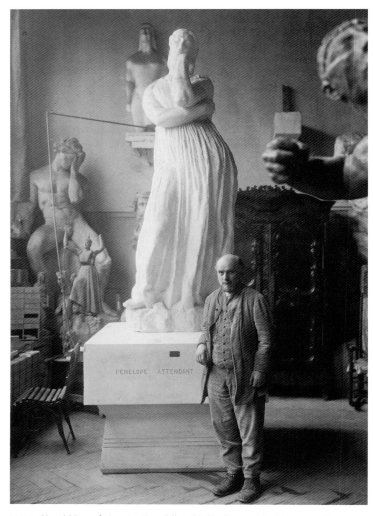

FIG. 7 **Henri Manuel**, *Antoine Bourdelle in his Studio, near the Monumental "Pénélope" in Plaster on a Plinth*, circa 1916, gelatin silver chloride print. Musée Bourdelle, Paris, MB Ph 213

the Metropolitan Museum of Art to focus on the Archaic artworks.[61] Robert Laurent directly evoked the Archaic-style eye in several of his sculptures, including his *Reclining Figure* relief (**PLATE 46**).

As the scholar Susan Rather notes, this interest in Archaic art led artists to "the appreciation—and appropriation—of other art that had been overlooked as a result of the nineteenth-century bias towards Naturalism."[62] Discussions of the Archaic style (itself informed by Eastern influences on Greek art) overlapped with the interest in Etruscan, Egyptian, Near Eastern, Gothic, Byzantine, and Indian art, which had been staples of museum collections for over a century and marked a difference from the classical, Renaissance, and academic canons. Folk traditions also took on a larger role in these discourses after the 1880s, and

Laurent, Nadelman, and Zorach would have been intimately familiar with such traditions from their Breton, Lithuanian, and Polish heritages.

As African and Oceanic artworks entered Europe's visual culture in increasing quantities in the early 1900s, modern artists quickly took inspiration from these new forms as well.[63] Though major cultural differences informed the reception of the Archaic sources and these African and Oceanic pieces, they were often enfolded into the diversity of new classicism. The tastemakers of the early twentieth century collected a wide range of art that supported this type of amalgamation. The gallery owner Joseph Brummer, well known as the principal dealer of African art in Paris between 1908 and 1914, described himself as an antiquarian and primarily sold antiquities from Greece, Rome, and Egypt.[64] The poet Guillaume Apollinaire decorated his own quarters with folk-art puppets, Cubist paintings, African art, and more.[65]

Lachaise, Laurent, Nadelman, and Zorach each had opportunities to explore the diversity of these sources in France, setting the stage for a lifelong engagement with folk, non-Western, and historic art. Laurent viewed African art in Pablo Picasso's studio in 1906. The other three men also investigated what they broadly termed primitive sources—including the Archaic as well as African and Oceanic art—and applied the lessons to their art throughout their careers. Scholars have noted that even Nadelman, who is closely aligned with the classical style, drew inspiration from "Cycladic, Egyptian, Minoan, and Iberian sculptures."[66]

In the nineteenth and early twentieth centuries, commentators used the term "primitive" to describe the diverse artistic traditions that lay beyond the classical, Renaissance, and academic styles.[67] Some commentators eventually used different vocabulary, but the use of "primitive"—or "primitivism"—as a type of catch-all term was widespread among artists.[68] Many Europeans of Nadelman's milieu, for instance, described American folk art as a type of primitivism.[69] William Zorach argued that Archaic art "embodied all the finest qualities of simplicity and development of form with the purity and direct expression of all primitive art. It is an art expression of a gentle, kindly, full-blooded people; without desperate fears and complexes, full of tender gravity and vitality."[70] He later used the same terminology and adjectives for an analysis of African art. Likewise, in a discussion

of Archaic Greek sculpture, fifteenth-century Italian painting, and Egyptian, Mexican, African, and Sumerian art, the British sculptor Henry Moore noted that all "primitive art" manifests a striking quality of "intense vitality." He continued, "it is something made by people with a direct and immediate response to life. Sculpture and painting for them was . . . a channel for expressing powerful beliefs, hopes, and fears."[71] Robert Laurent described the folk carvings of his native Brittany in similar terms.[72]

The lack of distinction between cultures and time periods encapsulated by the use of the term "primitive" is undoubtedly problematic. As Moore's writing reveals, many artists and critics believed that the primitive transcended formal qualities, instead revealing a type of art making rooted in emotion and passion rather than intellect, rigor, training, and calculation. Though this construction emerged from a reductive and over-simplified view of non-Western and noncanonical European art, it appealed to those who wanted to pursue a universal version of modernism based on sincerity and authenticity of expression. The diversity of the aesthetics that they referenced was secondary to the (ostensibly) recognizable qualities of vitality, passion, and earnestness that united the styles. As a case in point, Gaston Lachaise wrote to his wife Isabel, "the most primitive, the most embryonic, have been the greatest artists—The Aztecs, drunk with fire and the monstrous and mystic blood of the devil; and also the warm, gray ashes completely still and white from burning." He believed that his own "mad enthusiasm" for making art inspired by Isabel was similar, declaring that it emerged from "My intoxication with you—driven to fiery white distraction from your mind and body."[73]

Robert Laurent

The new classicism's multiple sources played an important role in the career of the Breton-born artist Robert Laurent. Nearly a decade younger than Lachaise and Nadelman, Laurent arrived in the French capital in 1905 as a teenage student alongside Hamilton Easter Field, his American mentor and benefactor. Field had first discovered Laurent in the Frenchman's native village of Concarneau and relocated the precocious artist and his family to New York in 1902. After returning to Brittany in 1904, Laurent moved to Paris, where the well-connected Field had

arranged a job for him in the store of Ernest Le Véel, a dealer in Japanese ukiyo-e woodblock prints. Laurent developed a profound interest in the elegant frontality and planarity of these prints, which he eventually collected with Field.[74]

When Laurent settled in Paris, he intended to become a painter. Field arranged for him to train with his own cousin Frank Burty, an early champion of Cubism and collector of African art, as well as an intimate of Pablo Picasso, Amedeo Modigliani, and other artists.[75] Several months after arriving in the city, Laurent saw Maillol's *La Méditerranée*. He probably developed a fuller understanding of Maillol's art through his connec-tion to Ambroise Vollard, whom he had met in his work with Le Véel.[76] Laurent remembered Maillol's art for its "grand style and smooth well rounded forms." This impression and his first encounter with the woodcarv-ings of Paul Gauguin at the Salon d'Automne of 1906 were influential in his decision to become a sculptor.[77]

That year, the organizers of the Salon d'Automne exhibited about a dozen of Gauguin's woodcarvings among his paintings, prints, and ceramics. The critic Octave Maus focused on the internationalism of Gauguin's aesthetic, which set the stage for the diver-sity of new classicism. In Maus' words, "from the combination of all the scattered forces in the universe, new truths will be born."[78] Gauguin's technique and style in works such as *Soyez mystérieuses* of 1890 (**FIG. 8**) had a direct impact on the sculpture of the next generation. The relief reveals the raw energy of Gauguin's art while demonstrating his nuanced treat-ment of the wood surface. The texture and grain of the material add an emotional dimension to the carvings, combining sensuality, physicality, and intensity in his figures. As the art historian Elizabeth Childs notes, the "panels insist on their palpable materiality . . . over the subjects of the scenes."[79]

Though Gauguin carved *Soyez mystérieuses* in 1890, the exhibition of the work sixteen years later sparked a renewed interest in the direct carving of sculpture. Unlike conventional carving techniques of the nineteenth century, which relied on a pointing machine, with direct carving artists cut into stone or wood themselves, often without making a preparatory model. Paul-Louis Rinuy has pointed out that the technique's resurgence reached its pinnacle in 1907, with artists including Joseph Bernard, Constantin Brancusi, André Derain, Henri Matisse, and Pablo Picasso all

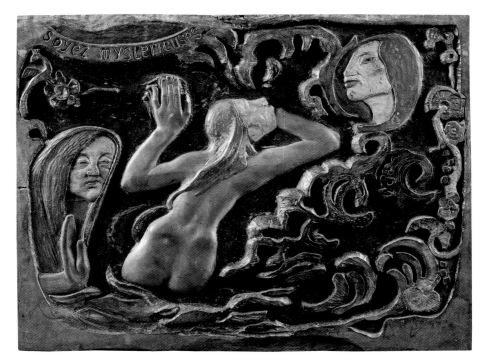

FIG. 8 **Paul Gauguin** (France, 1848–1903), *Soyez mystérieuses (Be Mysterious)*, 1890, polychrome wood relief, 28 3/4 x 37 1/2 x 2 inches. Musée d'Orsay, Paris, France, RF 3405

executing directly carved works.[80] Over the course of the next three decades, the technique became a dominant mode of modernist sculpture, with Robert Laurent, who had been in Paris in 1907, as one of its foremost practitioners.

For Laurent, direct carving allowed him to bridge his modern style with the folk traditions of his native Brittany. Describing his childhood there, he asked, "how can one be born in such a place and not become an artist?" noting the omnipresence of Breton art and granite sculpture in the region's hamlets.[81] Laurent cherished the spirit of the carver that he found in his native Breton carving, highlighting what he saw as the direct impulse of the artists whose sculpture asserted their faith.[82]

Following his sojourn in Paris, Laurent enjoyed a period in Rome before returning to the United States in 1910. In the Italian city, he may have honed his technical skills as a sculptor and craftsman, perhaps training with the little-known Italian wood carver Giuseppe Doratori and the painter-turned-sculptor Maurice Sterne, another artist inspired by Archaic art.[83] His growing facility with carving and composing sculpture became apparent shortly after his return to the United States, when his earliest works signaled something new in American sculpture. He was among the very first to introduce African aesthetics to American

modernism in carvings from 1913, 1914, and 1915, including *Head (or Mask)* (PLATE 5). Though he executed *Head* around 1915, many of the earlier examples predate Alfred Stieglitz's exhibition of Marius de Zayas' collection of African sculpture at his 291 gallery in 1914, which proved to be a landmark moment for accelerating American interests in African art.[84] Unlike several of his contemporaries who later drew inspiration from African sources, however, Laurent shied away from rough surfaces or highly exaggerated features. Rather, he melded African influences with the folk traditions he knew from Brittany and with the Archaic and architectural forms he valued in the work of Maillol and his teacher Sterne. This type of layering of sources and fusing diverse inspirations into composite forms recalled examples that Laurent had seen in Paris, including the work of direct carvers such as Amedeo Modigliani—a friend of his teacher Burty.

Laurent exhibited *Nile Maiden* (PLATE 52) and *Princess* (PLATE 53) at his first American solo exhibition at the Daniel Gallery in 1915. The two reliefs attracted the attention of the noted Philadelphia collector Dr. Albert C. Barnes, who purchased them and ordered several frames from the artist.[85] The reliefs show a modern sophistication and delicate lightness in their curves. Rather than a composition with the traditional frontality that Europeans ascribed to African art, Laurent

chose profile views for both faces while offering different perspectives of the bodies. The compressed space of the relief and the organization of the figure against the backdrop echo the Japanese print style that he knew well.

Nile Maiden shows the head and torso of a woman. The pronounced, shallow curve of the eye suggests Archaic and African influences. The artist elegantly balanced the eye with corresponding curves in the nose and lips. The woman's long fingers braid tubes of hair that flow over her nude breasts. The sculpture's title refers to Africa, though the evocation of Egypt points to an artistic culture that could be claimed by both classical and so-called primitive traditions.

In *Princess*, which Laurent executed at about the same time, the artist increased his focus on sculptural rhythm and experimentation. The subtle energy in the progression of the form—in the sweeping and undulating path from toes to shoulder—recalls the harmonies of line, curve, and volume that Nadelman helped pioneer in France. As with *Nile Maiden*, the surfaces and the exquisite treatment of the curled hair have a delicacy and textural regularity that belies the complicated curves and overlapping planes of relief. In both sculptures, the bodies appear smooth and polished, while Laurent left his chisel marks visible in the background. The contrast accentuates Laurent's direct connection to the artwork by signaling the carving process, allowing the refined treatment of the figures to testify to his skill at manipulating the hard material.

As Laurent developed as an artist, he gained fluency in manipulating the surface effects of stone as well as wood. For instance, in *Hero and Leander* (**PLATE 18**), the smooth polish and slight twist in the torso of Hero, the female figure, convey an elegant sensuality, while the rougher carving and granular tactility of Leander's chest suggest his masculinity. As Laurent worked the stone, which recalled the material of France's famous medieval cathedrals, he allowed its natural shape and hardness to dictate his architectural composition and simplification of forms. The artist organized the composition with a pronounced frontal orientation, creating a singular point of view. Nevertheless, he maintained a sense of animation by arranging multiple layers of sculptural depth in three planes, moving forward from the figures' heads to the front area of the sculpture where their legs intertwine. With its serene poses, simplified forms,

and earthbound heaviness, the sculpture recalls the modernized Archaic precedents of Maillol and Sterne. Laurent compounded these allusions in his representation of Leander's prominent eyebrows and nose, which form an Archaic, stylized *Y* framing his almond-shaped eyes.

William Zorach

While Laurent brought direct carving to modern art in the United States, in the following years William Zorach became the American movement's leading spokesman. Though he had a delayed start—only beginning to sculpt in 1917 after an early career as a painter—Zorach first gained an introduction to the mode in 1911 while in Paris, where the world of modern art opened to him for the first time. He wrote of the influence of seeing Japanese prints, the art of Gauguin, and paintings by Picasso and Cézanne. As he channeled these precedents, his painting took on a three-dimensional quality, leading him to determine that he "must carry it over into the true three-dimensional art—that of sculpture."[86]

Born in Lithuania, Zorach first came to the United States in 1893, where his family settled in Ohio.[87] After academic training in Cleveland and experience working for a lithographer, Zorach set off for Paris, where he took courses at a series of art academies, including the Académie Colarossi and La Palette. At the latter, Zorach studied with the Scottish painter John Duncan Fergusson, who was developing his modernist style at the intersections of Fauvism and German Expressionism.[88] Zorach noted that Fergusson was the most influential teacher for his artistic development.[89] That said, Zorach's most significant introduction at La Palette was to Marguerite Thompson, a fellow American student, whom he would later marry and who exerted a powerful influence on his art making.

During his year in France, Zorach worked exclusively in two-dimensional media. Nevertheless, he recalled moments of sculptural innovation, describing the sculpture he saw there as part of "the Revolution in art."[90] Like Nadelman—and perhaps alongside him—Zorach spent time with artists who gathered at the Café du Dôme.[91] With his future wife Marguerite, he met many avant-garde personalities, including Picasso and the Russian direct carver Ossip Zadkine, as well as the famed American writer and collector

FIG. 9 **Charles Sheeler** (United States, 1883–1965), *African Negro Sculpture*, plate 4, circa 1919, gelatin silver print, sheet and image: 8 7/8 x 5 7/8 inches. Smithsonian American Art Museum, Washington, D.C., Gift of Dahlov Ipcar and Tessim Zorach, 1968.154.808.4

Gertrude Stein.[92] These experiences in Paris created a lasting impact on his perspectives on art and the avant-garde. In his autobiography, he wrote, "A person evolves and develops his art through contacts and influences. . . . One has to absorb influences and through them develop one's own expression." Only after he studied at La Palette, he explained, could he move beyond conventional traditions and become freer as an artist.[93] Open to these lessons, Zorach approached art in America in a new way upon his return. He recalled his first year back in the United States with Marguerite in vivid terms: "We were modern (wildly modern) in days when a mere handful of people in America even knew Cubists and Fauves existed. We were drunk with the possibilities of color and form, and the new world that opened up."[94]

Zorach's earliest carvings evoke the lessons he learned in Paris, where he was fascinated by the experimentation he saw at the Salon d'Automne of 1911—one of the first exhibitions that introduced Cubism to the general public. His initial sculpture,

Waterfall (PLATE 44), for example, reveals the combination of fractured forms and African inspirations that he found in France. The artist originally intended the work to be a woodcut, but, enthralled by the cutting process, he kept carving to create a relief. He depicted a woman raising her arms and clasping her hands above her head. Her bent elbows create a diamond shape framing her face, offering an angularity that finds visual harmony with the triangular form of the drapery at her waist. In the drapery, position of the legs, and waterfall in the background, Zorach created a series of overlapping relief planes that recall the fractured, geometric aesthetic of Cubist paintings. The stylized treatment of the woman's arms—the ovoid shapes of the biceps and the forearms— reflects a modernist breakdown of anatomy in favor of more abstract, simplified renderings of musculature. Moreover, as Roberta K. Tarbell has noted, Zorach's depiction of the woman's eyes and nose recall a generalized impression of African masks, especially the ways European artists such as Picasso or Zadkine had interpreted these forms years earlier.[95]

Zorach described his turn to sculpture in the context of his admiration for "primitive" art.[96] About 1920, remembering his experiences in Paris, he felt an urgency to break from his mature painting style and begin sculpting. "I had been carving little things with a penknife," he later wrote. "My carvings were simple, rather primitive. I had never had any training in sculpture. . . . In sculpture I was free. I approached sculpture directly without inhibitions."[97] To cultivate this style, he visited American museums and galleries, looking at non-Western art and appreciating what he called its "power, versatility, and imagination."[98]

Zorach's writing often focused on his spirit as a sculptor, positioning himself within the rhetoric of the avant-garde. He was less expressive about his formal choices, which nevertheless reveal his efforts to navigate diverse sources and techniques in order to create a universal art. *Young Boy* (PLATE 51), for instance, shows his negotiation of the interplay between African sources and his lifelong interest in representing those close to him. The powerful sculpture depicts his son Tessim with his arms raised tightly alongside his body. The pose evokes Fang reliquary statues from western Africa that had been displayed in the 1914 exhibition of the de Zayas collection at Stieglitz's 291 gallery. Later, Zorach purchased an expensive portfolio of

photographs of de Zayas' collection by the American modernist Charles Sheeler (**FIG. 9**). Though it is a specific quotation of non-Western sculpture, *Young Boy* nevertheless suggests the simplified formal qualities and sense of architectural abstraction that informed the sculpture Zorach viewed in Paris. What is more, carving with a penknife and chisel allowed the artist to add layers of meaning and surface effects that recall the rough and aggressive style of early direct carving works by artists such as Zadkine.

As Zorach noted in a 1963 letter, he had discussed sculpture with Zadkine during 1911, when the two men and Marguerite visited the Salon d'Automne.[99] More than half a century later, Zorach remembered them watching "Lembruck [*sic*] touching up his *Kneeling Figure*." The precise memory is revealing, as Wilhelm Lehmbruck's sculpture, one of the preeminent modernist artworks in the contemporary discourse, served as an important touchstone for both Laurent (see **PLATE 55**) and Zorach in the early 1930s, when the German artist had two exhibitions at the Museum of Modern Art. Like Maillol and Hildebrand, Lehmbruck prioritized architectural unity in sculpture, noting that a good sculpture must read "like a good composition, like a building, where each measurement corresponds.... There is no monumental art, architectural art, without contour and silhouette."[100]

In *Kneeling Woman* (**FIG. 10**), a work exhibited in Paris and again at the Armory Show of 1913, Lehmbruck rendered an over-life-size woman with her right knee on the ground. The left foot also touches the base, as the position of the bent left leg thrusts the figure's left knee over her toes. The position of the legs creates a series of zigzag patterns, all in virtually the same sculptural plane. The downward glance complements the balance of the bent and elongated arm and the stillness of the torso for a contemplative effect. The entire figure appears unified in its gesture, creating a simplified whole, organized by the harmony of the total body rather than by the independent movements of a limb or a look.[101]

Zorach clearly had Lehmbruck's example in mind when he executed *Spirit of the Dance* for Radio City Music Hall in 1932. The original aluminum cast (**FIG. 11**) uses the sheen and reflective qualities of the soft metal material to create a textural richness and sense of energy. In updating Lehmbruck's example, Zorach inverted the orientation of the legs and added a degree

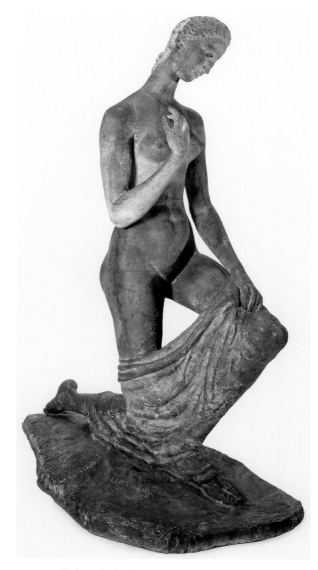

FIG. 10 **Wilhelm Lehmbruck** (Germany, 1881–1919), *Kneeling Woman*, 1911, cast stone, 69¼ x 54½ x 27½ inches. Albright-Knox Art Gallery, Buffalo, New York, Charles Clifton Fund, 1938, 1938:12

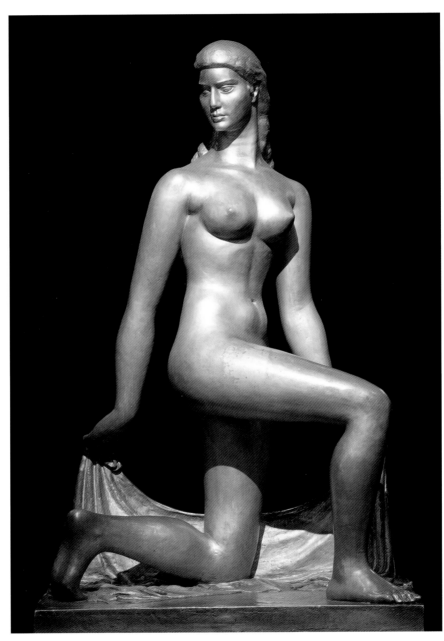

FIG. 11 **William Zorach** (United States, born Lithuania, 1889–1966), *Spirit of the Dance*, 1932, aluminum, 78 inches (height). Radio City Music Hall, New York

of controlled motion. The horizontal alignment of the head compounds the sense of movement that emerges from the angled legs. Rather than organizing the composition on a single line, Zorach arranged the sculpture as a series of intersecting planes, which nevertheless offer stable organization that regulates the verve. Whether in aluminum in the bustling setting of Radio City, or later in a bronze version installed at Zorach's Robinhood Cove home in Maine (PLATE 15), the sculpture balances modern sensibilities and contemporary allusions to dance with its architectonic structure and harmony of line, curve, and volume.

Unlike Lachaise, Laurent, and Nadelman, who spent extended time in Paris, thinking about the artistic developments as aspiring—and in Nadelman's case, accomplished—sculptors, Zorach interpreted the cutting-edge developments without his own three-dimensional practice in mind. Living in Paris as a painter, he discovered the precedents that led him to be modern. He processed many of these impulses only after he returned to the United States, but acknowledged that his experiences abroad were the catalyst for his mature œuvre and career as a sculptor.

Lachaise, Laurent, Nadelman, and Zorach experienced Paris at a crucial moment in the history of modernism, when artists sought to break radically with the past and chart a new sculptural direction. Their equivocal engagement with the style of Rodin, their rupture with the academic tradition, and their interest in noncanonical sources and techniques represented currents vital to sculpture in Paris between 1900 and World War I. That said, these tenets were not nearly as common in the sculpture made across the Atlantic in this period. In many circles, this new aesthetic was also undesired in the United States. Lorado Taft, an academic sculptor and admirer of Rodin, described the state of American sculpture in a 1917 lecture. He contrasted the modest virtues of his country's art with the modernist interventions of Henri Matisse and Alexander Archipenko, two titans of the post-Rodin reaction. Taft stated:

> We Americans have been told more than once that we are too sane to become great artists. We accept the dubious compliment and acknowledge that we do not expect to find a [Jean-Baptiste] Carpeaux nor a[n Ivan] Mestrovic among us, but neither shall

we add to the world's horrors through the misguided activity of a Matisse or an Archipenko. It is out of the question; in this unresponsive atmosphere of ours such things as they put forth would simply die of neglect. The excremental school makes no appeal to the average American.[102]

Though colorful in his language, Taft was far from clairvoyant in his pronouncement. During the next decade, the anti-Rodin reaction that Lachaise, Laurent, Nadelman, and Zorach had experienced in Paris developed in America, and Archipenko himself arrived in the country and affirmed his place as a leading avant-garde sculptor with transnational appeal.[103]

Lachaise, Laurent, Nadelman, and Zorach did not create art in the same Cubist style as Archipenko, but their sculpture nevertheless emerged from the same set of aesthetic and cultural circumstances that produced such forays into abstraction. Their style and technical approaches continuously recall the trends of European sculpture during the early twentieth century, when Maillol, Bourdelle, Brancusi, and others used the human body as the starting point for an investigation of new forms of sculptural harmony. As they exhibited this art, Lachaise, Laurent, Nadelman, and Zorach became leading figures in bringing the international aesthetic of modernism to the mainstream in America (see Roberta K. Tarbell's essay in this catalogue).

As Shirley Reece-Hughes explains in this catalogue, once settled in America, these immigrant artists searched for something distinctly local that could harmonize with their propensity for sculpture rooted in the values of universal authenticity and new European innovations.[104] They embraced their American surroundings, finding inspiration in the country's folk art, popular imagery, modern technologies, and local cultures. In so doing, they asserted the American dimension of their modernism, which was crucial as they assimilated into a new country. At the same time, they never forgot their common experiences in Paris, which instilled shared priorities for sculpture based on a simplification of forms, the elegant grouping of line, mass, and curve, and the potential of "new classical" sources. These formal principles and the accompanying attitudes about sculptural possibilities remained fundamental to their New World innovations, allowing them to create a new aesthetic from their transnational experiences.

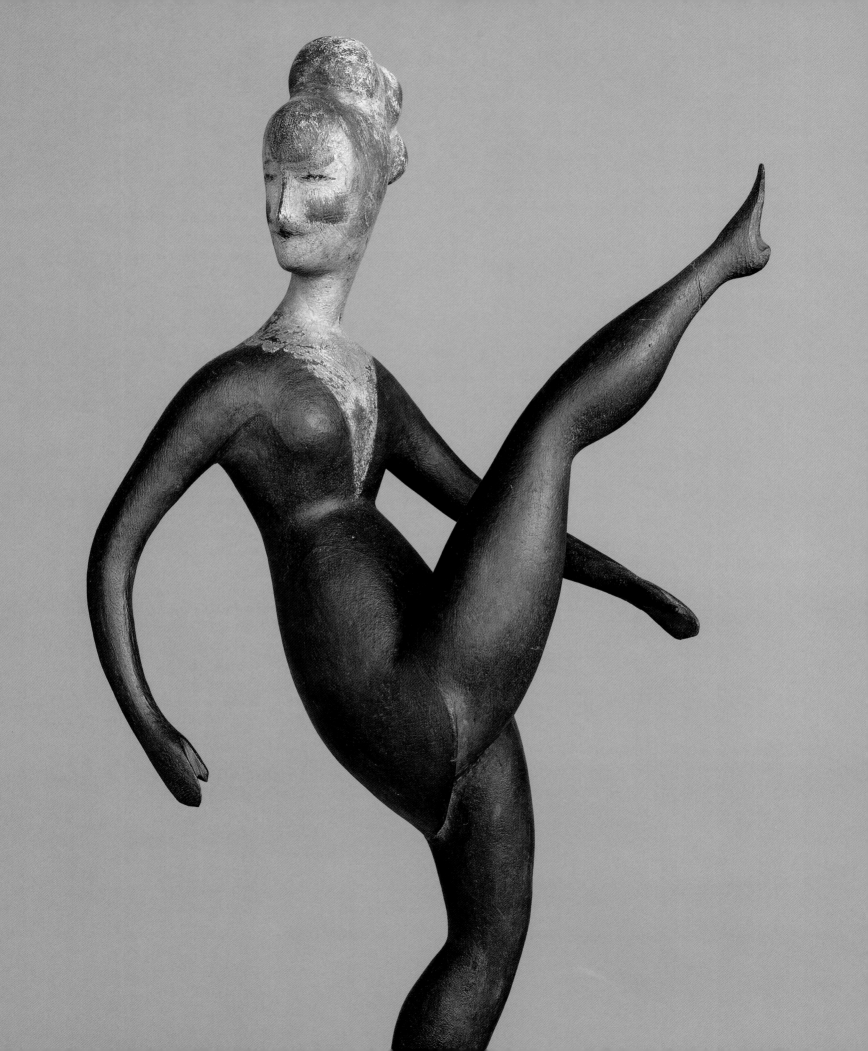

Embracing American Folk

SHIRLEY REECE-HUGHES

The word "folk" in America means all of us.

—ELECTRA HAVEMEYER WEBB, 1953[1]

Among a dramatic influx of immigrants at the turn of the twentieth century, Gaston Lachaise, Robert Laurent, Elie Nadelman, and William Zorach arrived in the United States between the years 1893 and 1914.[2] They entered a largely unfamiliar world of American modernity and its attendant challenges of urban life, alienation, isolation, and poverty. "I did not adjust easily to life in America," Zorach recalled in his autobiography. "The people I lived among were a mystery to me. . . . I was surrounded by unknown and often hostile forces and events." Zorach was only four years old when he emigrated in 1893 from Lithuania to the United States, where he lived in "the slums of Cleveland."[3] Nadelman, on the other hand, was a mature, worldly artist at the time of his immigration to New York City in 1914. Yet he, too, was unprepared for the vagaries of American life. "Everything is disgraceful and brutal here," he wrote to his friend Henri-Pierre Roché. "How far they are from Europe! I couldn't tell you how much I'd like to see Paris again!"[4]

Unlike many turn-of-the-twentieth-century immigrants, who segregated themselves into neighborhoods where they could maintain the native languages, cultures, and customs of their homelands, Lachaise, Laurent, Nadelman, and Zorach integrated into American society—thrust into a world that was reorienting its production, consumerism, and entertainment to serve a swelling population. The introduction of Henry Ford's

automobile assembly line, mass-produced items such as the Eastman Kodak Company's Brownie cameras and Victrola phonograph players, and popular entertainments like Ziegfeld's Follies represented an unprecedented era of democratic consumption.[5]

While the mass culture of the New World was a dramatic change of pace for the four artists from abroad, the country's populist amusements influenced their sculptural outputs. Hoofers and acrobats from vaudeville and circus shows inspired the artists' exploration of bodily movements in three dimensions, as Nadelman demonstrated in his flexing *Dancer* (originally titled *High Kicker*; **PLATE 41**) and Lachaise revealed in his buoyant *Two Floating Nude Acrobats* (**PLATE 25**). But the artists also turned to their wives and children as inspiration, as Zorach's *Mother and Child* (**PLATE 42**) and Lachaise's *Standing Woman* (also known as *Elevation*; **PLATE 16**) demonstrate. Whether their models were stage performers or family members, these modernists embraced the human figure as a leitmotif.[6]

Lachaise, Laurent, Nadelman, and Zorach's commitment to exploring corporeal sculpture in America, particularly quotidian subjects, was also an extension of their formal studies in Paris. In addition to the influence of sculptors such as Auguste Rodin and Aristide Maillol, the four artists witnessed how painters like Paul Cézanne, Edgar Degas, Pablo Picasso, and Georges Seurat emphasized everyday subjects. By painting circus performers, café dwellers, bathers, dancers, and laundresses, these Frenchmen connected their art to modern life, particularly the shifting class relations in Paris, a city undergoing radical economic and industrial changes. These French painters also demonstrated to the four sculptors the plastic potential of quotidian figures, as Cézanne and Picasso treated their subjects with an illusionism that approached sculptural qualities. Although the four artists did not depict social realities the same way the painters did, they developed their own vernacular themes after settling in the United States. From the relaxed intimacy of Lachaise's *Woman Seated* (**PLATE 28**) and Zorach's *The Artist's Daughter* (**PLATE 12**), to the alluring quaintness of Nadelman's *The Hostess* (**PLATE 40**) and Laurent's *The Bather* (**PLATE 31**), depictions of everyday subjects allowed the artists to reimagine sculpture for a modern audience.

Their interest in the American vernacular led Lachaise, Laurent, Nadelman, and Zorach to explore the country's historic folk art and its rural environments. During the summer months, they sought solace and creative inspiration away from the hectic pace of New York City. Nadelman purchased a home in Riverdale, New York, while Lachaise, Laurent, and Zorach gravitated towards the rustic hamlets of Ogunquit and Georgetown in Maine, where they collected early American furniture and folk art. In these eighteenth- and nineteenth-century paintings and sculptures, decoys, quilts, ship's figureheads, furnishings, and other creations, Lachaise, Laurent, and Zorach found objects imbued with a communal purpose that appealed to their desire to belong in the New World. Nadelman, too, was drawn to utilitarian folk arts created for the people. After he married the heiress Viola Spiess Flannery in 1919, the couple amassed a collection of folk art that was international in scope.[7] Nadelman's fortune afforded him a cosmopolitan lifestyle that Lachaise, Laurent, and Zorach would never enjoy. But, as immigrants, all four sculptors faced the same challenge of forming and negotiating their artistic identities in the United States during the interwar period.

Describing immigrant perspectives, historian Roger Daniels observed, "While most immigrants were, almost by definition, future oriented, their visions of both the present and the future would be modified significantly by the cultural environment of their past."[8] This was certainly true of Lachaise, Laurent, Nadelman, and Zorach, whose work during the interbellum period revealed their forward-thinking approach to creating sculpture, aspects of their native cultures, and formative experiences in Paris. As modernists, all four sculptors combined these influences as they embraced America's vernacular life, translating family members and mass-cultural performers into sculpture to feel more assimilated in their new home.

Searching for a Community

What life have you if you have not life together?
There is no life that is not in community.
—T. S. ELIOT, "Choruses from *The Rock*," 1934[9]

In search of kinship in the New World, Laurent and Zorach aligned themselves closely with art colonies, while Lachaise and Nadelman gravitated to artists' societies. All four were original members of the

Modern Artists of America and also joined or affiliated with other organizations such as the Society of Independent Artists and the Penguin in New York City.[10] These societies provided the artists with opportunities to integrate within American modernist circles and exhibit their sculpture in the 1910s and early 1920s. "The first time that I saw Laurent's work," remarked art critic Horace Brodsky, "was at the Penguin Gallery . . . where he showed a small figure in wood."[11]

Established by Walt Kuhn, the Penguin was an informal club housed in a brownstone located on Fifteenth Street between Union Square and Fifth Avenue. Kuhn freely exhibited members' work in the front parlor and provided a weekly sketch class with live models in a back room. "We drew, chatted, gossiped, laughed, and smoked," remarked Penguin member Louis Bouché. Lachaise, Laurent, and Nadelman were all members of the Penguin in the late 1910s, and their circus-themed works were perhaps inspired by Kuhn, who was passionate about painting showgirls, clowns, and acrobats. Bouché described how "everyone respected [Kuhn's] genius for putting an idea across."[12] He certainly made the Penguin a convivial environment for newly arrived immigrants like Lachaise, Laurent, and Nadelman. "Any artist who came to America," according to Bouché, "was immediately welcomed."[13]

Laurent and Hamilton Easter Field—a painter, collector, critic, and founder of the journal *The Arts*— also created two inviting coteries for immigrant artists and nascent modernists in Brooklyn, New York, and Ogunquit, Maine. Field first met the twelve-year-old Laurent in Concarneau, Brittany, when he was traveling through Europe studying painting. He brought the young boy to America as his protégé in 1902. At his Brooklyn brownstones on Columbia Heights, Field founded an exhibition space for emerging talent and a school where he and Laurent taught classes during the fall and winter seasons.[14] He exhibited his own paintings and Laurent's work along with that of other modernists such as Bouché, Maurice Sterne, and Stuart Davis. "For many years," Bouché recalled, Field's home "remained an exilitary [*sic*] artists' locale where ideas were exchanged and work was being accomplished."[15]

Some of the lively discourses at Field's residence were probably centered on his wide-ranging art collection, which Laurent studied assiduously. Nadelman

FIG. 12 **Kitagawa Utamaro** (Japan, 1753–1806), *"Kaiyoikomachi": A Geisha in her Lover's Room, from "Futaba gusa Nanakomachi,"* circa 1803, woodblock color print on Japanese mulberry paper, 15 x 9 15/16 inches. Brooklyn Museum, Museum Collection Fund, 20.930

was reportedly part of these conversations with Laurent, attending Sunday parties hosted by Field and his mother at their Brooklyn home.[16] He evidently brought drawings to show to Field on one occasion, since after the host's untimely passing from pneumonia in 1922, Nadelman wrote to Laurent inquiring about the works on paper.[17] Field particularly valued drawings, collecting masterful works by Renaissance artists. But his tastes were eclectic; he acquired Greco-Roman glass, Hellenistic Tanagra figurines, Flemish furniture, Japanese ukiyo-e woodblock prints, Chinese pottery, and African art, among many other objects.

Field's appreciation of "any art," as he described it, reflected early modernists' openness to global arts at the turn of the twentieth century. "For our modern man is no longer a creature of local tradition," wrote Field, "but a citizen of the world, the heir of the ages."[18] In France, Pablo Picasso and Paul Gauguin's appreciation of the arts of Africa and Oceania deeply

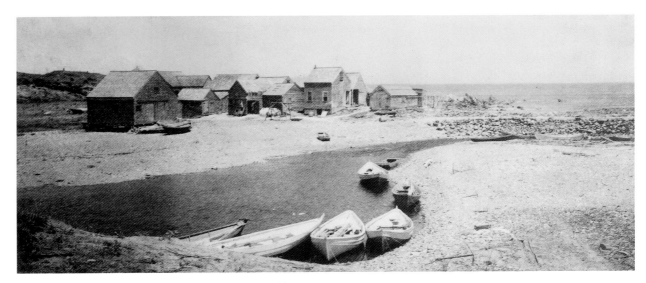

FIG. 13 **Unidentified artist**, *Some of the Fishing Shacks at Field's Summer School of Graphic Arts at Perkins Cove, Ogunquit, Maine*, 1910s, photograph. Family of Robert Laurent

influenced Laurent and Zorach. When Laurent lived in Paris from 1905 to 1908, he drew directly from Japanese ukiyo-e prints and visited Picasso's studio to see his collection of African art.[19] The rigid frontality and oval eyes of African masks seemed to inspire some of the artist's earliest direct carvings in the United States, such as *Head (or Mask)* (PLATE 5). Yet this work also suggests the influence of ukiyo-e prints, particularly a woodcut by Kitagawa Utamaro in Field's collection (FIG. 12). At the crown of *Head (or Mask)*, Laurent delineated hair through deep striations, which became a recurring stylistic motif in his sculpture. These marks are similar to Utamaro's technique; his gouged strokes on a woodblock did not retain the ink, leaving faint white lines that highlight the strands of hair pulled back in a geisha's bun.

Although he began his career as a printmaker and painter, Zorach's transition to a sculptor was similar to Laurent's in his appreciation of non-Western art forms. As he described it, he increasingly painted figures and forms with "a three-dimensional quality" similar to Cézanne's illusionism. A few years after he returned home from Paris in 1911, he viewed an exhibition of African art at Stieglitz's 291 gallery. He also studied carvings by Aztec, Maya, and Inuit peoples at the American Museum of Natural History in New York.[20] Early, directly carved works such as *Young Boy* (PLATE 51) share stylistic affinities with African art, as Andrew Eschelbacher discusses in this catalogue (see pp. 14–15). Works like *The Artist's Daughter* (PLATE 12) reveal the

variety of international sources that inspired Zorach. The sculpture's three-quarter stance and folded arms recall the poses of Cycladic or Egyptian figures, while its medium of colored marble evokes imperial Roman statuary. Yet, as he directly carved into the unyielding stone, Zorach was able to personalize the work. He captured his daughter Dahlov's tender demeanor and adolescent features. Later in his life, he reflected on how the early twentieth-century appreciation of non-traditional, un-academic art had liberated his thinking:

> Modern Art to my generation was a spiritual awakening, a freeing of Art from the idea of copying Nature.... We discovered that Art didn't begin and end with the Greeks but embraced the art of Asia and Africa, the primitive and early arts of peoples as well as the immediate past and present.[21]

Artists and critics typically used the terms "primitive" or "primitivism" to describe art forms of non-Western origins, as well as American folk art, that they believed were original and authentic, since such art seemed uncorrupted by the mechanized, industrialized world.[22] Zorach commented that he valued "primitive" sculpture because of its unequalled "spiritual quality," which "transcended the flesh."[23] When Laurent exhibited his early direct carvings in wood, such as the reliefs *Nile Maiden* and *Princess* (PLATES 52 and 53)— works that appeared stylistically and thematically removed from modern Western culture—critics often described him as a "primitive."[24] He seemed to relish this attribution and its implications of his novelty,

later boasting, "I am a peasant and create sculpture like one."[25]

To emulate the lifestyles of so-called primitives and follow the European model of art colonies, Field and Laurent established a summer school in rustic Perkins Cove in Ogunquit, Maine, in 1911 (FIG. 13). When they first discovered the seaside hamlet, Laurent recalled that he "at once fell in love with its attractive fishing village, which reminded me of Brittany."[26] Ogunquit and its fishers' customs were perhaps similar to Bretons' folkways, which had motivated Paul Gauguin to alter his style and subject matter. "I love Brittany," Gauguin wrote to friends. "I find the wild and primitive here."[27] In the same way that the artist perceived Brittany as a pristine environment, seemingly representing purer values, Laurent and Field viewed Ogunquit as an unspoiled locale, apparently removed from modern decadence. If mined thoroughly, Field believed, Ogunquit would stir his circle to create novel artwork in the manner that France's seascape communities inspired its artists. "Open your eyes wide, get the local tang," Field urged his colony members. "There's as much of it right here in Maine, as there is in Monet's Normandy. But to get it you must live in touch with the native Ogunquit life, just as Monet wears the sabots and peasant dress of Giverny."[28]

Laurent followed Field's counsel, living in close contact with the seaside community. Although he would never become a Mainer, preferring to emphasize his native identity—he retained the French pronunciation of his first name, Robert, and often donned a Breton fishing shirt—Laurent drew thematic inspiration from his surroundings in Perkins Cove.[29] In *The Wave* of 1926 (PLATE 30), he imaginatively alluded to local fishers through a universal theme of sea mythology. This elliptical sculpture of a female nude lying on her side evokes one of the Nereids, goddesses of the ocean's bounty and protectors of fishermen and sailors. Laurent entwined her with a fish, both in the grip of waves defined by undulating folds highlighted with the artist's signature striated marks. The work also reveals Laurent's intuitive process of direct carving, as he allowed an ovoid piece of alabaster to dictate the forms. "I think I had the fish and then the figure," he remembered, "because I never plan a thing in advance."[30] Polishing the translucent surface of the alabaster to remove its raw, chalky surface, the artist evoked the

fluid feel of water that he knew intimately from living by the sea in both Concarneau and Perkins Cove.

Like Laurent, Zorach lived in a seaside art colony early in his American career. During the summers of 1916, 1921, and 1922, he and his wife Marguerite stayed in Provincetown, Massachusetts, where the couple taught classes and created modernist sets and costumes for the avant-garde productions of the Provincetown Players with Eugene O'Neill, then an unknown playwright. In this coastal town on the northern tip of Cape Cod, Zorach first purchased Borneo mahogany from a sea captain and directly carved sculptures in the round of his two children.[31] During his last summer in Provincetown in 1922, he created a curvilinear female body out of the reddish-brown wood, *Floating Figure* (PLATE 36), that embodied his "deep feeling of pleasure in the sea."[32] Similar to Laurent's formal concerns in *The Wave*, Zorach also emphasized volume, curve, and surface in this work. Both artists depicted ample female subjects lying on their sides, expressing rhythmic movement through the curves that cascade from the women's shoulders to their waists, hips, thighs, and feet. The palpable finishes of the sculptures, although one is alabaster and the other wood, reflect how the sculptors valued tactile surfaces to enliven their figures.

By the time he carved *Floating Figure*, Zorach was collecting objects from America's historic material culture. The sculpture's rigid symmetry and rough-hewn quality is reminiscent of non-Western sculpture, and in its scale, orientation, and emphasis on its contours, it vaguely resembles weathervanes by American folk carvers (FIG. 14). Zorach remembered becoming

FIG. 14 **Unidentified artist**, *Gabriel (Herald Angel) Weathervane*, circa 1850–1900, wood, 13 x 48 3/4 x 1 inches. New-York Historical Society, Purchased from Elie Nadelman, 1937.929

interested in American folk art in 1914, when he and Marguerite saw an elderly woman making a hooked rug.[33] The rug-maker may have struck a personal chord with Zorach, whose mother probably wove textiles for their home in the little village of Euberick in Lithuania.[34] Having met Field and Laurent around 1915, the artist was aware of his contemporaries' interest in American folk art. After he and Marguerite purchased a home in Georgetown, Maine, in 1923, Zorach recalled how their summers in Maine were spent "hunting antiques" with "lots of excitement."[35]

Considered among the first modernists to collect American folk art, Field and Laurent began searching Maine's antique shops for the work of the country's eighteenth- and nineteenth-century artisans and craftspeople shortly after establishing the Ogunquit colony in 1911. They decorated the artists' studios in Perkins Cove with affordable hooked rugs, paintings, duck decoys, chests, and early American furnishings that inspired a folk-art collecting craze among the colony members. When searching for folk objects with Laurent, fellow colonist Wood Gaylor remembered that they "were quite interested in art of any kind."[36] They appreciated the fact that the country's earliest artists, like those from other cultures, prioritized the directness of their expressions, seemingly unconcerned with stylistic trends or academic traditions.

While Laurent, Nadelman, and Zorach acquired early American treasures with a catholic approach, their broad sympathies to these objects betrayed their deeper quest to belong to American life. Scholar Kevin Murphy believes that their interest in creations by artisans and craftspeople of the past "went well beyond art":

> For immigrants or first-generation Americans who were active in modernist culture, adopting the attitudes and artistic practices they associated with the folk was a means of bringing themselves closer to the traditional culture of the United States at a moment of extreme political tension over immigration.[37]

The artists wanted to identify more closely with American culture, though their "attitudes and artistic practices" had been established by the time they began investigating folk culture. Elizabeth Stillinger agrees that early modernist collectors were motivated "by a desire to establish a connection with earlier American artists," and also notes that they already felt a "kinship with those artists' sensibilities and techniques."[38]

It was indeed true that Laurent and Zorach "felt a kinship with [this art]," as Dorothy Miller described it. She and her husband, Holger Cahill, who curated exhibitions dedicated to American folk art in the 1930s, knew the sculptors and their sentiments towards the art they acquired.[39] Laurent and Zorach particularly appreciated the truth to materials that American folk carvers practiced. But they, along with Nadelman and Lachaise, felt personal connections to the country's historic material culture.

All four sculptors undoubtedly perceived and valued the communal spirit embedded in the art forms, which appealed to their own search for community as immigrants. Folk art expressed a "connection to one's community and commitment to its values. [It] is an expression of involvement, of sharing," notes John Michael Vlach.[40] All works of folk art, Vlach observes, were "grounded in social demands and communal preservation . . . patterned out of ideas and values, passed on from generation to generation."[41] Decorating their homes with hooked rugs, early American furniture, and folk art, the four sculptors immersed themselves in the vernacular of the country's earliest societies. Field touted hooked rugs as "one of the most characteristic arts" of the United States, and the tradition of rug hooking may have originated in Maine.[42] Field said that these rugs expressed his "belief that instinct, feeling, is the essential thing in the creation of art," a philosophy commensurate with the attitudes of the artists, who actively acquired objects with communal meanings.[43]

Among the works in Laurent's folk collection, which included hooked rugs, cast-iron bootjacks, Pennsylvania chalkware, duck decoys, and animal sculptures, was an almost six-foot-tall cigar-store Indian.[44] Originally a nineteenth-century shop figure that stood outside a storefront to advertise the sale of tobacco to a largely illiterate populace, this Indian sculpture likely served the non-English-speaking immigrants who arrived sometime during the first two decades of the twentieth century, when Laurent did. The sculptor undoubtedly admired the work's universality and its embodiment of the country's direct-carving tradition. He was most likely unaware or unattuned to the fact that this caricatured trade figure perpetuated stereotypes of Native Americans.

Although photographs of Laurent's Indian do not exist, it was surely crowned with a feathered bonnet,

FIG. 15 **Unidentified artist**, *Tobacco Shop Figure, Indian Maiden*, 1865–75, wood, paint, metallic pigment, and iron, 67 1/2 x 15 x 19 3/4 inches. New-York Historical Society, Purchased from Elie Nadelman, 1937.1766

since virtually every extant trade figure, whether male or female, has this feature. An Indian maiden from Nadelman's collection (FIG. 15), for instance, wears a plumed headdress and has a compact form, as the artisan carved her arms close to her body. The headdress and figural form of the cigar-store Indian in Laurent's collection may have served as inspiration for the artist's monumental female sculpture *Daphne* (PLATE 13). In this seven-foot-tall work, he depicted the myth of the Greek naiad transforming into a laurel tree before Apollo, consumed by her beauty, can overtake her. The laurel leaves atop her head rise, split, and span in the same manner as a feathered Indian bonnet. Laurent also carved *Daphne's* limbs and Apollo's outstretched arm in a tight compositional format that reveals no open spaces, like many

examples of cigar-store Indians. Stylistic affinities aside, Laurent wanted *Daphne* to reveal his craftsmanship and the immediacy of his expression, and to be readily recognized by its audience in the same manner as trade figures.

The artisan who carved Laurent's trade figure, likely a former creator of ships' figureheads, learned his skills through the handed-down tradition of direct carving. Laurent, Zorach, and Nadelman appreciated the fact that America's eighteenth- and nineteenth-century craftspeople, whether sign painters, carvers, limners, weavers, or quilters, learned their skills through shared exchanges among family and community members, in the same manner as the European artisans of their native cultures. Finding these cultural connections between the folk artists of their original and adopted countries perhaps eased the four immigrants' transitions to American life as they negotiated their artistic identities in the United States.

Zorach undoubtedly drew connections between New England's folk sculptors and Lithuanian craftspeople. Both groups followed a tradition of wood carving that derived naturally from their woodland surroundings.[45] To fulfill the practical needs of everyday living, Lithuanians carved wooden shoes, household utensils, and religious objects. In the United States, Zorach himself carved some domestic objects for his family, including decorative handles for a large fork and spoon, as well as a clock case and a frame for a mirror.[46] With his modernist outlook and knowledge of handcraftsmanship from his cultural heritage, the artist apparently did not make distinctions between American folk and fine art. In referring to Maine's cultural heritage, for example, he described a continuous art history streaming from "the earliest settlers to the great woodcarvers of ships' figureheads and to the folk art painters of 18th and 19th centuries—and on to Homer, Hartley, and Marin, among the many I can name."[47]

Laurent similarly paralleled the objectives and techniques of historic French and American artisans, who worked to fulfill personal and communal needs. When he wrote about the Breton sculptors of the Calvary at Plougastel-Daoulas, who carved elaborate tableaux of the life of Christ in local Kersanton stone, he praised them for asserting their faith, rather than for consciously developing a style. "These masters did not have much influence from the outside," Laurent

commented. "Today one recognizes in these works a great style—a style that sprang from the soul of a people."[48]

Torso of a Woman from 1920–26 (PLATE 19), created largely from intuition, reflects Laurent's shared affinities with his contemporaries, as well as his medieval ancestors and American folk carvers. Lachaise reportedly encouraged his friend Laurent to focus on creating sculptures of female torsos.[49] In *Ogunquit Torso* (PLATE 54), for instance, Lachaise evoked female sensuality through the waving curves of a woman's trunk. While Lachaise sought to express his manifold perceptions of women in a single work of art, Laurent was less concerned with synthesizing an ideological view of womanhood.

Like the creations of Brittany's medieval stone-cutters and American folk carvers, *Torso of a Woman* emerged from Laurent's direct carving process: "What I enjoy the most is cutting direct in the material, starting generally without any preconceived idea, preferably

FIG. 16 **Unidentified artist**, *Figurehead with Dark Green Skirt*, 19th century, painted and carved wood, 56 inches (height). Penobscot Marine Museum, Searsport, Maine, Gift of Mrs. Parker Poe, 1961.19.2

into a block of stone, alabaster or wood having an odd shape. . . . It keeps you awake, looking for something to show up."[50] Laurent also gave this sculpture a slight narrative, as the female gestures demurely with her chin tilted downwards, one arm partially hidden behind her back and the other folded to reach her shoulder. His directness of expression recalled the bold female characters of Maine's ship figureheads that the artist knew. For the prows of smaller, privately owned vessels, carvers often created portraits of wives and daughters in wood and painted them to recreate their likenesses (FIG. 16). In contrast, Laurent evoked the identity of his model through only her pose, hairstyle, and visage. *Torso of a Woman* reveals how the modernist leveraged the expressive potential of limestone, allowing the subtlety of its variegated and tactile surface to serve the overall aesthetics of the work.

Laurent and Zorach's modernist works shared affinities not only with folk sculpture, but also with the early American portraits of children that they both collected.[51] The artists recognized that such eighteenth- and nineteenth-century portraits were objects of pride and filial unity for their original owners. The young child depicted in *Girl with Flowers* (FIG. 17) from Zorach's collection is an idyllic vision of innocence, suggesting the imagined virtues of a bygone era. The unknown artist contrasted the girl's pale skin with a black background, making her appear sculptural. The plastic quality of the figure surely appealed to Zorach; the painting was possibly a model for capturing and preserving moments from his children's daily lives.

In 1923, for instance, the sculptor directly carved a likeness of his young daughter Dahlov on a toy car in rosewood (see FIG. 49), then revisited the theme in pink granite seven years later with the same title, *Kiddy Kar* (PLATE 34). Both versions of the subject reflect the artist's penchant for creating sculptures that were devoid of open areas, rounded, and compact, similar to Laurent's *The Wave*. By treating his toddler daughter, seated on her toy car, as one continuous form, Zorach exalted the aesthetic lines of the sculpture's overall contours. Only slight details—the plaything's arching handlebars and wheels and Dahlov's curly hair and playsuit—indicate the subject of the work.

Laurent, too, rarely embellished his early figural sculptures with details such as clothing or accessories. Exceptions include *L'Indifferente* (FIG. 52), who sports a harlequin-styled necklace; the headdress-wearing

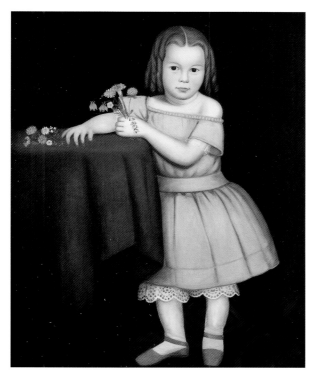

FIG. 17 **Unidentified artist**, *Girl with Flowers*, circa 1840s, oil on canvas, 36½ x 29 inches. Collection of the Newark Museum, Purchase 1931, Felix Fuld Bequest Fund, 31.145

Acrobat (PLATE 1); and the head-to-toe garbed couple in *Flirtation* (FIG. 18). The latter work, perhaps a love letter to his new wife, Mimi, also represents the artist's rare treatment of a genre theme (other than mother and child). The work may have connections to a folk sculpture from Laurent's collection, *Figure of Man with Grapes* (FIG. 19), that he reportedly found in Wells, Maine. This well-groomed figure served the community, standing on a bar to show patrons that the "fruit of the vine" was available. The folk sculpture of the jacketed man holding grapes is similar to the charmingly clothed male figure in *Flirtation*. A reviewer commented that the couple shown in that work had "a curious quality of pride. They seem old-fashioned folk who are satisfied with country living and old ways."[52] For Laurent, fashionably attiring his figures in a manner reminiscent of folk sculpture was a statement of modernity, as it was for Nadelman as well.

Having studied and lived in Munich and Paris in the early 1900s, Warsaw-born Nadelman reportedly came to the United States in 1914 at the request of cosmetics magnate Helena Rubinstein. She acquired all of his works from his 1911 Paterson Gallery exhibition in London, and Nadelman originally planned to stay in America only to complete a commission for her. The outbreak of World War I, however, meant Nadelman would have to sustain an artistic career in New York City.

In his first solo show at Alfred Stieglitz's 291 gallery in 1915, Nadelman revealed that he had apparently overcome his initial culture shock over the "brutal" United States. The show featured his plaster cast of *Man in the Open Air* (1915), which the artist later cast in a striking, large-scale bronze of approximately four feet, five inches tall (PLATE 9). In both the plaster and bronze versions, the sculptor modernized the classical motif of a figure leaning against a tree by giving the male tubular limbs and attiring him in a bowler hat and bowtie to reference popular culture. Nadelman also imbued the figure with a jaunty insouciance that reflected the sculptor's impressions of American contemporary life.

As several scholars have pointed out, Nadelman delighted in the whimsy of popular and folk culture in the United States.[53] Even though he knew Field, Laurent, and other folk art collectors, Nadelman and his wife Viola preferred to shop for their treasures alone, but they created their vast collection for the American public. When they opened their holdings as the Museum of Folk and Peasant Arts in 1926 in Riverdale on the Hudson in the Bronx, they intended to demonstrate to Americans that their own folk heritage derived from Europe. The displays not only showcased the aesthetic beauty of paintings, glassware, chalkware figures, ship's figureheads and other wood carvings, toys, dolls, and furniture, but also addressed the objects' specific functions, so that their original uses could be understood. For instance, home and business environments, such as a pharmacy, were installed to reconstruct past traditions of family and communal living.

Like Laurent and Zorach, Nadelman surely drew connections between the folk art he collected and the arts and crafts of his native heritage. As Avis Berman observed, Nadelman, born into the culturally rich environment of Poland, "could not have missed the efflorescence of folk and provincial sculpture" that reportedly filled the Polish countryside.[54] In particular, the country's sculpture flourished after the seventeenth century, when carpenters, joiners, and other artisans began placing sculptural crosses, posts with religious scenes, and shrines at crossroads in villages and towns. Like American folk carvers, Poland's earliest sculptors used shorthand expressive techniques, such

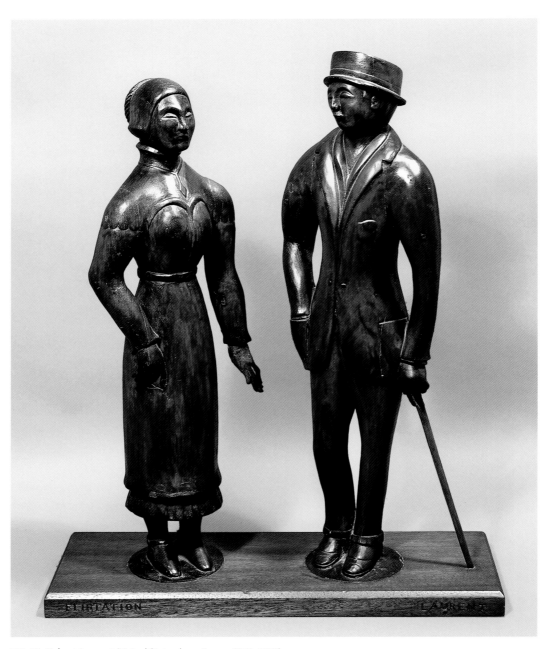

FIG. 18 **Robert Laurent** (United States, born France, 1890–1970), *Flirtation*, 1921, mahogany, 20 inches (height). Private collection

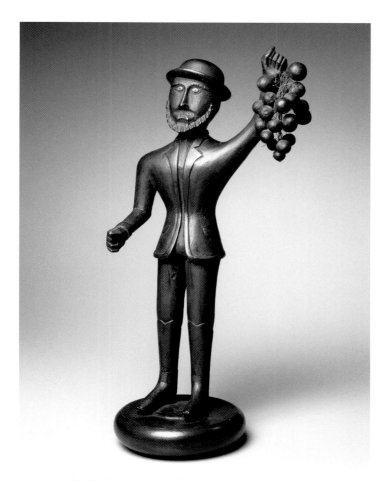

FIG. 19 **Unidentified artist**, *Figure of Man with Grapes*, circa 1860, wood, metal wire, and bone, 16½ x 7½ x 5¼ inches. Brooklyn Museum, Gift of The Guennol Collection, 2000.80

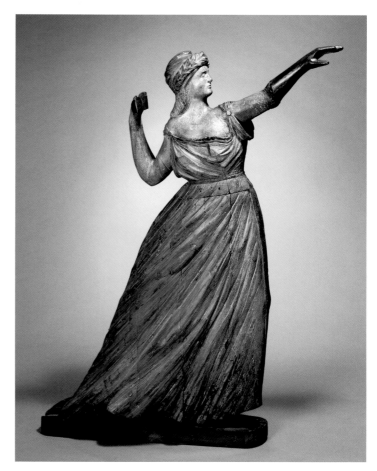

FIG. 20 **Henry Leach for Cushing & White Co.**, Waltham, Massachusetts, *Liberty*, 1868, carved and painted wood, 45½ x 39 x 13 inches. Collection of Shelburne Museum, Museum purchase, 1949, acquired from Edith Halpert, The Downtown Gallery, 1961-1.128

as exaggerating areas of a figural piece that they considered the most important.[55]

In Nadelman's folk art collection, the theatrical stance of an American weathervane pattern carved by Henry Leach and entitled *Liberty* (**FIG. 20**) is perhaps similar to the expressive postures and gestures used by Poland's folk carvers. With one arm dramatically extended and the other, which once held an American flag, bent in a curve behind her head, *Liberty* served as a functional weathervane and a patriotic symbol. Among his early sculptures that he produced in plaster casts and likely had fabricated by wood-carvers, Nadelman's *Chef d'Orchestre* of about 1919 (**PLATE 39**) stands in a pose strikingly similar to that of *Liberty*.[56] Whereas the weathervane is utilitarian, the maestro signifies the modern symphony at a time when dissonance and other avant-garde uses of sound revolutionized orchestra conducting. Lincoln Kirstein, an art critic, friend, and patron of the artist, commented, "the

sculptor has found here the precise posture to indicate the entire science and showiness of the bravura conductor from Berlioz to Leonard Bernstein."[57]

While Nadelman's *Chef d'Orchestre* is an individualized figure, part of an elite musical society, his pose, like that of *Liberty*, could be universally recognized as indicating direction. As the weathervane's outstretched arm would turn to designate the wind's path, the conductor's extended reach would signal which sections of the orchestra were to perform. Nadelman also painted the figure's face, hands, and attire with gesso to animate and describe him more concretely for an audience. According to Roberta J. M. Olson, the weathered appearance he gave to this work and his other gessoed wood sculptures evoked the distressed exteriors and palettes of the trade figures that he collected.[58]

Aware of Laurent, Zorach, and Nadelman's folk art collections, Lachaise reportedly appreciated

America's material culture, particularly hooked rugs and weathervanes.[59] After emigrating from Paris to Boston in 1906 to be near his true love and lifelong muse, Isabel Dutaud Nagle, Lachaise discovered Maine, the place that reminded him of home and where he seemed to feel most at ease in the United States. He began summering there in 1907 with Nagle, and a year later described the beauty of its variegated coastline of rocks and forests in a letter to his sister Allys in France.[60] Lachaise and Nagle settled in Georgetown, Maine, and encouraged the Zorachs to move to a nearby house formerly owned by a sea captain.[61] Lachaise also found camaraderie and support among Field's Ogunquit circle with Laurent, painter Katherine Schmidt, and her husband, Yasuo Kuniyoshi, a Japanese immigrant. Schmidt stated that she and Kuniyoshi were very fond of Lachaise and exchanged artwork with him.[62]

A photograph revealing the early American décor in Lachaise's second-floor library in his Georgetown home (FIG. 21) suggests he was a part of Zorach and Laurent's antique-hunting trips in the state, though it was more likely Nagle who did the actual shopping. As Zorach remembered of their days in Maine, "All of us were picking up early-American furniture and antiques. . . . A lot of us had acquired houses and had very little to furnish them with."[63] The interior of

Lachaise's library includes not only rustic furniture, which he had written to Laurent to inquire about, but also hooked rugs and what appears to be a folk painting, hanging above the rocking chair, that depicts a woman wearing a fashionable bustle.[64] The sculptor's interior surroundings of nineteenth-century furnishings and folk art undoubtedly helped him feel more a part of Maine's intimate artistic community.

Lachaise's initial acceptance into New York City's modernist circles occurred in 1918 when he exhibited his masterwork, *Standing Woman* (PLATE 16), at the Stephan Bourgeois Galleries. After years of working as an assistant in Boston at the atelier of Henry Hudson Kitson, who created public monuments, and then laboring as a primary carver in Paul Manship's studio in New York, Lachaise received his long-deserved recognition.[65] The sculpture astonished the critics, who unanimously praised Lachaise's vision of new womanhood, remarking that the work alluded to everything from a powerful pioneer woman to a female enchantress.[66] With one hip slightly higher than the other, and her curvaceous torso appearing disproportionately larger than her slender ankles and feet, the figure seems precariously balanced on her tiptoes.

In an article he penned for *Creative Art* in 1928, Lachaise romantically alluded to his burgeoning in

FIG. 21 *Second-Floor Library in Gaston Lachaise's Home, Georgetown, Maine,* undated photograph, 2 3/10 x 4 inches. Gaston Lachaise Collection, Yale Collection of American Literature, Beinecke Rare Book and Manuscript Library, Yale University, New Haven, Connecticut, YCAL MSS 434

America, stating "the New World is the most favorable place to develop a creative artist." Yet later in the essay, the artist noted, "Financial strain from all sides, no genuine support for the better part of a lifetime are yours." Fellow sculptor Reuben Nakian recalled that Lachaise "killed himself" doing commissions to support Nagle's lifestyle, which included renting a hotel room on Fifth Avenue in New York City.[67]

As a departure from commissions, and from depicting Nagle as a standing nude, Lachaise portrayed his wife in an everyday situation in *Woman Seated* (**PLATE 28**). Depicted as a modern lady of leisure, she is casually seated with her legs crossed and arms folded. Lachaise nickel-plated the areas of her strapless gown, slippers, and comb to create a luminous sheen that suggests she is attired for the cocktail hour. Even with its relatively diminutive height, standing about a foot tall, the sculpture expresses Nagle's proud bearing. As writer Llewelyn Powys described, Nagle had the demeanor of a "peacock" and the gait of an "empress."[68] By slightly twisting her torso, gently raising her right shoulder, and fanning the skirt of her dress to suggest a regal gown, Lachaise evoked his wife as an assertive woman with an imposing presence. While the sculpture is magisterial, its informality also reveals the artist's ease in adopting vernacular subjects in the United States.

Like Lachaise, Nadelman addressed the theme of contemporary leisure in *Seated Woman* (**FIG. 22**). As Barbara Haskell noted, such works reflected Nadelman's skill "in recording the dual aspects of modern leisure and mass culture."[69] The piece also revealed his desire to combine two different materials; the female figure is made of wood and her chair and the bow atop her head are constructed from iron. These materials, as Olson points out, related to American furniture, and the wrought-iron chair is reminiscent of the seating in both Paris cafés and American soda shops.[70] The figure's propriety, with her hands touching in her lap, makes her appear demure, unlike Lachaise's depiction of Nagle. Yet both Lachaise and Nadelman's interpretations of seated women reflect their shared concerns for expressing the female form through undulating curves that taper downwards to reveal slender ankles.

Nagle, the muse for virtually every sculpture Lachaise created, had similar proportions, with her legs attenuating from her thighs to her feet. Given the similar

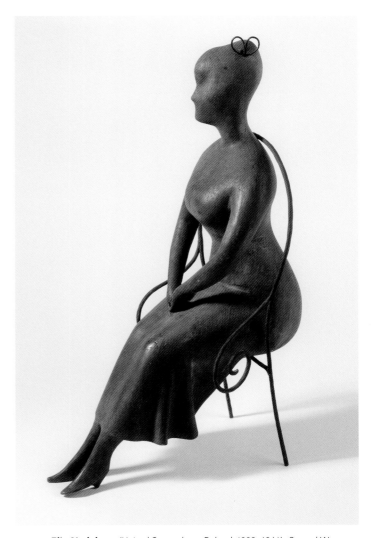

FIG. 22 **Elie Nadelman** (United States, born Poland, 1882–1946), *Seated Woman (Femme Assise)*, circa 1919–25, cherry wood and iron, 31 3/4 x 12 3/4 inches. Addison Gallery of American Art, Phillips Academy, Andover, Massachusetts, Museum purchase, 1955.8

FIG. 23 **Louis Raymond Reid**, "Prohibition and the Cabaret," *Shadowland*, September 1919, 40–41

shapes of Nadelman's female sculptures, it appears that the curvaceous woman with willowy ankles was a popular body type in the late 1910s, as seen in a photograph of cabaret dancers who tied their ankles with ballet ribbon to accentuate them (**FIG. 23**). As Kirstein confirmed, Nadelman "appropriated the shape and proportion[s]" of the era's female performers.[71] In this way, his sculptures were monuments to a dynamic age of theater that was rapidly disappearing.

A Lively Gesture

Nadelman viewed American vaudeville as "a rich and active deposit of folk tradition," according to Kirstein.[72] It is perhaps not surprising, then, that Lachaise, Laurent, Nadelman, and Zorach found vaudeville, burlesque, and dance and music halls as alluring as the country's folk past. To them, popular and folk culture represented the American vernacular; in using these sources as inspiration, the artists embraced current customs, traditions, and values of the United States. Florenz Ziegfeld's elaborately staged and costumed musical revue of dancing beauties, which opened in 1907, ushered in "the age when feminine curve and current topic were theatrically interwoven," as noted critic Louis Raymond Reid put it.[73] Attending such populist amusements inspired the four sculptors to explore corporeal modernity in the New World.

Although Lachaise had visited Paris's Montmartre neighborhood—home to the Moulin Rouge cabaret, circuses, and music and dance halls—before he

emigrated from France to the United States, he did not explore themes of female performers in his art while abroad.[74] Nadelman was also familiar with the nightlife of Paris when he resided there from 1904 to 1914. He dabbled in portraying women of the circus, such as the tubular-limbed *Standing Nude* (c. 1912; originally titled *Juggler*) and the relief *Woman on a Horse* (c. 1912; both at the Metropolitan Museum of Art, New York). But these early works in bronze, which appear more classically based, formal, and static, lacked the verve and simplicity of the performance-themed sculptures he created in the United States, such as *Circus Girl* (1920–24; Hirshhorn Museum and Sculpture Garden, Smithsonian Institution, Washington, D.C.).

Often described as vulgar or coarse, the American theatrical genres of vaudeville and burlesque, which featured variety acts, were considered undignified for middle-class audiences during the nineteenth century. By the early twentieth century, however, when Reid observed that "America became Stageland with a capital 'S,'" vaudeville and burlesque had joined the mainstream of bourgeois entertainment.[75] Lachaise, Laurent, Nadelman, and Zorach had many opportunities to attend popular stage shows. Both Nadelman and Lachaise frequented the National Winter Garden on Houston Street where Minsky's Burlesque, which featured comedy acts, chorus lines, and modest striptease dancers, among other acts, appealed to immigrants and America's upper echelons alike.[76]

Whether burlesque hoofers or vaudeville dancers, acrobats, or aerialists, these performers kicked, jumped, gesticulated, swirled, and suspended themselves to the sounds of jazz or other indigenous musical forms, making them symbols of modern American life to the four sculptors. The artists wanted to distill the entertainers' fleeting motions into a singular, sculptural pose that would be universally understood by their audience. "Modern art has developed a consciousness of the inner meaning of gesture," wrote Zorach in 1921, "the bowing of a head, the turn, the stop, the look in an eye, the curve of the mouth, the passing of two forms—passing."[77] He, Lachaise, Laurent, and Nadelman were all distinguishing their sculpture by revealing how expressive and emotive even subtle, yet carefully crafted gestures could be.

In the elegantly stylized *Dancer* of 1918 (originally titled *High Kicker*; **PLATE 41**), carved from cherry wood and painted with gesso, Nadelman condensed all

the multiplicity of movements in a routine into a single, hieratic pose.[78] He created more than one version of this figure, which reflected not only his love of it, but his desire to create multiples for patrons. Although *Dancer* draws comparisons to Georges Seurat's *Le Chahut* of 1890 (Kröller-Müller Museum, Otterlo, The Netherlands), in which the French artist depicted the scandalous high kicks of the cancan, Nadelman isolated the single performer.[79] As Berman recognized, Nadelman's different versions of the high kicker reflected the specialty acts of female vaudevillians.[80] These eccentric soloists often swung their legs high as they performed a series of combination kicks. According to Kirstein, vaudeville star Eva Tanguay inspired the pose for *Dancer* (FIG. 24).[81] Nadelman seemed to freeze her ephemeral motion of a high kick in permanent form in his sculpture, as the work's overall ruddy coloring and sinuous lines represent the artist's signature wood style.

After the tango became one of the most fashionable dances in America in the mid-1910s, Nadelman captured the fad, depicting its movements in a couple carved from cherry wood (PLATE 38). Exported from Argentina, the dance gained an even greater following in 1917 when Carlos Gardel released the song "Mi Noche Triste," with a passionate vocal and a deliberate beat that inspired Americans to learn the tango. Nadelman depicted dancing partners in the midst of an open embrace, rather than a closed one that would evoke arrested tension. The artist had completed a sequence of drawings that documented a couple moving to virtually every step of the dance (see PLATE 64). His final figural positions in the sculpture suggest a piquant moment of amour that relates to the romantic mood and spirit of Laurent's *Flirtation*. Nadelman's *Tango*, however, subtly evokes the early 1920s zeitgeist of dancing as a liberation of sexual mores.

In the 1920s, Zorach commented that he too "became deeply interested in the dance, and in the sculptural aspect of gesture."[82] Although dancing themes were not prominent in his œuvre, he explored the subject most fully in the 1930s. Whereas Nadelman addressed dances of mass culture, Zorach seemed inspired by Isadora Duncan, whose performances embodied the liberating tenets of early twentieth-century dance. Discarding ballet's formalism and wearing loose-fitting tunics, she moved in unorthodox ways, hopping, walking, or skipping with unabashed

FIG. 24 **White Studio**, New York, *High Kicker*, circa 1917, photograph matted with Elie Nadelman, *High Kicker* (PLATE 60), New York Public Library, *MGZGA Nad E Hig 1

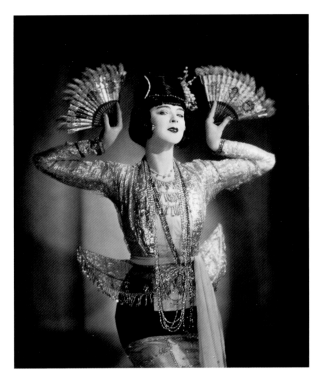

FIG. 25 **Nickolas Muray** (United States, born Hungary, 1892–1965), *Ruth St. Denis*, circa 1922–61, negative, gelatin on nitrocellulose sheet film, 10 x 8 inches. George Eastman Museum, Rochester, New York, Gift of Mrs. Nickolas Muray, 1977.0188.2462

Arms from one of St. Denis' dances. Fascinated by the East, St. Denis dressed in costumes and choreographed dances that were inspired by Asian, Egyptian, and Indian cultures. Photographs of her performing or posing for the camera often capture her with uplifted arms, similar to Lachaise's sculpture (**FIG. 25**). The artist used the expressive elevation of his figure's limbs, the turn of her head, and the tilt of her hands to make her appear as if she were having an epiphany.

Live performances by aerialists and acrobats intrigued Lachaise, as the performers' ability to overcome gravity evoked the physical energy of the modern era. Their example provided models of how to invest his figures with a sense of life. He continued to translate Nagle in his work, even in his equestrian and acrobatic figures, which, although bulbous, still seem capable of the precarious poses they hold. Lachaise seated his wife sidesaddle in *Equestrienne* (**PLATE 33**), with long, attenuating limbs that enable her to balance herself on the walking horse. The work is also an exquisite combination of curves that graduate in scale as they evoke the stride of the animal.

The poses of Lachaise's acrobatic sculptures suggest he sat in the audience at Minsky's Burlesque and other vaudeville shows watching tumblers and aerialists in motion. His sculpture *Acrobat* (**PLATE 17**, which he also sketched, **FIG. 26**) depicts a curvaceous female upside down, supporting her weight on one shoulder and one arm as her sinuous lines express the cadence of her body. The work is an inversion of *Standing Woman*—a figure whose delicate hands are serenely poetic—except that here the tumbler's fists and arrested pose of bodily strength suggest Lachaise's meditations on a woman's power. By contrast, the artist's pair in *Two Floating Nude Acrobats* (**PLATE 25**) embodies modern art's preoccupation with gesture as movement, as Zorach described it, particularly the powerful mystique of "two passing forms—passing."

The theme of acrobatic performers emerged in a few of Laurent's directly carved works. In 1921, his intuitive shaving of a block of mahogany created the muscular male equilibrist of *Acrobat* (**PLATE 1**). Given the figure's headdress, ornate detail at his neckline, and pantaloons, it seems that Laurent was recreating the dress of an "Eastern" performer, such as those in traveling minstrel acts (**FIG. 27**). These acts, like St. Denis' dances, reflected Americans' fascination with the so-called Orient, which they associated with

freedom to classical music by composers such as Franz Schubert and Ludwig van Beethoven.[83] Duncan flaunted her sexuality, sometimes even exposing a bare breast to shock and taunt her audiences.[84] Nude, barefoot, and holding a veil, the figure in Zorach's *Spirit of the Dance* of 1932 (**PLATE 15**) was most likely inspired by Duncan, a symbol of artistic independence and freedom for the sculptor's generation. His depiction of the dancer, gracefully kneeling at the finale of a performance, is perhaps an homage to Duncan after her untimely death in 1927.[85]

Lachaise may also have been referring to dance in *Nude Woman with Upraised Arms* of about 1926 (**PLATE 21**). A regular visitor to the circus, opera, and performances by pioneers of modern dance such as Duncan and Ruth St. Denis, Lachaise perceived bodily movements in sculptural terms. Writing to Nagle in 1910, he described an operatic performance by soprano Mariette Marazin in *Elektra*, stating: "she reaches a point where her gestures are like sculpture."[86] The same year he wrote to his wife to say that he had finished his first study of St. Denis, and that he needed Nagle to pose for the figure's feet.[87] Lachaise perhaps adapted the pose for *Nude Woman with Upraised*

arobat
first copy sold to
Iselin

plaster model
at studio

small

figure with Dolphin
plaster model in studio

FIG. 26 **Gaston Lachaise** (United States, born France, 1882–1935), Sketches of sculptures, June 1928, from "Journal: Reference to Sculpture and Drawings," June 1928–May 1931. Gaston Lachaise Collection, Yale Collection of American Literature, Beinecke Rare Book and Manuscript Library, Yale University, New Haven, Connecticut, YCAL MSS 434

FIG. 27 **Courier Company**, Buffalo, New York, *Al. G. Field Greater Minstrels*, 1900, color lithograph, 107 x 83½ inches. Library of Congress, Prints and Photographs Division, Washington, D.C.

FIG. 28 **Unidentified artist**, *Acrobat*, 3rd century BC, terracotta from Taranto, Italy. Museo Archeologico Nazionale, Taranto, Italy

the exotic. Since Laurent rarely adorned his figures, it suggests he may have witnessed the equilibrist and tried to translate him quickly into a readily available piece of wood. A year later, the artist envisioned one tumbler lifting another on her shoulders in the captivating relief *Acrobats* (PLATE 56). The partnering of the figures recalls Nadelman's dancers in *Tango*, since both artists explored the unspoken relationship between a couple in the midst of bodily interaction. While the scale of *Acrobats* rivals that of Lachaise's *Standing Woman*, Laurent's relief actually served for years as a door in a private home. His attention to such a utilitarian object suggests his lack of distinction between high and low culture, and his desire to carve every work of art with force and aplomb.

Circus performers also inspired Nadelman to explore new expressive heights. Audiences often perceived circus folk as unearthly because of their seemingly unnatural talents that ostracized them from mainstream society. According to Kirstein, though, Nadelman "always loved the circus as the apogee of the performing arts." The sculptor even collected circus-themed folk art, according to Olson.[88] In *Acrobat* of 1916 (PLATE 23), a figure arches his legs over his head in a handstand that had been a standard equilibrist pose since ancient times. Grecian sculptors used the same stance in terracotta figures from the third century BC (FIG. 28), which Nadelman may have been familiar with. Adding a bowtie, as the artist did in *Man in the Open Air*, the artist created a performer for a contemporary audience. Unlike the smooth, painted surfaces of Nadelman's wood sculptures, *Acrobat* has a palpable surface that gives the work a greater tactile quality and verve.

By about 1928, Nadelman had expanded his repertoire in both media and scale in *Two Circus Women* (PLATE 11). The women's voluminous quality and lack of physical definition depart radically from the sculptor's previous lyrical figures. The couple, consisting of plaster and papier-mâché and melded together, is distorted through its exaggerated proportions. Previously, Nadelman had treated vaudeville dancers, often described as brash or uncouth, as refined women. Here, though, the artist appears less concerned with social acceptability and more willing to explore the marginalized characters of itinerant circuses, who lived in their own insular worlds out of necessity. By using the everyday material of

papier-mâché, Nadelman suggested his desire to produce artworks for a mass audience.

After the stock market crash of 1929, Nadelman and his wife Viola lost their fortune and had to sell the majority of their folk art collection. When he returned to his studio, he began casting single, miniature plaster figures in multiple numbers that could be hand-held (**FIG. 29**). As Haskell suggests, the works were "so numerous that they seem almost to have been created to fill the void left by the loss of his folk art collection."[89] These approximately five-inch-tall sculptures were left unfinished and needed to lie flat. Although created in a variety of poses, they were often as bulbous as *Two Circus Women*. In many ways these late, more generalized, spherical works represented the sculptor's earliest objectives:

> If a piece of string is thrown on the ground it will form each time a new sinuous line.
> Can we call these haphazard lines, these forms, perfect forms?
> We cannot: since these forms have no meaning, they are incapable of perfection.
> But if we take this same string and try to enclose as much space as possible within its length we obtain a circle. We have there a line *with a significance,* perfect, that is, containing in itself the *idea* of perfection.[90]

For Nadelman, Lachaise, Laurent, and Zorach, creating significant, corporeal sculpture was a shared objective. All the artists were able to contain and express a motif within the confines of their sculptures, which were not overly embellished, but had independent vigor, subtle narratives, and rhythmic grace.

Robert Sturgis Ingersoll, the former president of the Philadelphia Museum of Art, once strolled through the outdoor court of the Rodin Museum in Philadelphia with Lachaise and Laurent. "To watch and hear those two touch and talk of those masterpieces," Ingersoll remarked, "was a lesson to this untalented amateur."[91] The two sculptors' conversation revealed their intimate knowledge of Rodin and their worldly perspectives as accomplished artists. They, like Nadelman and Zorach, were early modernists whose appreciation of global sources, historic folk art, and mass culture made them unique progenitors for future generations of American sculptors. Their immigrant identities helped them forge this path, as they never lost sight of their cultural pasts while creating forward-thinking sculpture for a modern audience. They perhaps believed, like continental philosophers before them, that within folk arts "lay the spirit and soul, the genius—indeed the unity of a people," which they wanted to be a part of.[92] For Lachaise, Laurent, Nadelman, and Zorach, becoming assimilated within America meant embracing its everyday life—whether as spectators, collectors, or, most importantly, as artists.

FIG. 29 **Elie Nadelman** (United States, born Poland, 1882–1946), *Untitled*, circa 1938–46, plaster, various dimensions. Whitney Museum of American Art, New York; Purchase, with funds from The Lauder Foundation, Evelyn and Leonard Lauder Fund, 97.144.42 (left) and 97.144.24 (right)

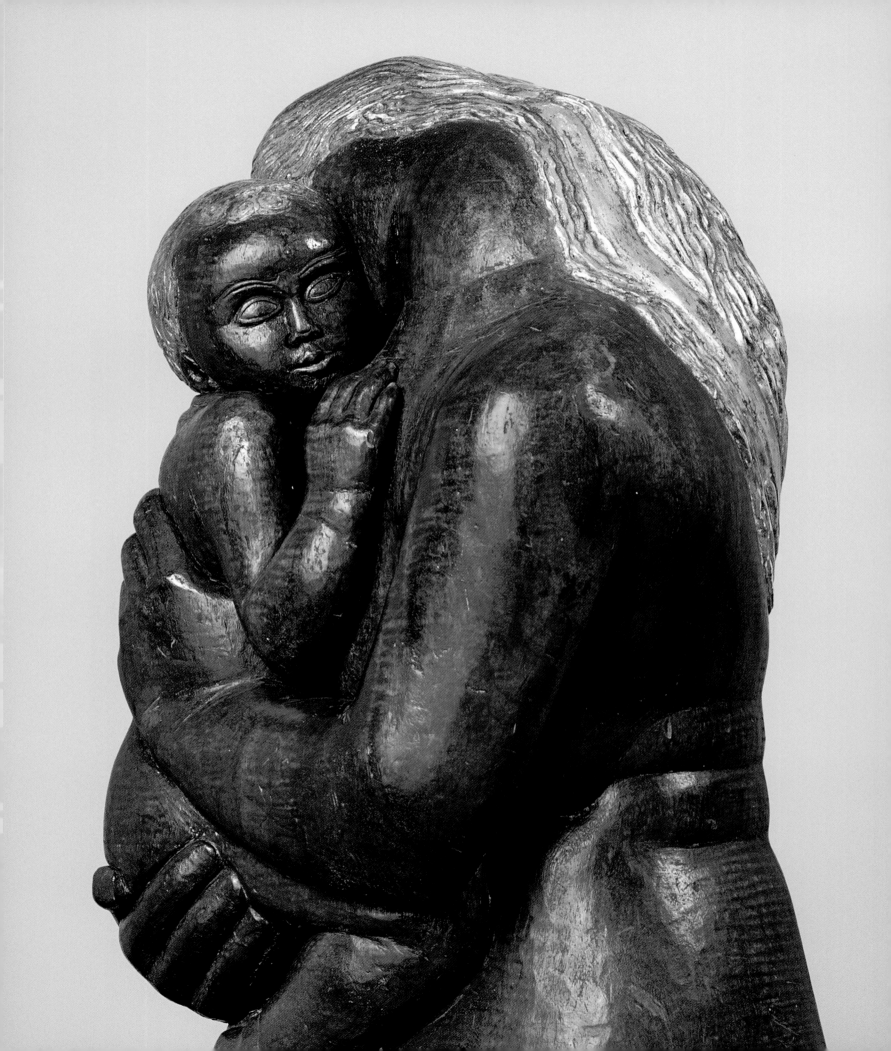

Modernism Becomes Mainstream: The Increasing Acceptance of the New American Sculptors

ROBERTA K. TARBELL

In 1929, celebrating the opening of the Museum of Modern Art in New York, Forbes Watson, editor of *The Arts* and *Creative Art*, declared, "The long battle for what we used to call 'modern' art has been won and the new museum is a symbol of the completed victory." He acknowledged that many "volunteers," including the writers for new art journals, had worked hard for over a decade for this to occur.[1] Critics, editors, gallery proprietors, and museum personnel collectively challenged the conservatism that dominated American art before World War I, increasing the market for and the appreciation of modern sculpture. During the second decade of the century, Gaston Lachaise, Robert Laurent, Elie Nadelman, and William Zorach struggled to find patrons and sufficient funds to support themselves with their art, but by the 1930s they were recognized as premier modern artists whose works were chosen for monumental public projects and solo exhibitions in prominent venues.

During the 1930s, large numbers of middle-class Americans began to engage with the culture of the visual arts in a new way. They gained greater exposure to art in such federally funded places as post offices and schools and at the largely privately supported world's fairs.[2] To attract new middlebrow patrons, museums began to teach art appreciation classes and to advertise in the mass media. The Pulitzer Prize–winning art critic Emily Genauer noted in 1938 that during the preceding five years, profound changes in the social basis for art had transformed the American art world. Consequently, she wrote, the average American man was beginning to see that art "is not something

conceived on Olympus, but is produced by people very much like himself."[3] Art had become popular—and even modern art was acceptable—by the time the United States entered World War II.

Positive Critical Response in New Journals

The Dial and *The Arts* were the most influential periodicals to promote modern art during the 1920s. In 1919, Scofield Thayer and James Sibley Watson, Jr., purchased *The Dial*, originally the journal of the New England Transcendentalists.[4] The frontispiece of their first issue in January 1920 was Lachaise's *Dusk* (FIG. 30), a small bronze relief sculpture of a floating horizontal woman.[5] Soon Thayer and Watson were joined by Gilbert Seldes and E. E. Cummings, with whom they had worked on *The Harvard Monthly* between 1913 and 1916. The editors shared goals of presenting the work of talented young American artists who had been neglected in the literature. Thayer promised "to represent the liberal trend in artistic effort, as contrasted on the one hand with the dyed-in-the-wool conservative and on the other with the hare-brained extremist."[6] True to his word, *The Dial* did not publish any reviews or illustrations of abstract, Dada, or Surrealist art; pre-Cubist Picasso and Lachaise were the artists most often represented.

Throughout the 1920s, the writers for *The Dial* educated a sophisticated group of intellectuals with insightful reviews and illustrations of modern

figurative art. Modern sculptors both contributed to and benefitted from this metamorphosis. *The Dial* reached a wider and broader audience than photographer and gallerist Alfred Stieglitz's *Camera Work*, the premier journal of the avant-garde in America from 1903 to 1917, but not as wide a readership as the more conservative *Atlantic Monthly* or *The New Republic*. Although *The Dial* published Ezra Pound's *Cantos V, VI,* and *VII* (1921) and *VIII* (1922) and T. S. Eliot's *The Wasteland* in 1922, it was not as revolutionary as *The Little Review* (1914–29), which was censored in 1921 for publishing serial chapters of James Joyce's *Ulysses*. Yet as Alan C. Golding points out, Thayer's relative conservatism "was, paradoxically, necessary to the *Dial*'s promotion of an aesthetic revolution . . . because he put experimental modernist work in a context that made it more palatable to a general audience."[7]

Henry McBride, who served as critic for *The Dial* from 1920 to 1929 and for *The New York Sun* from 1913 to 1949, was one of the most persuasive and insightful advocates for modernism. His frequent and readable explanations of avant-garde aesthetics fueled the metamorphosis of American artists and increased public appreciation of their work. His championship of Lachaise began in 1918 when he reviewed the sculptor's exhibition at the Stephan Bourgeois Galleries, which had shown American and European modern art since 1914. McBride observed that as a newcomer to the country, Lachaise felt "something extraordinary and powerful in our women. They seem to be energy incarnate. . . . These goddesses, the American women of 1914–1918, are the true equals of men."[8] His words were prophetic, appearing eighteen months before women won the right to vote in the United States. Decades later, scholars realized that Lachaise's iconography went beyond mere portraits of his wife, Isabel Dutaud Nagle Lachaise, and that the artist intended something more enduring and cosmic.[9]

In August 1920, McBride explained that his regular column for *The Dial* would be devoted to modern art rather than traditional academic styles.[10] As he had with Lachaise in 1918, he displayed his remarkable ability to discover new directions for American sculpture. At M. Knoedler and Company, a venerable gallery established in 1848, Nadelman showed works that included *Chef d'Orchestre* (PLATE 39) and *Tango* (PLATE 38). Reviewing the exhibition, McBride wrote:

Photograph by Ward *Courtesy of the Bourgeois Galleries*

DUSK. BY GASTON LACHAISE

FIG. 30 **Gaston Lachaise** (United States, born France, 1882–1935), *Dusk*, 1917, reproduced as frontispiece in *The Dial* 68, no. 1 (January 1920). The University of Chicago Library

Nadelman scandalized the staid frequenters of Knoedler's, that hall of classicism, by exposing there in sculpture his views of New York night life. Like all foreigners who come here, Mr. Nadelman has been seeing things we should have preferred him not to see. He heard possibly with pleasure our famous jazz orchestras but saw too many plump and tightly laced ladies dancing with popinjay youths to suit the sticklers for propriety.[11]

McBride perceived that both Lachaise and Nadelman were celebrating the American character through their iconography.

McBride turned his attention again to genre sculptures by Nadelman in 1925, reviewing the artist's second solo exhibition at Scott and Fowles Gallery. Nadelman may have joined Cummings, Lachaise, and McBride in visits to popular performances, the source of many of Nadelman's subjects for sculpture—including *Acrobat* (PLATE 23), which McBride illustrated.[12] The upside-down bronze figure balanced on his hands has propelled his legs over his head, in striking contrast to the artist's classicizing marble and bronze works and his wood sculptures. The critic was amazed at Nadelman's astonishingly skillful "caricatures in wood … his jokes upon New York humanity."[13] *Tango* and *Pianist*, along with Nadelman's other genre figures in wood, document his interest in American vernacular culture and in the folk sculpture that he was enthusiastically collecting with his wife, Viola Flannery Nadelman.[14]

A decade earlier, when McBride had walked into the exhibition of African art at Stieglitz's 291 gallery in 1914, he had found Zorach there.[15] All four modern sculptors had seen non-Western art and its incorporation into European avant-garde art in Paris. In the United States, they continued to be receptive to African sculpture, which they regularly viewed in New York in museums and at galleries.[16] McBride and the editors of *The Dial* promoted artists who were experimenting with the sculptural vigor of African objects. Further revealing their sensitivity to cutting-edge developments in American art, they published "A Wood Carving by William Zorach" in 1921, just as the artist started to concentrate on sculpture, and his African-inspired *Young Boy* (PLATE 51) the following year.[17]

In addition to McBride, author and artist E. E. Cummings was an important voice for *The Dial*. Cummings was a good friend of Lachaise. They visited each other's studios and enjoyed going together to the Winter Garden and to the Hippodrome Theatre, both

FIG. 31 **Gaston Lachaise** (United States, born France, 1882–1935), *La Montagne*, 1934, concrete, 48 x 108 inches, Frelinghuysen Morris House and Studio, Lenox, Massachusetts

in midtown Manhattan, to see theater, circus, vaudeville, and burlesque performances. Cummings brought attention to Lachaise's second show at Bourgeois in 1920 and described *The Mountain* (PLATE 26), recently transformed from plaster to black sandstone, as a superlative aesthetic victory.[18] Lachaise achieved the serenity and repose of his archetypal earth mother with undulating contour lines and designed her anatomical features with bulbous spheroids.[19] After Thayer had purchased the sandstone sculpture, Lachaise carved a more abstract version in limestone, which he replicated in bronze, positioned on a glass plinth, and sold to Stieglitz in 1927. Although less than eight inches high, Lachaise's monumental woman has the imposing grandeur and dignity of a mountain. In 1934, he further simplified the sculpture, enlarged it to heroic scale, cast it in tons of concrete, called it *La Montagne*, and installed it on six-foot concrete piers in a grove of trees at the home of writer and artist George L. K. Morris in Lenox, Massachusetts (FIG. 31).[20] Cummings, Thayer, Stieglitz, and Morris all recognized the importance of Lachaise's timeless, universal symbol of female essence.

As seen in Thayer's acquisition of the sandstone version of *The Mountain*, *The Dial*'s editors bought

FIG. 32 **Elie Nadelman** (United States, born Poland, 1882–1946), *Horse and Figure*, circa 1912, bronze, 7 3/4 x 10 3/4 inches. The Metropolitan Museum of Art, Bequest of Scofield Thayer, 1982, 1984.433.37

sculptures and drawings by the artists they promoted. During the early 1920s, for instance, Thayer purchased works of art in the United States and Europe to support artists and to use as illustrations in his journal.[21] Nicholas Joost, who has documented the history of the Dial Collection, wrote that it linked "the best of the preceding generation with the best of the contemporary."[22] Thayer most appreciated sculpture that Nadelman had executed in Paris, adding two small bronze reliefs from 1912, *Woman on a Horse* and *Horse and Figure* (FIG. 32), and *Horse* (circa 1914) to his collection. In 1923, Thayer commissioned Lachaise's *Nude Woman with Upraised Arms* (PLATE 21) and two bronze casts of his own portrait. Later, he purchased a cast of Lachaise's *Standing Woman* (also known as *Elevation*; 1912–15; cast 1930, now at the Metropolitan Museum of Art). *Nude Woman with Upraised Arms*, one of the sculptor's many interpretations of Isabel seated or reclining, is a superb example of his portrayals of the energy radiating from her and other contemporary women. Lachaise was also a masterful portraitist, conveying the depth of intellect and quirky personalities of

more than seventy sitters, including the leaders of *The Dial*: Watson, Marianne Moore, Thayer, and Cummings. These portraits entered Thayer's and Watson's collections.[23]

The Arts was the other prominent journal in the discussion of American modernism in the 1920s. Hamilton Easter Field, a supporter and patron of many artists, particularly Laurent (see Shirley Reece-Hughes' essay in this catalogue), had been an integral part of the transition to new ideas in aesthetics since the 1890s. Field initiated and began editing *The Arts* in December 1920, writing about half of its content until his death in April 1922. Whereas *The Dial* published modern literature and art, *The Arts* focused on the visual arts of the present and past. In his writings, Field stoked the tension between academic and modern sculptors. In his review of *Modern Tendencies in Sculpture*, a book by the conservative sculptor and writer Lorado Taft, Field complained that Taft had "an utter lack of comprehension when it comes to the radicals, to Matisse, to Brancusi, to Epstein. Many of the men who are today the pioneers

of modern sculpture in America are not mentioned, men like Nadelman, Jo Davidson, Hunt Diederich, Gaston Lachaise, Alfeo Faggi."[24]

Several articles in *The Arts* brought Laurent's innovative approaches to a discerning audience. The first was a May 1921 essay by artist, critic, and publisher Horace Brodsky, who applauded Laurent's adoption of the technique and aesthetics of direct carving and his intuitive feeling for simplified forms.[25] Brodsky pointed out the artist's sensitivity to the qualities inherent in his materials, declaring "I claim for him a position in the front ranks of sculptors."[26] Later that year, Field illustrated Laurent's mahogany *Acrobat* (PLATE 1) in his rambling review of summer art shows he had seen in New York, Connecticut, Massachusetts, and Maine. *Acrobat* demonstrates the carver's enjoyment of popular public entertainment and appreciation of folk art, which he and Field were among the first to collect.[27] The reductive rounded forms, near-symmetry, and incised geometric surface decoration of *Acrobat* relate to qualities in hand-carved toys.

Like Brodsky, the perceptive critic Mary Fanton Roberts was fascinated with the increased range and power of Laurent's sculpture, which she had seen at Bourgeois Galleries in 1922. She wrote in *The Arts*:

> His power to convey great beauty with very simple outline and empty spaces is extraordinarily interesting.... In his nature pieces you are astonished at the results obtained by this very arresting simplicity. Long slender stems support woodland flowers, with leaves unfolded as quietly and inevitably as Nature herself would handle the process.[28]

Carved wooden foliage, although abundant in American furniture and folk art, was unprecedented in three-dimensional sculpture at the time. Laurent had cut relief leaf forms on furniture for several years before he released his plants from their bondage. Alfeo Faggi, in the foreword to the brochure for the Bourgeois exhibition, noted that the sculptor had set aside the Greco-Roman tradition to embrace the sensitivity and metaphysical approach "of the art of the Orient" and to express joy in all of his works. Faggi celebrated the artist's independence and vitality, declaring, "we have a new Spring in art."[29] Such enthusiastic appreciation of Laurent's innovative works advanced the cause of modern sculpture.

In addition to printing favorable articles about American modernism, Field's journal also provided a place for new sculptors to publish their ideas. For instance, Field was quick to publish Zorach's essay explaining the preference of modernists for expressing the inner spirituality and abstract qualities of a natural object, rather than describing its appearance.[30] A reporter tried to publish her interview with Zorach about these new aesthetic philosophies in *The Christian Science Monitor*, but the arts editor refused, saying that the *Monitor* did not cover modern art and that he himself was personally opposed to it.[31] Field, however, offered Zorach an opportunity to express the central convictions of the Theosophical movement: that a spiritual essence transcended both art and material objects.[32] Zorach wrote that art is:

> a universal and cosmic expression of the soul of man, an expression of the realness of the universe and life.
>
> Form is the expression of an inner relation of lines, planes, volumes to each other, a relation such as holds the stars in their courses in the heavens, balances force against force, relates vacuums and solids, a thing as fundamental and cosmic as these.[33]

By publishing these ideas, Field provided an opportunity for Zorach to disseminate the shared transcendental beliefs that pervaded the aesthetics of the new American sculptors and the European avant-garde.

After Field's death from pneumonia in April 1922, the thirty-one-year-old Laurent, his sole heir, became executor of his estate, caretaker of his art collection, supervising manager of his schools and real estate in Ogunquit and Brooklyn, and owner of *The Arts*. Laurent had no interest in overseeing a journal and sold the rights to Gertrude Vanderbilt Whitney, an accomplished but conservative sculptor and the premier philanthropist of American art, who agreed to subsidize the journal.[34] Whitney's new editor was Forbes Watson, a supporter of modern art as critic for the *New York World* and the advisor for the various Whitney arts organizations until 1933, when he became the technical adviser for the short-lived federal Public Works of Art Project.

Zorach continued to publish his straightforward, passionate prose in *The Arts*, explaining the aesthetic philosophies of modern sculpture in an effort to appeal to art students, dealers, museum personnel, scholars, and patrons.[35] His paean to the Romanian-born Parisian sculptor Constantin Brancusi was part of an avalanche of exhibitions, reviews, special issues of publications, and newspaper articles about the

artist, all of which educated a wide public about modern sculpture.[36] Newspapers reported on Brancusi's two visits to New York in 1926 and the controversy surrounding his legal battle with United States Customs about whether *Bird in Space* was a sculpture or a manufactured item. The Brancusi controversy became a key turning point in American modernism. The basic tenets of modern sculpture were published frequently and prominently in the news sections of newspapers, not just in the arts sections, thus reaching a new and wider audience. As abstracted sculptures and direct carving became more familiar through the discussion of Brancusi's art, modern American artists witnessed a surge in positive reviews and more galleries were open to their art.

The Arts published positive reviews of Laurent's and Zorach's works that contributed to the sculptures' marketability. In 1926, Helen Appleton Read, the talented writer who had succeeded Field as the art critic for the *Brooklyn Daily Eagle*, wrote an insightful review for *The Arts* of Laurent's exhibition at Valentine Gallery: "Outside of academic circles, to be seen only in the galleries of dealers sympathetic to modern art or in independent exhibitions, a few sculptors were experimenting with form in accordance with their own personal predilections, notably Robert Laurent."[37] She praised Laurent's wood carvings of plants and flowers as his "unique contribution to sculpture":

> All of them . . . symbolize the essence of plant life, as Brancusi's bird forms symbolize the essential qualities of all birds. . . . A quality of fecundity and of elemental things further characterizes his work, and an element of serenity and repose, a suggestion that all things in their essence spring from one eternal source.[38]

A fine example of these remarkable botanomorphic abstractions is the fruitwood *Plant Form* (**PLATE 47**). Its paired undulating blades, clothed with an olive-green stain, are posed in a stylishly elegant and sensual dance.

In 1928, Forbes Watson, reviewing Zorach's solo exhibition at Kraushaar Galleries for *The Arts*, wrote that the artist had "won a position among the leaders in American sculpture because in addition to natural talent he has a liberal understanding of the meaning of sculpture and the respect for his medium, characteristic of the craftsman who does not dodge difficulties."[39] Partly because of support from *The Dial* and

The Arts, the "new sculptors" had become admirable and acceptable.

Journals devoted to academic American art, including *Art News* (founded 1902) and *Art in America* (founded 1913), slowly evolved to cover avant-garde art, but another new magazine, *Creative Art* (launched in 1927), actively promoted modern art and aesthetics.[40] Lachaise contributed "A Comment on My Sculpture" to *Creative Art* in 1928, explaining his cosmic goals and Jungian interpretations of *Standing Woman* and *The Mountain*.[41] He concluded that "the most favorable ground for the continuity of art is here," meaning that the United States had inspired him.[42] Lachaise's persistence in explaining his iconography helped others understand the deeper meaning of his monumental nude sculptures. In the same issue, Cummings expressed his excitement about the first bronze cast of *Standing Woman*, with its "masses poised against their own silence," which he had seen at the Brummer Gallery in March 1928. The poet's enthusiasm was contagious. Lachaise ordered five bronze casts of the work in 1930, several of which are now in major museums.[43] More than any other single sculpture, *Standing Woman* (**PLATE 16**) represents the achievement of these new American sculptors.

Expanding Exhibition Opportunities

In 1927, Stieglitz, impressed with Lachaise's originality and productivity, staged a one-man exhibition of his work at the Intimate Gallery; he was the only sculptor given a solo show there.[44] Among Lachaise's twenty sculptures on view were the bronze *Mountain* and seven portraits including *Georgia O'Keeffe*, stunning in alabaster (**FIG. 33**), *E. E. Cummings* in painted plaster, and *J. Sibley Watson, Jr.* in bronze. Stieglitz also selected a nickel-plated bronze statuette, *Standing Nude* (**PLATE 24**). This partially draped nude sculpture was an early work in Lachaise's series that combined a portrait of Isabel with his developing iconography of American womanhood.

The progressive journals and galleries that appreciated the sculptures of Lachaise, Laurent, Nadelman, and Zorach did not reach mass audiences, but they extended the acceptance of modern art and literature to supporters who could. During the 1920s, such patrons were wealthy and well informed. From Kraushaar Galleries in 1922, Duncan Phillips selected Lachaise's

conservative sculptures, *Peacocks* and *Sea Lion*. Later, he collected John Marin's paintings and wrote about them. He also added Lachaise's *John Marin* (FIG. 34), a spellbinding portrait head, to his museum's collection, located since 1921 near Dupont Circle in Washington, D.C.[45] Artists Lucy and Bill L'Engle met the Zorachs in Paris and introduced them to Lucy's brother, Congressman Lathrop Brown, and his wife, Helen, who were major collectors of works by both Zorach and his wife, Marguerite, a painter and textile artist.[46] In 1925, soon after Zorach had switched his primary medium from painting to sculpture, the Browns purchased his mahogany *Mother and Child* (PLATE 42), a secularized Madonna with greater emotional power and a more complex composition than his earlier columnar wood figures.[47] The Browns' collection, on view in their Beacon Street home in Boston, brought Zorach's remarkable carving to the attention of their prominent political and social friends.

Zorach's first solo exhibition of sculpture, at Kraushaar in 1924, appealed to art critics and collectors. Kenneth Noské, an architect for Robert J. F. Schwarzenbach, a wealthy silk importer and manufacturer, commissioned wood panels for the tycoon's new residence in New York from the artist.[48] For such an important commission so early in his career as a sculptor, Zorach worked out the complicated designs of these pairs of entwined figures in quarter-scale versions. Then, collaborating with Marguerite, he designed full-scale cartoons for two different pairs of doors. During the winter of 1924–25, he carved the first five-foot-high walnut pair for Schwarzenbach, *Figures and Animals*, in flat relief. In 1925, perceiving the robust potential of sculptural relief, Zorach carved the second set of Brazilian walnut panels, keeping them for himself. Both the reliefs in *Family Group* (*Father and Children* and *Mother and Child*) display voluminous rounded forms, along with rich, Art Deco–style curved parallel striations in the mother's hair and archaizing curls for the father's hair—very different from the fluid, unarticulated features of the figures he had modeled in the clay studies (later cast in aluminum; PLATE 57).[49]

Artists did not have to depend on galleries to expose their work to a few high-end patrons. Such new democratic organizations as the Society of Independent Artists (SIA) and the Salons of America sponsored large annual or semiannual non-juried art

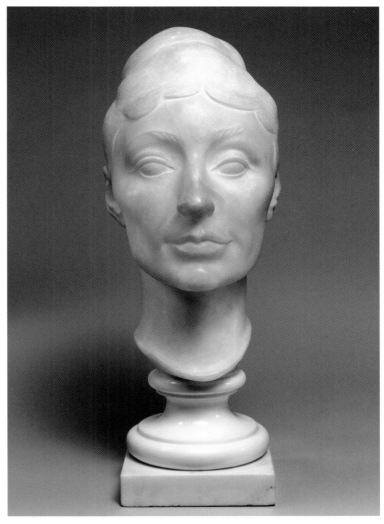

FIG. 33 **Gaston Lachaise** (United States, born France, 1882–1935), *Georgia O'Keeffe*, 1925–27, alabaster, 23 x 8¼ x 12¼ inches. The Metropolitan Museum of Art, Alfred Stieglitz Collection, 1949, 49.92.4

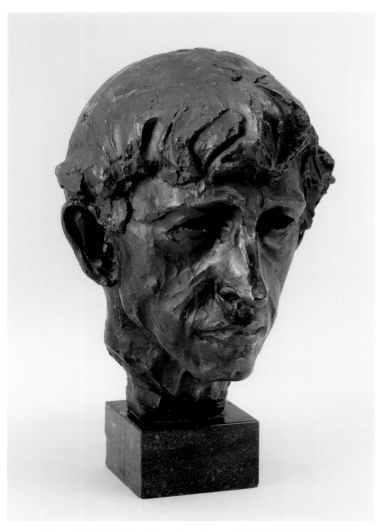

FIG. 34 **Gaston Lachaise** (United States, born France, 1882–1935), *John Marin*, 1928, cast 1930, bronze, 14¹/₂ x 9⁵/₈ x 9¹/₂ inches. The Museum of Modern Art, New York, Gift of Abby Aldrich Rockefeller, 154.1934

exhibitions of a wide range of art to an equally diverse audience. Walter Arensberg and his circle of European and American avant-garde artists founded the SIA in 1916, but almost immediately Walter Pach and John Sloan, among others, made it an American enterprise. Sloan continued to lead the organization until it folded in 1941 (the large public facilities required to display the shows were needed for war efforts). Nadelman, a member of the SIA for a few years, did not exhibit. Zorach showed his sculpture in 1922 and sporadically thereafter. Laurent and Lachaise exhibited with the SIA from 1917 to 1922, but then switched their allegiance to the Salons of America, founded by Field in 1922 and active until 1936. These independent organizations helped establish a broader base for the arts in New York.

Museums were slower to respond to the positive qualities of modern art than the progressive galleries, journals, patrons, and independent exhibition organizations. Until 1929, the Metropolitan Museum of Art was the only museum of art in New York showing American art. All the artists whom Daniel Chester French invited to "An Exhibition of American Sculpture" there in 1918 were connected to the conservative National Academy of Design and National Sculpture Society. Lachaise asked to be included, but French refused. During the 1920s, all four sculptors exhibited at the Whitney Studio and the Whitney Studio Club funded by Gertrude Vanderbilt Whitney and directed by Juliana R. Force. Later, all four were represented in the collections of the Whitney Museum of American Art, founded in 1931. Once Whitney and Force learned of the needs of artists, they helped with stipends, purchases, and commissions.[50] For example, between 1924 and 1935, as Force and Whitney became aware of Lachaise's need for money, they purchased four sculptures and two drawings. In 1928, when they realized that sculpture was underrepresented at the Whitney Studio Club galleries and circulating exhibitions, they organized "The First Annual Sculpture Show."[51] All but Nadelman exhibited regularly in the annual or biennial exhibitions at the Whitney Museum, which continue to the present day. The artists and works that Whitney, Force, and their organizations' various curators and directors—especially Lloyd Goodrich—collected and exhibited eventually became the canon of modern American art.

In 1928, when Lincoln Kirstein and Varian Fry heard that *The Dial* was going to cease publication,

they started and edited *Hound & Horn*, a quarterly journal devoted to European and American modern art. The little magazine favored Lachaise, whom A. Hyatt Mayor, curator of prints at the Metropolitan Museum of Art, described as the greatest living portrait sculptor.[52] That same year, Kirstein and two other sophomores, Edward M. M. Warburg and John Walker III, organized the Harvard Society of Contemporary Art. For the society's first show in February 1929, installed in two rooms in the Harvard Cooperative, Kirstein wrote that "the exhibition is an assertion of the importance of American Art. It represents the work of men no longer young [but] who have helped to create a national tradition—stemming from Europe, but independent."[53] The exhibition included the sculptors Lachaise, Laurent, Alexander Archipenko, and Alexander Calder.

The wealthy, erudite men who started the Harvard Society continued to impact American culture for decades.[54] John Walker was chief curator at the National Gallery of Art from 1939 to 1956 and director thereafter until 1969. Philanthropist Warburg, trustee of the Museum of Modern Art (MoMA) from 1932 to 1958, brought attention to Lachaise's sculptures of exaggerated female anatomy when he bought *Torso* from Kraushaar Galleries and donated it to the museum in 1934. *New York Times* critic Edward Alden Jewell recognized that this heroic plaster torso of a woman "is impressive by virtue of its great vigor and the strong simplicity of the modeling." Although puzzled by its arbitrary proportions, he concluded that "the torso is esthetically satisfying."[55]

Lachaise and Kirstein, viewing a statuette of an Egyptian god-king at the Metropolitan Museum of Art in 1933, decided that the sculptor should create a nude portrait of his friend and patron (**PLATE 20**). Lachaise conveyed Kirstein's legendary, commanding presence through his erect posture and athletic body, and Whitney bought the portrait for her new museum. After Lachaise's portrait head of Warburg was cast in bronze, he carved it in translucent alabaster (**PLATE 4**), a medium that conveys the young subject's vibrancy. Between 1932 and 1934, Warburg purchased eleven sculptures by Lachaise. Kirstein, along with George Balanchine and Warburg, founded the School of American Ballet in 1934 and several other organizations that led up to the New York City Ballet Company in 1948. Warburg and Kirstein joined with MoMA curators

René d'Harnoncourt and Holger Cahill to organize an exhibition of Lachaise's work on view in 1935—the museum's first retrospective awarded to a living sculptor. Without Kirstein, who organized the memorial show of Nadelman's work at MoMA in 1949 and published monographs on the sculptor, Nadelman might have been forgotten.[56]

Through its democratic policies, MoMA extended venues for modern American art to radio programs, community centers, and European museums and galleries. Lachaise, Laurent, Nadelman, and Zorach were among the thirty-five sculptors chosen by MoMA to represent the history of American sculpture in "Trois siècles d'art aux États-Unis" (Three centuries of art in the United States), on view at the Musée du Jeu de Paume in Paris from May through July 1938. MoMA was a pioneer in promoting modern sculpture to a wide range of middle-class Americans and to international audiences.

Edith Gregor Halpert was another crucially important catalyst who accelerated the pace of the acceptance of modern art. After she and Samuel Halpert, her painter husband, rented a shack on Perkins Cove in Ogunquit, Maine, from Laurent for the summer of 1926, she returned to New York and opened "Our Gallery" (soon to be called The Downtown Gallery). For the next four decades, the gallery materially supported American artists—for sculpture, especially Zorach, John Storrs, and Reuben Nakian.[57] Halpert's collaborations with Cahill and their friendship with and tutoring of Abby Aldrich Rockefeller (Mrs. John D. Rockefeller, Jr.) were critical for the future of modern and folk art in America. Rockefeller cofounded the Museum of Modern Art; had a profound but undercover influence on the prominence of art in Rockefeller Center; built a large private collection that included works by Lachaise, Laurent, Nadelman, and the Zorachs; founded the Abby Aldrich Rockefeller Folk Art Museum in Colonial Williamsburg, Virginia; and mentored her son, Nelson A. Rockefeller, who promoted and funded all these endeavors throughout his adult life.

In 1934, Halpert was the driving force for "The First Municipal Art Exhibition," which she and Cahill organized. They obtained sponsorship from Mayor Fiorello H. La Guardia and funding from Nelson A. Rockefeller.[58] Laurent and Zorach exhibited sculpture and drawings in this large show at the Forum, a gallery

FIG. 35 **Elie Nadelman** (United States, born Poland, 1882–1946), *Figures*, 1929–34, limestone, 144 inches (height). Fuller Building, 41 East 57th Street, New York

in the new RCA Building in Rockefeller Center. Lachaise withdrew in protest over the destruction that year of Diego Rivera's frescoed mural, *Man at the Crossroads*, because of its Communist iconography.[59] In the summer of 1937, the "Second National Exhibition of American Art" sponsored by the Municipal Art Committee was held in the American Fine Arts Society galleries. The Metropolitan Museum of Art selected its first Zorach sculpture from this show, his majestic Egyptian-like granite cat, *Tooky*, carved that year. Sculptures by Lachaise, Laurent, and Nadelman became part of the Metropolitan's collection beginning with bequests in the 1940s.[60] Exhibition venues at new societies and museums and the Metropolitan's increased patronage of modern art expanded the global exposure of our new sculptors beyond the confines of small commercial galleries.

New Deal Programs, Public Commissions, and World's Fairs

After the plunge of the New York Stock Exchange in October 1929, severe economic conditions decreased purchases by private patrons who, even if they appreciated modern art, were focused on their own financial situations. Galleries were hard pressed to market art, since it was now a luxury very few could afford. Nevertheless, independent art societies and the new museums continued to display the works of artists throughout the Depression years. In addition, new federal art programs and such privately supported projects as the Fuller Building, Rockefeller Center, and the Ellen Phillips Samuel Memorial in Philadelphia gave artists some support. These monumental public commissions demanded new, patriotic iconography and restricted the independent creative expression that modern sculptors treasured. During the 1930s, the artists continued to develop their personal style in independent figurative works, and all but Nadelman also worked with committees to determine the form and content of their public sculptures.

Nadelman created few public sculptures, missing out on New Deal and World's Fairs opportunities during the 1930s because he had broken off communication with the art world. One prominent private commission was for limestone relief sculptures and a clock (1929–34; **FIG. 35**), on the forty-story Art Deco Fuller Building on East 57th Street and Madison Avenue, which continue to greet the art-loving public

as they visit art galleries there.[61] Although the muscular male figures appear atypical in Nadelman's oeuvre, Kirstein related them to Nadelman's early work and to ancient precedents.[62] The heroic laborers in front of a panel of skyscrapers foreshadow Lachaise's sculptural reliefs of workmen on modern skyscrapers in Rockefeller Center.

Three large Sculpture Internationals, in 1933, 1940, and 1949, were sponsored jointly by the Philadelphia Museum of Art and the Fairmount Park Art Association to showcase American sculpture and to select artists for the Samuel Memorial, three terraces for sculpture located on Kelly Drive along the Schuylkill River in Philadelphia.[63] Hartley Burr Alexander, a professor of philosophy at the University of Nebraska and Scripps College and a self-styled iconographer, was instrumental in determining the overarching themes of American history and democracy for the Samuel Memorial and many other major projects of the 1930s, including Rockefeller Center and the World's Fairs.[64] Alexander's national themes, which emphasized the positive values of democracy and capitalism, seemed appropriate to the architects and commissioners of many architectural and monumental complexes of the 1930s.

Alexander worked with the architect Paul Cret and the architectural firm of Zantzinger, Borie and Medary on the symbolic program for the Samuel Memorial. Laurent's nine-foot-high bronze sculpture, *Spanning the Continent* (**FIG. 36**), one of the first of the seventeen monuments commissioned for the Memorial, was installed in 1938 in the Central Terrace. Laurent depicted an idealized pioneer man and woman with a wagon wheel to symbolize the hardy American people who blazed trails and traveled by covered wagon to fulfill the nation's ideology of Manifest Destiny. In 1934, Lachaise completed a one-quarter-scale bronze model for *Welcoming the Peoples* (or *The Melting Pot*; **FIG. 37**), but he died before he was able to execute the full-scale sculpture.[65] Lachaise composed monumental male and female nude figures standing on a high, rectangular platform, flanking a taller central plinth that depicts immigrants of varying ethnicities. Laurent's and Lachaise's interpretations linked art and ideology to create pride in the nation's unique qualities.

Rockefeller Center, one of the most remarkable architectural complexes in history, was developed

FIG. 36 **Robert Laurent** (United States, born France, 1890–1970), *Spanning the Continent*, 1937, bronze on granite base, 110 x 94½ x 47 inches. City of Philadelphia, Commissioned by the Fairmount Park Art Association (now the Association for Public Art), bequest of Ellen Phillips Samuel

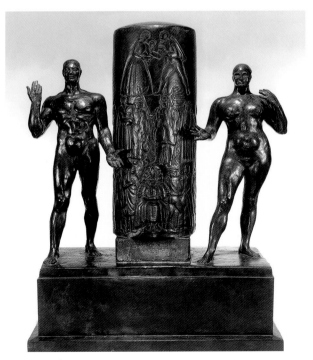

FIG. 37 **Gaston Lachaise** (United States, born France, 1882–1935), *Welcoming the Peoples* (also known as *The Melting Pot*), circa 1935, bronze, 37¾ x 29 x 14¼ inches. Philadelphia Museum of Art, Gift of the Fairmount Park Art Association, 1992, 1992-98-1

and funded by John D. Rockefeller, Jr., as his most significant business endeavor. This cluster of stream-lined Moderne limestone skyscrapers and theaters, constructed between 48th and 51st Streets and Fifth and Sixth Avenues in New York City, involved dozens of architects, urban planners, and artists, along with about forty thousand workers. In 1931, Rockefeller commissioned Alexander to develop the unifying theme of "Frontiers of Time" for the ornamentation of the buildings in Rockefeller City (the original name for the center). Believing that this complex would rival historical monuments of the past, Alexander wanted to communicate the idea that because the geographic frontiers of the United States had closed, the paths to the future were new frontiers in economics, religion, politics, and science. Scholar William J. Buxton has recently determined that after Alexander was fired, his successors appropriated his ideas.[66] The significance of Alexander's iconography probably has escaped the millions of people who have walked through the center,

but visitors did become familiar with the modern figurative sculptural forms that embodied his ideas.

Although Radio City Music Hall, designed by Edward Durrell Stone, was part of Rockefeller Center, it was not included in Alexander's formal iconographic program. Laurent and Zorach created over-life-size sculptures for the hall's interior, designed by Donald Deskey. In 1932, after consulting with Edith Gregor Halpert and Abby Aldrich Rockefeller, Deskey selected Laurent's *Goose Girl* for the mezzanine (**FIG. 38**), Gwen Lux's *Eve* for the foyer (**FIG. 39**), and Zorach's *Spirit of the Dance* (see **FIG. 11**) for the main lounge. These female nude figures, cast at Roman Bronze in the then ultramodern medium of aluminum (donated by the R. J. Reynolds Company), were in place by December 1932. *Goose Girl*, inspired by Laurent's memories and the folklore of Brittany (also a favorite subject of Paul Gauguin), alluded to the peacefulness of peasant life. Laurent's goose and girl pose in a graceful pas de deux in front of a tinted mirror

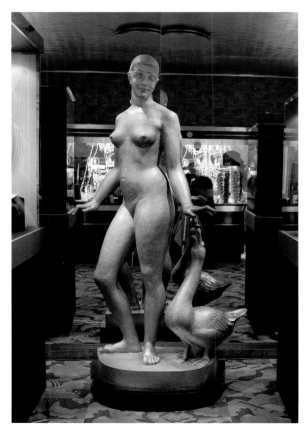

FIG. 38 **Robert Laurent** (United States, born France, 1890–1970), *Goose Girl*, 1932, aluminum, 82 inches (height including base). Radio City Music Hall, Rockefeller Center, New York

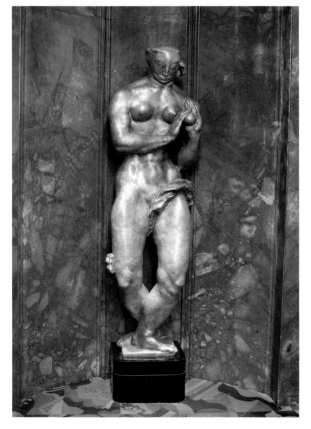

FIG. 39 **Gwen Lux** (United States, 1908–2001), *Eve*, 1932, aluminum, 68 inches (height). Radio City Music Hall, Rockefeller Center, New York

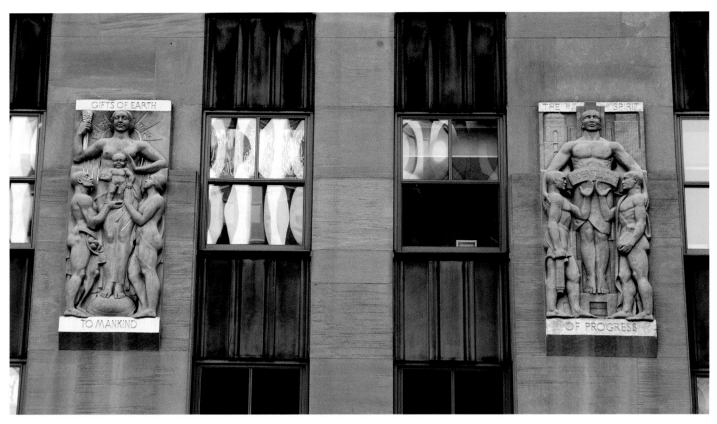

FIG. 40 **Gaston Lachaise** (United States, born France, 1882–1935), *Aspects of Mankind*, 1932–34, limestone, 136 x 48 inches each. 1250 Avenue of the Americas, Rockefeller Center, New York

that transforms the gray of the aluminum to warm brown tones.

In December of 1932, Lux's and Zorach's sculptures disappeared from view; Laurent's apparently proved too difficult to move. S. L. (Roxy) Rothafel, the manager of Radio City Music Hall, said that despite the fact that the Rockefellers liked the sculptures, he did not, and added that the figures' nudity would compromise the morals of young patrons.[67] After Zorach exhibited a full-scale model of *Spirit of the Dance*, which was well received by art critics and the general public when shown at the Downtown Gallery and the Architectural League, the aluminum sculptures were returned to their designated places in the theater, where they remain on view to the present day.[68]

At 30 Rockefeller Center (1250 Avenue of the Americas), architect Raymond Hood commissioned Lachaise to carve *Aspects of Mankind*, four eleven-by-thirty-three-foot Indiana limestone panels, which were installed in 1932 and gilded in 1934 (**FIG. 40**).[69] The subtitles for *Aspects of Mankind* were *Gifts of*

Earth to Mankind, *The Spirit of Progress*, *Genius Seizing the Light of the Sun*, and *The Conquest of Space*—all themes Alexander had chosen to express the supremacy of the United States. In each panel, a central, frontal, partially draped divinity (three male and one female) is flanked by a pair of nude figures in profile (five male and three female), which are half the size of the gods and the goddess. The same managing architects who had destroyed Rivera's mural located Lachaise's relief sculptures several stories up—far above Lee Lawrie's three dramatic polychromed and gilded limestone and glass reliefs, *Wisdom*, *Sound* (representing radio), and *Light* (representing television), at the central entrance.[70] Alexander selected the inscription for Lawrie's *Wisdom*: "Wisdom and Knowledge Shall Be the Stability of Thy Times."[71] After the elevated subway tracks on Sixth Avenue were torn down in 1939, pedestrians could see Lachaise's designs, whether or not they appreciated the intricate iconography.

The next year, Nelson A. Rockefeller commissioned Lachaise to create *To Commemorate the Workmen of the Center* on the façade of 45 Rockefeller Plaza, the

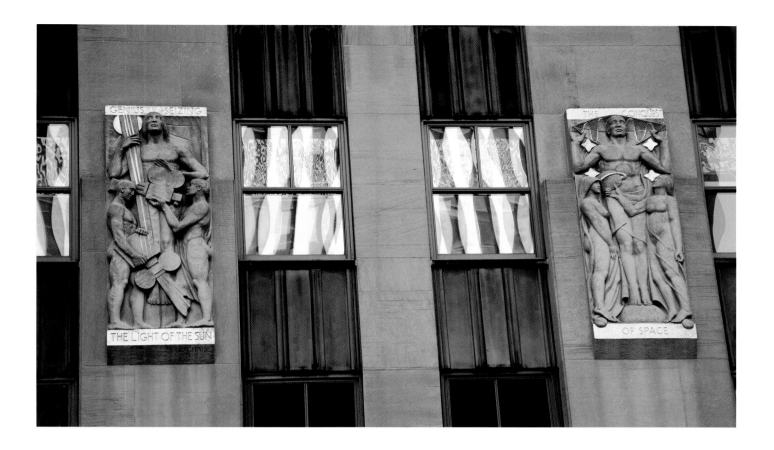

International Building (**FIG. 41**). Lachaise carved lime-stone reliefs of *Construction*, two workers riding a steel beam, and *Demolition*, in which one worker holds a crowbar and another an acetylene torch.[72] Alexander, Hood, and Rockefeller shared convictions that hard work, the core of the nation's success, was the way out of the Depression.

Alexander's themes also were central to the World's Fairs of the 1930s, which promoted national pride and generated hope during a decade of deep despair. "The Century of Progress" of 1933–34 in Chicago was the first world's fair in the United States to rely solely on private funding. Laurent, Lachaise, and Zorach all exhibited sculpture at "A Century of Progress Exhibition of Paintings and Sculpture 1934" at the Art Institute of Chicago, which brought some of their finest works to a national audience.[73] Alexander, building on concepts developed for Rockefeller Center, assisted Hood in developing thematic designs for the Electrical Group at the fair. Hood commissioned Lachaise's polychromed plaster portal, *The Conquest of Time and Space*, a twenty-four-foot-high relief over

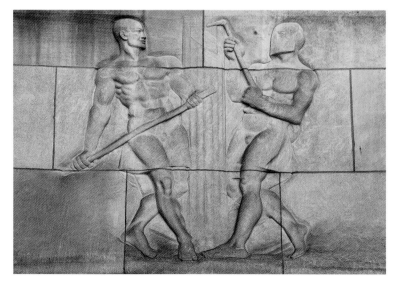

FIG. 41 Gaston Lachaise (United States, born France, 1882–1935), *To Commemorate the Workmen of the Center*, 1935, limestone, 84 x 144 inches. 45 Rockefeller Plaza, Rockefeller Center, New York

FIG. 42 **William Zorach** (United States, born Lithuania, 1889–1966), *Builders of the Future*, 1939, staff (plaster, cement, and fiber), 197 inches (height). New York World's Fair. Photograph, The New York Public Library, Manuscripts and Archives Division, New York World's Fair 1939–1940 Records, MssCol 2233

FIG. 43 **William Zorach** (United States, born Lithuania, 1889–1966), *Benjamin Franklin*, 1936, marble, 82 x 38 x 22 inches. National Postal Museum, Washington, D.C. / Fine Arts Program, U.S. General Services Administration, Commissioned through the Section of Fine Arts, 1934–1943, Fine Arts Collection, U.S. General Services Administration, FA591

the entrance to the Communications Hall of the Electrical Group.[74] In the relief, a standing male nude harnesses electrical power and communication with wires indicated by a grid of lines. Lachaise's sculpture communicated that the United States had used electrical and telephone networks to unify the nation.

The 1939 World's Fair used Alexander's theme of "Building the World of Tomorrow," which, as in 1933, celebrated the country's highly trained workforce, industrial superiority, and advances in health, science, and technology.[75] Large-scale outdoor sculptures in plaster were commissioned from Laurent (*The Hunt* and *Forester*), Zorach (*Builders of the Future*; FIG. 42), and others, but all were "junked and buried in Flushing Meadow" after the Fair.[76] Zorach and the rest of the artists' and selection committees for the Northeast claimed that bringing together a "cross-section of the

work being done in this country" was extremely difficult, as art in metropolitan areas was created to higher standards than in the rest of the country.[77] Similar to the Chicago World's Fair, the New York World's Fair sponsored a survey exhibition of "American Art Today," directed by Cahill, which included both academic and modernist works.

The federally funded New Deal art programs, created in response to the Depression, provided work for thousands of artists, commissioned works for public spaces, and expanded the public's awareness of art. In 1936, Zorach carved his first full-length conventional portrait, *Benjamin Franklin* (FIG. 43), funded by the Section of Painting and Sculpture of the Treasury Department, for the Post Office buildings in Washington, D.C. When the monumental sculpture carved from pink Tennessee marble was installed in

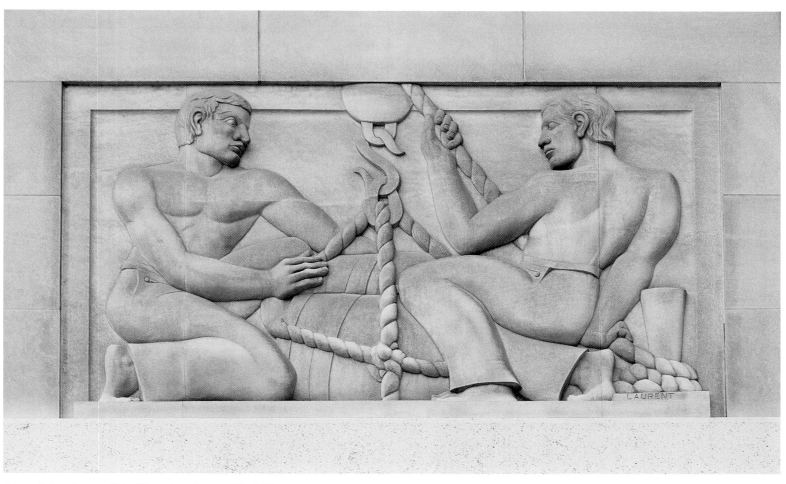

FIG. 44 **Robert Laurent** (United States, born France, 1890–1970),
Shipping, 1938, limestone, 72 ¾ x 144 ¼ inches. Federal Trade
Commission Building, Washington, D.C., New Deal Art Program Fine
Arts Collection, U.S. General Services Administration, FA555

1937, critics complained that Zorach had given Franklin a Quaker costume, even though the Founding Father was not a Quaker.[78] Another Treasury Department project was Robert Laurent's *Shipping* of 1938 (**FIG. 44**), one of four limestone reliefs for the Federal Trade Commission located in the Federal Triangle, across the street from the National Gallery of Art in Washington, D.C. The designs of the reliefs were simpler and more modern than the sculptural decorations for other Federal Triangle buildings, which had used Beaux-Arts symbolism and style. Despite the architects' preference for the modern style, the Section's committee members criticized the lack of anatomical correctness in Laurent's figures—characteristic of his figurative sculptures throughout his career—and he had to redesign the model several times.[79] Although the outdoor sculptures from the World's Fairs were destroyed and many of the exterior reliefs embellishing Rockefeller Center's buildings are difficult to see, these overdoor panels on the Federal Trade Commission building are in place for passersby to view.

Postscript

Just after the United States entered World War II, Zorach started to carve in marble *The Future Generation*, a family group that the Whitney Museum purchased from his one-man exhibition at the Downtown Gallery in 1949. Zorach believed that during times of war, celebrating the universal value of family was important. He carved his torso *Victory* (**FIG. 45**) in response to the decisive Allied D-Day victory on June 6, 1944. In 1941, Laurent's relief sculptures *Spirit of Drama* and *Spirit of Music* and Thomas Hart Benton's "Century of Progress" murals were unveiled in the new Auditorium Building at the University of Indiana, where Laurent was a professor of art from 1942 to 1960. Like Zorach's wartime works, Laurent's reliefs emphasized positive aspects of life.

The tides of culture always shift. Pioneering modernist sculptors initially stirred up controversy, but later found important private and public support for their art. Nelson A. Rockefeller continued to purchase the work of Lachaise, Nadelman, and Zorach—artists he had met because they were friends of his mother. During the 1960s, when he became interested in monumental sculpture, he acquired Lachaise's *Standing Woman*

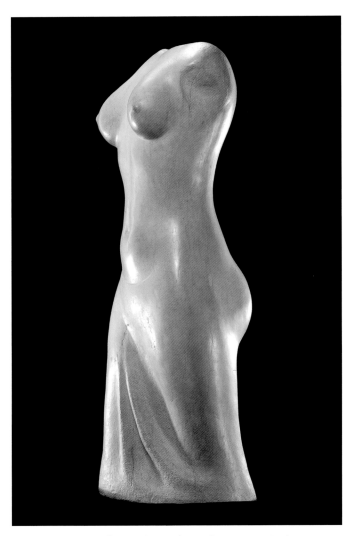

FIG. 45 **William Zorach** (United States, born Lithuania, 1889–1966), *Victory*, 1944, marble, 42 3/8 x 15 x 12 1/8 inches. Smithsonian American Art Museum, Washington, D.C., Gift of Mrs. Susan Morse Hilles, 1971.76

(cast 1967) and works by Nadelman.[80] Although many had forgotten Nadelman, Rockefeller had not. Rockefeller remembered the sculptor as "a curious and wonderful man" who interested him because of "the beauty and the wit of his pieces" and the "very democratic concept of making many of his sculptures in *papier-mâché*, with the idea that they would be more financially available to the public."[81] Rockefeller owned thirty of Nadelman's doll-like papier-mâché figures and had two groups of circus performers (one nude and one costumed), originally executed during the late 1920s, enlarged to about five feet high (see **PLATE 11**) and cast in bronze. Rockefeller, Kirstein, and the architect Philip Johnson later collaborated in enlarging to monumental size and replicating these two paired sculptures in marble for the Promenade of the New York State Theater (now the David H. Koch Theater) at Lincoln Center, where they still preside today, known as *Two Female Nudes* (**FIG. 46**) and *Two Circus Women*. The aesthetic choices and formal solutions of Lachaise, Laurent, Nadelman, and Zorach represent significant trends in early twentieth-century sculpture. Their works, located in countless museums, public places, and private collections, guarantee their enduring presence.

The story of the opportunities for modern art to be communicated and appreciated by journals, commercial galleries, and private and public patrons and institutions reveals an upward trajectory during the 1920s. In this decade, Lachaise, Laurent, Nadelman, and Zorach evolved from little-known, early career innovators into widely accepted modern masters. The audience for American art changed from an inner circle of informed and elite connoisseurs to a large segment of the middle class, which encountered their modern sculpture in a widening circle of venues, including large non-juried exhibitions, museums, privately funded commercial building complexes, world's fairs, federal buildings, and many buildings for new cultural institutions. By World War II, modern sculpture had become undeniably popular.

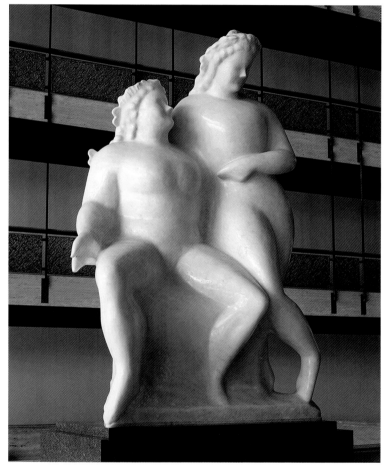

FIG. 46 **Elie Nadelman** (United States, born Poland, 1882–1946), *Two Female Nudes*, 1964–65, marble, approximately 228 inches (height). David H. Koch Theater, Lincoln Center for the Performing Arts, New York

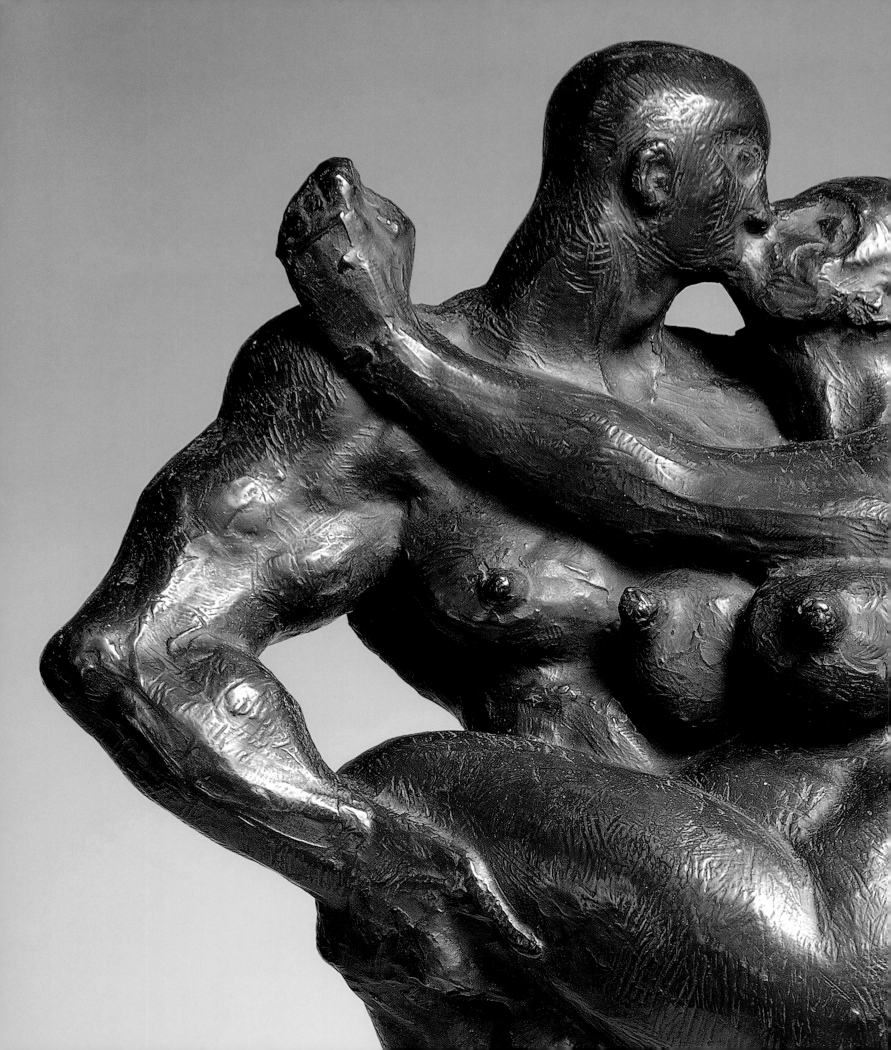

On the Surface: Innovations of Material and Technique

ANDREW J. ESCHELBACHER AND RONALD HARVEY

In his influential 1947 guidebook to making sculpture, William Zorach instructed his students to think about their materials while they were designing their forms. "Each material," he wrote, "has a character and quality of its own."[1] This counsel signals the importance of the physical properties of wood, stone, metal, and other materials to the development of modern sculpture. As Elie Nadelman argued, materials have a "plastic life" that artists must respect. "A simple stone," he wrote, "demonstrates its will by refusing all positions we might wish to afford it unless they are suitable, and it maintains that position which its weight, in accord with its shape, demands."[2]

Zorach and Nadelman, along with Gaston Lachaise and Robert Laurent, were among the pioneers of a generation of sculptors who focused on creating harmony between their compositions and their sculptures' natural surfaces and textures.[3] This marked a departure from the approach of many nineteenth-century artists, who were often willing to employ new industrial techniques and large teams of craftsmen in order to execute the same sculpture in bronze, marble, zinc, and more—all available at different sizes and price points.[4] For these earlier sculptors, offering their art in a variety of materials was a democratic statement. They were creating work for collectors across many strata of society, ensuring that the consumption of culture was no longer reserved for the nobility, clergy, and wealthy.

Near the turn of the twentieth century, however, artists and critics began to question what these practices meant for art making. In the 1890s, Auguste Rodin's rival Jules Dalou

believed that "a work of art is made for a specific material and for a specific dimension, and to change these variables is to falsify the object."[5] The following generation—that of Nadelman and Brancusi, Laurent and Modigliani—latched on to these ideas and shared a widespread philosophy that sculptors should look to their stones, woods, metals, and more to guide their compositions.

At various points throughout their careers, Lachaise, Laurent, Nadelman, and Zorach noted the significance of their materials. They designed forms and treated surfaces specifically to extract as much meaning as possible from the physical characteristics of their artwork. Yet the relationship of sculpture to its materials was always more complicated than idealistic rhetoric. For instance, despite his pronouncement, Dalou is best represented in the world's museums through countless bronze editions of his terracotta sculptures. Then as now, finances, technique, processes, and aesthetic aims complicate the creation of a seamless unity between composition, surface, and material, and the way artists address these challenges reveals deep insight into real-world sculptural concerns. For Lachaise, Laurent, Nadelman, and Zorach, however, the links between materiality, composition, and meaning were constantly at the forefront of their conception of art and demonstrated the inventive possibilities as well as the formal challenges of creating modern sculpture.

Wood

Laurent, Nadelman, and Zorach participated in a renaissance of fine-art wood sculpture during the first half of the twentieth century. Sculpture in wood had a long history in many different cultures, leading the eminent scholar Nicholas Penny to call wood the "most universally and commonly favored" material.[6] Though wood sculpture had largely fallen out of favor in eighteenth- and nineteenth-century European art, in the decades around World War I artists frequently returned to it as they sought to revitalize sculptural processes.

Wood was a natural choice for the many artists who were critical of the factory system of sculptural production that reigned in the nineteenth century. Artists such as Auguste Rodin employed teams of up to fifty artisans to execute the molds, casts,

and finishes of his sculptures. Though artisans working under a sculptor's direction could also create wood works, the material seemed divorced from these industrial production methods, especially as many associated wood sculpture with direct carving, folk arts, and the indigenous traditions of African and Oceanic sculpture.

As many artists—first in Europe, and later in the United States—considered these influences, wood sculpture seemed to offer a way to create art with a sense of immediacy, spontaneity, and authenticity. While this vision was often rooted in a reductive perspective on non-Western sources, the European modernists drew parallels between their process and those of African and Oceanic carvers. Moreover, artists such as Zorach, as well as Paul Gauguin and Aristide Maillol before him, appreciated the ability to sculpt in wood without any specific training. Indeed, Zorach developed his first wood sculpture, *Waterfall* (**PLATE 44**), in 1917 through improvisation, carving a butternut board past the point of his planned woodcut.[7] He and his wife Marguerite intended to create two woodcuts (see Marguerite's *Mother and Child*, **PLATE 43**), but William remembered: "I got so fascinated carving that I didn't stop with a woodcut. I developed a fine and most original bas-relief."[8] As he later described the process, "Carving in wood is one of the simplest and most delightful forms of sculpture. . . . It is a medium particularly free from complications. It is not heavy or expensive to handle like stone, nor is it complicated like clay—it does not have to be put into expensive metal to be permanent and reach its completion."[9]

In addition to the sense of immediacy and the expediency of the process, wood carving allowed artists to leave marks of their personal touch on their sculpture's surface. This could signal a type of authentic production that respected the characteristics of the organic material and the artist's direct engagement with the process, which was especially important for carvers who subscribed to the dominant ideology of truth to materials. These artists believed that the wood (and later the stone) they carved had a character of its own that determined a sculpture's form and meaning. Sculpting his *Daphne* (**PLATE 13**) in 1940, for example, Robert Laurent followed the shape of his piece of wood. He wrote: "I was faced with a tall narrow uneven [piece] of mahogany. I started to work around the upper part probably having unconsciously

in mind a figure. . . . The torso was the first part to take shape. The arms in such a narrow space had to be planned in an upward position. It was then Daphne entered my mind."[10]

Laurent continued to cut away the wood to create the seven-foot-tall sculpture that depicts the Greek heroine in the middle of her transition into a laurel tree. He had explored the link between flora and figures in earlier works such as *Plant Form* of about 1924–28 (**PLATE 47**), which gives a type of bodily structure to the undulating leaves that rise from the base. In *Daphne*, Laurent alluded to similar connections, though he used Apollo's left arm, which reaches up to press against Daphne's right leg, to signal the mythological story. Rather than showing fear, Daphne communicates an otherworldly stoicism as her arms rise to become branches of the tree. To compound this effect, Laurent refrained from an overly sensuous surface treatment, instead waxing the work to create a subtle sheen that emphasizes the patterning of the grain and the reflection of light.[11] As a result, the work centers on the authenticity of the relationship between subject, form, and material. Every gesture and feature emphasizes the thin, natural character of the organic wood, which underscores both the mythological and the sculptural transitions taking place.

As modern artists continued to develop an interest in the art of diverse folk, African, and Oceanic societies, the origin of their carving materials became important. Zorach frequently noted the sources of his wood, linking his own practice to the cultures that inspired him. For instance, he introduced sculptures depicting his son Tessim (**PLATE 51**) and daughter Dahlov (**FIG. 47**), which recall specific Fang reliquary sculptures from West Africa, with a memory of buying "two pieces of mahogany . . . which a sea captain had brought back from Africa many years ago."[12] Zorach had seen the Fang works at 291, Alfred Stieglitz's well-known gallery, in an exhibition of Marius de Zayas' collection. He remembered that the group of sculptures "had an extraordinary magic and spiritual quality that is unequaled; it showed the spirit of man in all his terror and awe of the forces of the universe; it transcended the flesh; and it had almost unbelievable power, versatility, and imagination."[13]

Zorach described his process for carving the African wood in romantic terms. Working away from his studio, he held the wood between his knees and

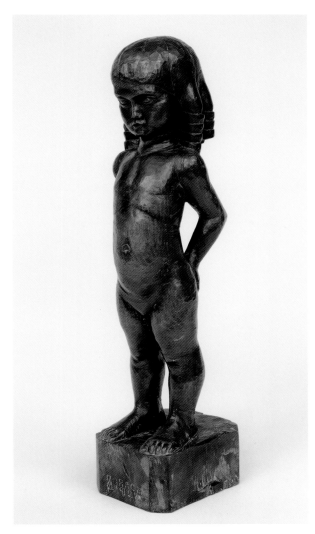

FIG. 47 **William Zorach** (United States, born Lithuania, 1889–1966), *Figure of a Child*, 1921, mahogany, 23⅛ x 5¼ x 6¼ inches. Whitney Museum of American Art, New York; Gift of Dr. and Mrs. Edward J. Kempf, 70.61

cut away at it with small carpenter's chisels and a penknife while his naked children frolicked around him.[14] He used a technique that left his carving marks visible and evoked the chiseled surface of the African carving he had seen at Stieglitz's gallery, as well as at art and ethnographic museums on both sides of the Atlantic. The artist surely felt that the African origin of the mahogany specifically lent itself to the poses and processes for these sculptures.

Direct carving was not the only technique available to artists who wanted to sculpt in wood. Elie Nadelman frequently worked in the material, though he began his process by modeling in plaster, in the same way that he developed bronze and marble sculpture.[15] As a result, sculptures such as *The Hostess* (PLATE 40) may exist in multiple materials. Despite his pronouncements about a material refusing any shape that is not inherent to its form, Nadelman was fairly liberal in moving between wood, bronze, and stone. In France, he initially used mahogany as a less expensive alternative to marble because its surface could maintain a similarly elegant sheen.[16]

Unlike direct carvers, Nadelman enlisted the support of artisans and skilled woodworkers to execute his sculptures. He began this technique in France and continued it in the United States, where he used solid pieces of wood during his first years in the country. Starting in the late 1910s, Nadelman stopped working with single pieces, instead joining a series of smaller blocks together. Rather than creating these composite forms in his studio, he teamed with craftsmen, including architectural sculptor John H. Halls and the carpentry firm J. and W. Robb, to prepare his blocks and rough out his forms.[17] The curator Valerie Fletcher argues that this new technique was an aesthetic choice, as it approximated the "charming shop figures [Nadelman] so recently discovered" and was amassing as part of his folk art collection.[18] After the components were glued and joined together, Nadelman's studio assistants would finish the carving and surface detail, as seen in *Chef d'Orchestre* (PLATE 39). In this way, the artist created a hybrid technique that allowed him to evoke wooden folk sculptures while simultaneously producing modern representations of twentieth-century American subjects featuring his characteristic tubular forms and simplified anatomy.[19]

Nadelman frequently completed these sculptures by adding color to his surfaces with a combination of

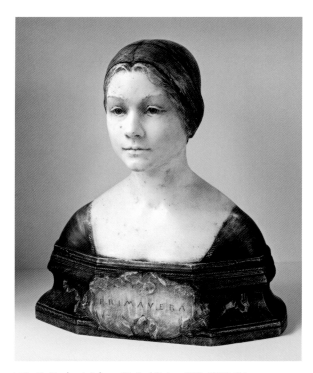

FIG. 48 **Herbert Adams** (United States, 1858–1945), *Primavera*, 1890–92, polychrome marble, 21½ x 18½ x 9¾ inches. National Gallery of Art, Washington, D.C., Corcoran Collection (Museum Purchase), 2014.136.255

paint, stain, and gesso—a thin, white paint mixture traditionally used as a primer. Scholar Barbara Haskell suggests that this use of polychromy emerged from the artist's memory of European wood altarpieces, specifically those from Germany and Poland. She explains, "Nadelman emulated the mottled quality of these fifteenth-century Gothic carvings by diluting his gesso and rubbing it away to reveal portions of the reddish brown understain."[20] In works such as *Chef d'Orchestre*, *Tango* (PLATE 38), and *Dancer* (PLATE 41), Nadelman applied his pigment in broad sections to complement the simplified and rounded treatment of the anatomy. While he used different hues and distinguished certain bodily and fashion details, he did not work in the imitative style of polychromy employed by certain predecessors and contemporaries such as Herbert Adams (FIG. 48).[21] The generalized treatment of color and non-uniform surface of Nadelman's work seem to artificially age his sculpture. The grain of the wood, the joins between blocks, and the understain rise to the surface, lending the sculptures a worn, folk aesthetic.

While polychromy was central to Nadelman's practice, adding new hues to existing materials was anathema to the philosophy of truth to materials.

Therefore, Laurent and Zorach did so infrequently. When they did, they generally used stain that could accentuate the grain and texture of wood, as in Laurent's *Plant Form*. Zorach, for his part, experimented with polychromy in his 1922 *Mother and Child* (**PLATE 42**), which is unique in his wood sculpture for its style of coloration. He added gold leaf to the heads of the figures using a traditional frame-maker's technique, applying a base layer of gesso, a coating of red bole (a type of clay), and finally the metal leaf. This process lent a warm hue to the gilding, which Zorach burnished to allow hints of red to peek through. Using the traditional bole, the sculptor softened the transition between the organic mahogany bodies and the metallic hair. Though the gilding proved effective in this application, amplifying the tender scene of maternal love with a sense of religiosity, Zorach refrained from adding color in other instances. Instead, he relied on the graining and natural hue of the wood, enhanced by oils and polish, to tone his surfaces in works such as the original rosewood carving of *Kiddie Kar* (**FIG. 49**).[22]

Stone

While an interest in wood sculpture reemerged in the twentieth century, stone—and marble above all— had been the dominant material of the medium since antiquity. Lachaise, Laurent, Nadelman, and Zorach all worked in various types of stone, including marble, but also granite, limestone, alabaster, and more. Some carved directly, while others worked with artisans, using a pointing machine that transferred the measurements of the preparatory model to the stone block. This carving technique allowed artists to rough out their sculptures quickly before working with skilled craftsmen to achieve the desired form, surface, and nuance.

For Lachaise and Zorach, working in stone was an important statement of artistic identity. The two men and their wives had been friendly at the end of the 1910s and into the early 1920s. Isabel Lachaise even introduced Marguerite Zorach to the property at Robinhood Cove, Maine, that the Zorachs bought in 1923.[23] William Zorach, however, later recalled that his move to carving stone in the same year caused a rupture in their friendship. He remembered Lachaise telling him that he "had no business carving stone— it was perfectly all right to do wood carving but not

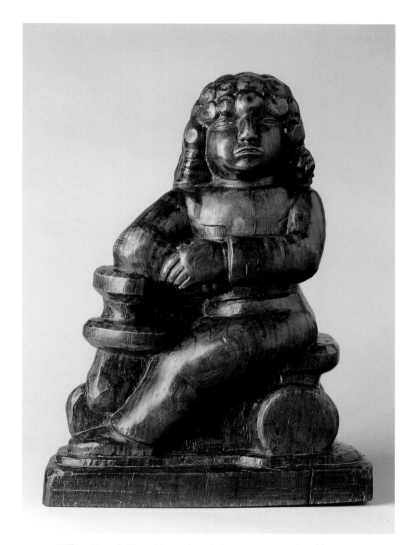

FIG. 49 **William Zorach** (United States, born Lithuania, 1889–1966), *Kiddie Kar*, circa 1923, rosewood, 18¼ x 13⅞ x 8 inches. Collection of Middlebury College Museum of Art, Vermont, Purchase with funds provided by the Friends of Art Acquisition Fund and the Christian A. Johnson Memorial Fund, 1994.007

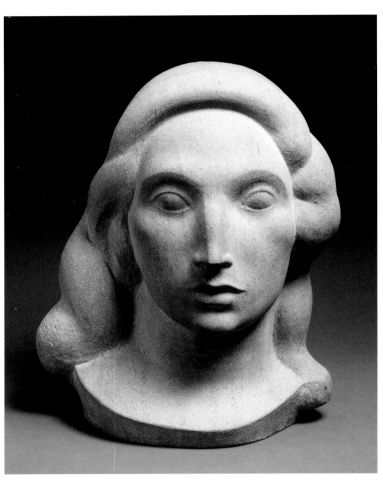
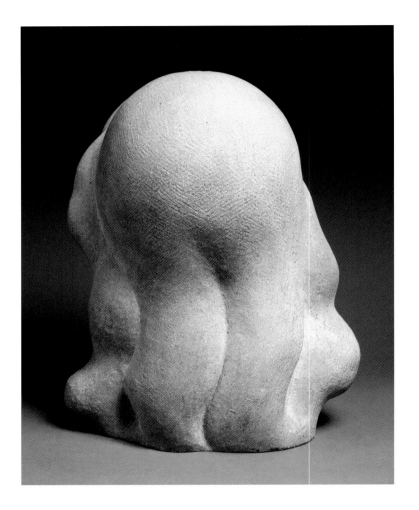

FIG. 50 **Gaston Lachaise** (United States, born France, 1882–1935), *Head of a Woman*, 1917, sandstone, 14 inches (height). Bernard Goldberg Fine Arts LLC, New York

stone sculpture." Zorach continued, "I suppose he felt I was a painter and as long as sculpture was a hobby with me it was all right, but when I began to work seriously at sculpture he resented it."[24] While Zorach's statement is a one-sided account of the breakdown of a relationship, it shows his association of carving stone with an assertion of artistic identity.

Though Zorach and Laurent are America's best-known carvers of the 1910s, Lachaise carved directly in stone before they did. For instance, in 1917, he created a series of three female busts (FIGS. 50 and 51) in sandstone—a material that is softer than marble but can wear down the sculptor's tools.[25] While each work is unique, they all share a sense of mass, simplification of forms, and smooth surfaces. Lachaise's direct technique allowed him to render solidly the strength of his sitter's neck and the broad and strong contours of her head, giving the statue a proud attitude. This was a natural style for the artist in depicting his wife and muse Isabel, the inspiration for all three works.[26]

Lachaise experimented with color in one version of *Head of a Woman*, which he stained and gilded (FIG. 51). The thin application of tinting unifies the color, while letting the sandstone's rough texture glint beneath the surface. When Lachaise gilded the lips and eyes, he gave the sculpture's sensual qualities an ethereal dimension, since the soft but vibrant metal glimmers against the brown backdrop. Critics such as A. E. Gallatin noted the effect of polychromy on the artist's sculptural harmony: "Lachaise often stains or gilds portions of his marble and stone heads, as did the Greeks, the Egyptians and the Gothic sculptors . . . uniting color with form."[27]

Lachaise also added color to his marble *Nude on Steps* (PLATE 22), in which a golden bather's cap immediately attracts the viewer's attention. The striking hue contrasts with the smooth, natural texture of the white marble surface. Working on a much larger scale than usual for his bas-reliefs, the artist created a deceptively complicated composition. In a scene with multiple planes of relief, the large figure balances on the steps with a combination of mass and graceful movement.[28] The upward energy of the left knee balances the reverse extension of the right arm and turn of the head. Behind, a cloth encircles the head and torso, extending to the fingers of the outstretched left hand. Lachaise created even more variation in the depth of this relief through a series of incised lines

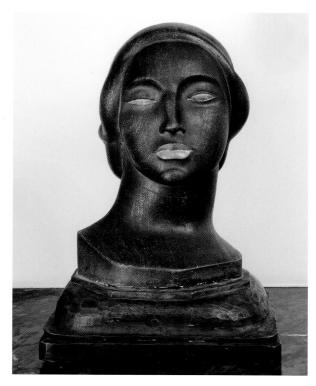

FIG. 51 **Gaston Lachaise** (United States, born France, 1882–1935), *Head of a Woman*, 1917, sandstone, 15 x 9½ x 16¾ inches. Bernard Goldberg Fine Arts LLC, New York

that suggest the movement and folds of drapery. The confluence of sinuous movement and geometrical forms harmonize on the marble surface to create an elegant expression of a striding woman, who is at once modern and classicized.

Like Lachaise, many sculptors enjoyed working in marble. Laurent created many artworks in the material, and Nadelman frequently used marble because of its classical allusions.[29] In works such as *Mercury Petassos* of about 1914 (see FIG. 6), the stone's smooth, white grandeur supports the classicizing treatment of pose, emphasizing the links between Nadelman's modern simplification of anatomy and the Grecian sculpture that inspired him. He continued to carve in the material for the rest of his life, executing standing figures, busts, and even small figurines in marble. He excelled at leveraging the varied plastic qualities of the stone, for instance in elegant busts such as *Head of a Woman* (PLATE 6), in which he juxtaposed a variety of surface treatments in the hair, face, and shawl.

Zorach appears to have executed his first stone sculpture in marble, a bust of his daughter Dahlov from which he later created a small edition of terracotta versions. When he exhibited the work at the

FIG. 52 **Robert Laurent** (United States, born France, 1890–1970), *L'Indifferente*, 1920–21,
Caen stone, 9 inches (height). Bernard Goldberg Fine Arts LLC, New York

Kraushaar Galleries in 1924, the critic Augusta Owen Patterson noted, "It is evident that Mr. Zorach enjoyed his work in a new medium, that he has been interested not only in his idea but in the actual physical attack with mallet and chisel."[30] He also chose the material for his *Victory* of 1944 (see **FIG. 45**), which celebrated the United States' triumph in the Second World War. The surface of the sculpture—a fragment of the goddess Nike—communicates an idealized sense of purity. Zorach's minimal handling of the form created broad planes of uninterrupted marble that commemorated the military success while evoking the glories of the distant past.

Though Nadelman insisted that materials had important plastic life that must determine their forms, his largest works in marble—the two pairs of circus figures (see **FIG. 46**) on the promenade of the New York State Theater (now the David H. Koch Theater at Lincoln Center)—are at odds with the surface effects he originally created. He initially modeled the female figures in plaster at life size before covering them with a layer of papier-mâché (**PLATE 11**). The soft feel and stippled texture of the surface amplifies the fusion between the figures, which meld into each other. The combination of surface and form fosters a sense of intimacy and earthiness in the original work that the monumentally scaled marbles, created well after the artist's death, cannot replicate. The technical necessities of carving led to more defined distinctions between the women; additionally, the smooth white finish and hard surface reject the gentle fusion that had produced the evocative effect in the initial version. That said, the new material augments the enlarged forms with a striking monumentality appropriate for their public setting.

Like Zorach, Laurent began carving in stone after several years of working exclusively in wood.[31] Beginning in about 1920, Laurent experimented with several types of stone, achieving marked success in works such as *L'Indifferente* (**FIG. 52**), exhibited at the Modern Artists of America exhibition in 1922. The material, Caen stone (a fine limestone from northwestern France), was appropriate for this early foray because of its relative softness and the ease of cutting directly into its surface.[32] These characteristics allowed Laurent to amplify the decorative effects in his sculpture, giving different textures to the skin, clothing, and hair. The tilt of the head and expressive face reveal the artist's

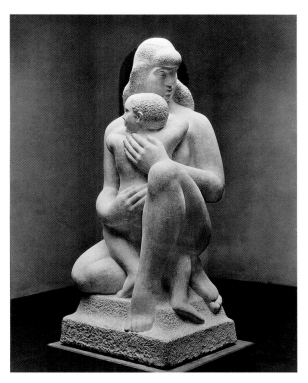

FIG. 53 **Charles Sheeler** (United States, 1883–1965), *Mother and Child by William Zorach*, circa 1930, gelatin silver print. The Metropolitan Museum of Art, Gift of Tessim Zorach, 1984, 1984.1048.6

skill at adding a sense of personality to the artwork at an early stage of his stone carving.

Throughout his career, Laurent worked in a variety of stones, including different types of limestone for *Hero and Leander* (**PLATE 18**) and the hulking *Torso of a Woman* (**PLATE 19**). Limestone had served as an important building and sculpture material for France's Gothic cathedrals, a marker of cultural pride for the French-born Laurent. Many in the nineteenth and early twentieth centuries associated these cathedrals and their direct stone carvings with folk traditions and a type of Gothic primitivism that should inform modern art. This material allowed Laurent to draw links between his role as an American modernist and the sources in his native Brittany that had kindled his passion for the arts. After Laurent moved to Bloomington, Indiana, in 1942 to teach at Indiana University, he executed *Hero and Leander* and several other works for the school in Indiana limestone.[33] The local material amplifies the idea of place that the sculptures communicate.

Both *Hero and Leander* and *Torso of a Woman* leverage limestone's combination of elegance and mass in frontally oriented compositions. The organization of forms in each suggests a relationship to the physical

dimensions of architecture, as if the works could have been designed as part of a building. While the scale and physical weight of these figures assert a powerful presence, Laurent took advantage of the limestone's warm tone to imbue the sculptures with a natural and organic effect that softened the look of the surface.[34] The inherent qualities of the individual stone blocks also shine through, especially in *Hero and Leander*, in which natural inclusions run down Leander's chest and back.

In addition to these more massive sculptures, Laurent worked extensively with smaller alabaster stones. Over the course of fifty years, he executed more work in the material than any other American modernist sculptor, including Lachaise, who used it for important portraits of Georgia O'Keeffe (see **FIG. 33**) and Edward M. M. Warburg (**PLATE 4**). Laurent developed a special acumen for negotiating the opacity and translucency of alabaster, extensively preparing the stone to eliminate its natural chalk crust. As a result, in works such as *The Wave*, *The Bather*, and *Wind* (**PLATES 30, 31**, and **32**), Laurent's polished alabaster absorbs light, animating the surfaces of his figures with a glowing smoothness and the illusion of flesh.

Like Laurent, Zorach also chose his stones based on the surface effects they could create, often searching for specific types of granite in his walks along the Maine coast near his home. He noted that beneath their surfaces, Maine boulders held "beautiful colors, textures, and patterns."[36] In the *Head of Christ* of 1940 (**PLATE 49**), he extracted the expressive potential of black Maine granite to break from the countless representations of Christ in white marble, bronze, or wood. The porphyritic texture of the stone—with large crystals set in the larger mass—offered a bristling surface animation, enlivening the image of the Christian savior.

Many of the stone works that Zorach initially created are smaller in scale, since large, directly carved stone projects proved complicated and financially risky. When he did execute massive pieces such as *Mother and Child* (**FIG. 53**), however, he developed a process that allowed him to rough out the silhouette of the sculpture with the aid of a clay model. He explained:

> I took the clay sketch and put it on a table in a dark room. I made a little hole in a piece of paper, put a light behind it, and threw a shadow on a large piece of paper tacked on the wall. By moving the table back and forth I could establish the exact dimensions of the figure in the stone. Then I traced the four sides

of the silhouette on the stone and cut away to within an inch or so of the outline. In doing this, I kept away from the surface of the form, allowing myself room to carve.[37]

Though this process lacked direct carving's traditional spontaneous composition that Laurent described with relish, it allowed Zorach to engage viewers on a monumental scale.[38] Nevertheless, he could avoid the mechanical pointing process and maintain the balance of bulk, unity, and planar elegance of his preferred aesthetic.

Metal

Modernist attitudes towards sculpture in metal shifted considerably in the first decades of the twentieth century. In addition to the arrival of new materials for casting, artists sought new finishes and patinas that could distance their artwork from the factory-style production that had recently dominated European sculpture. Many of these concerns were reactions against the process of Auguste Rodin, whose use of craftsmen typified the industrialized techniques that critics vilified in the early twentieth century.[39]

Aware of the issues surrounding bronze sculpture, Lachaise drew on his experiences as a studio assistant and an apprentice in René Lalique's workshop to take an active role in every step of his casting process.[40] In the Philadelphia Museum of Art's cast of *Standing Woman* (also known as *Elevation*; **PLATE 16**), for instance, Lachaise used his file to abrade the surface in the area of the monumental figure's breasts.[41] While this treatment was unique among the casts made during his lifetime, the pitting effect at the top of the torso draws the viewer's attention and catches light in complex ways.[42] Moreover, the hand-treated surface serves as a visible mark of the artist's touch.

Lachaise developed many different techniques for the casting and finishing of his sculptures, including a mirror finish that offered another alternative to the nineteenth-century factory production.[43] Constantin Brancusi had employed similar surfaces in certain of the bronze versions of works such as *Bird in Space* (**FIG. 54**), which gained significant notoriety in America in the 1920s (for more, see Roberta K. Tarbell's essay in this catalogue). Nadelman and Lachaise also employed the smooth finish in their sculptures (for instance, see **PLATES 7** and **54**). Although the faultless

finish required extensive work to remove any signs of the casting process, the resulting surface bore no trace of the artist's hand. Instead, it displayed a slick aesthetic that reflected the machine age's energy and promise of perfection.

Because direct carving emerged partly as a response to the industrialism of the bronze casting and marble pointing of the nineteenth century, casting would appear antithetical to the doctrine of truth to materials. Zorach nevertheless produced casts and editions in bronze (*Child on a Pony*, PLATE 27), terracotta (*Dahlov [The Artist's Daughter]*, PLATE 50), and plaster. While the contrast between his rhetoric of direct carving and these works reveals a fissure that separates his ideology and practice, Roberta K. Tarbell notes that the artist "enjoyed seeing what his designs looked like in several different media."[44] That said, Zorach rarely modeled sculpture for casting in the traditional sense. Instead, for bronze sculptures such as *Head* or *Bathing Girl* (PLATES 35 and 45), he frequently cast molds from the original carvings.

The signs of the original process remain in *Bathing Girl*, in which the different leg lengths are byproducts of the shape of the original wood sculpture. Moreover, the simplified elegance of the composition emerged from the streamlined design that Zorach developed while working in the hard wood of Borneo mahogany.[45] The high finish of the polished wood translated to the smooth, even surface of uninterrupted contours and color in the bronze version. Likewise, *Head*, a work the sculptor excerpted from his monumental *Mother and Child*, reflects the mass and weight of the original carving.[46] The unique cast alters the viewer's perception of the sitter, and the transformation to a golden colored bronze creates tension between the sleek, Art Deco styling of the material and the gravity of the form. Moreover, as Zorach isolated the head from the original composition of a maternal embrace, the woman's penetrating expression emerges as a powerful sign of her character and independence.

Laurent also sculpted in bronze, executing works in the lost-wax process. Since antiquity, artists had used this multistep technique, which involved models, molds, melted wax, and poured bronze. Despite the advent of more straightforward casting processes such as sand-casting, many nineteenth- and twentieth-century artists held the lost-wax technique in higher esteem because of its historic value and the difficult process

FIG. 54 **Constantin Brancusi** (France, born Romania, 1876–1957), *Bird in Space*, 1924, polished bronze, black marble base; 50 5/16 inches (height), 17 11/16 inches (circumference), 6 5/16 inches (base height); Philadelphia Museum of Art, The Louise and Walter Arensberg Collection, 1950, 1950-134-14, 15

that marked an artist's merit and skill. Laurent began using the technique in the 1930s for sculptures such as *Kneeling Figure* (PLATE 55), which won the Art Institute of Chicago's prestigious Logan Purchase Prize in 1938. Beginning with modeling clay, Laurent built up his image of the woman with thick limbs, simplified anatomy, and planar forms, recalling the aesthetic he used in his direct carving. Here, the look that Laurent typically achieved through direct carving operates as a formal style that transcends the actual technique of cutting directly into material.

Though clearly a skilled modeler, Laurent preferred direct carving and often bridged additive and reductive processes. Working in plaster, he created blocks from which he could cut away material, allowing him to execute large works without the cost or risks associated with purchasing substantial amounts of limestone or marble. If he was unhappy with his carving, he could add more plaster and begin again. Moreover, he could exhibit his plaster sculptures before executing them in more permanent materials. In this way, he returned to sculptural conventions of the nineteenth century,

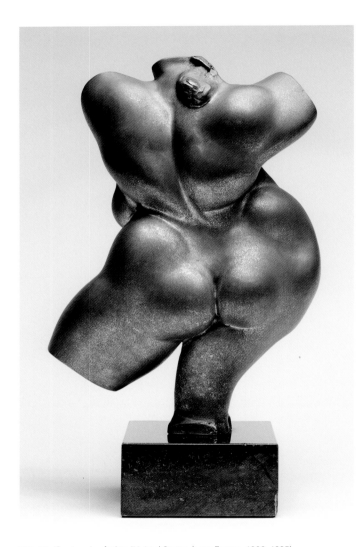

FIG. 55 Gaston Lachaise (United States, born France, 1882–1935), *Female Figure*, 1931, aluminum cast on marble base, 11⅚ x 8¼ x 2¼ inches (not including base). Philadelphia Museum of Art, Gift of George Howe, 1942, 1942-12-3

when artists would exhibit their plasters at national exhibitions, executing bronze or marble versions only when there were commissions that would cover the costs of casting or pointing.[47]

Bronze, of course, was not the only metal available to Lachaise, Laurent, Nadelman, and Zorach. All four artists experimented with modern materials that were emerging as sculptural options. Zorach, Laurent, and Lachaise (**FIG. 55**), for example, executed projects in aluminum, which had only become a possibility for sculptors in the second half of the nineteenth century.[48] The R. J. Reynolds Company donated aluminum for sculptures to Radio City Music Hall in 1932, ensuring that the metal would become the material of choice for several works in the new theater. Along with sculptor Gwen Lux, who executed a statue of *Eve* (see **FIG. 39**), Zorach and Laurent employed the new material in large-scale statues. In Zorach's *Spirit of the Dance* (see **FIG. 11**) and Laurent's *Goose Girl* (see **FIG. 38**), the silvery gray metal appears softer than traditional bronze, creating a sense of fluidity and warmth that absorbs the natural light while offering a metallic sheen. Critics such as Louise Cross quickly pointed out that Zorach modified his typical composition, writing, "the forms are his usual ones, but made slender and fluid to suit the new medium. The light should flow subtly and pleasantly over the polished surface, for his training as a painter has made him especially sensitive to delicate light values."[49] The surface sleekness of these aluminum sculptures was appropriate for the Art Deco setting of the theater. Zorach's much smaller *Family Group* (**PLATE 57**), by contrast, used the soft sheen and luminosity of aluminum as a decorative aesthetic for a modern domestic interior during the Jazz Age.

In addition to aluminum and other new materials, sculptors experimented with an electroplating method that had also emerged in the nineteenth century. The process became immediately popular for its ability to create less-expensive editions of work in the decorative arts and jewelry. Artists could treat an object with a substance such as graphite to make it electrically conductive. They then placed it in a salt solution alongside a bar of another metal, often nickel or copper. At that point, the sculptor and his or her team added an electrical charge, producing a reaction between the treated surface of the base object and the metallic bar. Through this process, a veneer of metal formed over the original object, making it look

like cast metal without the expense and complications of bronze casting processes.[50]

Barbara Haskell has noted that electroplating—also called electrotyping or galvanoplasty—appealed to Nadelman "because of its potential for unusual finishes and its ability to replicate bronze, which allowed him to make art that was populist and affordable without being condescending."[51] For his *Bust of a Woman* (PLATE 10), exhibited in his 1927 exhibition at the Knoedler Gallery, the artist used the technique to layer a veneer of copper over a plaster sculpture. At first glance the work recalls bronze, but the lack of definition in the facial features, as well as the evident polishing marks on the surface, produce a softer, less refined aesthetic than Nadelman typically achieved with his bronzes. As he developed the technique in both bust and full-size figures, he would often paint the surfaces in his typical folk style, though these colors have largely faded over time.

Lachaise also turned to electroplating in a series of sculptures cast in the 1920s. Unlike Nadelman, however, Lachaise focused less on the potential to create bronze-like textures and more on the possibility of adding color to his work. In statuettes such as *Standing Nude* and *Woman Seated* (PLATES 24 and 28), he augmented the dark bronze with areas of silver-colored nickel. The fusion between the nickel veneer and bronze forms created important accents, allowing Lachaise to focus the viewer's attention on different bodily details. In *Standing Nude,* for instance, the sculptor covered most of the front of the figure with a layer of vibrant nickel, though he allowed areas of bronze to remain visible at the figure's hair, eyes, lips, breast, pubis, and toes. Lachaise did not apply any nickel covering to the back of the sculpture or the drapery. The contrast between the materials not only accentuates the crucial bodily details, but varies the play of light on the sculpture's surface. Whereas the sheen of the nickel reflects light and amplifies the figure's Art Deco energy, the bronze seems to absorb it. The interaction of the two metals combines with the smooth rounded curves and roughly modeled drapery to produce a varied, constantly shifting, and engaging visual object.

Wood, metal, and stone were not the only materials in which Lachaise, Laurent, Nadelman, and Zorach created art, and their forays into them surpass the brief discussions here. Throughout their careers, they all worked in two-dimensional media (see Michaela R. Haffner's essay in this catalogue) and continually probed other types of sculptural surfaces. In the 1930s, for instance, Nadelman created an extensive set of small plaster and earthenware figures that evoked circus themes as well as dolls, blurring the boundaries between high and low art through theme, composition, and material (see FIG. 29). As they negotiated each material, the artists' spirit of invention pushed the boundaries of their art and encouraged viewers to consider the physicality of the medium.

Among the so-called fine arts, sculpture is unique in its relationship to the viewer. Whereas paintings tend to occupy two-dimensional space against walls at the edges of rooms, and architecture generally operates on a scale that defines a person's physical environment, sculpture exists in relation to human beings on an immediate, bodily level. As seen in the art of Lachaise, Laurent, Nadelman, and Zorach, the materiality—as well as the scale—of a sculpture is central to mediating the relationship between the object and the viewer, often adding additional layers of significance by signaling social or cultural meaning.

New approaches to materials mark the history of sculpture in the twentieth and twenty-first centuries. Artists including Alexander Calder, David Smith, Louise Nevelson, Isamu Noguchi, Richard Serra, and Kara Walker—to highlight just a small sample—have reconsidered the potential of material to create new meaning and amplify the emotional interaction between artworks and viewers. The work of Lachaise, Laurent, Nadelman, and Zorach, distant as it may seem from paradigm-shifting sculpture such as Serra's *Tilted Arc* (1981) or Walker's *A Subtlety, or the Marvelous Sugar Baby* (2014)—nevertheless anticipated future directions in sculptural experiments with material and technique. The sculptors were part of an important transnational break from traditions. Even when they used conventional materials such as bronze and marble, they posed new questions about the material significance of their sculptures. Though their practice did not always align with their rhetoric, the potential of materiality to create meaning remained at the forefront of their art.

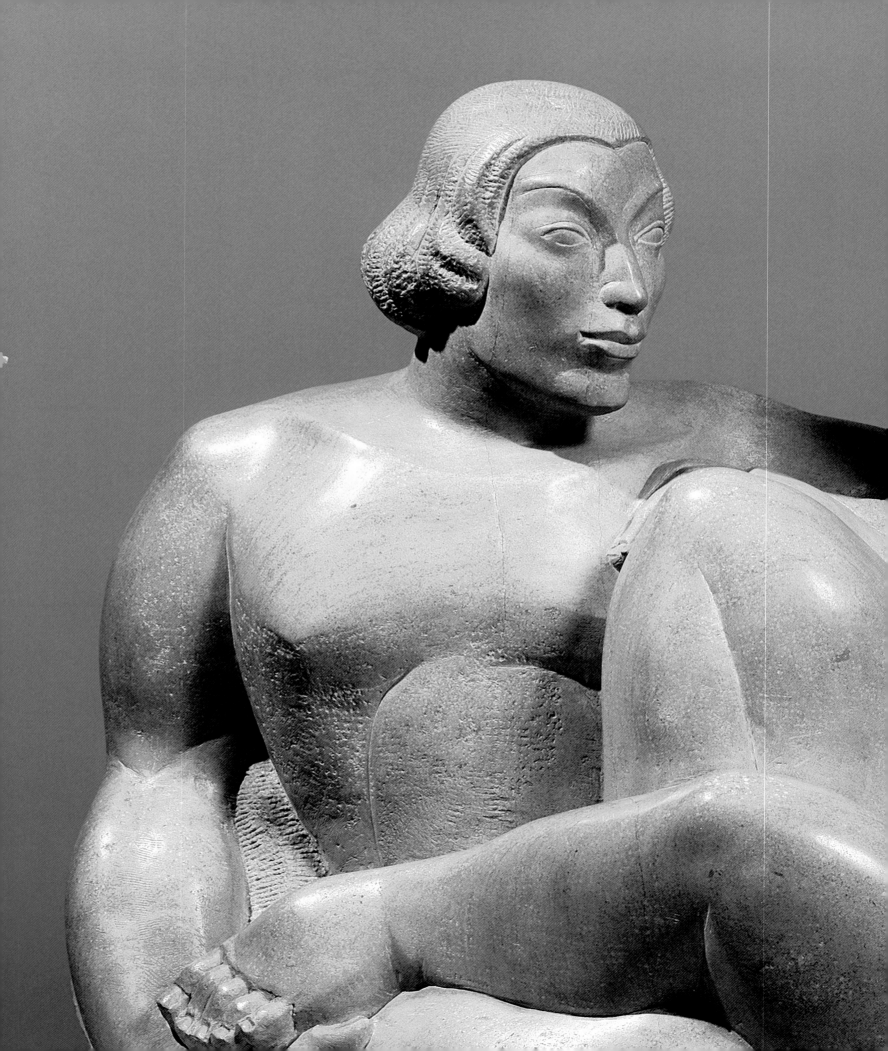

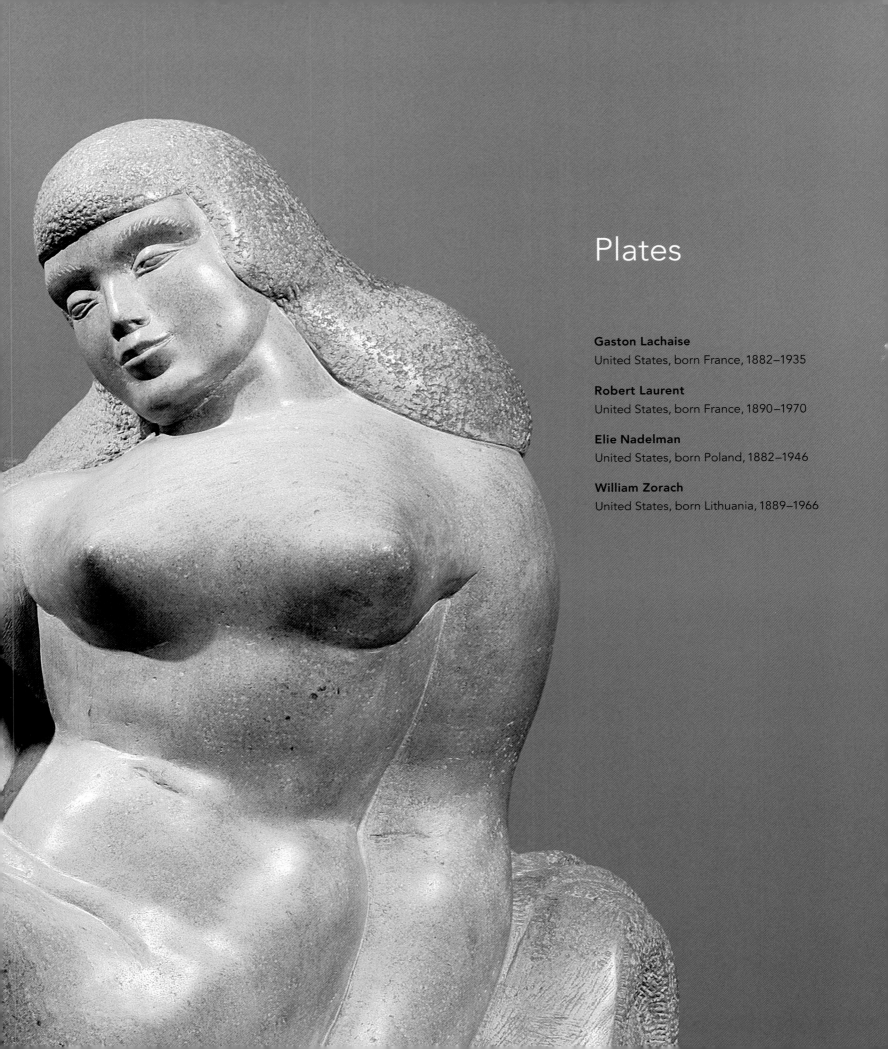

Plates

Gaston Lachaise
United States, born France, 1882–1935

Robert Laurent
United States, born France, 1890–1970

Elie Nadelman
United States, born Poland, 1882–1946

William Zorach
United States, born Lithuania, 1889–1966

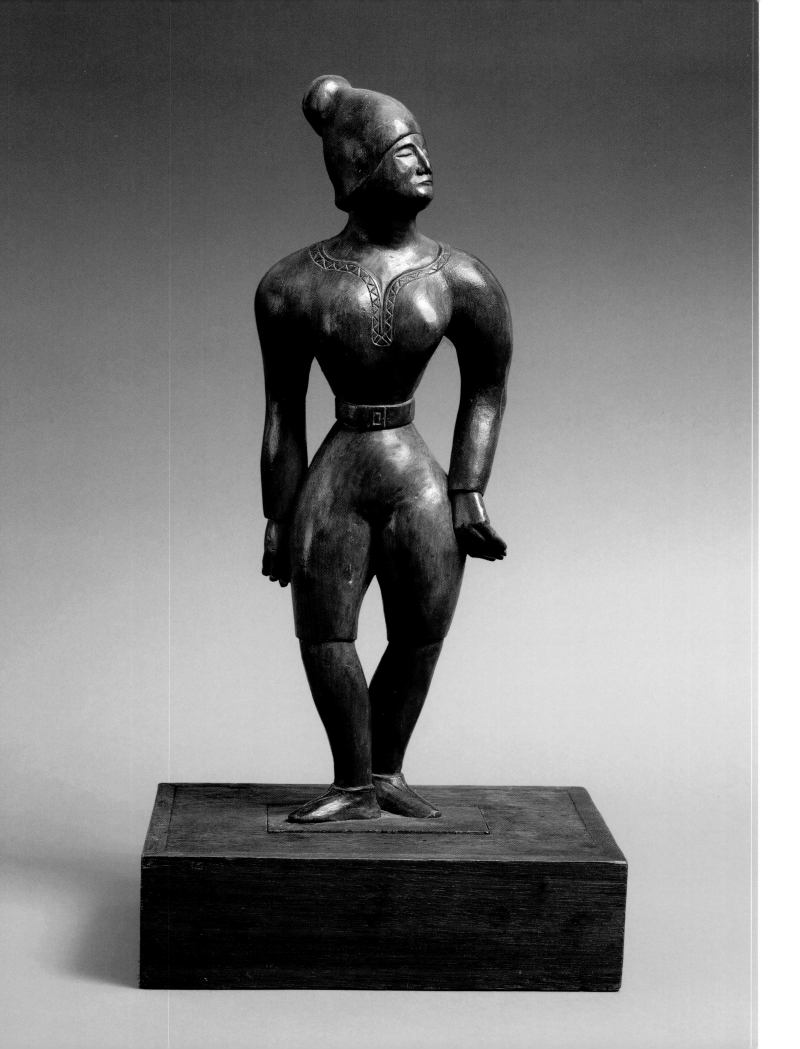

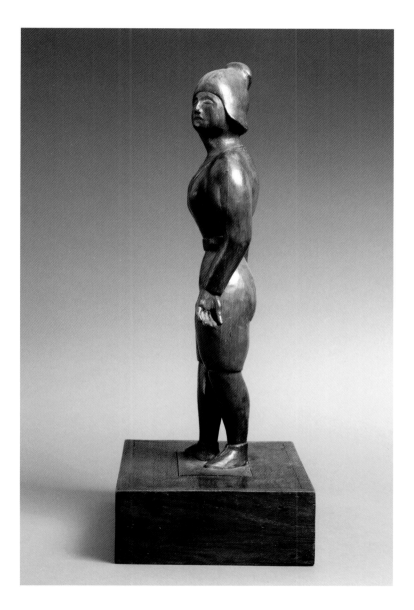
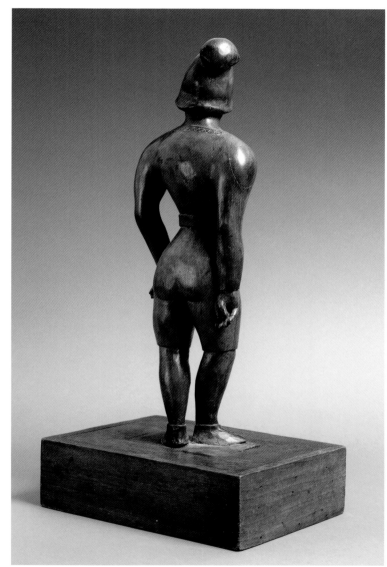

PLATE 1
Robert Laurent
Acrobat, 1921
Wood, 20½ x 10½ x 8 inches

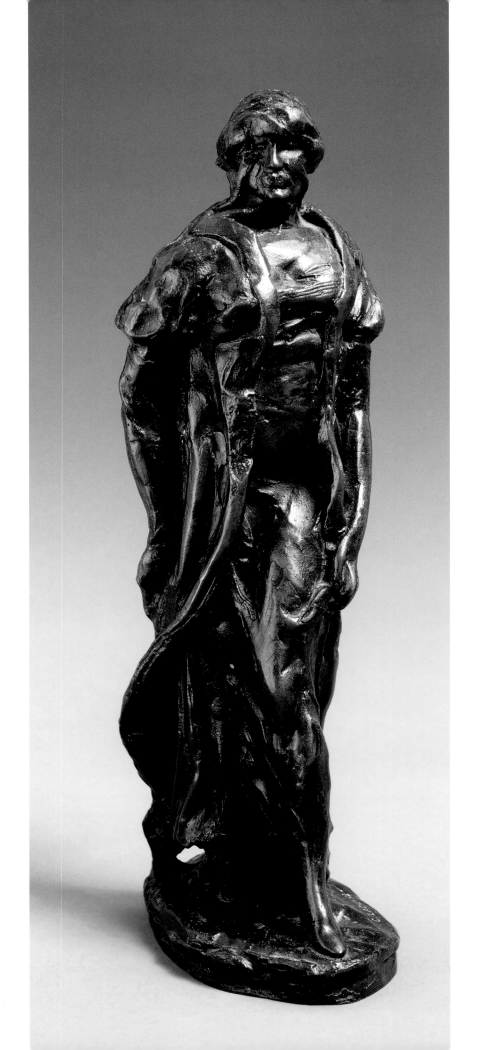

PLATE 2
Gaston Lachaise
Woman Walking, modeled circa 1911, cast 1917
Bronze, 11¼ inches (height)

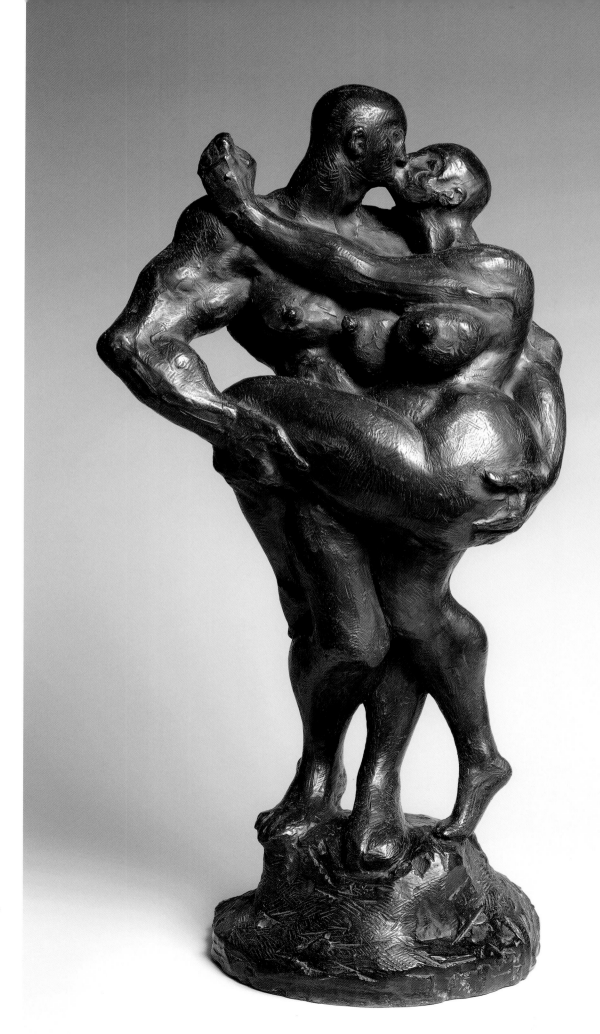

PLATE 3
Gaston Lachaise
Passion, modeled 1930–34, cast 1936
Bronze, 25 3/8 x 12 1/8 x 9 inches

PLATE 4
Gaston Lachaise
Head of Edward M. M. Warburg, 1933
Alabaster, 14½ x 8 x 9 inches

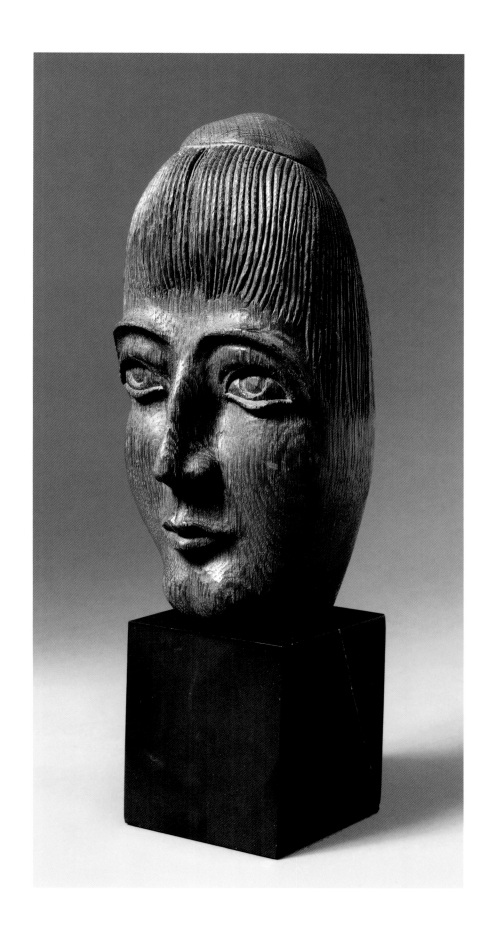

PLATE 5
Robert Laurent
Head (or Mask), circa 1915
Walnut on marble base, 8½ x 4 x 3⅝ inches

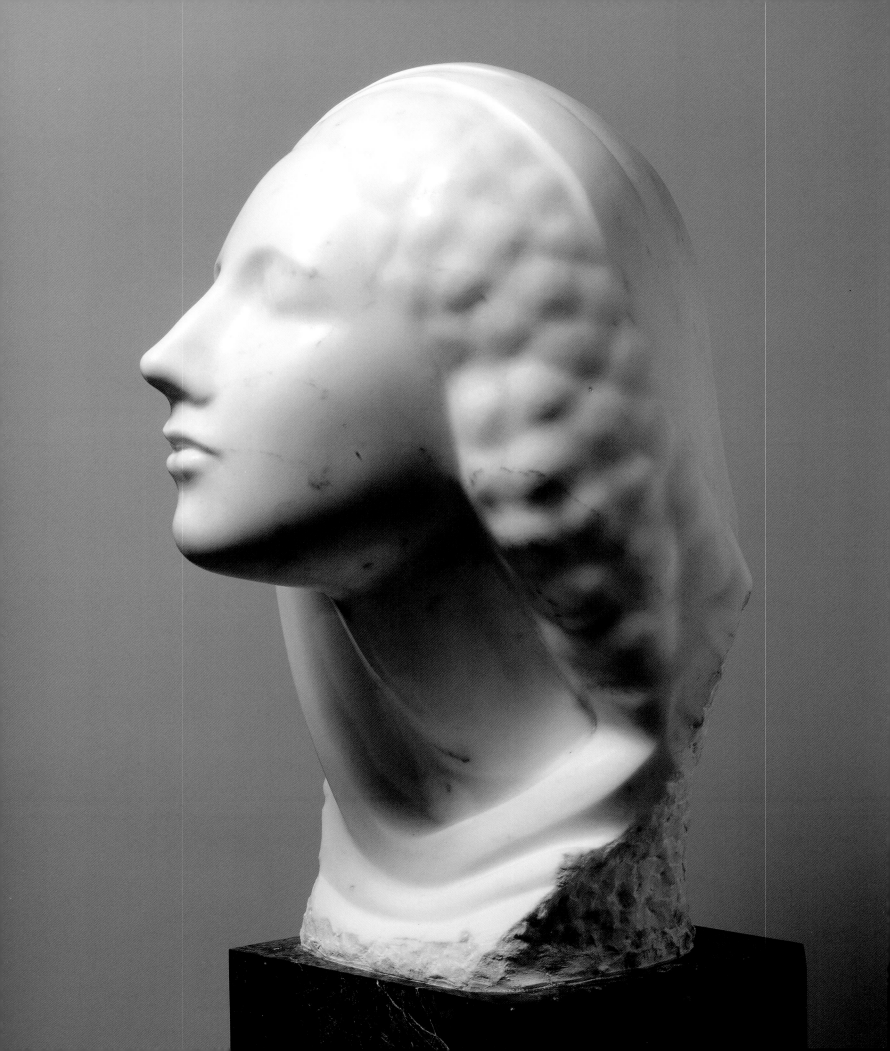

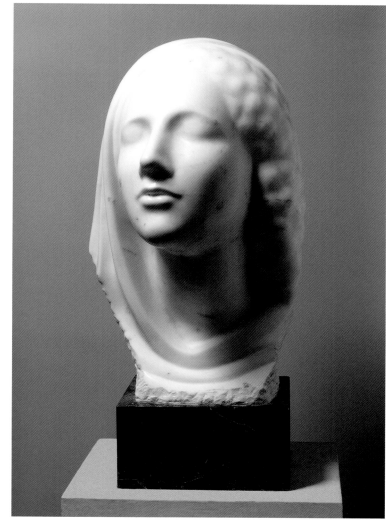

PLATE 6
Elie Nadelman
Head of a Woman, circa 1920
Marble, 17½ x 11 x 12 inches

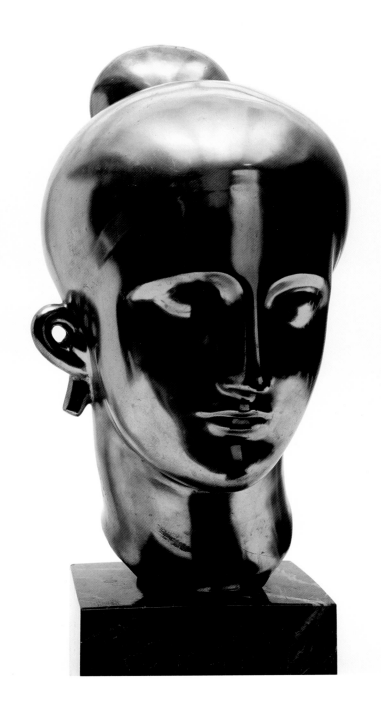

PLATE **7**

Elie Nadelman

Head of a Woman, circa 1916–32

Bronze, 18¾ x 10 x 15½ inches

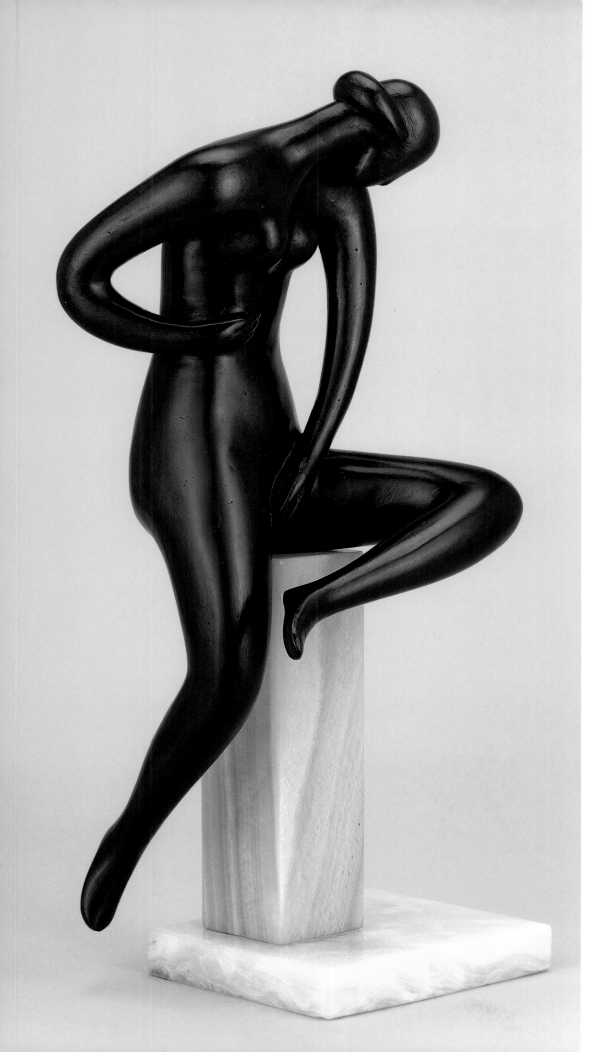

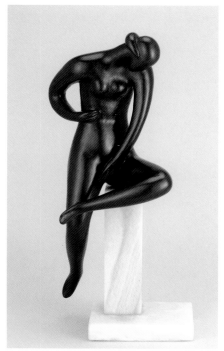

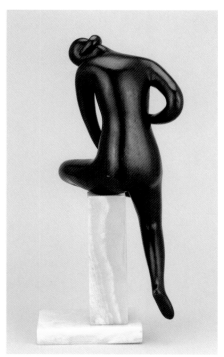

PLATE 8
Elie Nadelman
Seated Female Nude, 1915
Bronze on onyx plinth, 17 x 7½ x 6 inches

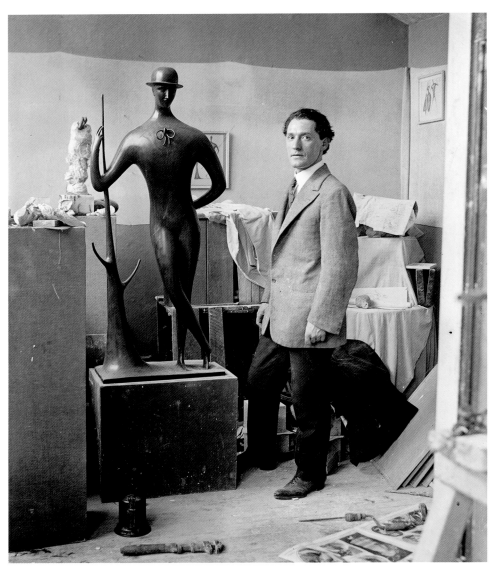

Elie Nadelman in his studio with *Man in the Open Air*, 1919

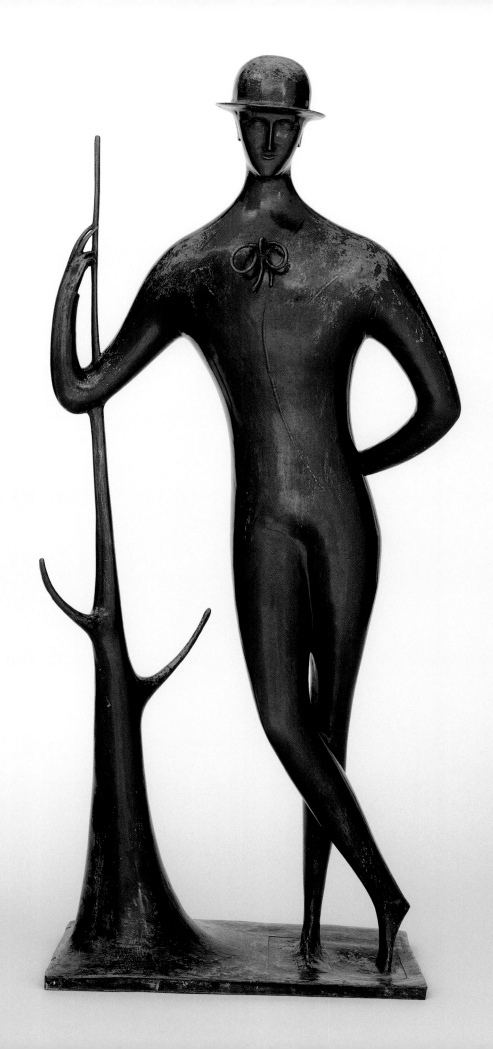

PLATE 9
Elie Nadelman
Man in the Open Air, circa 1915
Bronze, 54½ x 11¾ x 21½ inches

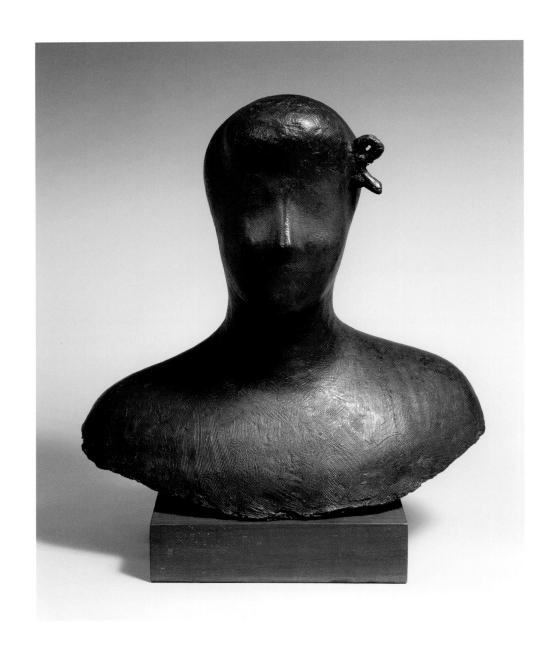

PLATE 10
Elie Nadelman
Bust of a Woman, circa 1926–27
Galvanoplasty, 21 x 21 x 14 1/2 inches

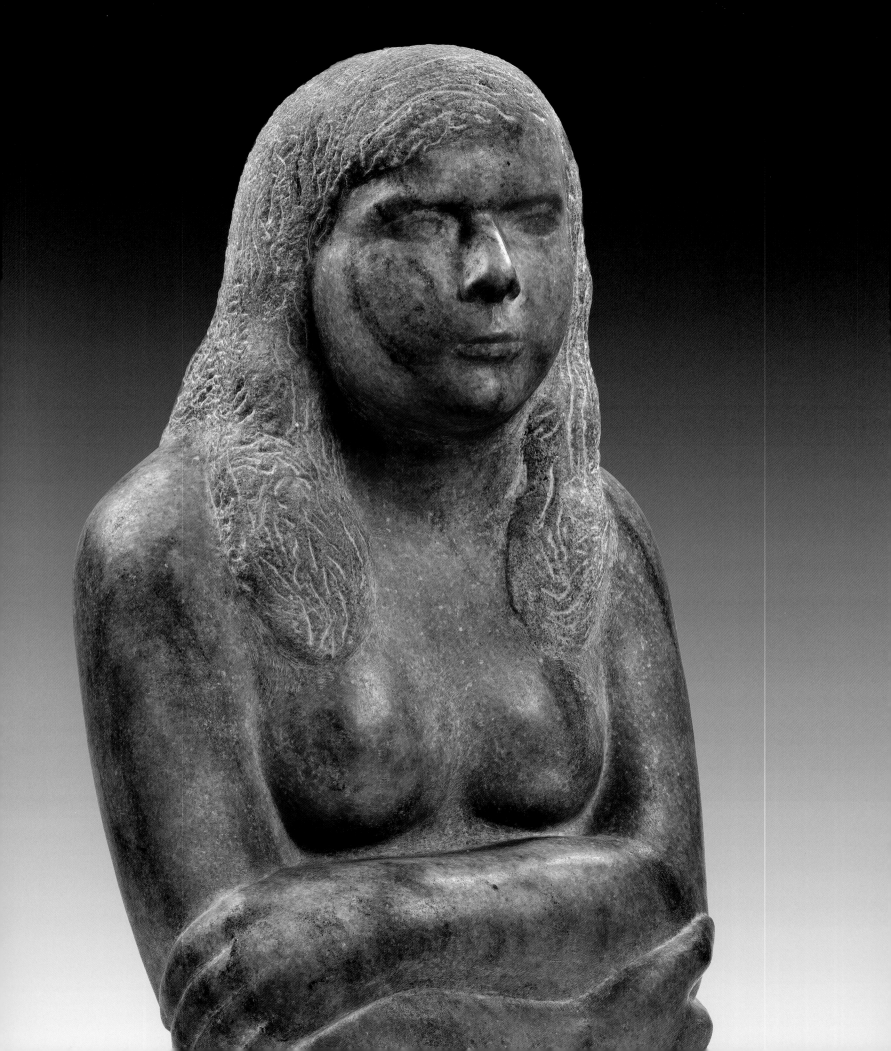

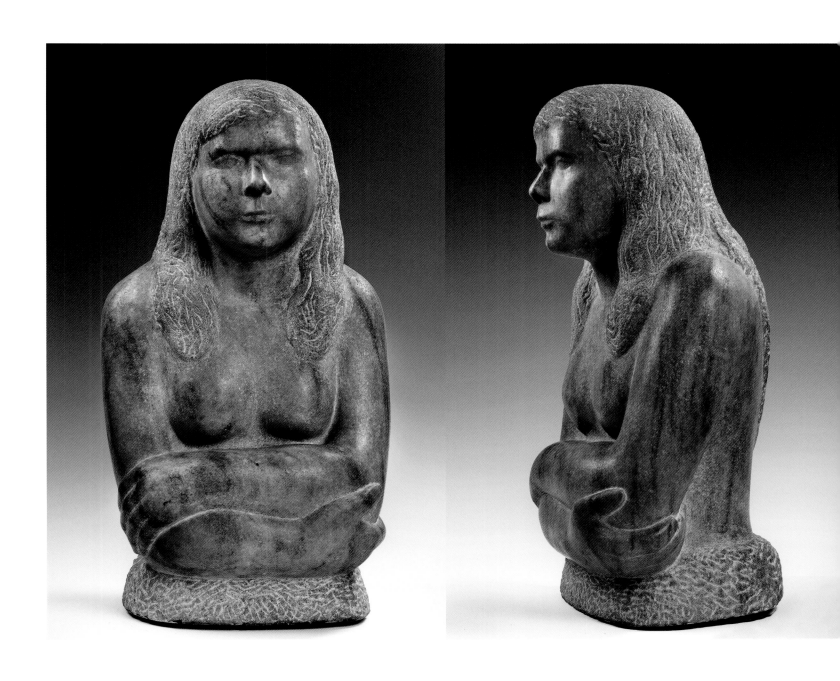

PLATE 12

William Zorach

The Artist's Daughter, 1930

Marble, 25 3/8 x 12 1/4 x 10 1/2 inches

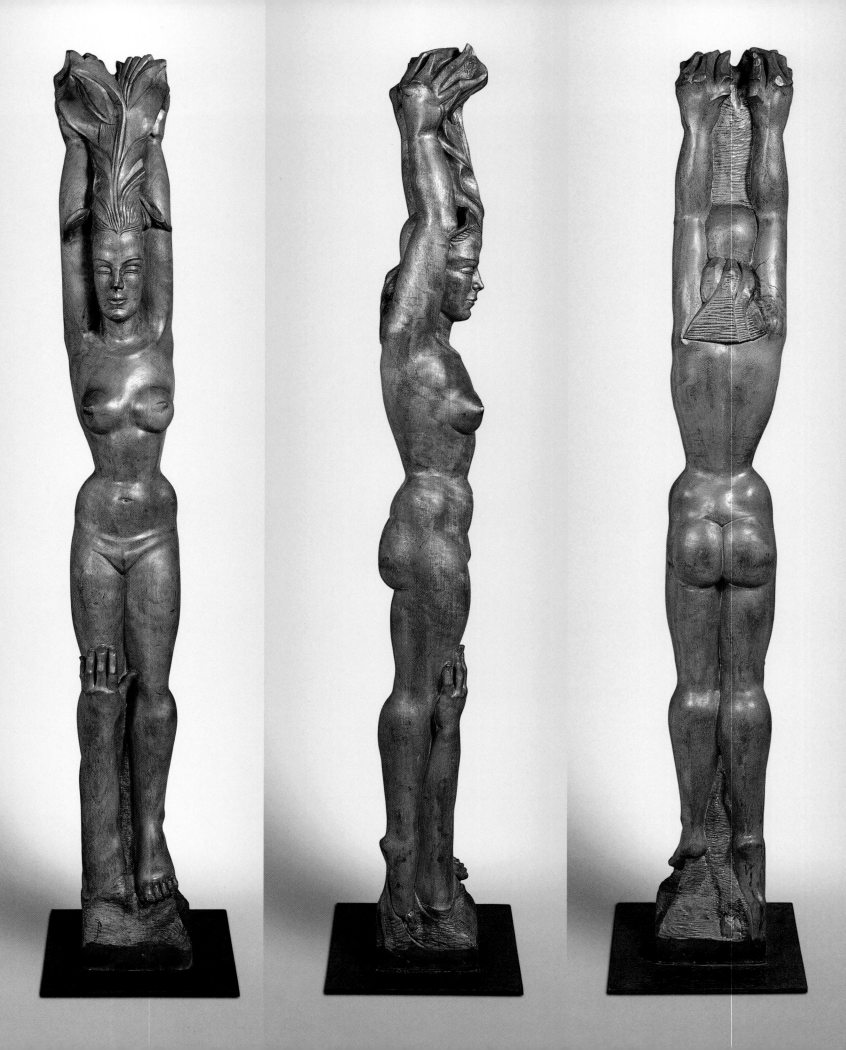

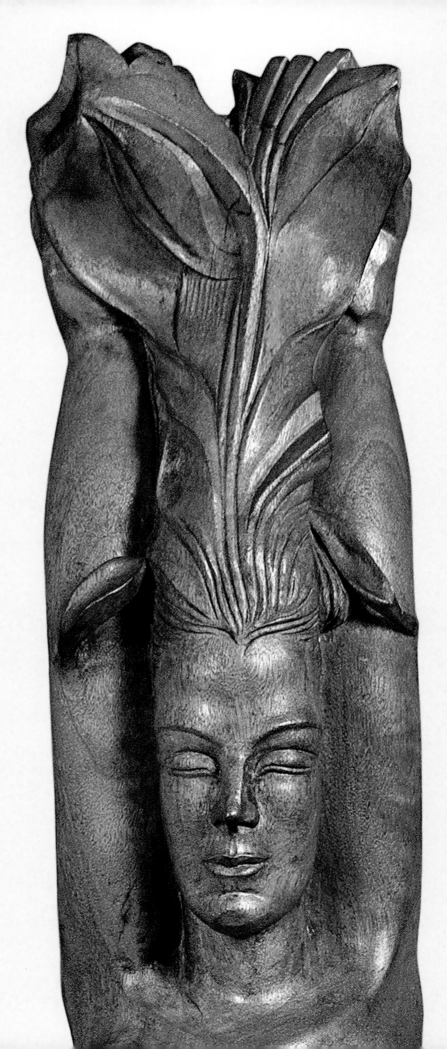

PLATE **13**
Robert Laurent
Daphne, 1940
Wood, 84 x 10 x 9 inches

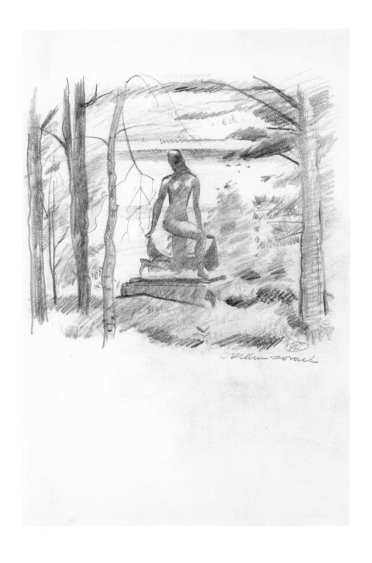

PLATE 14
William Zorach
Spirit of the Dance, circa 1955
Graphite on wove paper, 10⅚₆ x 6¹¹⁄₁₆ inches

PLATE 15
William Zorach
Spirit of the Dance, 1932
Bronze, 78 inches (height)

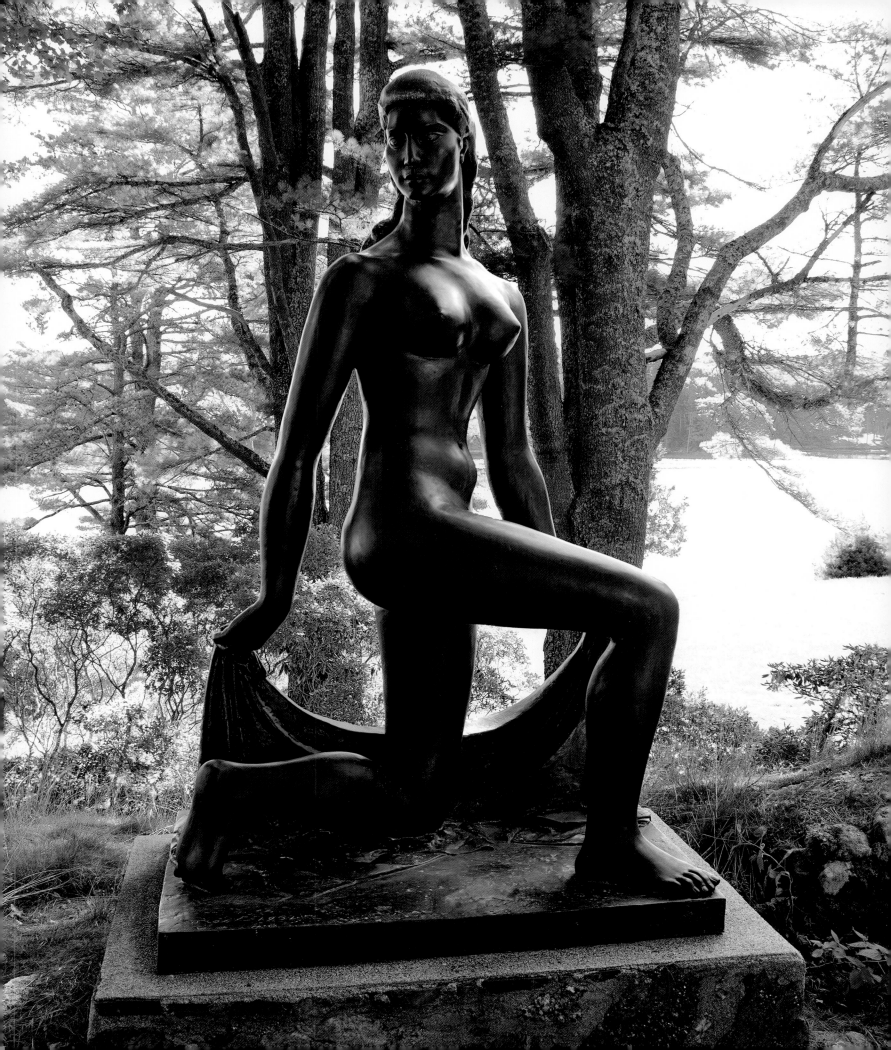

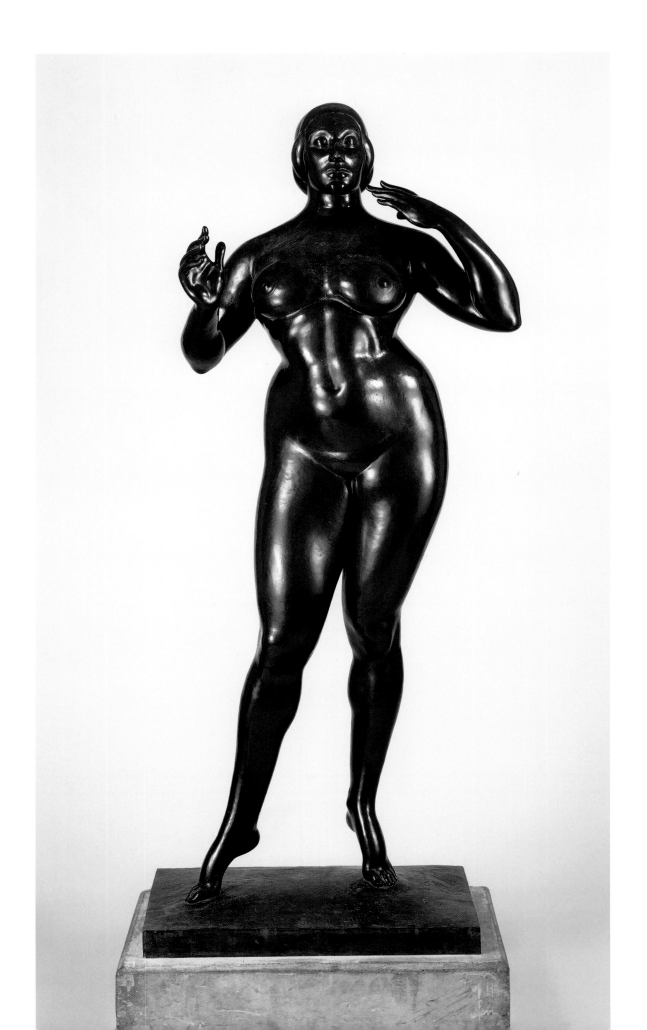

PLATE **16**
Gaston Lachaise
Standing Woman, 1912–27
Bronze, 72 x 28 x 17 inches
(including bronze base)

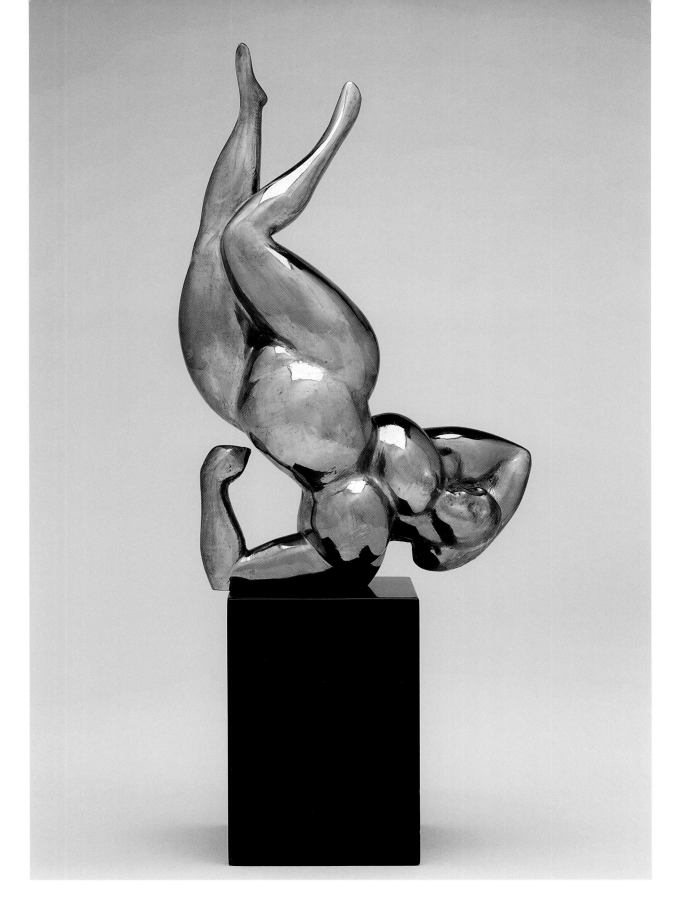

PLATE **17**
Gaston Lachaise
Acrobat, 1927
Bronze, 10¾ x 6½ x 3½ inches

PLATE **18**
Robert Laurent
Hero and Leander, circa 1943
Limestone, 27 x 39 x 20 inches

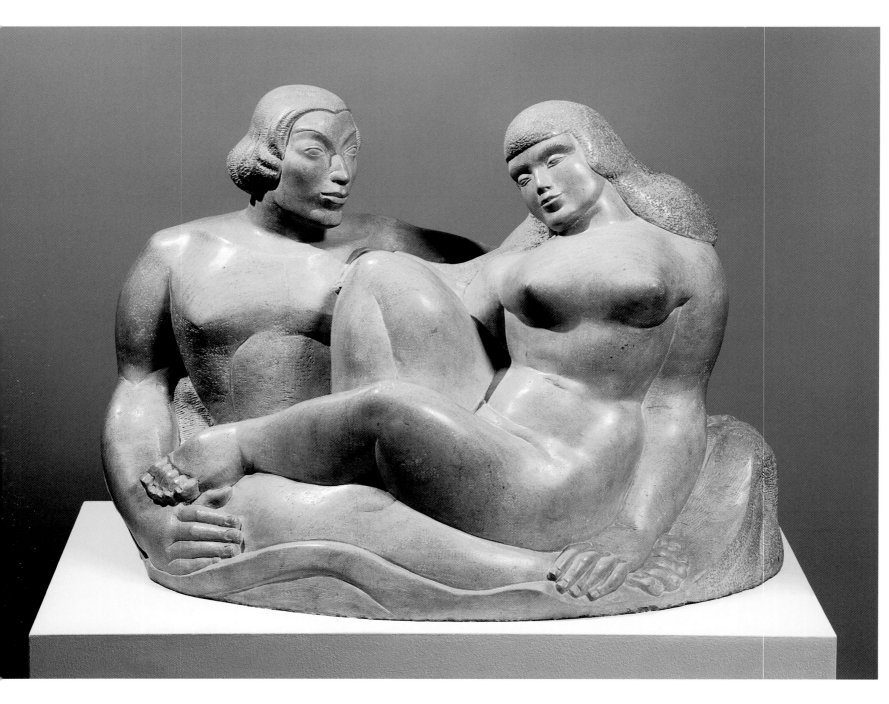

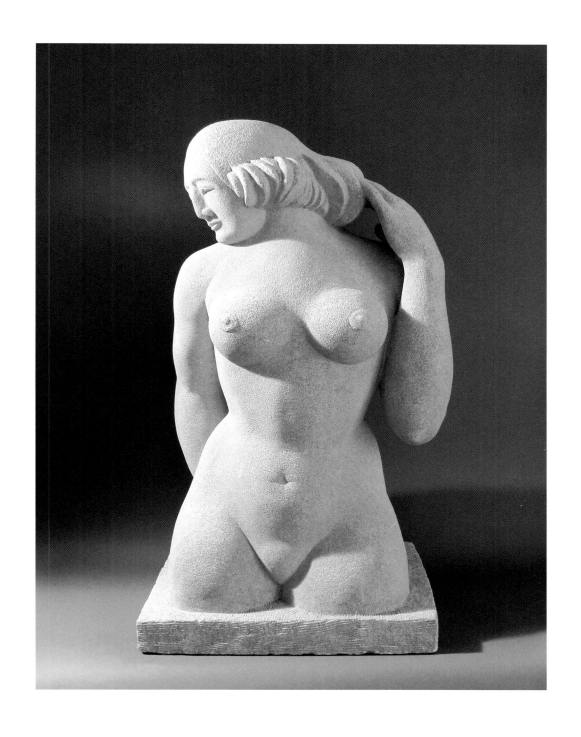

PLATE 19
Robert Laurent
Torso of a Woman, 1920–26
Limestone, 26 x 15 x 10 inches

Gaston Lachaise with *Man Walking (Portrait of Lincoln Kirstein)*, 1933

PLATE 20
Gaston Lachaise
Man Walking (Portrait of Lincoln Kirstein), 1933
Bronze, 23 1/2 inches (height)

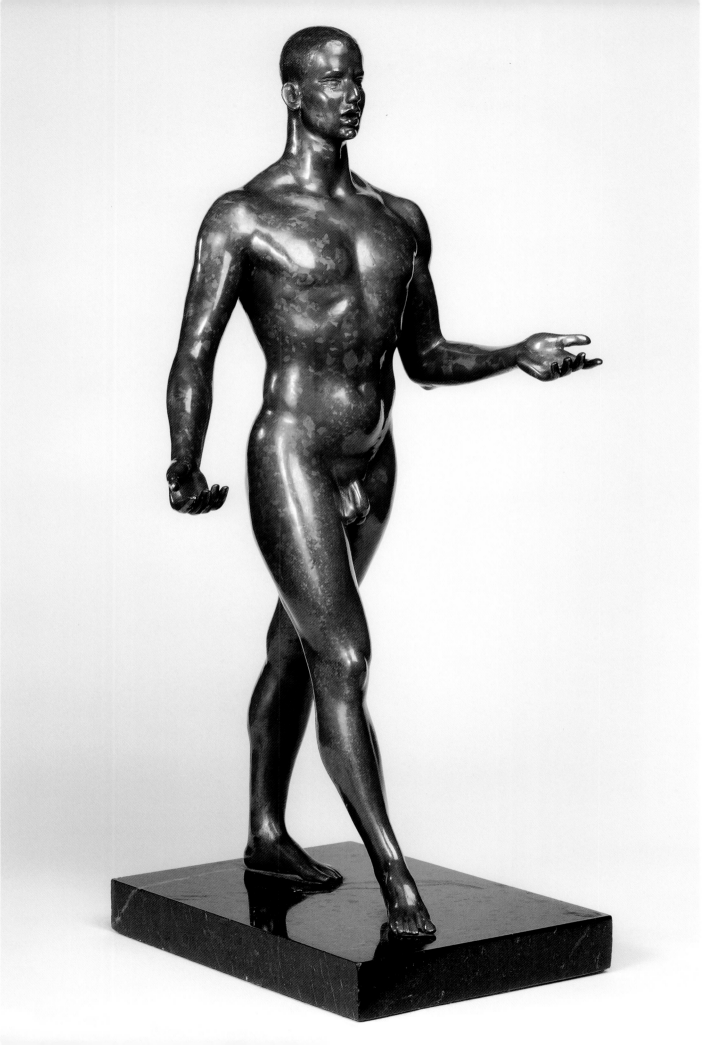

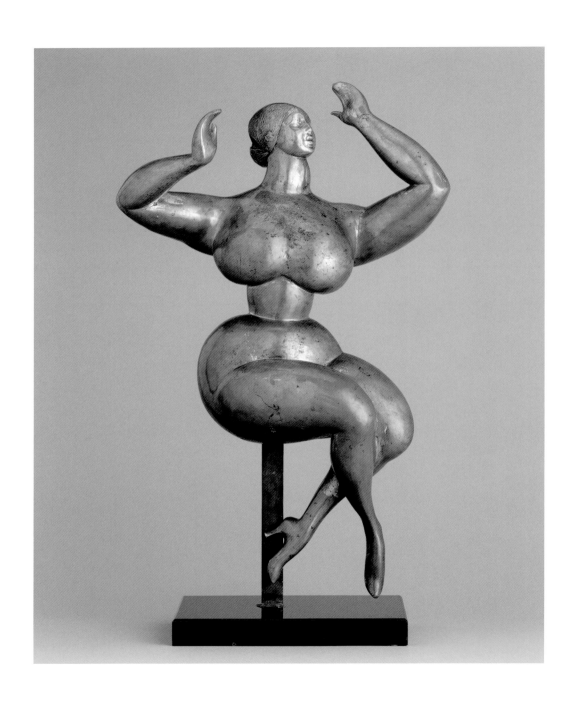

PLATE 21
Gaston Lachaise
Nude Woman with Upraised Arms, circa 1926
Bronze, 20 ¼ x 11 ½ x 6 ½ inches

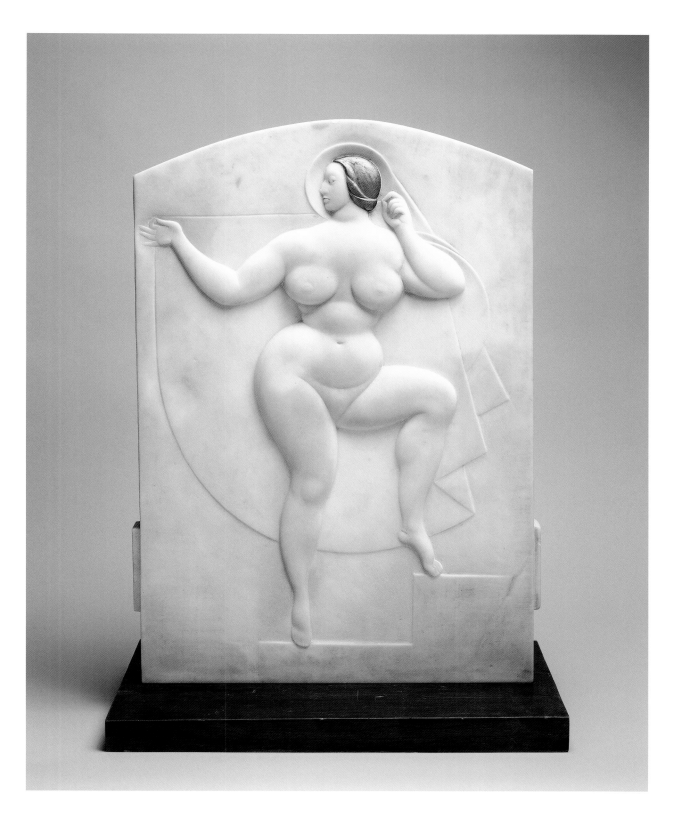

PLATE **22**
Gaston Lachaise
Nude on Steps, 1918
Polychromed marble on wood base,
29³⁄₈ x 20 x 2¹⁄₂ inches

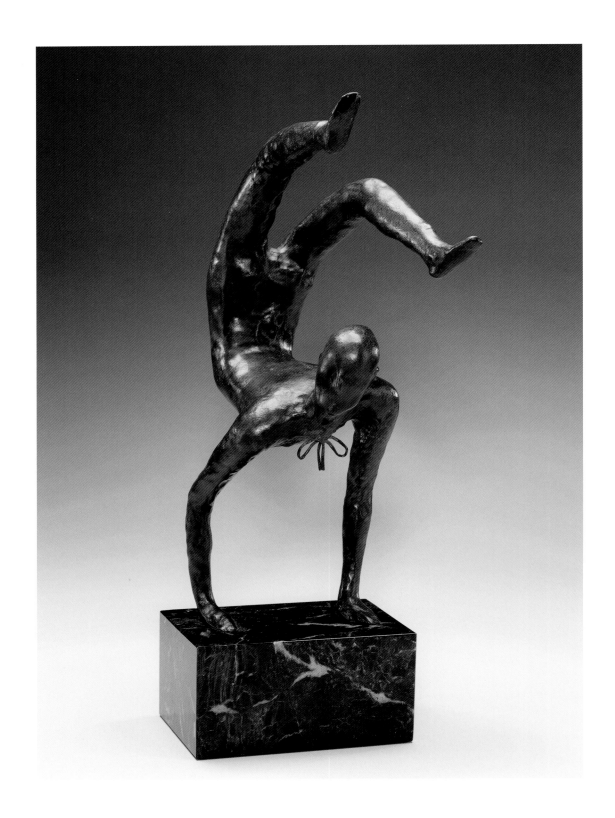

PLATE 23
Elie Nadelman
Acrobat, 1916
Bronze, 17½ x 6 x 9¼ inches (including base)

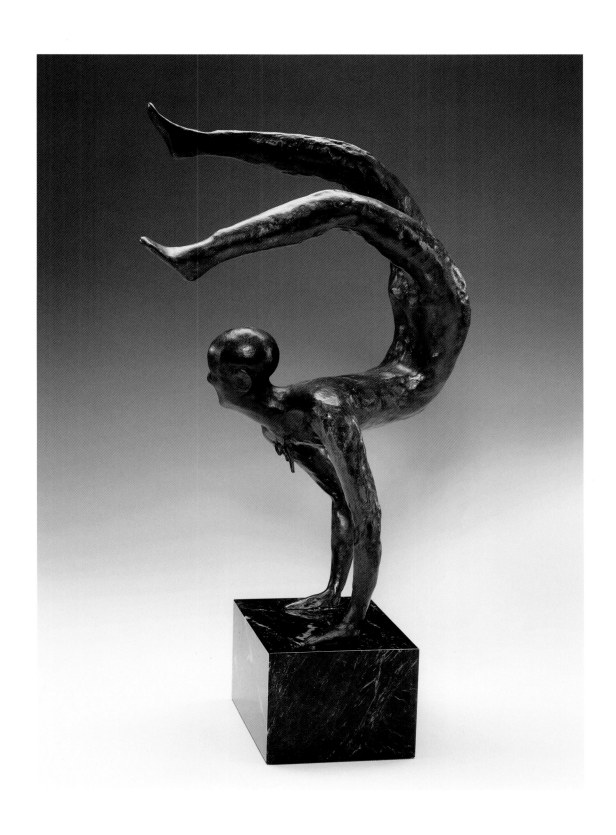

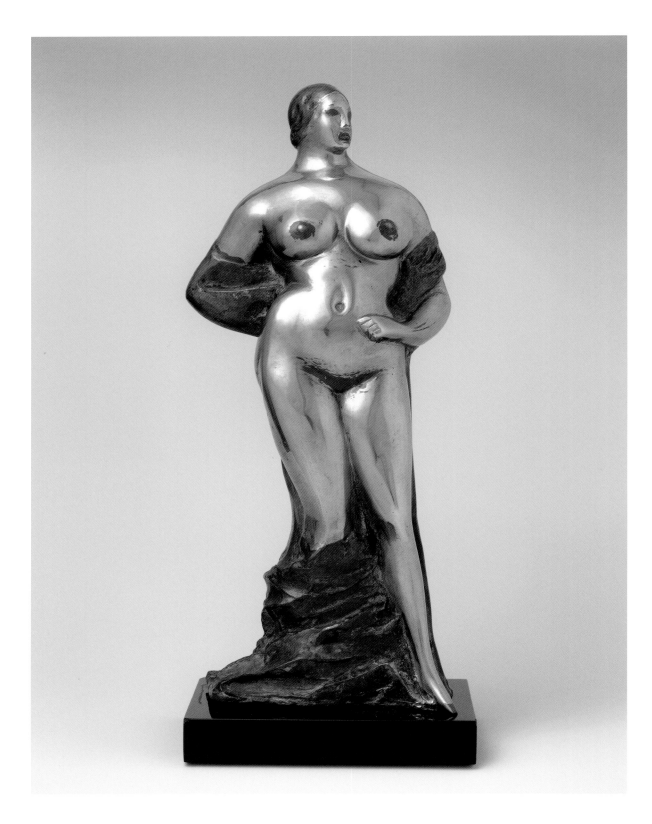

PLATE 24
Gaston Lachaise
Standing Nude, modeled circa 1915–17, cast circa 1925–27
Nickel-plated bronze, 18 x 5$\frac{1}{2}$ x 4 inches

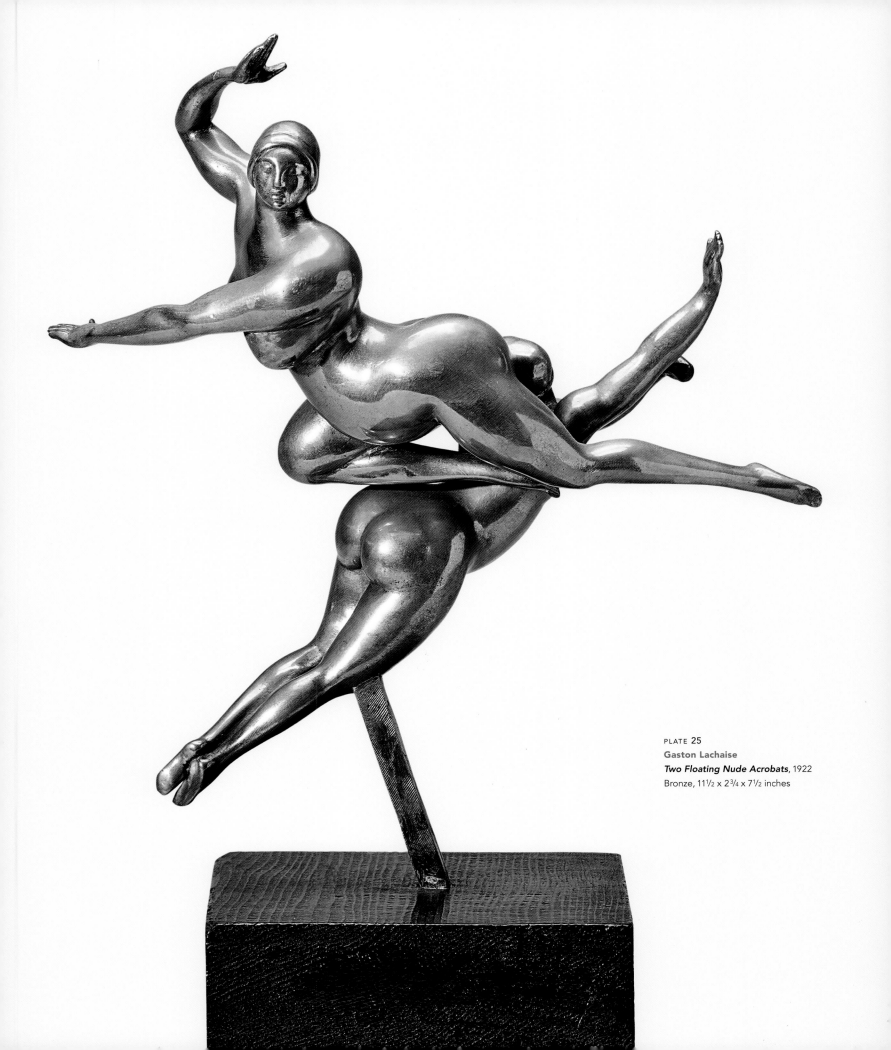

PLATE 25
Gaston Lachaise
Two Floating Nude Acrobats, 1922
Bronze, 11½ x 2¾ x 7½ inches

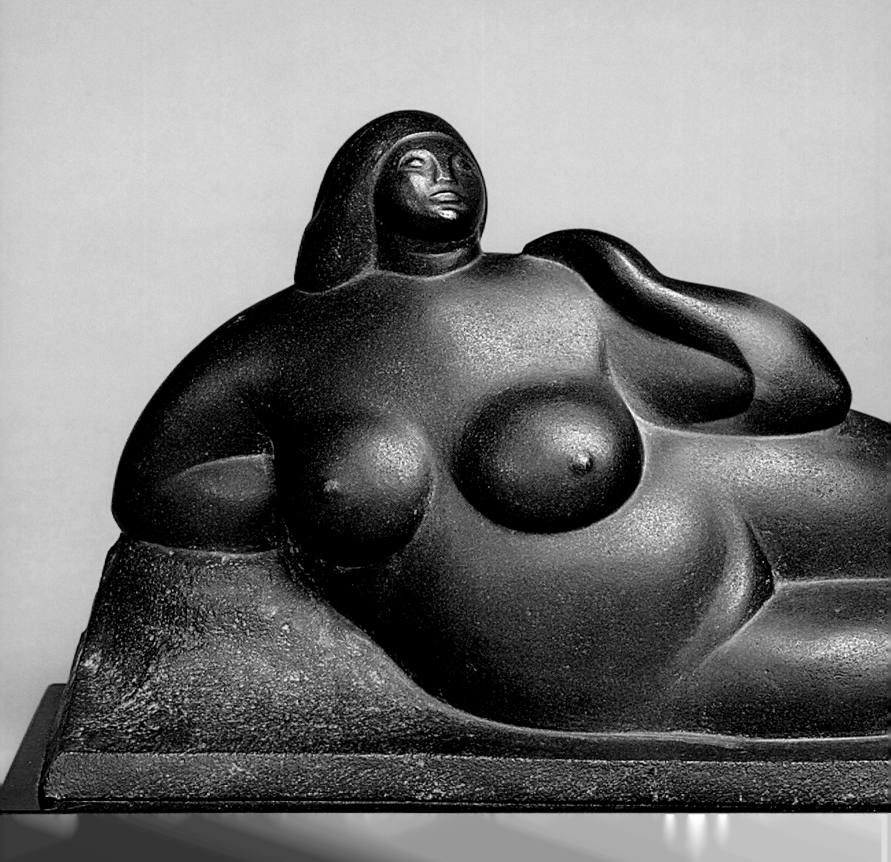

PLATE 26
Gaston Lachaise
The Mountain, 1913, carved 1919
Sandstone, 8 3/8 x 18 1/8 x 5 3/4 inches

PLATE **27**
William Zorach
Child on a Pony, 1934
Bronze, 24½ x 19½ x 10 inches

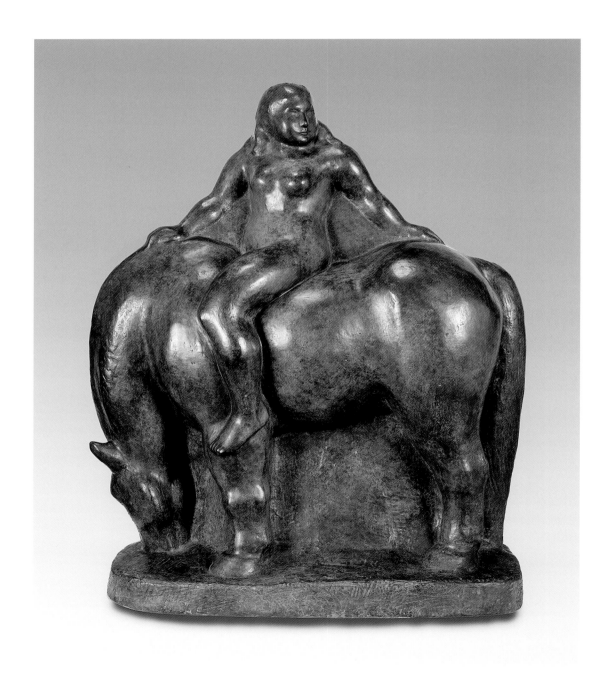

PLATE 28
Gaston Lachaise
Woman Seated, modeled 1918, cast 1925
Bronze with nickel plate, 12 inches (height)

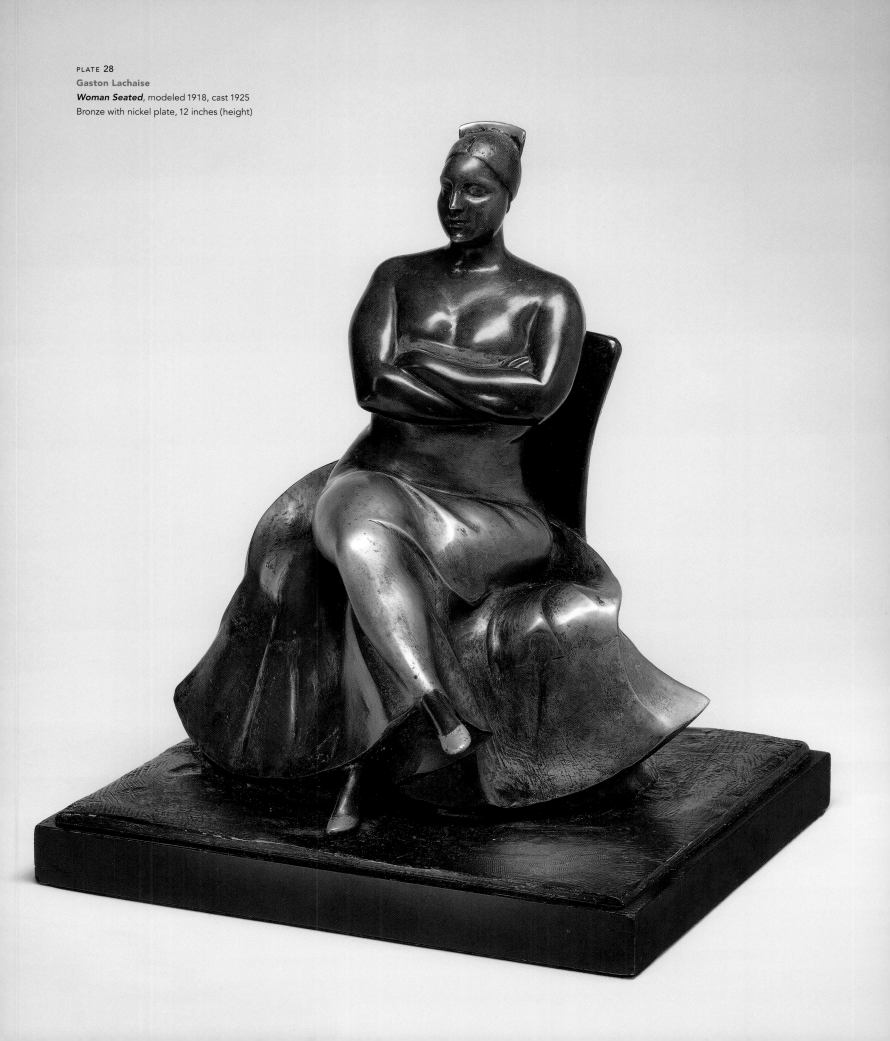

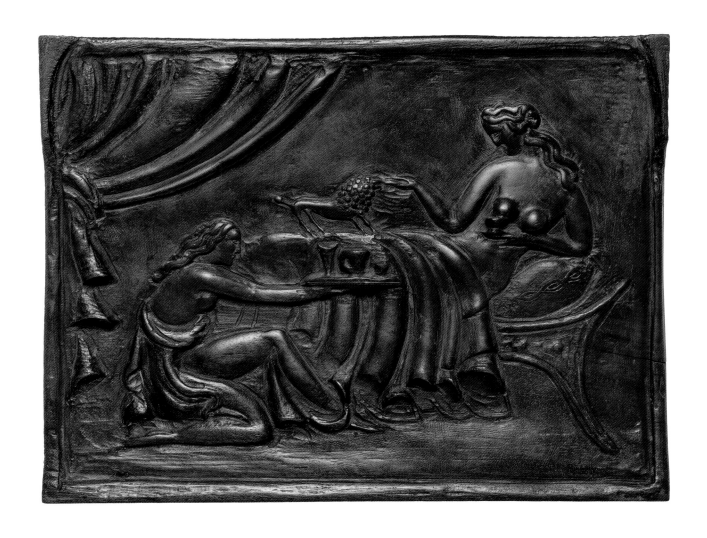

PLATE 29
Elie Nadelman
Woman with Poodle, circa 1914–15
Carved wood relief, 11½ x 15 x 2 inches

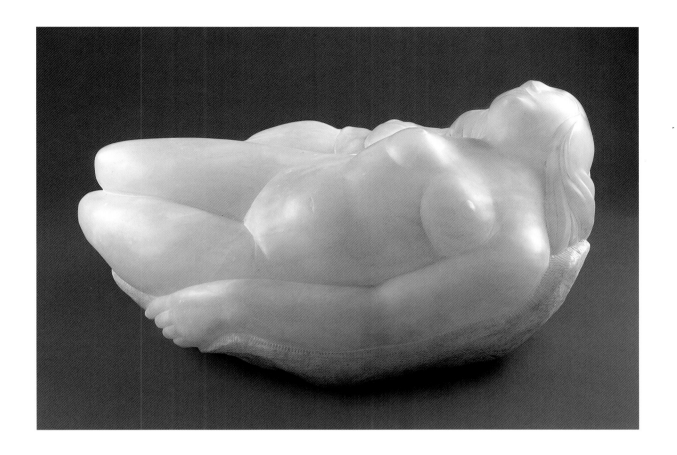

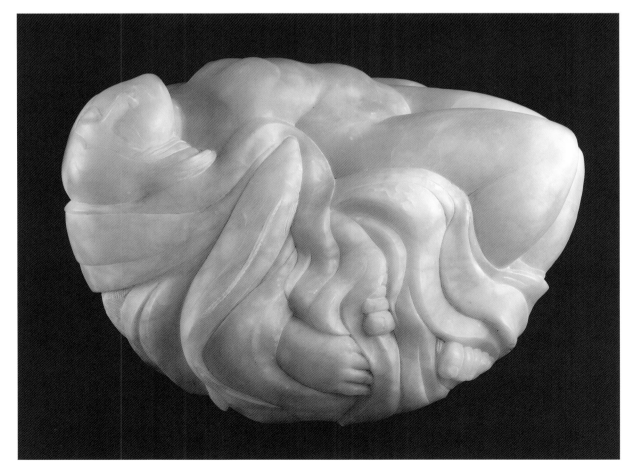

PLATE **30**
Robert Laurent
The Wave, 1926
Alabaster, 13½ x 24½ x 20 inches

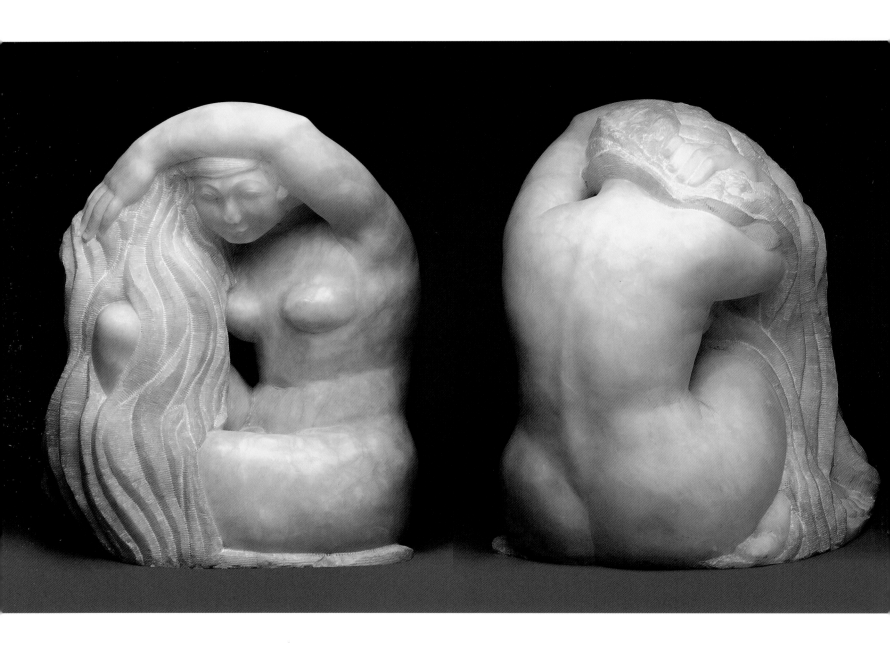

PLATE **31**
Robert Laurent
The Bather, circa 1925
Alabaster, 26 ³/₄ x 22 ¹/₁₆ x 13 ⁹/₁₆ inches

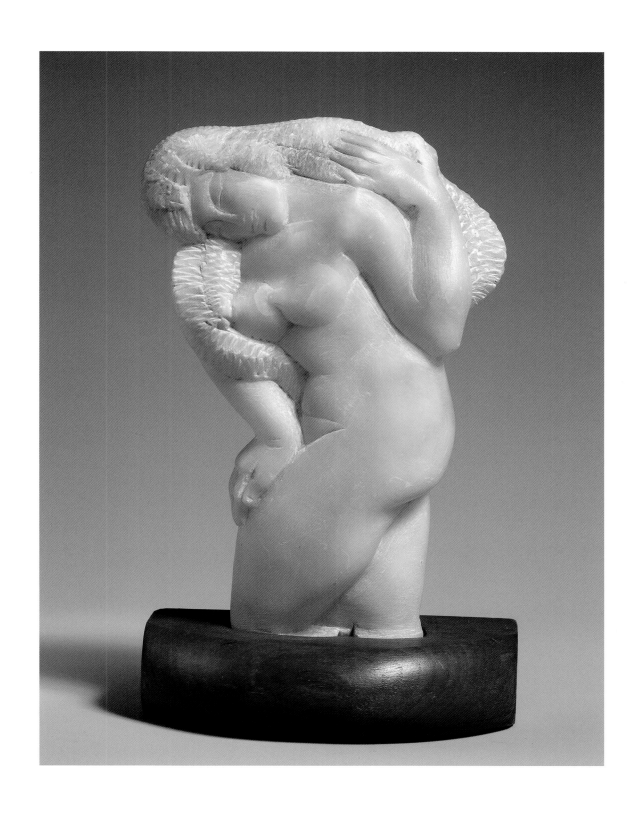

PLATE 32
Robert Laurent
Wind, 1946
Alabaster, 8 7/16 x 4 1/2 x 2 1/2 inches

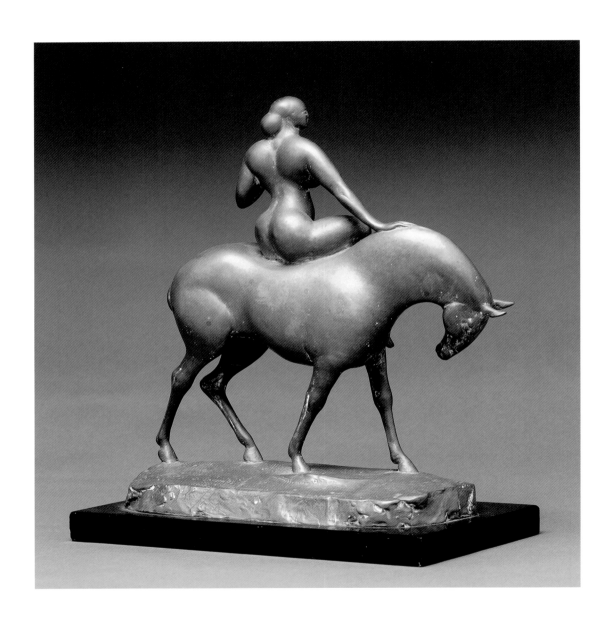

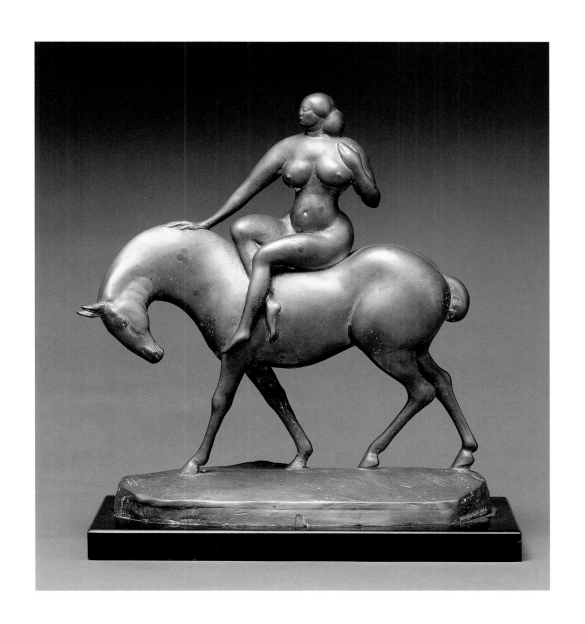

PLATE **33**

Gaston Lachaise

Equestrienne, 1918

Gilt bronze, 10 ⅝ x 10 x 4 ⅝ inches

PLATE **34**
William Zorach
Kiddy Kar, 1930
Granite, 20½ x 13 ¼ x 8 ¼ inches

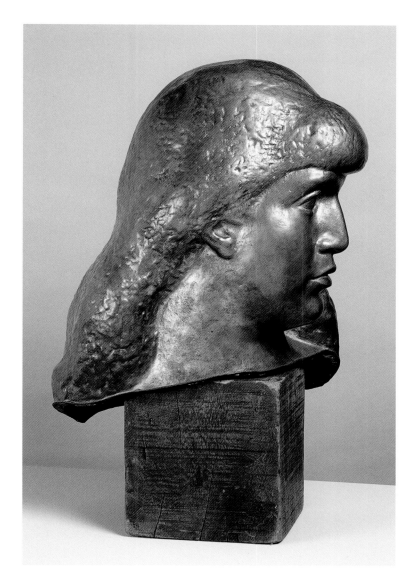
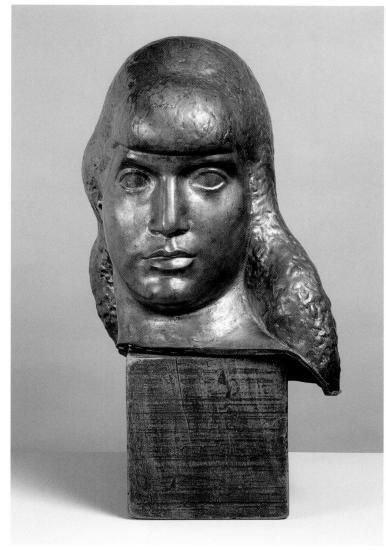

PLATE 35
William Zorach
Head, 1930
Bronze, 24 x 9½ x 12 inches

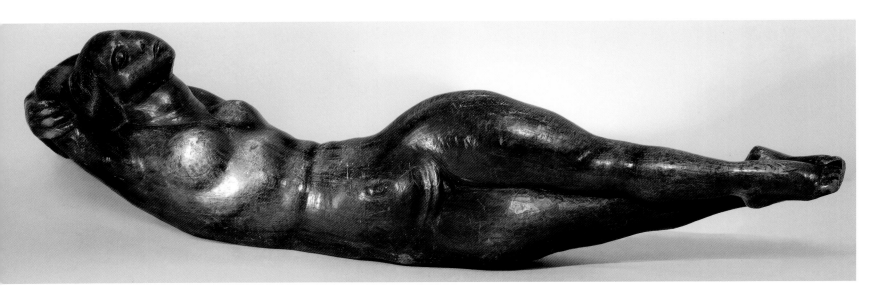

PLATE **36**
William Zorach
Floating Figure, 1922
Borneo mahogany, 9 x 33¼ x 7 inches

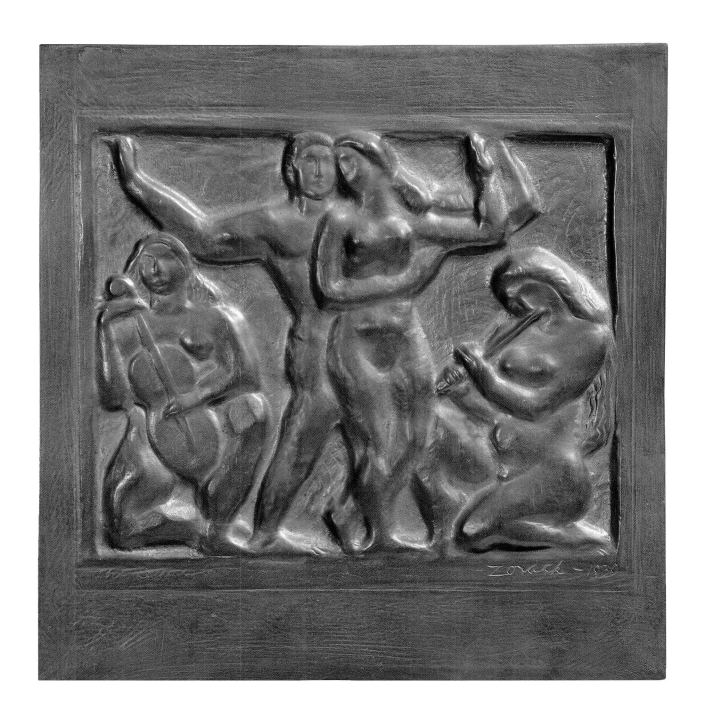

PLATE 37
William Zorach
The Dance, 1930
Bronze, 8 5/8 x 9 x 1 1/8 inches

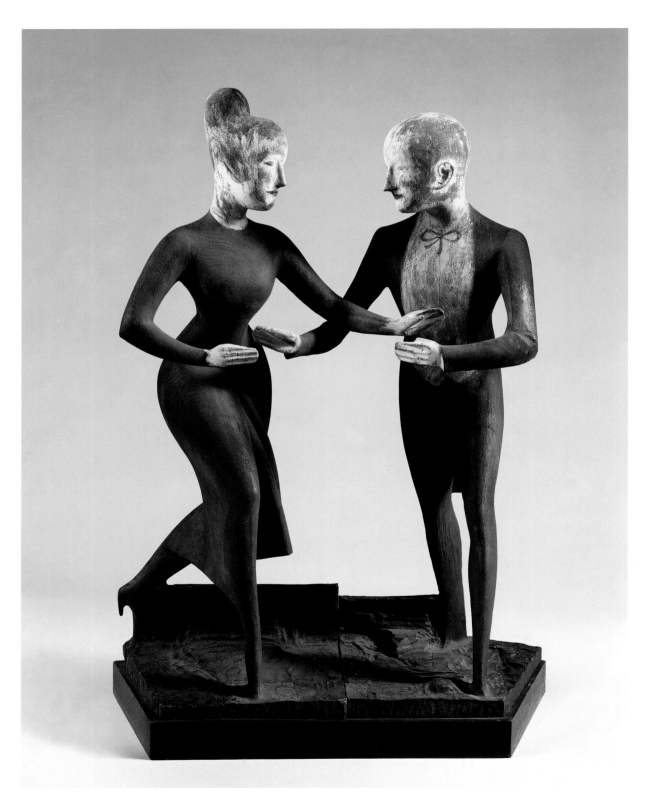

PLATE 38
Elie Nadelman
Tango, circa 1920–24
Painted and gessoed cherry wood,
36 x 25 5/8 x 13 7/8 inches

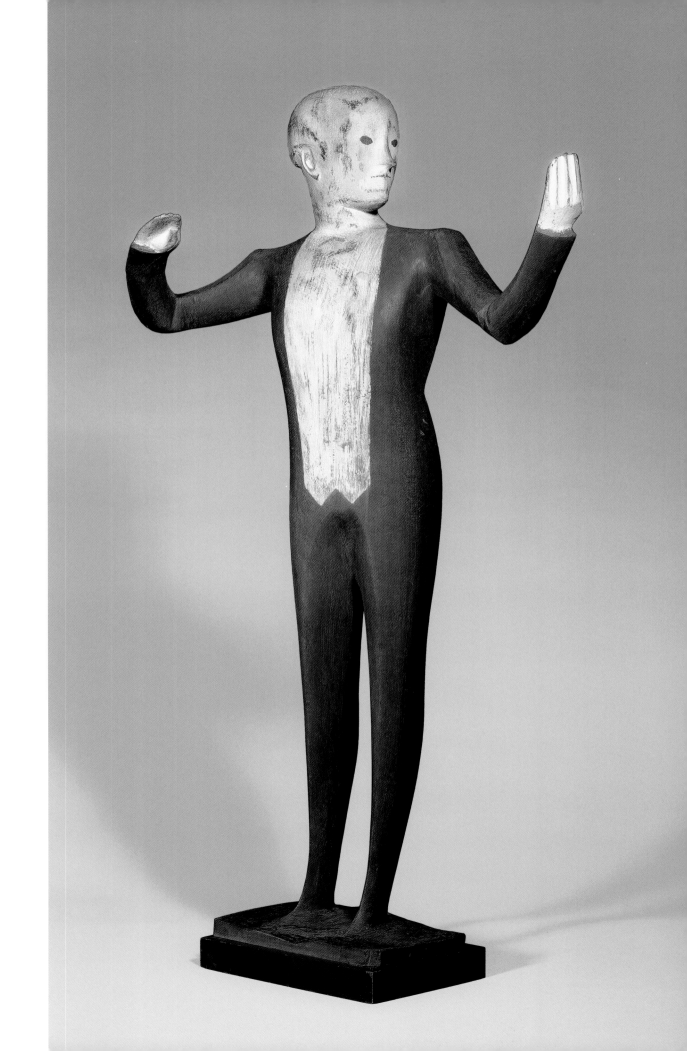

PLATE **39**
Elie Nadelman
Chef d'Orchestre, circa 1919
Stained and gessoed cherry wood,
38 ½ x 22 x 11 inches

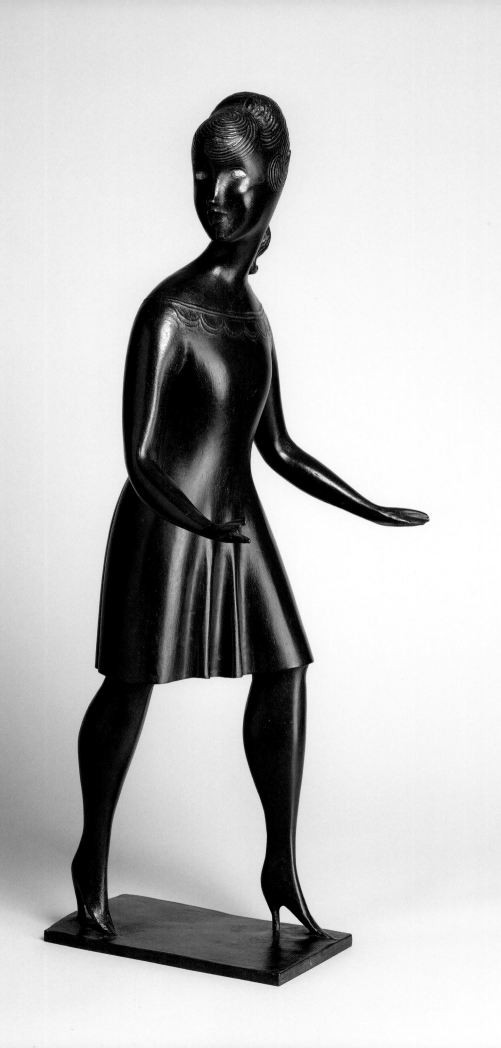

PLATE 40
Elie Nadelman
The Hostess, circa 1928
Bronze, 29⅞ x 10⅛ x 12⅞ inches

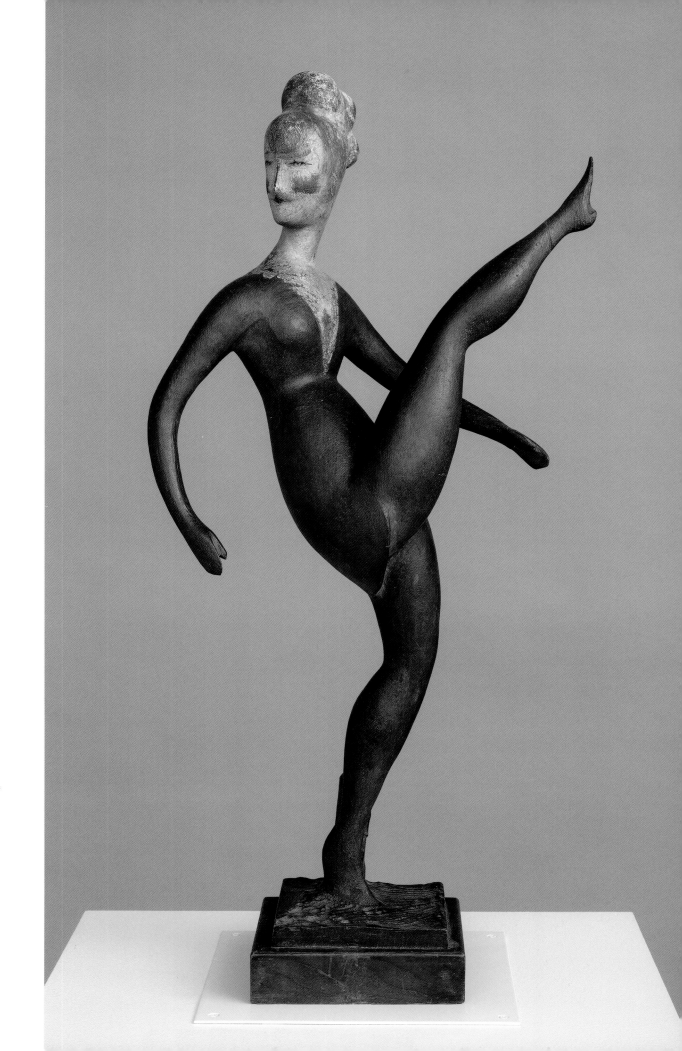

PLATE 41
Elie Nadelman
Dancer, 1918
Cherry wood and mahogany,
28¼ inches (height)

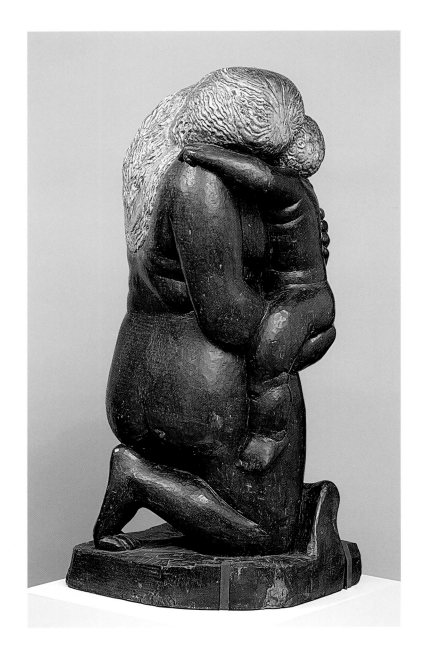
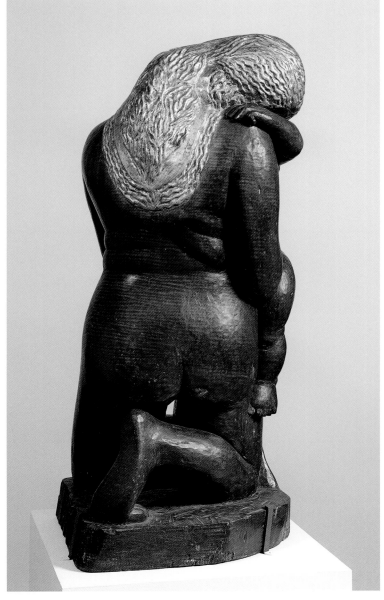

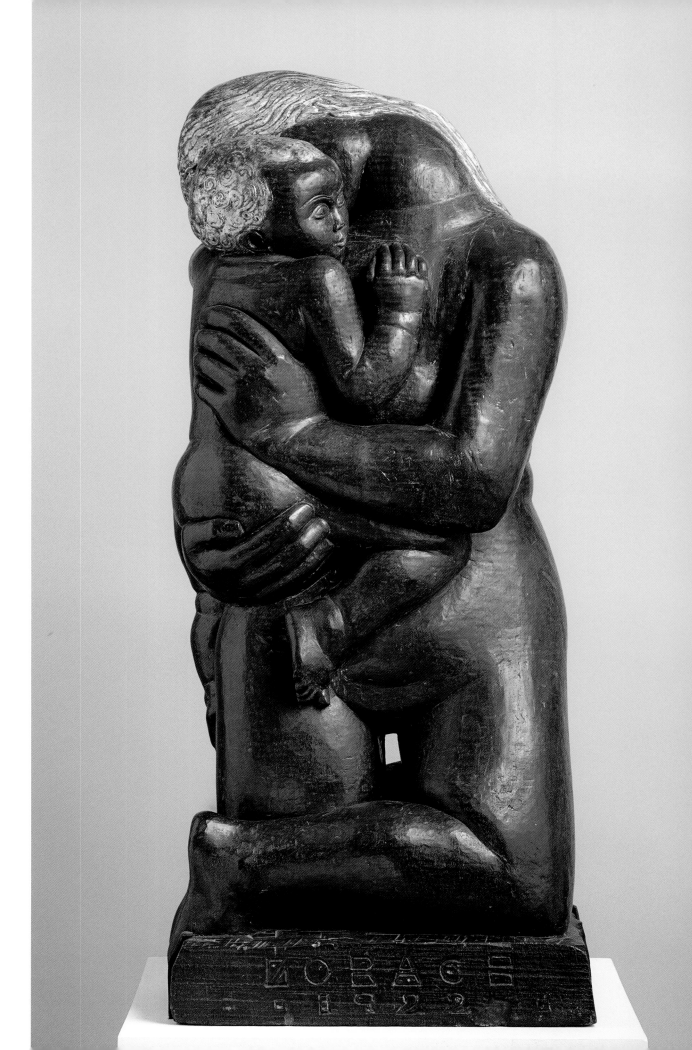

PLATE 42
William Zorach
***Mother and Child**, 1922*
Mahogany, 31 x 12 x 12 ½ inches

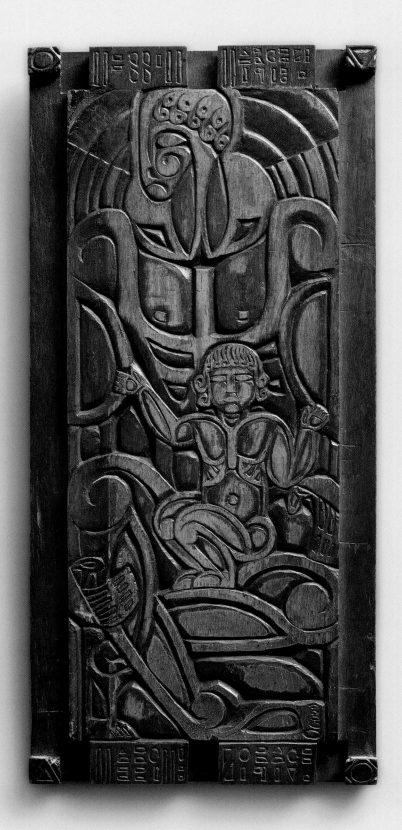

PLATE 43
Marguerite Zorach
United States, 1887–1968
Mother and Child, 1917
Butternut, 16 x 7 3/8 inches

PLATE 44
William Zorach
Waterfall, 1917
Butternut, 15 3/4 x 7 1/2 inches

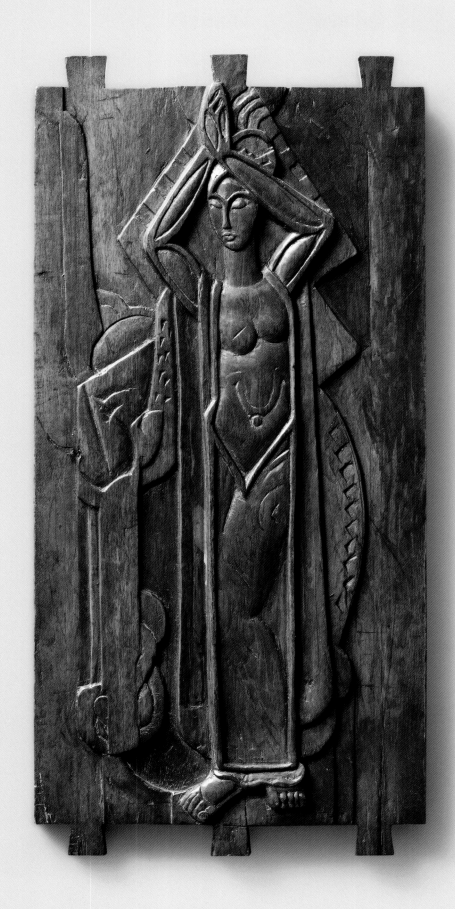

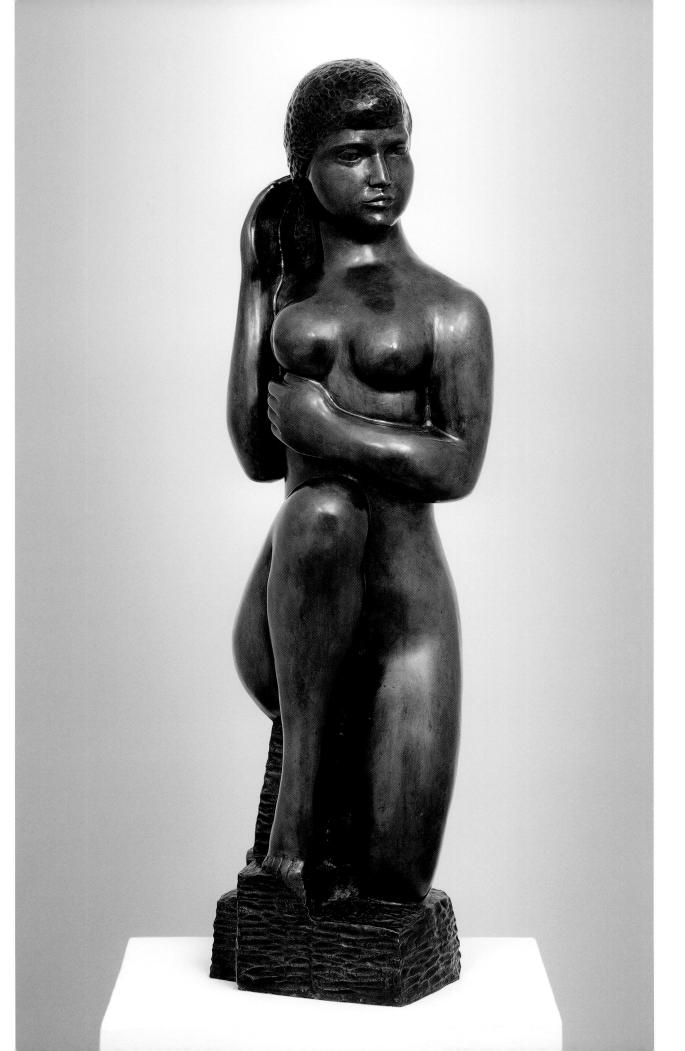

PLATE 45
William Zorach
Bathing Girl, circa 1934
Bronze, 44 x 12 x 11 inches

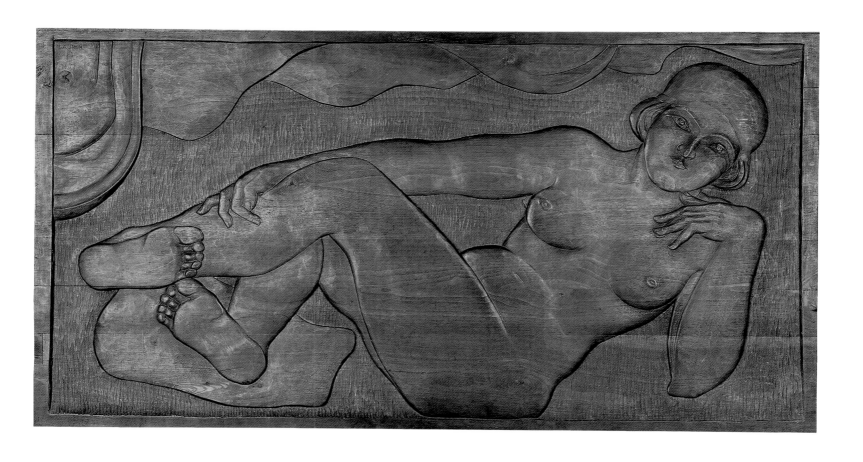

PLATE 46
Robert Laurent
Reclining Figure, 1934
Mahogany, 28 1/16 x 52 x 1 3/4 inches

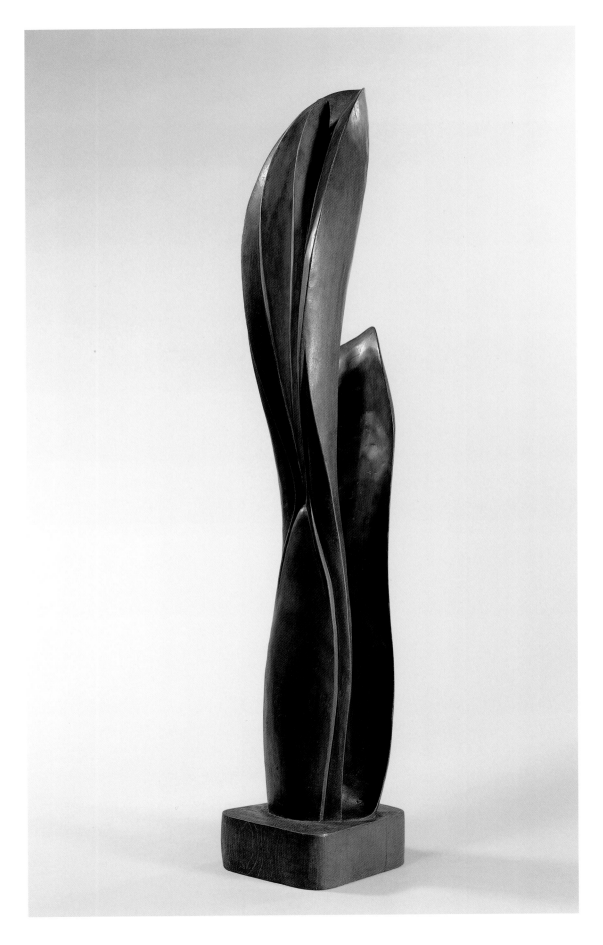

PLATE **47**
Robert Laurent
Plant Form, circa 1924–28
Stained fruitwood, 32 x 5¾ x 5¾ inches

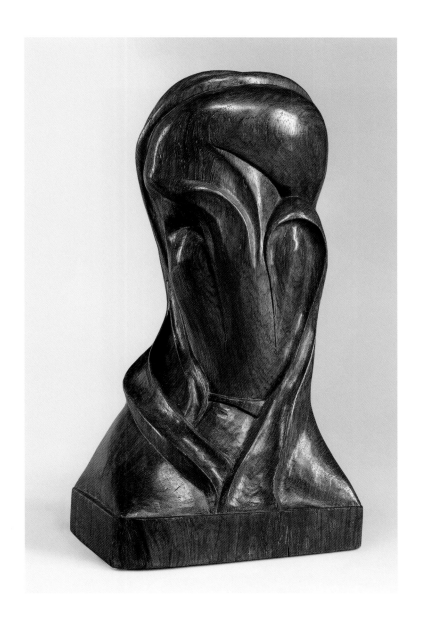

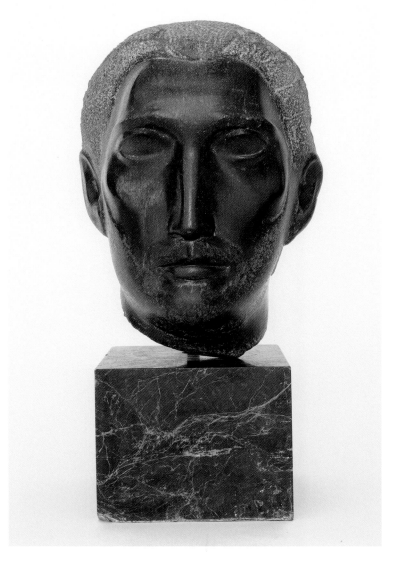

PLATE 48
Robert Laurent
Head (Abstraction), 1916
Carved mahogany, 15 x 8 x 6 inches

PLATE 49
William Zorach
Head of Christ, 1940
Stone, 20⅝ x 10¼ x 11⅝ inches (including base)

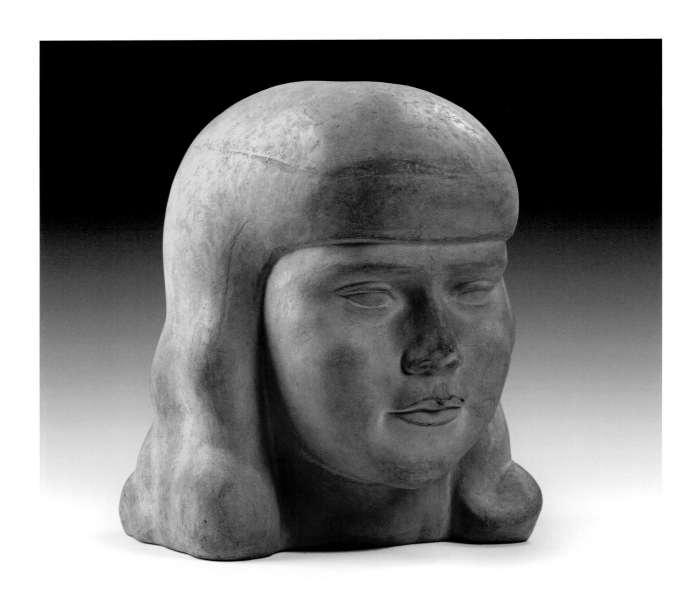

PLATE 50

William Zorach

Dahlov (The Artist's Daughter), 1920

Terracotta, 13½ x 10⅝ x 10½ inches

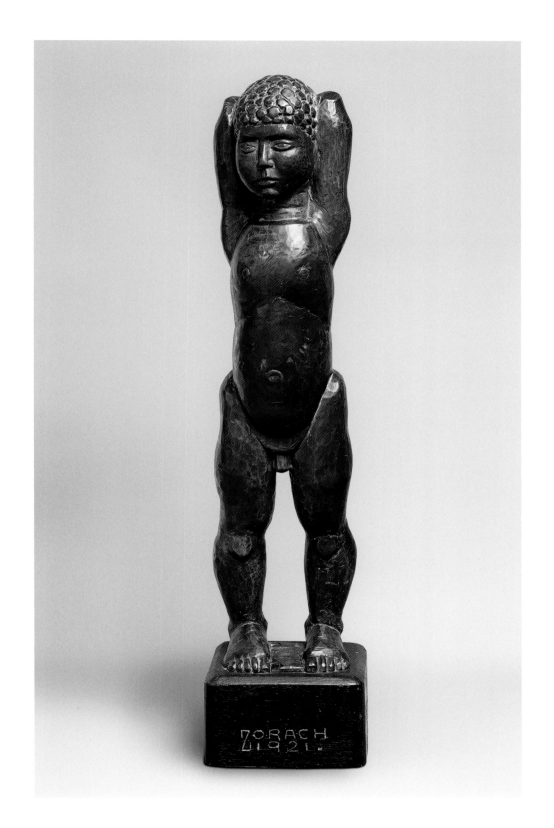

PLATE **51**
William Zorach
Young Boy, 1921
Mahogany, 22 x 5 x 4 ¾ inches

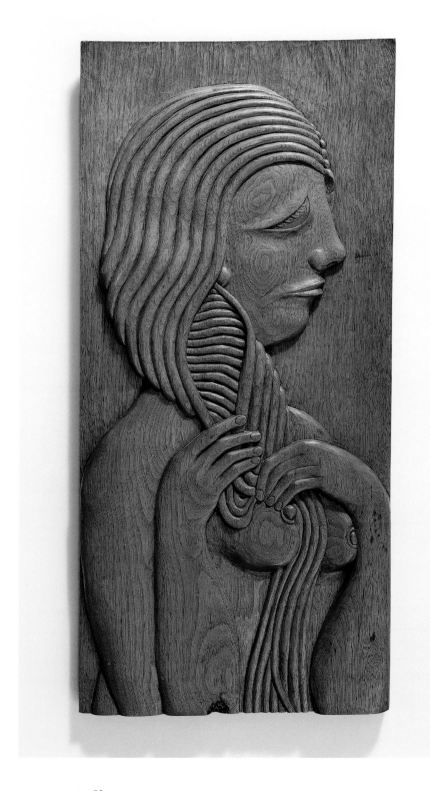

PLATE 52
Robert Laurent
Nile Maiden, circa 1914
Carved wood, 25 3/16 x 11 7/16 x 1 3/16 inches

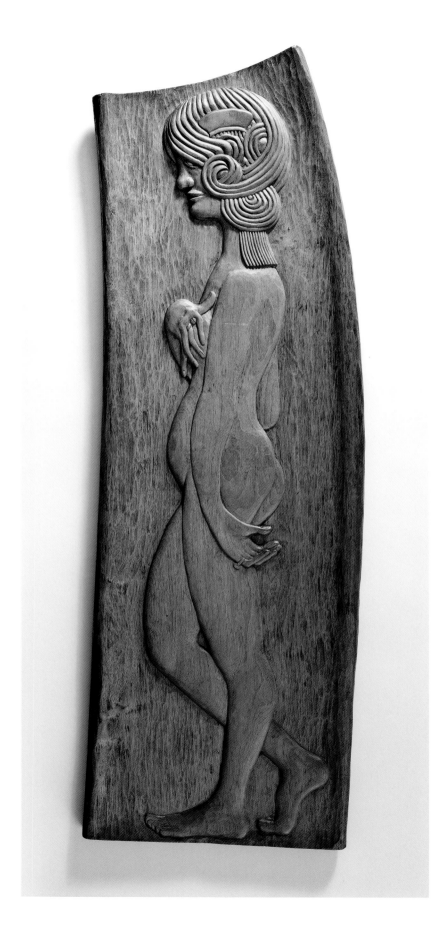

PLATE 53
Robert Laurent
Princess, circa 1914
Carved wood, 42$^{15}/_{16}$ x 14 x 1$^{3}/_{16}$ inches

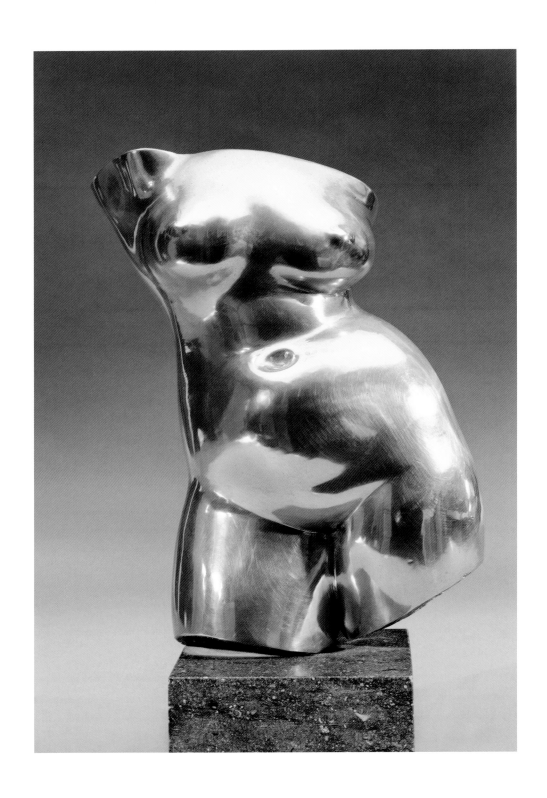

PLATE **54**

Gaston Lachaise

Ogunquit Torso, 1925–28

Bronze, 12³⁄₄ x 4 x 6¹⁄₂ inches

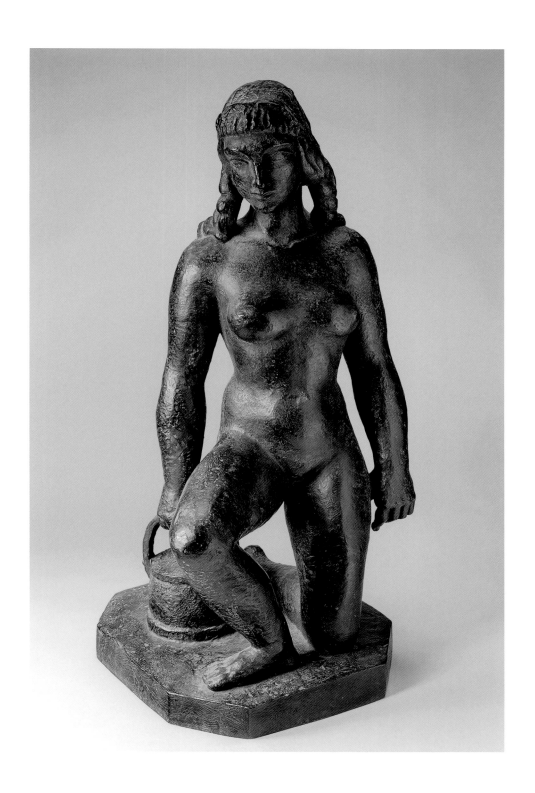

PLATE 55
Robert Laurent
Kneeling Figure, modeled 1935, cast by 1938
Bronze, 23 x 10½ inches

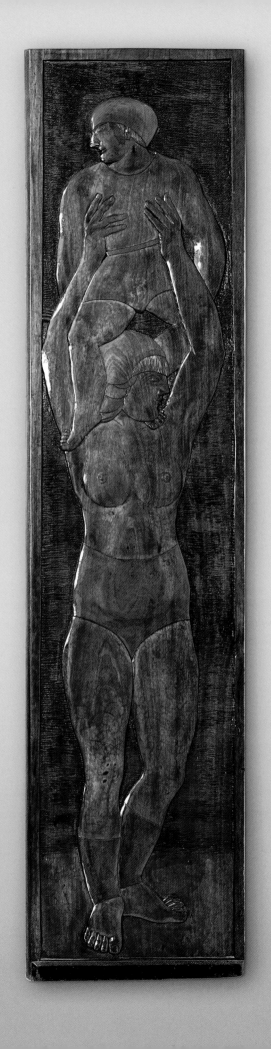

PLATE **56**
Robert Laurent
Acrobats, 1922
Mahogany, 92 x 21½ inches

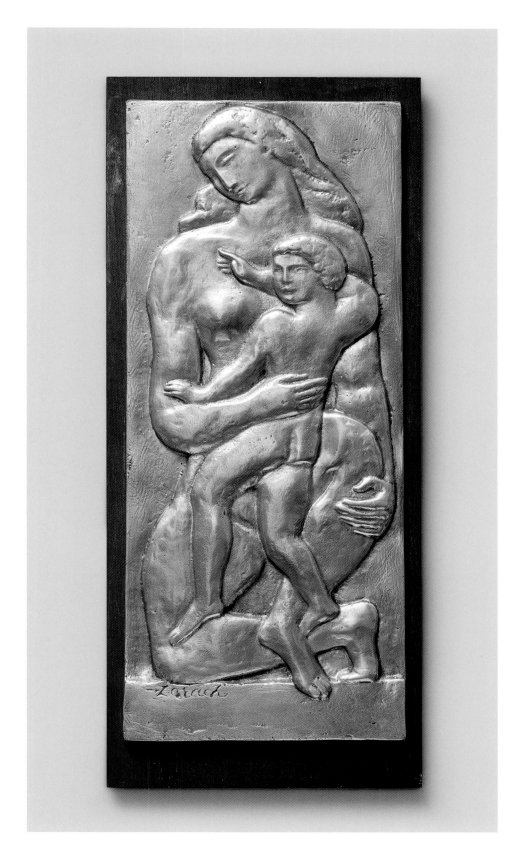

PLATE 57

William Zorach

Family Group (Mother and Child), 1925

Aluminum on mahogany panel, 17 1/16 x 7 9/16 x 1 1/16 inches

PLATE 58
Elie Nadelman
*Head, **Side View***, 1906–7
Ink and graphite on paper mounted to cardboard,
10¼ x 7⅞ inches

Sculpting Lines on Paper

MICHAELA R. HAFFNER

At the beginning of the twentieth century, Elie Nadelman, Gaston Lachaise, Robert Laurent, and William Zorach pioneered modern sculptural practices that redefined the technique and aesthetic of working with tactile media in the United States. Here, we bring together graphic work by these four modernists that reveals how drawing, or the sculpting of lines on paper, shaped their three-dimensional output.

Elie Nadelman

In 1921, reflecting on his draftsmanship over the past two decades, Elie Nadelman boasted that his graphic experimentations had "completely revolutionized the art of our time." By celebrating the unprecedented modernism of his drawings, Nadelman underscored his belief that the twentieth century's most significant stylistic innovation—abstraction—was born of the graphic medium. Nadelman was primarily a sculptor, yet in claiming a "plastic significance" for his drawings that would influence the "art of the future," he revealed the fundamental importance that linear design played within his three-dimensional work.[1]

Nadelman's drawings reflect an evolution of styles. Scholars have dissected his aesthetic influences in detail, from the Greek classicism that earned him the moniker "Praxitelmann" (referring to the famed sculptor Praxiteles) to the geometric abstraction that rivaled Pablo Picasso's Cubism. The artist borrowed from sources as diverse as Georges Seurat's contemporary silhouettes, Auguste Rodin's strong contour line, and

American Fraktur calligraphy.[2] The underlying formal element of his varied draftsmanship, however, was the curve. As Nadelman famously wrote in 1910, "I employ no other line than the curve, which possesses freshness and force. I compose these curves so as to bring them in accord or in opposition to one another. In that way I obtain the life of form, i.e. harmony."[3] The sculptor employed the intersection of curves in what Lincoln Kirstein called his early scientific "recherches" (*Head, Side View*; PLATE 58); the continuous arc in the silhouettes of his figural studies (*Two Standing Nudes*; PLATE 59); and the sweeping line in his sketches of dance (*High Kicker*; PLATE 60). He even took the curve to abstraction in *Seated Figure* (PLATE 61), reducing contour to a series of opposing arcs and bends that suggests form. Although the artist used subtle hatching and ink washes to indicate modeling in his drawings, the sinuous line most fully conveys this "life of form."

Unlike the other sculptors in this catalogue, Nadelman exhibited and published his drawings independently of his sculpture, most notably with a portfolio of facsimiles of drawings titled *Vers l'unité plastique* in 1914 and its republication as *Vers la beauté plastique* in 1921.[4] Although these earlier Paris drawings served as independent studies of form, his drawings after 1913 shared the themes and compositions of his three-dimensional work. Drawings like *Study for "Man in the Open Air"* (PLATE 63), *High Kicker*, and *Study for "Tango"* (PLATE 64) are striking in their close formal and thematic relationships to his sculpture, while remaining innovative in their own right. For instance, conservators speculate that Nadelman experimented with allowing mold to grow on the paper to create atmospheric effects in *Study for "Man in the Open Air."*[5] Likewise, in drawings such as *High Kicker*, the artist played with a wet brush to dilute ink contour lines and create depth. With his use of nontraditional drawing techniques, Nadelman revealed his dependence on the graphic medium as a source of creativity and experimentation.

Gaston Lachaise

E. E. Cummings' observation that Gaston Lachaise was a "man through whose touch a few cubic inches become colossal" rings as true for his drawings as it does for his sculpture.[6] In the figural study *Nude* (PLATE 66), a monumental woman seems to strain against the paper edges despite crouching, her swollen breasts and belly filling the entire composition. A prolific draftsman, Lachaise worshipped the epic in his sketches and sculpture, idolizing the physical and metaphorical power of "Woman," his voluptuous muse.[7]

The artist's extensive graphic production reveals his experimentation with this immense mass and scale. Through fluid contour lines, volumetric treatment of form, and a simplification of female anatomy, Lachaise created a dramatically proportioned body that juxtaposed a bulging midsection with attenuated limbs. He refined this archetypal female physique on paper, developing a curvaceous model that radiated an impossible sense of both buoyancy and weightiness. In drawings such as *Kneeling Nude* (PLATE 67), a female figure is simultaneously grounded by her expansive hips and thighs and uplifted by her floating arms and flexed feet. Closely related in posture to the alabaster relief *Nude on Steps* (PLATE 22), the fluid sketch exemplifies Lachaise's pursuit of capturing the majestic image of "Woman."

Lachaise conjured the epic in his graphic work not only through sheer size, but also through his treatment of the full-figured woman as symbolic. His drawings are independent meditations on the female figure that, with such generic titles as *Nude* or *Woman*, prioritize a universal female anatomy over individual identity.[8] By suspending his often faceless figures in a blank negative space, void of context, the artist evoked the otherworldly conception of "Woman" expressed in his 1928 essay, "A Comment on My Sculpture": "'Woman,'—spheroid, planetary, radiative— . . . entirely projected beyond the earth, as protoplasm, haunted by the infinite, thrust forth man, by means of art, towards the eternal."[9]

Lachaise's allusion to the supernatural coincides with his pursuit of drama in his drawings. From using a garish lime-green crayon in the sketch *Nude*, to splattering ink and leaving a footprint on the paper sheet in *Figure with Ink Splash* (PLATE 68), the artist emphasized spectacle. He gave his figures exhibitionist postures that suggest the burlesque and theater shows he often attended and sketched.[10] While Lachaise produced hundreds of drawings that did not typically serve as direct studies for sculpture—he made some for the sole purpose of selling to raise cash quickly— he also used sketches to aid in the development of his sculptural compositions.[11] Just as *Madame Lachaise* (PLATE 69) shares a contrapposto stance with the bronze

FIG. 56 **Gaston Lachaise** (United States, born France, 1882–1935), *Seated Woman*, 1921, crayon on paper, 3⅝ x 9⅞ inches. The Metropolitan Museum of Art, Bequest of Scofield Thayer, 1982, 1984.433.226

Standing Woman (also known as *Elevation*; **PLATE 16**), so *Seated Woman* (**FIG. 56**) recalls the position of repose of its related sculpture (**PLATE 26**). Ultimately, Lachaise's draftsmanship is expressive and controlled, solid yet airy, and above all, a complete homage to the female form.

Robert Laurent

During the 1920s, Robert Laurent hosted a weekly drawing circle at his Brooklyn home where friends like Wood Gaylor, Stefan Hirsch, and Yasuo Kuniyoshi gathered to socialize and sketch live models.[12] Despite organizing these congenial artist evenings, Laurent did not rely heavily on preparatory drawings in his creative practice. In fact, there is little evidence in this exhibition for the connection between his sketches and sculpture, as Laurent did not create the scores of figural studies that fellow sculptors Lachaise and Nadelman so often committed to paper. Instead, Laurent drew scenes from nature that reflect his frequent trips to Ogunquit, Maine, from seagulls in flight to sleeping dogs on porches, and sketched portraits of his friends.

The rare figural studies brought together here demonstrate Laurent's studied draftsmanship, with its slow-moving and detailed line, and his meditation on how sculptural material dictates form and aesthetic. Fellow sculptor Zorach addressed this issue when he explained, "A sculptor does not create the same form or idea for bronze as for wood or for stone. . . . Your design forms should grow out of your findings and experience with materials."[13] Laurent's drawings reveal a diverse range of styles, from the naturalism of *Female Torso* (**PLATE 72**) to the abstraction of *Woman* (**PLATE 73**), which seem to anticipate different sculptural media

through their attention to surface effects. His delicate line and soft shading in *Female Torso* convey the supple flesh and curves of the female body, a surface quality that the artist achieved masterfully in carved alabaster. By contrast, the solid contour lines and tubular forms in *Untitled (Figure Study)* (**PLATE 74**) suggest a shape and silhouette inherent to the casting process, apparent in the closely related aluminum sculpture *Pearl*.[14] Despite uncertainty about whether these drawings served as direct studies for sculpture, it is clear that Laurent was interested in experimenting with the tactile properties of his graphic work.

Laurent's limited drawing production indicates his involvement with the revival of direct carving at the beginning of the twentieth century. Unlike his peers Nadelman and Lachaise, Laurent was deeply entrenched in the movement's ethos of discovery and spontaneity, and accordingly, its lack of compositional planning. He relished the thrill of cutting into a wood or stone block, and through chisel and mallet, discovering the hidden shapes within. He explained in 1942: "I like to cut without any preconceived idea, to grab forms that might suddenly show up while working."[15] Laurent's improvised carving thus rendered preparatory drawing unnecessary for—and even incompatible with—his sculptural practice. A drawing such as the Cubist-inspired *Woman* stands alone as an independent study of form and space. The dissection of the figure's torso into a series of ovals and triangles is a practice of anatomy rather than a preparation for sculpture in the round. Despite Laurent's adherence to direct carving, his description of his sculptural approach as "the simplification of lines and forms" underscores his view of carving as linear.[16]

William Zorach

In his instructional guide to sculpture from 1947, William Zorach expounded on the significance of drawing as a planning tool: "It is the means whereby I capture the fleeting movement and gesture and make available for future use my observation and sensitivity to the life around me."[17] The artist's formative background in painting made him a strong proponent of drawing as a way of taking "notes" about the visual world.[18] In one such sketch, titled *Marguerite and Tessim* (PLATE 78), he quickly recorded a familial scene of his wife and son by marking their architectural surroundings with rudimentary lines. Although Zorach's early direct carving practice honored the movement's mission of freeing form from raw material, he later merged this spontaneous method with the preparatory nature of his painting background. He explained, "I have no set rule of procedure with carving. Sometimes I let the stone suggest its possibilities. Sometimes I work from drawings. Sometimes I make a small rough model in clay."[19]

Zorach's use of the graphic medium allowed him to refine and edit compositions before the costly and time-intensive carving process. From figural studies (*Nude Young Woman*; PLATE 79) and portraits (*Dahlov*; PLATE 80) to preparatory cartoons for reliefs (*Sketch for Plaque "The Dance"*; PLATE 81), his drawings are diverse in function and reveal his predisposition for creating settings, in contrast to the isolated figural studies of his peers. A comparison of the preliminary sketch for *The Dance* with the final bronze relief plaque (PLATE 37) shows Zorach's compositional planning and keen sense of revision as he removed the sketch's equine figure from the final sculpture. While the artist often started carving by tracing a drawing onto the relief, this sketch's loose strokes and simplified forms suggest it was an early version of the composition.[20]

Although Zorach's reliance on drawings upends the presumption that his direct carving was always impromptu, his closed and compact sculptures show that he gave full primacy to the block of raw material. He preserved the inherent shape and materiality of the medium, but used initial drawings to free the subject from the constraints of the natural form. He explained, "Cutting into the stone without a preliminary sketch . . . too often results in a four-sided silhouette or an engraved relief on a rounded form too closely bound to the original mass of the stone."[21] Zorach's use of drawing allowed him to embrace the natural material without limiting the subject's potential.

The four modernist sculptors presented here harnessed the graphic medium to explore form and composition. Whether drawings were used as direct studies (Nadelman's *High Kicker*, for example) or were simply created to practice the elegant curves of female anatomy (such as Lachaise's *Nude, Number 1*; PLATE 70), the sketches provided an outlet for the artists to translate an abstract idea onto paper. The act of marking the paper, of sculpting forms with ink and crayon on a paper medium, allowed them to meditate on subject and style without the high stakes of marble, wood, or bronze. Even the direct carvers Laurent and Zorach capitalized on the graphic medium to fully liberate and flesh out their designs.

Each artist embraced drawing uniquely, from Laurent, whose draftsmanship alternated between bold abstraction and sensitive naturalism, to Zorach, whose rough shorthand captured the intimacy of everyday life. While Nadelman used the simple, unmodulated line to emphasize his archetypal androgynous silhouette (*Two Standing Nudes*), Lachaise employed the singular line to highlight the rolling curves of his hypersexualized "Woman" (*Seated Woman*). However, the drawings also unveil fascinating links between the modernists, from Zorach's strikingly Lachaise-esque figural study *Nude Young Woman* to the avant-garde Cubism shared by Nadelman and Laurent.

The drawings made by Nadelman, Lachaise, Laurent, and Zorach at the beginning of the twentieth century raise important questions about how the sculptors used a two-dimensional medium to conceive of their three-dimensional work. While there is no universal method among the four modernists, Nadelman's belief that "plasticity" derives from "a wonderful force, a life"—as opposed to inherent three-dimensionality—suggests that drawings themselves can capture the spirit and inventiveness of the sculptors' modernism.[22]

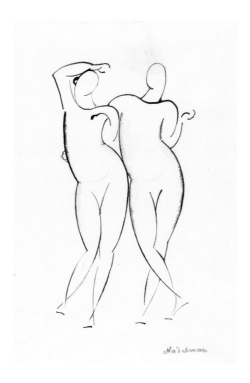

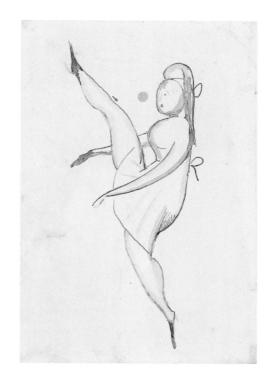

PLATE 59

Elie Nadelman

Two Standing Nudes, circa 1907–8

Ink, wash, and graphite on paper,
13⅝ x 8⅝ inches

PLATE 60

Elie Nadelman

High Kicker, circa 1917

Pen and ink on paper, 10 x 6¾ inches

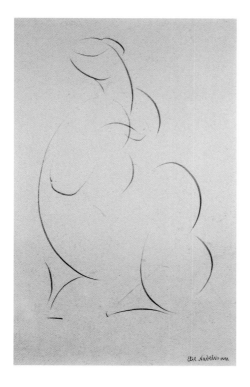

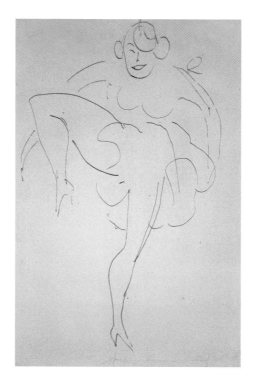

PLATE 61

Elie Nadelman

Seated Figure, circa 1908–10

Ink on paper, 11¾ x 7¾ inches

PLATE 62

Elie Nadelman

Study of a Female Variety Dancer, circa 1919

Pen on paper, 12½ x 8 inches

PLATE 63

Elie Nadelman

Study for "Man in the Open Air," circa 1914–15

Watercolor, ink, and pencil on paper,
10³⁄₄ x 7¹⁄₈ inches

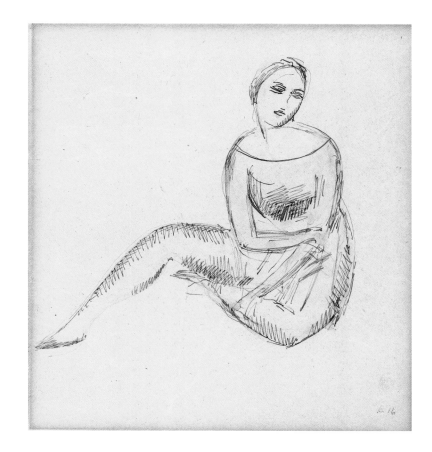

PLATE 64
Elie Nadelman
Study for "Tango," circa 1917
Pen with ink wash on paper, 9⅞ x 7⅞ inches

PLATE 65
Elie Nadelman
Seated Dancer, 1919
Ink on paper, 10⅛ x 8 inches

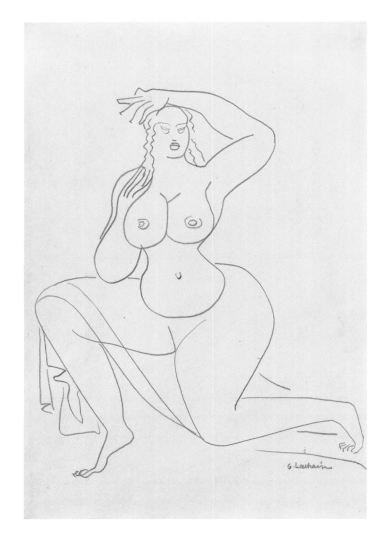

PLATE 66
Gaston Lachaise
Nude, circa 1924
Crayon on thin cream Japan paper,
11¹⁵/₁₆ x 5⁹/₁₆ inches

PLATE 67
Gaston Lachaise
Kneeling Nude, circa 1922–32
Pencil on paper, 18 x 12 inches

PLATE 68
Gaston Lachaise
Figure with Ink Splash, circa 1929–31
Graphite and ink on paper, 24 x 19 inches

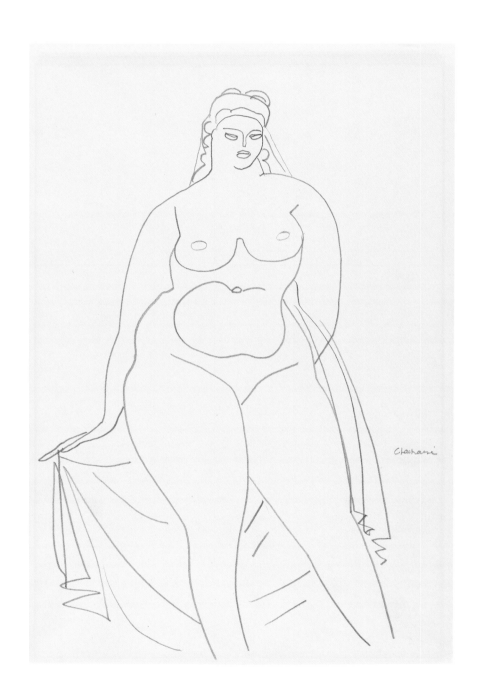

PLATE 69

Gaston Lachaise

Madame Lachaise, circa 1930

Pencil on paper, 17 7/8 x 11 13/16 inches

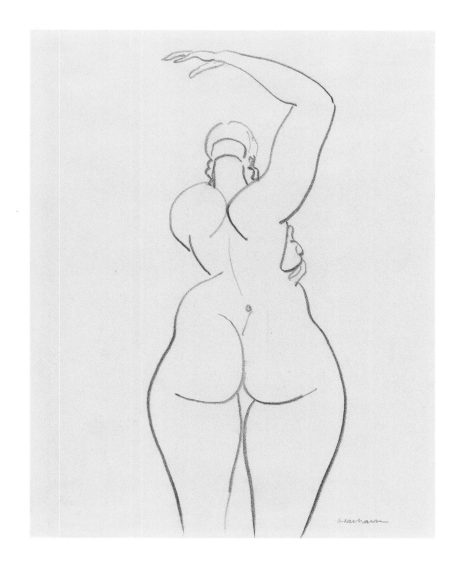

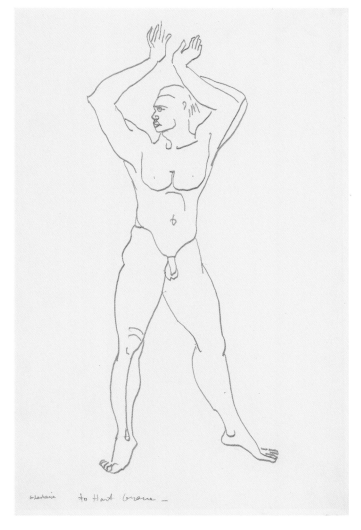

PLATE 70
Gaston Lachaise
Nude, Number 1, undated
Graphite pencil on paper, 11 x 8½ inches

PLATE 71
Gaston Lachaise
Harold Hart Crane, circa 1923
Graphite on paper, 19 x 12⅛ inches

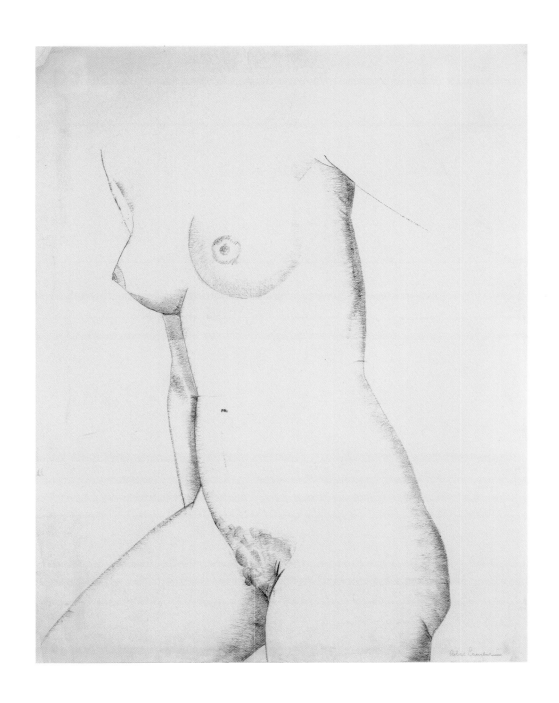

PLATE 72
Robert Laurent
Female Torso, circa 1925
Crayon on paper, 22 x 17 inches

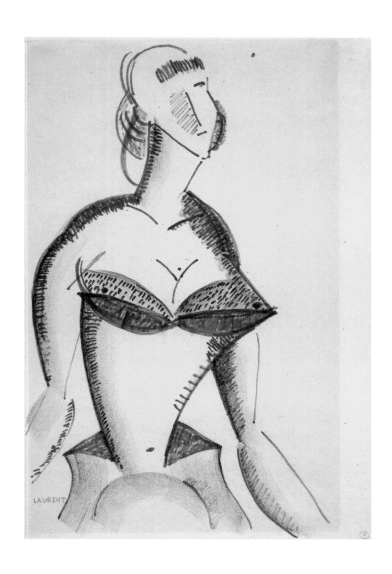

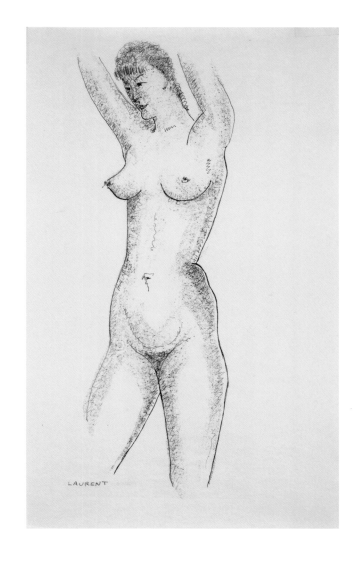

PLATE 73
Robert Laurent
Woman, circa 1940
Pen, ink, and crayon on paper, 16 x 10⅝ inches

PLATE 74
Robert Laurent
Untitled (Figure Study), first half 20th century
Ink and crayon on paper, 17½ x 10¼ inches

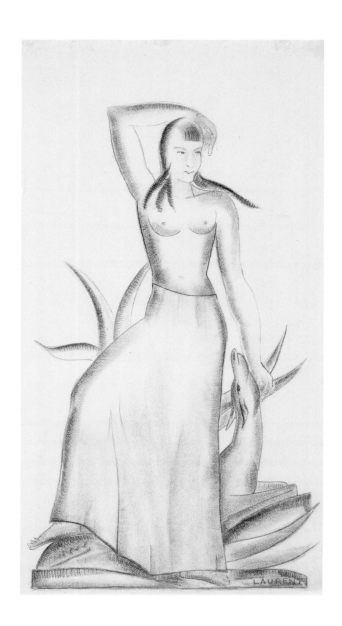

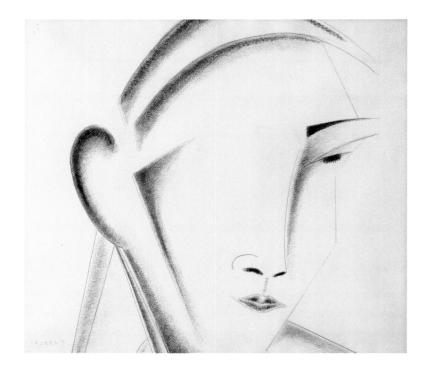

PLATE **75**
Robert Laurent

Woman and Doe, Study for Sculpture,
first half 20th century
Crayon on paper, 21 x 11¼ inches

PLATE **76**
Robert Laurent

Abstract Head, circa 1915
Graphite on paper, 11⅛ x 12¾ inches

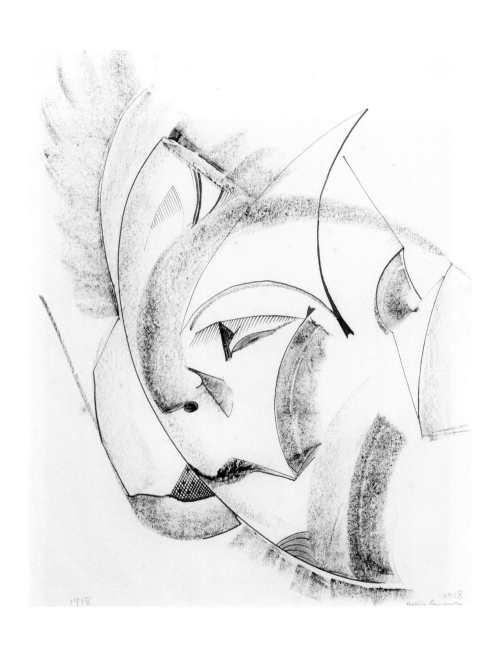

PLATE 77
Robert Laurent
Abstract Head, undated
Graphite on paper, 9¾ x 7¾ inches (sight)

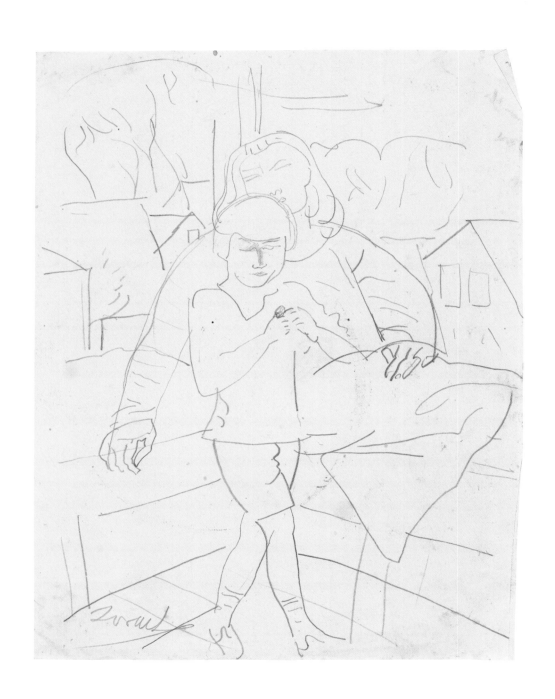

PLATE **78**
William Zorach
Marguerite and Tessim, undated
Pencil on paper, 10⁷⁄₈ x 8³⁄₈ inches

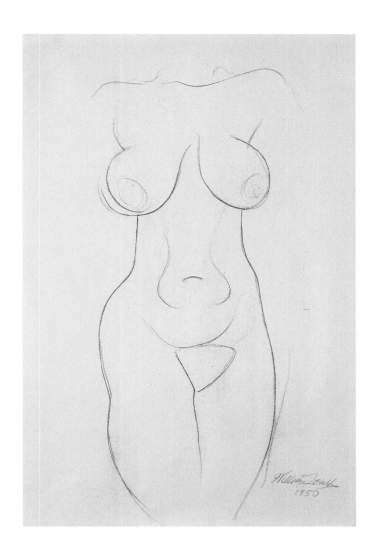

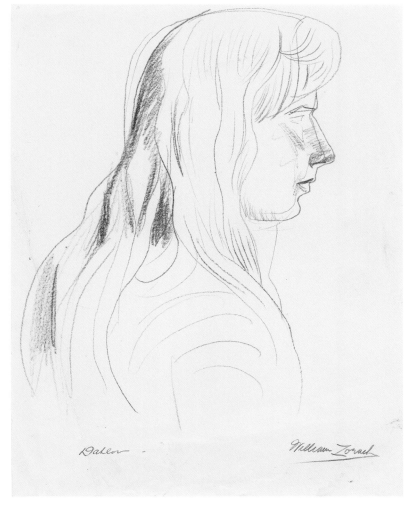

PLATE 79
William Zorach
Nude Young Woman, 1950
Pencil on paper, 18 x 19¾ inches

PLATE 80
William Zorach
Dahlov, undated
Pencil on paper, 10¹⁵/₁₆ x 8⁷/₁₆ inches

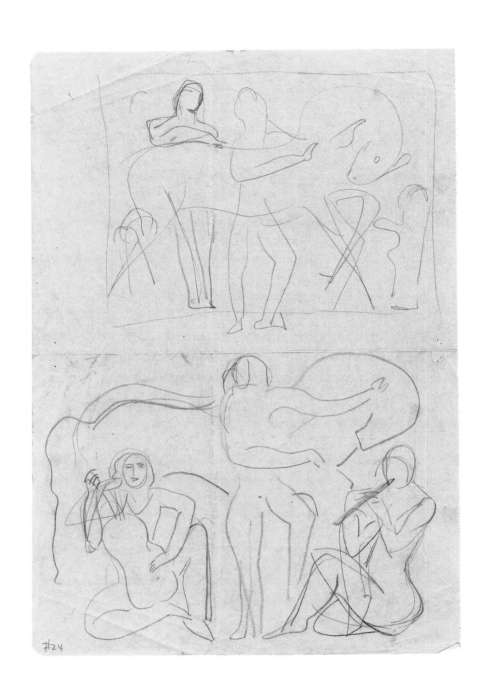

PLATE 81

William Zorach

Sketch for Plaque "The Dance"
(**Untitled—Ship Deck** on verso), undated
Pencil on paper, 13⅞ x 9½ inches

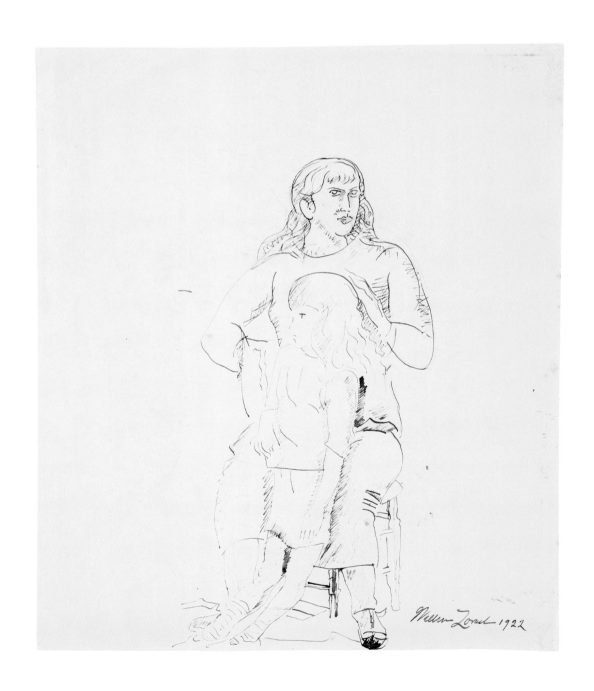

PLATE 82
William Zorach
Sketch of Mother and Child, 1922
Ink on wove paper, 12⁷/₁₆ x 10¹/₂ inches

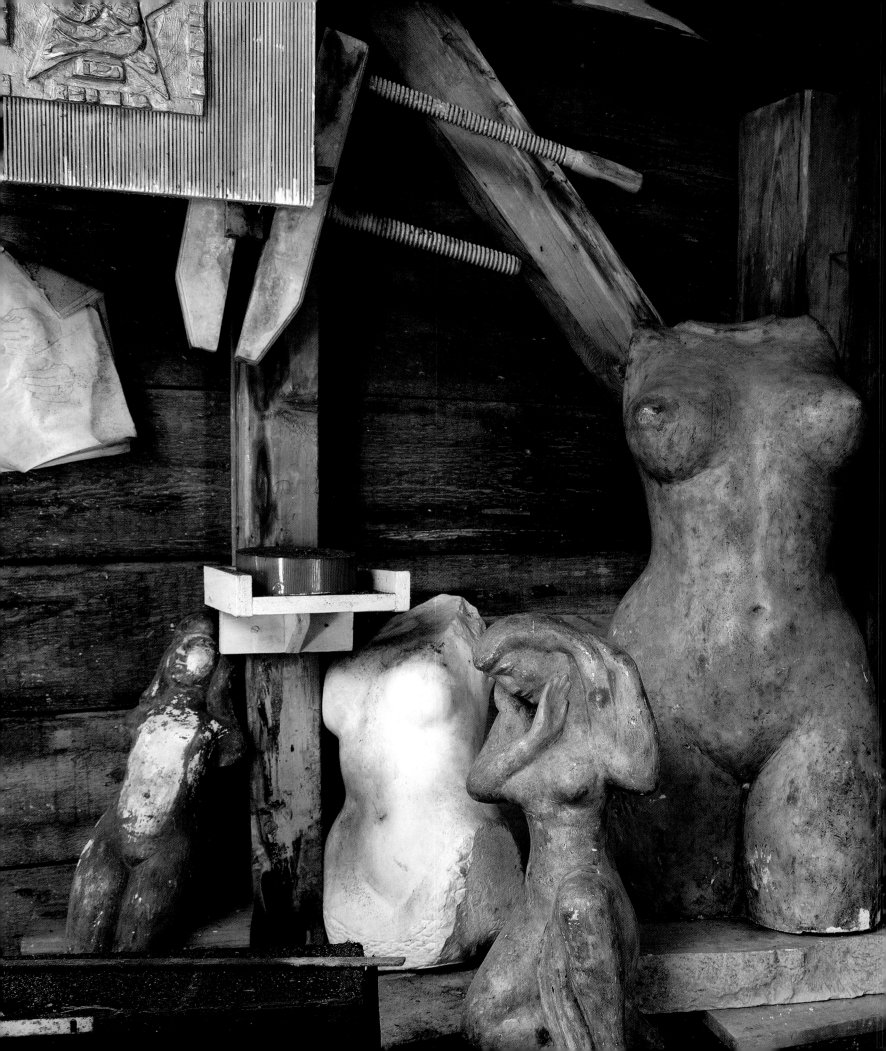

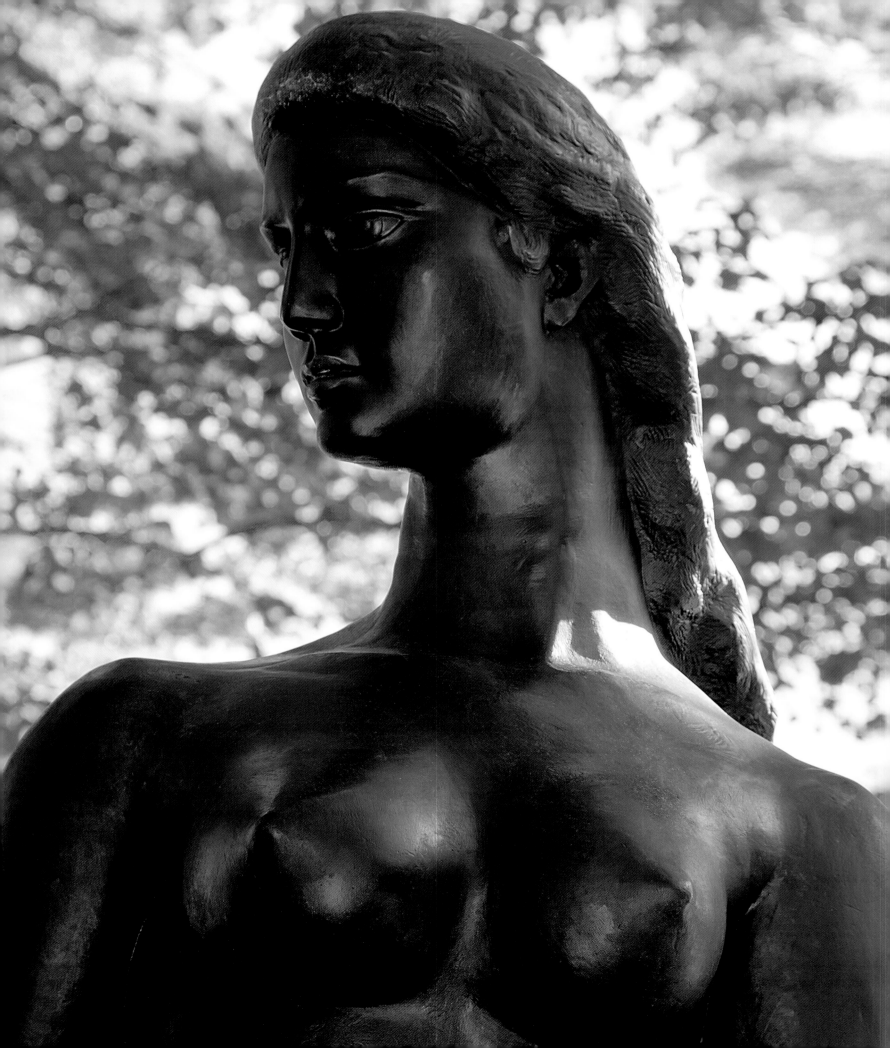

Notes

Paris and the Birth of a New American Sculpture

1. Catherine Chevillot, "Le problème c'était Rodin," in *Oublier Rodin? La sculpture à Paris, 1905–1914*, ed. Catherine Chevillot (Paris: Musée d'Orsay, Réunion des Musées Nationaux, 2009), 19.

2. The Place d'Alma had previously been the site of Gustave Courbet's one-man exhibition in 1867 outside of the Exposition Universelle of that year. The 1900 pavilion, however, was newly constructed for Rodin's show.

3. For more on the 1900 exhibition, see Antoinette Le Normand-Romain, ed., *Rodin en 1900, L'exposition de l'Alma* (Paris: Musée Rodin, Réunion des Musées Nationaux, 2001); and Ruth Butler, *Rodin: The Shape of Genius* (New Haven, Conn., and London: Yale University Press, 1993), 349–61.

4. Ilene Susan Fort, "The Cult of Rodin and the Birth of Modernism in America," in *The Figure in American Sculpture: A Question of Modernity*, ed. Ilene Susan Fort (Los Angeles: Los Angeles County Museum of Art, 1995), 25–26.

5. Bernard Barryte, "Rodin and America: An Introduction," in *Rodin and America: Influence and Adaptation, 1876–1936*, ed. Bernard Barryte and Roberta K. Tarbell (Stanford, Calif.: Cantor Arts Center, 2011), 30–31.

6. Fort, "The Cult of Rodin," 29–30.

7. Ibid., 23.

8. For example, see Zorach's comparison of Rodin and Jacob Epstein in William Zorach, *Art Is My Life: The Autobiography of William Zorach* (Cleveland and New York: World Publishing, 1967), 138, as well as E. E. Cummings' claim that Lachaise's style "negated" Rodin. E. E. Cummings, "Gaston Lachaise," *The Dial*, 68, no. 2 (February 1920): 204. In addition, Laurent listed other sculptors, including Aristide Maillol and Paul Gauguin, as greater influences, though he enjoyed a visit to the Rodin Museum in Philadelphia alongside Lachaise. R. Sturgis Ingersoll, "Sculpture in a Garden," *Magazine of Art* 35, no. 5 (May 1942): 171.

9. Lincoln Kirstein, *Elie Nadelman* (New York: Eakins Press, 1973), 9. *Practicien* and *metteur au point* are French terms for the studio assistants who carried out significant parts of the actual fabrication of sculpture, often specializing in the physical carving of marble using a pointing machine.

10. While Lachaise never mentioned attending the exhibition, his writing from the period is almost nonexistent. Lachaise scholar Virginia Budny and Paula Hornbostel, director of the Lachaise Foundation, concur that Lachaise almost certainly attended Rodin's exhibition, especially since he collaborated on a sculpture that earned a prize at the neighboring Exposition Universelle. Virginia Budny, email to author, April 26, 2016; Paula Hornbostel, email to author, April 26, 2016.

11. On Lachaise's process, see Julia Day et al., "Gaston Lachaise: Characteristics of His Bronze Sculpture" (Advanced-Level Training Program Completion Paper, Straus Center for Conservation and Technical Studies, Harvard Art Museums, 2012), 9–11.

12. Roberta K. Tarbell and Ilene Susan Fort, "American Sculpture and Rodin," in Barryte and Tarbell, *Rodin and America*, 145.

13. A. E. Gallatin recalled that Lachaise said that he continually sought "to simplify and simplify his art still more." A. E. Gallatin, "Gaston Lachaise," *The Arts* 3, no. 6 (June 1923): 398.

14. Cummings, "Gaston Lachaise," 196.

15. André Salmon, "La sculpture vivante," *L'Art vivant*, no. 31 (1926): 258–60. For a broader discussion of this anti-Rodin revolution, see Chevillot, "Le problème c'était Rodin," 17–23.

16. William Tucker, *Early Modern Sculpture* (New York: Oxford University Press, 1974), 86.

17. When Maillol initially exhibited the plaster version of the sculpture at the Salon d'Automne, he called the work *Woman*, but the sculpture is more commonly referred to as *La Méditerranée*.

18. Roger Fry, "The Sculptures of Maillol," *Burlington Magazine for Connoisseurs* 17, no. 85 (April 1910): 31. Fry writes, "His figures have the *occhi tardi e gravi* and the *grande autorità* of the magnanimous spirits of antiquity described by Dante. . . . But Maillol is no classicist in the old-fashioned way." For a larger discussion of Maillol and archaic ideas, see Susan Rather, *Archaism, Modernism, and the Art of Paul Manship* (Austin: University of Texas Press, 1992), 88–92.

19. Jacques Tournebroche, "La Sculpture," *La Raison*, October 29, 1905.

20. André Gide, "Promenade au salon d'Automne," *Gazette des Beaux-Arts*, November 1905, 476.

21. Catherine Chevillot, "Forme close avant éclatement," in *Oublier Rodin*, 159.

22. Catherine Chevillot, "L'exposition du musée d'Orsay," *Dossier de l'art*, no. 161 (2009), 7.

23. The École Gratuite du Dessin (known colloquially as the Petite École) was a free, state-run institution geared towards educating industrial and decorative artists from the working class. The École Bernard Palissy, which was not state-run, had a similar mission of educating industrial and decorative artists. On Lachaise's time there, see Gerald Nordland, *Gaston Lachaise: The Man and His Work* (New York: George Braziller, 1974), 6.

24. Franck Joubin, "Gaston Lachaise (1882–1935): Un sculpteur pour l'Amérique" (Mémoire de recherche, École du Louvre, Paris, September 2015), 32–33.

25. Nordland, *Gaston Lachaise*, 8–9.

26. On the understanding of the sources of Lalique's aesthetic at the turn of the century, see Paule Bayle, "Chez Lalique," *L'art décoratif*, May 1905, 217–24.

27. Marie-Odile Briot, "The Physics and Metaphysics of Jewelry: 'Something That Has Never Been Seen Before,'" in *The Jewels of Lalique*, ed. Yvonne Brunhammer (Paris and New York: Flammarion, 1998), 58.

28. Lincoln Kirstein, *Gaston Lachaise: Retrospective Exhibition, January 30–March 7, 1935* (New York: Museum of Modern Art, 1935), 8.

29. Briot, "The Physics and Metaphysics of Jewelry," 58.

30. Gaston Lachaise, "Autobiography," Gaston Lachaise Collection, Yale Collection of American Literature, Beinecke Rare Book and Manuscript Library, New Haven, Connecticut, YCAL MSS 434, Box 8 (hereafter Lachaise Collection), Dossier "Writings by Gaston Lachaise, (Autobiography)," folio 12; Lachaise Collection, Allys Lachaise, Dossier "Writings by Allys Lachaise (Gaston Lachaise)," folio 69.

31. Nordland, *Gaston Lachaise*, 18–19.

32. On *Nude with a Coat* and its connection to *Standing Woman (Elevation)*, see Virginia Budny, "Gaston Lachaise's American Venus: The Genesis and Evolution of *Elevation*," *The American Art Journal* 34/35 (2003/2004), 118.

33. Virginia Budny noted Lachaise's admiration for both sculptures in her lot notes for this sculpture in Christie's sale 2318, "Important American Paintings," May 20, 2010, lot 78. He was not alone in his regard for Rodin's striding figure. Albert Elsen described Rodin's *Walking Man*, one of the great successes of the 1900 exhibition, as "a powerful figure whose legs scissor space" and noted that the work "haunted the imaginations of sculptors as diverse as Maillol, Duchamp-Villon and Boccioni." Elsen, *Pioneers of Modern Sculpture* (London: Hayward Gallery, 1973), 25.

34. There is an account that attributes the unique surface to the inclusion of Kirstein's mother's dressing set in the casting alloy. This is likely apocryphal. Peter C. Sutton describes the story about Mrs. Kirstein's gold as a legend in "Gaston Lachaise, *Man Walking (Portrait of Lincoln Kirstein)*," in *Face and Figure: The Sculpture of Gaston Lachaise*, ed. Kenneth E. Silver (Greenwich, Conn.: Bruce Museum of Art, 2012), 63. During a February 21, 2016 meeting with me, Virginia Budny also rejected these assertions as pure fiction.

35. Christoph Brockhaus, "Wilhelm Lehmbruck, Aristide Maillol et Auguste Rodin," in Chevillot, *Oublier Rodin*, 26.

36. Adolf von Hildebrand, "Foreword to the Third Edition," *The Problem of Form in Painting and Sculpture*, trans. Max Meyer and Robert Morris Ogden (New York: G. E. Stechert, 1907), 11.

37. Ibid., 12.

38. Kirstein, *Gaston Lachaise*, 16.

39. Salon records show that Lachaise lived at 14 avenue du Maine in 1901 before moving to 57 rue de Vanves (renamed rue Raymond-Losserand in 1945). Gerald Nordland recounts that the years after 1900 were "a romantic time of self search by Lachaise for a place in adult society. He explored the city's museums and galleries, read poetry and philosophy, participated in the student art life." Nordland, *Gaston Lachaise*, 7.

40. Kenneth E. Wayne, "Modigliani and Montparnasse," in *Modigliani and the Artists of Montparnasse*, ed. Kenneth E. Wayne (Buffalo, N.Y.: Harry N. Abrams in association with the Albright-Knox Art Gallery, 2002), 119.

41. Lorado Taft, *Modern Tendencies in Sculpture*, The Scammon Lectures for 1917 (Chicago: University of Chicago Press for the Art Institute of Chicago, 1921), 38.

42. Kirstein, *Elie Nadelman*, 6.

43. Ibid., 27. On the Polish art community in Paris, see Ewa Bobrowska, "Polish Artists in Paris, 1890–1914: Between International Modernity and National Identity," in *Foreign Artists and Communities in Modern Paris, 1870–1914: Strangers in Paradise*, ed. Karen L. Carter and Susan Waller (Burlington, Vt.: Ashgate, 2015), 83–96. While Nadelman was an important part of the artistic milieu at Montparnasse, he mostly disappeared from the social scene between 1906 and 1909 when he retreated to his studio for a period of intense work.

44. See also Barbara Haskell, *Elie Nadelman: Sculptor of Modern Life* (New York: Whitney Museum of American Art, 2003), 25.

45. Lincoln Kirstein, *The Sculpture of Elie Nadelman* (New York: Museum of Modern Art, 1948), 26.

46. Suzanne Ramljak, "The Sculptor of Poise: Elie Nadelman and Classicism," in Suzanne Ramljak et al., *Elie Nadelman: Classical Folk* (New York: American Federation of Arts, 2001), 22.

47. Guillaume Apollinaire, "Les peintres russes impasse Ronsin. La vérité sur l'affaire Steinheil" (October 31, 1910), in *Apollinaire, Chroniques d'art 1902–1918*, ed. L.-C. Breunig (Paris: Gallimard, 1960), 162.

48. Pick Keobandith, *Elie Nadelman: Les années parisiennes 1904–1914*, trans. Jeff Conlan (Paris: Galerie Piltzer, 1998), 74.

49. Haskell, *Elie Nadelman*, 29.

50. Elie Nadelman, "Photo-Secession Notes: The Photo-Secession Gallery," *Camera Work*, no. 32 (October 1910): 41.

51. Ibid.

52. Keobandith, *Elie Nadelman*, 14–15.

53. Athena Tacha Spear, "Elie Nadelman's Early Heads, 1905–1911," *D. P. Allen Art Museum Bulletin* 27–28 (Spring 1971): 202.

54. Elie Nadelman, letter in "Pure Art? Or 'Pure Nonsense'? Nine Selected Letters from Our Readers," *The Forum* 74 (July 1925): 148.

55. Michael Lloyd, "Twentieth-Century Sculpture," *Art and Australia* 20, no. 1 (Spring 1982): 68.

56. André Gide, review of Galerie Druet exhibition, April 25, 1909, quoted in Ramljak, "The Sculptor of Poise," 22.

57. Penelope Curtis, *Sculpture 1900–1945: After Rodin* (Oxford: Oxford University Press, 1999), 219.

58. Wayne, "Modigliani and Montparnasse," 17.

59. A. A. Donohue, *Greek Sculpture and the Problem of Description* (Cambridge: Cambridge University Press, 2006), 101–20.

60. "Elie Nadelman," *L'art décoratif*, March 1914, 111; Haskell, *Elie Nadelman*, 30.

61. Zorach's grandson Peter, who accompanied his grandfather to the Metropolitan Museum of Art on multiple occasions, has recounted this story repeatedly. Personal communication from Peter Zorach to author, June 24, 2016.

62. Rather, *Archaism, Modernism, and the Art of Paul Manship*, 160.

63. There is an extensive body of scholarly research that focuses on the role of African art in the development of European and American modernism, including the Metropolitan Museum of Art's 2012 exhibition *African Art, New York, and the Avant-Garde*; Jean Laude, *La peinture française et l'art negre (1905–1914)* (Paris: Éditions Klinksieck, 1968); Jack Flam with Miriam Deutch, *Primitivism and Twentieth-Century Art: A Documentary History* (Berkeley, Los Angeles, and London: University of California Press, 2003); as well as countless other museum exhibitions, books, and articles that explore the topic within a narrower focus on the influence of African art on a single artist or small group of artists.

64. Kenneth Wayne, "The Role of Antiquity in the Development of Modern Sculpture in France, 1900–1914" (Ph.D. diss., Stanford University, 1994), 121.

65. See Claire Bernardi, "Apollinaire, le regard en liberté," in *Apollinaire: Le regard du poète* (Paris: Musées d'Orsay et de l'Orangerie and Gallimard, 2016), 45–59.

66. Edith Balas, *Joseph Csáky: A Pioneer of Modern Sculpture* (Philadelphia: American Philosophical Society, 1998), 15.

67. This vocabulary—and the issues connected to it—are undoubtedly thorny. In addition to being a term of aesthetic critique, the term "primitive" is associated with the sociopolitical rhetoric of European colonialism when the term functioned as an adjective for colonized people. This terminology rightfully became more complex in the late twentieth century as scholars began to investigate the links between primitivism and imperialism. For examples of the evolution of this discourse, see: William Rubin, ed., *"Primitivism" in 20th Century Art: Affinity of the Tribal and the Modern* (New York: Museum of Modern Art, 1984); Patricia Leighten, "The White Peril and *L'Art nègre*: Picasso, Primitivism, and Anticolonialism," *Art Bulletin* 72, no. 4 (December 1990): 609–30; Fred R. Meyers, "'Primitivism,' Anthropology and the Category of 'Primitive Art,'" in *Handbook of Material Culture*, ed. Chris Tilley, Susanne Kuechler, Michael Rowlands, Webb Keane, and Patricia Spyer (London: Sage Publishing, 2006), 267–84; Susan M. Vogel, *Primitivism Revisited: After the End of an Idea* (New York: Sean Kelly Gallery, 2007); Daniel J. Sherman, *French Primitivism and the Ends of Empire, 1945–1975* (Chicago: University of Chicago Press, 2011); and many other sources on this theme.

68. For example, see Robert Goldwater, *Primitivism and Modern Art* (New York: Random House, 1938).

69. Richard Pells, *Modernist America: Art, Music, Movies, and the Globalization of American Culture* (New Haven, Conn.: Yale University Press, 2011), 15. Many thanks to Shirley Reece-Hughes for drawing my attention to this citation.

70. William Zorach, *Zorach Explains Sculpture: What It Means and How It Is Made* (New York: American Artists Group, 1947), 259.

71. Henry Moore, "Primitive Art," *The Listener*, April 24, 1941, 598–99, reprinted in *Henry Moore: Writings and Conversations*, ed. Alan Wilkinson (Berkeley and Los Angeles: University of California Press, 2002), 102–16.

72. Robert Laurent Papers (hereafter Laurent Papers), Archives of American Art, Smithsonian Institution, Washington, D.C. (hereafter AAA), reel N68-3, frame 3.

73. This letter in the Lachaise Collection is classified as coming from 1913–15. Virginia Budny quotes from the letter extensively in "Gaston Lachaise's American Venus," 118.

74. In addition, Laurent also created handmade copies after eighteenth- and nineteenth-century Japanese works.

75. Modigliani executed a portrait of Burty in 1914. Burty apparently also introduced Laurent to Pablo Picasso in 1906. Peter V. Moak, ed., *The Robert Laurent Memorial Exhibition, 1972–73* (Durham, N.H.: University of New Hampshire, 1972), 15.

76. Ibid.

77. Letter from Robert Laurent to Roberta K. Tarbell, 1970, quoted in Tarbell, "The Impact of the Armory Show on American Sculpture," *Archives of American Art Journal* 18, no. 2 (1978): 3.

78. Quoted in Isabelle Cahn, "Belated Recognition: Gauguin and France in the Twentieth Century, 1903–1949," in *Gauguin Tahiti*, ed. George T. M. Shackelford and Claire Frèches-Thory (Boston: MFA Publications, 2004), 292.

79. Elizabeth C. Childs, "Gauguin and Sculpture: The Art of the 'Ultra-Savage," in *Gauguin: Metamorphoses*, ed. Starr Figura (New York: Museum of Modern Art, 2014), 39.

80. Paul-Louis Rinuy, "1907: Naissance de la sculpture moderne? Le renouveau de la taille directe en France," *Histoire de l'art*, no. 3 (October 1988): 67–74.

81. Robert Laurent, "Sculpture in Brittany," *The League* 6, no. 1 (January 1934): 17.

82. Laurent Papers, AAA, reel N68-3, frame 3.

83. No documentation is currently available that confirms Laurent studied with Doratori, and several scholars and commentators have suggested that the link is apocryphal.

84. Stieglitz hosted an exhibition at his 291 gallery titled "Statuary in Wood by African Savages: The Root of Modern Art," from November to December 1914. While there was a growing interest in African art in American modernist circles, the Stieglitz-de Zayas project was remarkable in the United States since it showed African objects as art, not ethnographic artifacts.

85. Special thanks to Barbara Buckley for her information about Laurent's frames in the Barnes Foundation's collections and to Nancy Ravenel for sharing her research on the frames.

86. Zorach, *Art Is My Life*, 65.

87. Zorach created confusion regarding his age by claiming to have been born in 1887. Roberta K. Tarbell has clearly shown, however, that Zorach was indeed born in 1889 and the earlier date was part of his effort to appear older at the time of his marriage to the artist Marguerite Thompson in 1912. Roberta K. Tarbell, "Catalogue Raisonné of William Zorach's Carved Sculpture" (Ph.D. diss., University of Delaware, 1976), 1:5.

88. Ibid., 1:16.

89. William I. H. Baur, *William Zorach* (New York: Whitney Museum of American Art, 1959), 12–13.

90. Zorach, *Zorach Explains Sculpture*, 292.

91. Zorach, *Art Is My Life*, 20–22.

92. Ibid., 24.

93. Ibid., 32–33.

94. Quoted in Baur, *William Zorach*, 13.

95. Tarbell, "William Zorach's Carved Sculpture," 1:58.

96. Zorach, *Art Is My Life*, 65.

97. Ibid., 65–66.

98. Ibid., 66.

99. William Zorach to Ossip Zadkine, April 10, 1963, Archives du Musée Zadkine, Paris, legs Valentine Prax, 1981. In *Art Is My Life*, Zorach described his time with Zadkine as tense because of a personal conflict over Thompson's attention. However, a 1963 letter that Zorach sent to Zadkine reveals a more substantive artistic interaction. Zorach, *Art Is My Life*, 24.

100. Quoted in Brockhaus, "Wilhelm Lehmbruck, Aristide Maillol et Auguste Rodin," 26.

101. Werner Schnell, "Quelques réflexions sur la gestuelle, l'exemple de *L'Agenouillée* de Wilhelm Lehmbruck, héritière de Ferdinand Hodler," in Chevillot, *Oublier Rodin*, 203.

102. Taft, *Modern Tendencies in Sculpture*, 118.

103. On the anti-Rodin reaction in the United States, see Jennifer Jane Marshall, "The Rodinoclasts: Remaking Influence after Rodin," in Barryte and Tarbell, *Rodin and America*, 279–307.

104. They also shared these values with the gallery owner Joseph Brummer, who likely had met all four men in Paris before he immigrated to America in 1914. Wayne, "The Role of Antiquity in the Development of Modern Sculpture," 137.

Embracing American Folk

1. Electra Havemeyer Webb, "Folk Art in the Shelburne Museum," *Art in America* 43 (May 1955): 15, and quoted in David Park Curry, "Slouching Towards Abstraction," *Smithsonian Studies in American Art* 3, no.1 (Winter 1989): 54.

2. Zorach arrived in 1893, Laurent in 1902, Lachaise in 1906, and Nadelman in 1914. Census data reports that approximately 18,239,000 immigrants arrived in the decades between 1891 and 1920. By 1924, more than twenty million immigrants had come to America, making this three-decade period's rate of immigration the highest in U.S. history. See Roger Daniels, *Not Like Us: Immigrants and Minorities in America, 1890–1924* (Chicago: Ivan R. Dee, 1997), viii.

3. Zorach was a child when he emigrated from Lithuania to the United States with his mother and siblings. His father, having lost his livelihood due to the Russian oppression of Jewish families, had left for America three years earlier. The artist's father found adjusting to American life very difficult. William Zorach, *Art Is My Life: The Autobiography of William Zorach* (Cleveland and New York: World Publishing, 1967), 5–6.

4. Nadelman to Roché, December 29, 1914, Henri-Pierre Roché Papers, Harry Ransom Humanities Research Center at the University of Texas at Austin. Quoted in Barbara Haskell, *Elie Nadelman: Sculptor of Modern Life* (New York: Whitney Museum of American Art, 2003), 73.

5. In 1900, the Eastman Kodak Company debuted the new box camera, the Brownie, which had a fixed focus and was so easy to use that a quarter of a million were sold in the first year, breaking all records. In 1913, at Henry Ford's automotive plant in Highland Park, Michigan, the assembly line ushered in an age of mass production. Founded in 1901, the Victor Talking Machine Company introduced the Victrola in 1906, enabling a wider dissemination of music through phonograph playing. In 1910, Florenz Ziegfeld, Jr. introduced a vaudeville revue known as the Ziegfeld Follies on Broadway. The revue included legendary comics and musicians such as W. C. Fields, Will Rogers, Fanny Brice, Bert Williams, and Irving Berlin. One of its signature acts was a line of seminude chorus girls based on the Folies Bergère.

6. The human figure as the leitmotif for American sculptors in the early twentieth century is addressed by the authors Ilene Susan Fort, *The Figure in American Sculpture: A Question of Modernity* (Los Angeles: Los Angeles County Museum of Art, 1995).

7. For more on the Nadelmans' extensive collection, see Margaret K. Hofer and Roberta J. M. Olson, *Making It Modern: The Folk Art Collection of Elie and Viola Nadelman* (New York: New-York Historical Society, 2015), 116–327.

8. Roger Daniels, *Coming to America: A History of Immigration and Ethnicity in American Life*, 2nd ed. (New York: HarperCollins Publishers, 2002), 118.

9. T. S. Eliot, *T. S. Eliot: Collected Poems, 1909–1962* (Orlando, Fla.: Harcourt Brace Jovanovich, 1991), 154.

10. At the Society of Independent Artists, organized in 1916 in New York City and whose slogan was "No Jury—No Prizes," they enjoyed lively exchanges with their contemporaries and experienced the same noncompetitive spirit of exhibiting modeled by the Salon des Indépendants and the Salon d'Automne in Paris. The Society was formally announced in "Art Notes: Plans of the Society of Independent Artists," *New York Times*, January 20, 1917. The announcement for the "Modern Artists of America" stated that they organized for the purpose of "holding exhibitions, conducting discussions and organizing all forces interested in the art of today." Quoted in "Modernists Form New Artist Society," *American Art News*, March 25, 1922, 3.

11. Horace Brodsky, "Concerning Sculpture and Robert Laurent," *The Arts* 1, no. 5 (May 1921): 13.

12. Louis Bouché Papers, 1880–2007 (hereafter Bouché Papers), Archives of American Art, Smithsonian Institution, Washington, D.C. (hereafter AAA), reel 688, frames 707, 709.

13. Oral history interview with Louis Bouché, conducted August 7, 1959, by James Morse, AAA, http://www.aaa.si.edu/collections /interviews/oral-history-interview-louis -bouch-11613. For a thorough discussion of

the Penguin and its activities, see Christine I. Oaklander, "Walt Kuhn and the Penguin: High Jinks and Experimental Art," *Archives of American Art* 49, nos. 3–4 (Fall 2010): 50–59.

14. As Doreen Bolger documents, in 1916 Field bought an adjacent building at 110 Columbia Heights and opened the Ardsley School of Modern Art, where he and Laurent taught a variety of courses. Bolger, "Hamilton Easter Field and His Contribution to American Modernism," *The American Art Journal* 20, no. 2 (1988): 98.

15. Bouché Papers, AAA, reel 688, frame 754. Also quoted in Bolger, "Hamilton Easter Field," 98.

16. Elizabeth Stillinger, "The Nadelmans in Context: Early Collectors of Folk Art in America," in Hofer and Olson, *Making It Modern*, 42.

17. Nadelman wrote to Laurent in 1922 to inquire about some drawings he had left with Field, probably at his Brooklyn residence. Nadelman to Laurent, December 26, 1922, Robert Laurent Papers, 1869–1973 (hereafter Laurent Papers), AAA, reel N68-3, frame 56.

18. Hamilton Easter Field, *The Technique of Oil Paintings and Other Essays* (Brooklyn, N.Y.: Ardsley House, 1913), 9. For more on Field's collecting of Japanese prints, see Bolger, "Hamilton Easter Field," 83–84. The breadth of Field's artistic interests was revealed in auctions of the collection at the New American Art Galleries. See American Art Association, *Catalogue of the Antique Furniture, Rugs, Tapestries, Curios, Antiquities, and Studio Effects; Part II* (New York: American Art Association, 1922); and Stillinger, "The Nadelmans in Context," 42.

19. Laurent sold Japanese woodcuts in the shop of Ernest Le Véel. For more on Laurent and his study of Japanese prints, see Norman Kent, "Robert Laurent: A Master Carver," *American Artist* 29, no. 5 (May 1965): 42–43.

20. Zorach, *Art Is My Life*, 65–66.

21. William Zorach, "Where Is Sculpture Today?" *College Art Journal* 16, no. 4 (Summer 1957): 329–30.

22. Helen Appleton Read used the term "American primitives" in her review of the first public exhibition of American folk art, "Early American Art," organized by artist Henry Schnakenberg and held at the Whitney Studio Club in 1924. Read, "Introducing the Cigar Store Indian into Art," *Brooklyn Eagle*, February 17, 1924. As Richard Pells notes, European artists and intellectuals viewed virtually all of American popular culture—vaudeville theatre, Hollywood, cartoons, comic strips, and dance styles—as primitive. Pells, *Modernist America: Art, Music, Movies, and the Globalization of American Culture* (New Haven, Conn.: Yale University Press, 2011), 15. The fascination with the primitive was so pervasive that it even appealed to a mass audience in Edgar Rice Burroughs' exotic adventure novel *Tarzan of the Apes* in 1914, later translated into more than fifty languages and numerous cinematic versions. See also Andrew J. Eschelbacher's essay in this catalogue.

23. Zorach, *Art Is My Life*, 66; also quoted in Roberta K. Tarbell, "Primitivism, Folk Art, and

the Exotic," in Fort, *The Figure in American Sculpture*, 114.

24. In a review of his work at the Daniel Gallery, the author noted that his works were reduced to the "most primitive elements," in "Pictures and Carvings at Daniels' [*sic*]," *American Art News* 8, no. 25 (March 27, 1915): 2. Laurent's work had been referred to as "primitive in conception" in "Hamilton Easter Field's Exhibit," *American Art News* 14, no. 20 (February 19, 1916): 3. The directly carved wood sculptures he exhibited in an exhibition entitled "Introspective Art" at Gertrude Vanderbilt Whitney's studio club, for example, spurred one critic to comment on the artist's ability to play "his part of primitive with great intelligence." "Introspective Art" ran from March 20 to April 3, 1917, and featured painters such as Benjamin Kopman, George Fuller, Abraham Harriton, and Jennings Tafel. "National Academy of Design: Second Notice; Other Exhibitions," *New York Times*, March 25, 1917.

25. Robert Laurent, statement in interview with Roberta K. Tarbell, 1970, quoted in Tarbell, "Primitivism, Folk Art, and the Exotic," 122; also quoted in Kevin D. Murphy, "International Folkfashioning," *The Magazine Antiques* 177, no. 1 (January/February 2010): 200.

26. Field purchased a large lot of land, converted parts of old barns into artists' studios, and established the Ogunquit School of Painting and Sculpture with Laurent in 1911. Open during the summers, the school attracted artists such as Yasuo Kuniyoshi, Adelaide J. Lawson, Lloyd Goodrich, Wood Gaylor, Katherine Schmidt, and Bernard Karfiol, many of whom were studying at the Art Students League in New York City during the fall and winter seasons. As the colony developed a reputation as a hub of liberal artistic exchanges, it attracted visitors such as Marsden Hartley and Abraham Walkowitz, as well as Lachaise and Zorach. For more on Hamilton Easter Field, see Bolger, 78–107. Laurent's quote about Perkins Cove and Brittany derives from Laurent Papers, AAA, reel N68-3, frame 3.

27. Paul Gauguin to Émile Schuffenecker and Vincent Van Gogh, reproduced in Belinda Thompson, ed., *Gauguin: Maker of Myth* (London: Tate Modern: 2010), 111.

28. Field, *The Technique of Oil Paintings*, 58; also quoted in Murphy, "International Folkfashioning," 200; and in Donna M. Cassidy, *Marsden Hartley: Race, Region, and Nation* (Lebanon, N.H.: University Press of New England, 2005), 178.

29. My thanks to my colleague Andrew J. Eschelbacher for sharing this idea with me.

30. Interview by Arlene Jacobowitz with Robert Laurent, 1966, "Listening to Pictures: Interviews," transcripts of interviews conducted for the "Listening to Pictures" exhibition held at the Brooklyn Museum from 1968–1973, Brooklyn Museum Library, Special Collections.

31. Zorach, *Art Is My Life*, 66.

32. Ibid., 67. Roberta K. Tarbell notes that the sitter for the sculpture was reportedly a professional swimmer who lived with the Zorach family that summer. Rather than trying to recreate the physique of an athlete, the cylindrical form of the figure derived from its

origins as a mahogany log. Tarbell, "William Zorach's Reclining Figures," *Archives of American Art Journal* 15, no. 4 (1975): 4, 7.

33. Wanda Corn, "The Return of the Native: The Development of Interest in American Primitive Painting" (M.A. thesis, New York University, 1965), 13.

34. Zorach, *Art Is My Life*, 3.

35. Ibid., 88.

36. By the late 1910s, Wood Gaylor, Katherine Schmidt and her husband, Yasuo Kuniyoshi, and Bernard Karfiol were all avidly collecting folk art. Painter and colony member Dorothy Varian recalled a hunting trip that Karfiol, Laurent, and Kuniyoshi took to a Quaker village. They were gone for two or three days, spent approximately twenty-seven dollars among them, and had to hire a truck to bring back their early American treasures. Dorothy Varian relayed this story to scholar Wanda Corn. Cited in Corn, "The Return of the Native," 13; Wood and Adelaide Lawson Gaylor Papers, 1866–[circa 1986], AAA, reel D160, frame 355.

37. Murphy, "International Folkfashioning," 199. Murphy noted that Laurent "developed an approach to materials that was informed by the folk art he collected and studied." Ibid., 200.

38. Stillinger, "The Nadelmans in Context," 47.

39. Oral history interview with Dorothy C. Miller, May 26, 1970–September 28, 1971, AAA, reel 4210, frame 694, p. 23. Cahill organized exhibitions such as *American Primitives: An Exhibit of the Paintings of Nineteenth Century Folk Artists* at the Newark Museum in 1930, which Laurent, Nadelman and Zorach lent works to, and *American Folk Art: The Art of the Common Man in America, 1750–1900,* at the Museum of Modern Art in 1932. He and his friend the gallery owner Edith Gregor Halpert tried to promote an ancestral connection between the stylistic objectives of modern, living artists and America's bygone artisans and craftspeople. In an article devoted to primitive art's place within the country's culture, Cahill claimed, "Folk art gives modern art an ancestry in the American tradition and shows its relation with the work of today." Holger Cahill, "Folk Art: Its Place in the American Tradition," *Parnassus* 4, no. 3 (March 1932): 4.

40. John Michael Vlach, "American Folk Art: Questions and Quandaries," in *Critical Issues in American Art: A Book of Readings*, ed. Mary Ann Calo (Boulder, Colo.: Westview Press, 1998), 120.

41. Ibid., 112.

42. Hamilton Easter Field, "American Hooked Rugs," *The Arts* 1, no. 5 (May 1921): 28. Stacy C. Hollander notes that "Rug hooking . . . is thought to have origins in Maine and the Canadian Provinces." Hollander, "Manifesting an Entrepreneurial Spirit," in *Folk Art in Maine: Uncommon Treasures, 1750–1925*, ed. Kevin D. Murphy (Camden, Maine: Down East, The Maine Folk Art Trail, 2008), 11.

43. Field, "American Hooked Rugs," 31.

44. Laurent Papers, AAA, reel 2067, frame 633.

45. Victoria Feldon, *Lithuanian Folk Art* (University of California, Los Angeles: U.C.L.A. Ethnic Art Galleries, 1966), 11–12.

46. Tarbell, "Primitivism, Folk Art, and the Exotic," 122.

47. Downtown Gallery Records, 1824–1974, bulk 1926–1969, AAA. Zorach, William, undated, reel 5556 (Box 27), frame 1118.

48. Robert Laurent, "Sculpture in Brittany," *The League* 6, no. 1 (January 1934): 6.

49. Peter V. Moak, ed., *The Robert Laurent Memorial Exhibition, 1972–1973* (Durham, N.H.: University of New Hampshire, 1972), 19.

50. Laurent Papers, AAA, reel N68-3, frame 16.

51. For more on Laurent and Zorach's folk art collections, see Elizabeth Stillinger, *A Kind of Archeology: Collecting American Folk Art, 1876–1976* (Amherst and Boston: University of Massachusetts Press, 2011), 159–74.

52. Mary Fanton Roberts, "Mrs. Roberts' Department," *The Arts*, vol. 2, no. 5 (February 1922): 298.

53. See Avis Berman, "Sculptor in the Open Air: Elie Nadelman and the Folk and Popular Arts," in *Elie Nadelman: Classical Folk*, by Suzanne Ramljak (New York: American Federation of Arts, 2001); Haskell, *Elie Nadelman*; and Lincoln Kirstein, *Elie Nadelman* (New York: Eakins Press, 1973).

54. Berman, "Sculptor in the Open Air," 48.

55. Kazimierz Pietkiewicz, *Polish Folk Art* (Warsaw, Poland: Polonia Publishing House, 1966), 25–26.

56. For more on Nadelman's plaster casts, including one for *Chef d'Orchestre*, see Hofer and Olson, *Making It Modern*, p. 334.

57. Lincoln Kirstein, "Elie Nadelman: Sculptor of the Dance," ed. Marian Eames and Lincoln Kirstein, *Dance Index* 7, no. 6 (1948): 147.

58. Hofer and Olson, *Making It Modern*, p. 348.

59. Gerald Nordland, *Gaston Lachaise: The Man and His Work* (New York: George Braziller, 1974), 127.

60. Gaston Lachaise to Allys Lachaise, November 1908. Letters cited here and all further references to Lachaise's correspondence are from the Gaston Lachaise Collection, Yale Collection of American Literature, Beinecke Rare Book and Manuscript Library, Yale University, New Haven, Connecticut, YCAL MSS 434 (hereafter Lachaise Collection). Transcripts and translations of letters are by Phyllis Samitz Cohen and Paula R. Hornbostel.

61. Stillinger, "The Nadelmans in Context," 45.

62. Laurent stated that Yasuo Kuniyoshi was in Ogunquit, Maine, by July 1919 in Laurent, "Memories of Yas," *College Art Journal* 13, no. 1 (Fall 1953): 6. Schmidt discusses her time in Maine with Kuniyoshi in an oral history interview with Katherine Schmidt, December 8–15, 1969, AAA, http://www.aaa.si.edu/collections/interviews/oral-history-interview-katherine-schmidt-12892.

63. Zorach, *Art Is My Life*, 88.

64. Lachaise to Laurent, September 8, 1922, Laurent Papers, AAA, reel N68-3, frame 51.

65. In referring to Lachaise's work in Manship's studio, Nakian stated: "[Lachaise] did all the carving—the ornament and the figures and everything, you know." Oral history interview with Reuben Nakian conducted June 9–17, 1981, by Avis Berman, AAA, http://www.aaa.si.edu/collections/interviews/oral-history-interview-reuben-nakian-11707.

66. For a thorough, contextual discussion of Lachaise's *Standing Woman* and its various casts, see Virginia Budny, "Gaston Lachaise's American Venus: The Genesis and Evolution of *Elevation*," *The American Art Journal* 34/35 (2003/2004): 62–143.

67. Gaston Lachaise, "A Comment on My Sculpture," *Creative Art*, vol. 3, no. 2 (August 1928); reprinted in Jean-Loup Champion, ed., *Gaston Lachaise, 1882–1935* (Paris: Éditions Gallimard, 2003), 133–34; oral history interview with Reuben Nakian, AAA. For more details on the types of commissions Lachaise completed, see Nordland, *Gaston Lachaise*, 28–29.

68. Quoted in Budny, "Gaston Lachaise's American Venus," 72.

69. Haskell, *Elie Nadelman*, 117.

70. Hofer and Olson, *Making It Modern*, 338.

71. Kirstein, "Elie Nadelman: Sculptor of the Dance," 149.

72. Ibid., 132.

73. Louis Raymond Reid, "A Review of the Revue," *Shadowland* 1, no. 4 (December 1919): 16.

74. Nordland quotes from pp. 8–9 of Lachaise's unpublished autobiography in the Lachaise Collection: "I drifted to studio parties, yet not to wildly—To Montmartre . . . Le Moulin Rouge—on few occasions and for better times to The Concert Rouges." Nordland, *Gaston Lachaise*, 7.

75. Reid, "A Review of the Revue," 16. For a discussion on the acceptability of popular entertainment for the middle class from the nineteenth to the twentieth centuries, see LeRoy Ashby, *With Amusement for All: A History of American Popular Culture Since 1830* (Lexington: University Press of Kentucky, 2006), 147–210.

76. Kirstein mentions that Nadelman frequented the National Winter Garden in Kirstein, "Elie Nadelman: Sculptor of the Dance," 143. Lachaise attended the National Winter Garden with friend and poet E. E. Cummings. See Phyllis Sammitz Cohen, "The Gaston Lachaise Collection," *The Yale University Library Gazette* 58, nos. 1/2 (October 1983): 70. For more on the audiences attending Minsky's Burlesque, see Morton Minsky and Milt Machlin, *Minsky's Burlesque: A Fast and Funny Look at America's Bawdiest Era* (New York: Arbor House Publishing, 1986), 29.

77. William Zorach, "The New Tendencies in Art," *The Arts* 2, no. 1 (October 1921): 11.

78. Kirstein, "Elie Nadelman: Sculptor of the Dance," 131.

79. Haskell, *Elie Nadelman*, 130.

80. Berman, "Sculptor in the Open Air," 68.

81. Kirstein, *Elie Nadelman*, 296–97; Hofer and Olson, *Making It Modern*, 344.

82. William Zorach, "The Background of an Artist," *Magazine of Art* 34, no. 4 (April 1941): 238.

83. For more on Isadora Duncan's contributions to dance, see Bruce Robertson, "American Modernism and Dance: Arthur B. Davies's *Dances*, 1915," in *Dance: American Art, 1830–1960*, ed. Jane Dini (Detroit: Detroit Institute of Arts, 2016), 120–21.

84. Terri A. Mester, *Movement and Modernism: Yeats, Eliot, Lawrence, Williams, and Early Twentieth-Century Dance* (Fayetteville: University of Arkansas Press, 1997), 12.

85. For more on Zorach's *Spirit of the Dance*, see Zorach, *Art Is My Life*, 91–93.

86. Lachaise to Nagle, 1910, Lachaise Collection.

87. Ibid. Lachaise met Ruth St. Denis, who wrote about their meeting in her diary. Carolyn Kinder Carr and Margaret C. S. Christman, *Gaston Lachaise: Portrait Sculpture* (Washington, D.C.: National Portrait Gallery with the Smithsonian Institution Press, 1985), 8.

88. Lincoln Kirstein, *The Sculpture of Elie Nadelman* (New York: Museum of Modern Art, 1948), 52; Hofer and Olson, *Making It Modern*, 348.

89. Haskell, *Elie Nadelman*, 187.

90. Elie Nadelman, *Exhibition of Sculpture by Eli [sic] Nadelman* (London: Wm. B. Paterson Gallery, 1911), 7–8. Emphasis in original.

91. R. Sturgis Ingersoll, "Sculpture in a Garden," *Magazine of Art* 35, no. 5 (May 1942): 171.

92. Simon J. Bronner, "Folk Art on Display: America's Conflict of Traditions," *American Quarterly* 45 (March 1993): 130.

Modernism Becomes Mainstream: The Increasing Acceptance of the New American Sculptors

1. F[orbes] W[atson], "To Our New Museum," *The Arts* 16, no. 1 (September 1929): 46–49.

2. Isadora Anderson Helfgott, "Introduction: 'This New American Reaction to Art,'" in *Framing the Audience: Art and the Politics of Culture in the United States, 1929–45* (Philadelphia: Temple University Press, 2015), 1.

3. Emily Genauer, "Hope for Art Show at World's Fair: Directors to Meet Societies Which Protested Exclusion of a National Exhibition," *New York World-Telegram*, February 5, 1938, 13, quoted in ibid.

4. The Transcendentalists included Ralph Waldo Emerson and Margaret Fuller, the first editors of *The Dial* in 1840, and Henry David Thoreau, who contributed to this journal devoted to free expression of thought.

5. Lachaise's *Dusk* was published in *The Dial* 68, no. 1 (January 1920).

6. Scofield Thayer, "What the *Dial* Will Do During 1920," *The Dial* 68, no. 2 (February 1920): II.

7. Alan C. Golding, "*The Dial*, *The Little Review*, and the Dialogics of Modernism," *American Periodicals* 15, no. 1 (2005): 42.

8. Henry McBride, "Gaston Lachaise," *The Sun*, February 17, 1918. The sensation of the exhibition was the full-scale plaster version of *Standing Woman*.

9. For reinterpretations of Lachaise's iconography, see Virginia Budny, "Gaston Lachaise's American Venus: The Genesis and Evolution of *Elevation*," *The American Art Journal* 34/35 (2003/2004): 62–143; and Budny, "Provocative Extremes: Gaston Lachaise's Women," *Sculpture Review* 63, no. 2 (2014): 8–19.

10. *The Dial* 69, no. 2 (August 1920): 157–61.

11. Ibid., 157. Nadelman's exhibition of sculpture and drawings was on view at Knoedler's from October 27 to November 8, 1919.

12. Henry McBride, "Modern Art," *The Dial* 78, no. 6 (June 1925): 527–29. *Acrobat*, *Tango*, and *Pianist* are illustrated between pages 474 and 475.

13. Ibid., 528–29.

14. See Margaret K. Hofer and Roberta J. M. Olson, "The History of the Nadelman Folk Art Collection," in *Making It Modern: The Folk Art Collection of Elie and Viola Nadelman* (New York: New-York Historical Society, 2015).

15. "African Art and Stieglitz," *New York Sun*, November 8, 1914.

16. In 1910 the American Museum of Natural History had created African Hall, a permanent ethnographic installation selected from the three thousand objects from the Congo Free State that Leopold II, the king of Belgium, had donated to the museum in 1907. In the spring of 1914 Robert Coady was the first to show African artifacts as art at his Washington Square Gallery. Charles Sheeler photographed the African sculptures on view at Marius de Zayas' Modern Gallery in New York and published them as a 1918 portfolio titled *African Negro Sculpture*, which Zorach owned. See Virginia-Lee Webb, "Art as Information: The African Portfolios of Charles Sheeler and Walker Evans," *African Arts* 24 (January 1991): 56–63, 103–4; and Yaëlle Biro, ed., *African Art, New York, and the Avant-Garde* (special issue no. 3 of *Tribal Magazine*; New York: Metropolitan Museum of Art, 2012).

17. Both *Artist's Daughter* (*The Dial* 70, no. 2 [February 1921]: 166) and *Young Boy* (*The Dial* 72, no. 3 [March 1922]: 290) are captioned "A Wood Carving by William Zorach."

18. E. E. Cummings, "Gaston Lachaise," *The Dial* 68, no. 2 (February 1920): 204. The stone *La Montagne*, photographed by Charles Sheeler, was the frontispiece illustration for *The Dial* 70, no. 3 (March 1921).

19. See Erich Neumann, *The Great Mother: An Analysis of the Archetype*, trans. Ralph Manheim (Princeton, N.J.: Princeton University Press, 1963), 44–46. Carl Jung had published numerous books on archetypes by 1916. How much Lachaise knew of Jung's theories of archetypes when he created early versions of *The Mountain* is not clear, but concepts of a universal symbol are central in his art.

20. Kirstein had introduced Morris to Lachaise, who posed for a half-length nude marble portrait and a bronze statuette, *Boy with Tennis Racket*, both completed in 1933.

21. Nicholas Joost, "The Dial Collection: Tastes and Trends of the 'Twenties," *Apollo* 94 (December 1971): 495; and Joost, *Scofield Thayer and* The Dial: *An Illustrated History* (Carbondale and Edwardsville: Southern Illinois University Press, 1964).

22. Joost, "The Dial Collection," 495.

23. See Carolyn Kinder Carr and Margaret C. S. Christman, *Gaston Lachaise: Portrait Sculpture* (Washington, D.C.: National Portrait Gallery with the Smithsonian Institution Press, 1985). When Thayer died in 1982, the Dial Collection was given to the Metropolitan Museum of Art. Watson donated Lachaise's works to the University of Rochester. See *Gaston Lachaise: Sculpture and Drawings* (Rochester, N.Y.: Memorial Art Gallery of University of Rochester, 1979).

24. Hamilton Easter Field, review of Lorado Taft, *Modern Tendencies in Sculpture* (Chicago: University of Chicago Press, 1921), *The Arts* 1, no. 6 (June–July 1921): 59.

25. Horace Brodsky, "Concerning Sculpture and Robert Laurent," *The Arts* 1, no. 5 (May 1921): 12–15. Brodsky promoted Vorticism in London and in New York. He was involved with writing for and editing avant-garde periodicals in New York, including *The Playboy: A Portfolio of Art and Satire* (1919–24), which published the works of Lachaise and the Zorachs; *Rainbow* (1920); and *Art Review* (1921).

26. Ibid., 14.

27. Hamilton Easter Field, "Comment on the Arts," *The Arts* 1, no. 7 (August–September 1921): 28–44. Laurent's *Acrobat* (identified as *Wood Figure*) is illustrated on p. 39.

28. Mary Fanton Roberts, "Mrs. Roberts' Department," *The Arts* 2, no. 5 (February 1922): 298.

29. Alfeo Faggi, "Foreword," *Exhibition of Sculptures by Robert Laurent* (New York: Bourgeois Galleries, March 1922).

30. William Zorach, "New Tendencies in Art," *The Arts* 2, no. 1 (October 1921): 10–15. The essay was based on a lecture Zorach had presented in Provincetown, Massachusetts, earlier that year. Field noted (p.1) that Zorach was "so well known" that he needed no introduction.

31. Alice Lawton (Editorial Department, *The Christian Science Monitor*, Boston) to William Zorach, October 2, 1921, William Zorach Papers, Archives of American Art, Smithsonian Institution, Washington, D.C., microfilm NY59–1: 44.

32. The Theosophical Society, founded in 1875 by Helena Petrovna Blavatsky and Henry Steel Olcott, is still active today. Modern artists were exposed to theosophical concepts as published by Wassily Kandinsky in *Camera Work* in 1912 and in his book *The Art of Spiritual Harmony*, trans. M. T. H. Sadler (London: Constable and Company; New York: Houghton Mifflin, 1914). See Gail Levin and Marianne Lorenz, *Theme and Improvisation: Kandinsky and the American Avant-Garde, 1912–1950* (Boston: Little, Brown, 1992); and Ruth Bohan, "Dreier's Artistic Philosophy," in *The Société Anonyme's Brooklyn Exhibition: Katherine Dreier and Modernism in America* (Ann Arbor, Mich.: UMI Research Press, 1982), 15–24.

33. Zorach, "New Tendencies," 12–13.

34. Avis Berman, *Rebels on Eighth Street: Juliana Force and the Whitney Museum of American Art* (New York: Atheneaum, 1990), 185.

35. For *The Arts*, Zorach also wrote "The Sculpture of Edgar Degas," *The Arts* 8, no. 5 (November 1925): 263–65; "The Sculpture of Constantin Brancusi," 9, no. 3 (March 1926): 143–50; and "The Child and Art," 16, no. 6 (February 1930): 394–97.

36. Brancusi was ever-present with his solo shows at the Wildenstein and Brummer Galleries (1926), the Arts Club of Chicago (1927), and at Brummer (1933–34). He also had significant representation in group shows of the Quinn (1926) and Gallatin (1927) collections and in the Société Anonyme's exhibition at the Brooklyn Museum (1926). Both *The Little Review* 8, no. 1 (Autumn 1921) and *This Quarter* 1, no. 1 (Spring 1925) focused on Brancusi.

37. Helen Appleton Read, "Robert Laurent," *The Arts* 9, no. 5 (May 1926): 252. The essay (pp. 251–59) included nine illustrations of his sculpture. The Valentine Gallery, founded by F. Valentine Dudensing in 1924 in partnership with Pierre Matisse (until 1931), promoted avant-garde art in New York City until 1948.

38. Ibid., 256, 258.

39. Forbes Watson, "New York Exhibitions," *The Arts* 13, no. 3 (March 1928): 192. Watson placed an image of Zorach's *Male Cat* on the cover.

40. Albert and Charles Boni published *Creative Art: A Magazine of Fine and Applied Art* in New York between 1927 and 1933 under the direction of various editors, including Forbes Watson, Rockwell Kent, Henry McBride, and Lee Simonson. It incorporated another magazine, *The Studio* of London, and was continued by the *Magazine of Art* in 1934.

41. Lachaise, "A Comment on My Sculpture," *Creative Art* 3, no. 2 (August 1928): xxiii. By 1928, Lachaise was directly aware of Jung's and Freud's ideas. He created portraits of Thayer, who became a patient of Freud's in Vienna in 1926, and of L. Pierce Clark, M.D., and Christiana Morgan, who were scholars of or advocates for Freud and Jung.

42. Ibid., xxvi.

43. E. E. Cummings, "Gaston Lachaise," *Creative Art* 3, no. 2 (August 1928): xxviii. Isabel Lachaise donated the 1927 cast, also exhibited at Harvard in 1929, to the Art Institute of Chicago in 1943. In 1936, the Whitney Museum of American Art was the first museum to acquire a bronze cast of *Standing Woman*. Museums with casts ordered by Lachaise in 1930 include the Metropolitan Museum of Art, the Albright-Knox Art Gallery, the Saint Louis Museum of Art, the Virginia Museum of Fine Arts, and the Philadelphia Museum of Art.

44. "Gaston Lachaise Sculptures," Intimate Gallery, New York, March 7–April 3, 1927.

45. Leigh Bullard Weisblat, "Lachaise," in *The Eye of Duncan Phillips: A Collection in the Making*, ed. Erika D. Passatino and David W. Scott (Washington, D.C.: Phillips Collection; New Haven, Conn.: Yale University Press, 1999), 412.

46. Lathrop Brown was a roommate of Franklin Delano Roosevelt at both Groton and Harvard. They had known Zorach as a painter, but the exhibition at Kraushaar alerted them to his new métier. They had purchased five of Marguerite Zorach's tapestries at her exhibition at the Daniel Gallery in 1918 and all of her textiles on view at the Montross Gallery during February 1923. These sales provided enough income to allow William Zorach to pursue his new enthusiasm for sculpture.

47. Zorach's last oil painting, *Mother and Child* (Metropolitan Museum of Art), composed similarly to the 1922 sculpture, was illustrated in *The Dial* 85, no. 6 (December 1928), opposite p. 453. The mahogany *Mother and Child* was exhibited at the Society of Independent Artists in 1922 and in the "International Exhibition of Modern Art" assembled by the Société Anonyme at the Brooklyn Museum in 1926. It was illustrated in *The Dial* 81, no. 1 (July 1926), after p. 46, and in Augusta Owen Patterson, "A House Built by Charles Bulfinch," *Town and Country*, November 15, 1932, 28.

48. Henry McBride, "William Zorach's Work at Kraushaar," *New York Sun*, October 25, 1924; Augusta Owen Patterson, "Arts and Decoration," *Town and Country*, November 5, 1924, 42; "Zorach Shows Work in Three Mediums," *Art News* 23, no. 3 (October 25, 1924): 4; and "Modern Art's Days of Martyrdom Gone Forever," *New York World*, October 26, 1924. In 1926, Schwarzenbach commissioned Zorach to create bronze relief panels and doors, and a seven-foot "Silk Clock," for his new Schwarzenbach Building on South Park Avenue. "Silk Clock Is Dedicated," *New York Times*, May 13, 1926, 42.

49. Zorach, "Reminiscences of William Zorach," typescript of interviews by Louis M. Starr, 1957, Columbia Center for Oral History Archives, Rare Book and Manuscript Library, Butler Library, Columbia University, 307. The Zorach family gave the cartoons to the Smithsonian American Art Museum, the Schwarzenbach's doors are unlocated, and the artist kept the second set of relief panels.

50. Berman, *Rebels on Eighth Street*, documents Force's and Whitney's support of dozens of American artists. See also Roberta K. Tarbell, "Gertrude Vanderbilt Whitney as Patron," in Roberta K. Tarbell and Patricia Hills, *The Figurative Tradition and the Whitney Museum of American Art* (Newark, Del.: University of Delaware Press, 1980), 10–22.

51. Berman, *Rebels on Eighth Street*, 251.

52. A. Hyatt Mayor, "Gaston Lachaise," *Hound and Horn* 5, no. 4 (July–September 1932): 564.

53. Lincoln Kirstein, "Preface," *The Harvard Society of Contemporary Art* (Cambridge: Harvard Cooperative Society, February 1929), n.p.

54. Nicholas Fox Weber, *Patron Saints: Five Rebels Who Opened America to a New Art, 1928–1943* (New York: Alfred A. Knopf, 1992).

55. Edward Alden Jewell, "A Season's Sculpture: Retrospective Glance—Barnard's Arch—Rockefeller Center—Torso by Lachaise," *New York Times*, July 22, 1934, section 9, p. 7. Warburg purchased *Torso* from Kraushaar Galleries.

56. Kirstein's monographs on Nadelman are: *The Sculpture of Elie Nadelman* (New York: Museum of Modern Art, 1948); *Elie Nadelman Drawings* (New York: H. Bittner, 1949); and *Elie Nadelman* (New York: Eakins Press, 1973).

57. See Lindsay Pollock, *The Girl with the Gallery: Edith Gregor Halpert and the Making of the Modern Art Gallery* (New York: Public Affairs, 2006).

58. "First Municipal Art Exhibition: Paintings, Sculpture, Drawings, Prints by Living American Artists Identified with the New York Art World," The Forum, RCA Building, Rockefeller Center, New York, February 28–March 31, 1934. See Edward Alden Jewell, "In the Realm of Art: First Municipal Art Exhibition," *New York Times*, March 4, 1934, sect. 9, p. 12.

59. Gerald Nordland, *Gaston Lachaise: The Man and His Work* (New York: George Braziller, 1974), 179n111.

60. See Joan M. Marter, "Gaston Lachaise" and "Elie Nadelman," in *American Sculpture in The Metropolitan Museum of Art II: A Catalogue of Artists Born between 1865 and 1885*, ed. Thayer Tolles (New York: Metropolitan Museum of Art, 2001), 660–703. Georgia O'Keeffe donated three sculptures by Lachaise with the Alfred Stieglitz Collection in 1949. In 1970 Kirstein donated thirteen small shellacked plaster figures by Nadelman. Thayer's bequest in 1982 included two of Lachaise's full-scale bronze sculptures, *Standing Woman* (cast 1930) and *Nude Woman with Upraised Arms*, along with Nadelman's small bronze reliefs *Horse and Figure*, *Woman on a Horse*, and *Horse*. *Singer*, a small bronze sculpture by Laurent, was purchased in 1941 but never exhibited. In 1983 the sculptor's sons, John and Paul Laurent, donated a signature alabaster carving, *Mélisande* (1945).

61. The Fuller Building, designed by Walker and Gillette and located at 41 East 57th Street at Madison Avenue, was one block from the new Museum of Modern Art, which from 1929 to 1939 was in the Heckscher Building at 730 Fifth Avenue (corner of Fifth Avenue and 57th Street). This location increased the museum-going public's awareness of Nadelman's architectural sculptures. Pierre Matisse, the gallerist who in 1924 had partnered with F. Valentine Dudensing at the Valentine Gallery to show Laurent's sculpture, started his own gallery in the Fuller Building in 1931.

62. Kirstein, *Elie Nadelman*, 230.

63. See R. Sturgis Ingersoll, "The Ellen Phillips Samuel Memorial," in *Sculpture of a City: Philadelphia's Treasures in Bronze and Stone* (New York: Walker Publishing in conjunction with the Fairmount Park Art Association, 1974), 250–57; Abby Rebecca Eron, "Visualizing American History and Identity in the Ellen Phillips Samuel Memorial" (M.A. thesis, University of Maryland, 2014); and "Ellen Phillips Samuel Memorial (1933–1961)," Association for Public Art, http://www.associationforpublicart.org/artwork/ellen-phillips-samuel-memorial/.

64. Alexander also established the inscriptions and symbolic content of the Nebraska State Capitol (1919–33) and the Los Angeles Public Library (1924), working with architect Bertram Goodhue and sculptor Lee Lawrie.

65. See "The Last Work of Gaston Lachaise," *American Magazine of Art* 29, no. 8 (August 1936): 518–19.

66. William J. Buxton, "Imagining Rockefeller Center," Rockefeller Archive Center Research Reports Online, 2009, http://www.rockarch.org/publications/resrep/buxton3.pdf. George Vincent, who had been President of the Rockefeller Foundation during the 1920s, included Alexander's ideas in "A Decorative Scheme for Rockefeller Center," which he submitted in 1932.

67. The critic who wrote "Exhibit Statue Which Roxy Rejected," *New York World Telegram* (December 31, 1932), affirmed the general appreciation when he claimed that it was "the finest thing [Zorach] has ever done, even superior to the monumental 'Mother and Child.' . . . Its strength, grace and rhythmic plasticity make it easily one of the most important pieces of modern sculpture."

68. Edward Alden Jewell, "Art in Review," *New York Times*, December 28, 1932, 13. Jewell wrote that this sculpture of a dancer "is a superb work of art. Not only is it one of the finest things this highly gifted sculptor has produced, it is, as well, one of the most significant pieces of plastic art ever produced in America." Zorach's sculpture was reinstated at Radio City on March 10, 1933: "Banned Nude Art Back in Radio City," *New York Times*, March 12, 1933, F29. To protest Roxy's rejection, the Architectural League of New York featured Zorach's painted plaster sculpture in its annual exhibition in February 1933.

69. The RCA Building, with addresses of both 30 Rockefeller Center and 1250 Avenue of the Americas, also known as the GE Building and 30 Rock, became the Comcast Center in 2015. Christine Roussel, *The Art of Rockefeller Center* (New York: W. W. Norton, 2006), 12, 150–57, 308.

70. Ibid., 155; and Daniel Okrent, *Great Fortune: The Epic of Rockefeller Center* (New York: Penguin Books, 2003), 291–92.

71. This motto, adapted from Isaiah 23:6 and from the motto of Queen's University, Kingston, Ontario, Canada, was suggestive of the sources that Alexander used to justify American democracy and capitalism.

72. Roussel, *The Art of Rockefeller Center*, 250–54, 308. See Melissa Dabakis, *Visualizing Labor in American Sculpture* (New York: Cambridge University Press, 1999) for the history and iconography of American workers as depicted by American sculptors.

73. Lincoln Kirstein lent Lachaise's bronze portrait head. The Downtown Gallery lent Laurent's life-size aluminum *Pearl* and Zorach's Spanish Rosa marble *Mother and Child*. Zorach contributed his York fossil *Affection*, which the Munson-Williams-Proctor Art Institute in Utica, New York, acquired ten years later. B. D. Saklatwalla lent Laurent's alabaster *American Beauty*. Saklatwalla's Vanadium Corporation of America in Pittsburgh mined and refined vanadium ore. His collection of modern art was exhibited at the Carnegie Institute in 1934.

74. Emily Francisco, "To Infinity and Beyond: The Electrical Building, Stellar Imagery, and Conquering the Skies at the 1933–34 Chicago World's Fair" (research paper, Syracuse University, 2015).

75. *American Art Today: New York World's Fair* (New York: National Art Society, 1939).

76. William Zorach, *Art Is My Life: The Autobiography of William Zorach* (Cleveland and New York: World Publishing, 1967), 115.

77. John Gregory, Paul Manship, and William Zorach, "On Contemporary Sculpture," *American Art Today*, 171.

78. For Zorach's difficulties with *Benjamin Franklin*, see George Gurney, *Sculpture and the Federal Triangle* (Washington, D.C.: Smithsonian Institution Press, 1985), especially 302–4 and 325–32.

79. Ibid., 368–73. The other panels are *Industry* by Chaim Gross (student of Nadelman and Laurent), *Agriculture* by Concetta Scaravaglione (student of Zorach and Laurent), and *Foreign Trade* by Carl L. Schmitz; the architectural firm was Bennett, Parsons and Frost.

80. Nelson A. Rockefeller, "Introduction," in William S. Lieberman and Alfred H. Barr, Jr., *The Masterpieces of Modern Art: The Nelson A. Rockefeller Collection*, ed. Dorothy C. Miller (New York: Hudson Hills Press, 1981), 16, 18.

81. William S. Lieberman, "The Nelson A. Rockefeller Collection," in Lieberman and Barr, *The Masterpieces of Modern Art*, 43–44. Lieberman recalled Rockefeller's words without citing a source for them.

On the Surface: Innovations of Material and Technique

1. William Zorach, *Zorach Explains Sculpture: What It Means and How It Is Made* (New York: American Artists Group, 1947; New York: Dover Publications, 1996), 56. Citations refer to the Dover edition.

2. Elie Nadelman, "Elie Nadelman of Paris," *Camera Work* 48 (October 1916): 10.

3. See also Susan Rather, *Archaism, Modernism, and the Art of Paul Manship* (Austin: University of Texas Press, 1992), 117–18. Rather argues that this increased focus on material and process was a significant aspect of what she terms "archaism" in the early twentieth century, because "the emphasis on the medium, whether stone or bronze, works to destroy the academic illusion of transparency . . . often to the detriment of naturalistic illusion."

4. See June E. Hargrove, *Carrier-Belleuse: Le maître de Rodin* (Paris: Éditions de la Réunion des musées nationaux, 2014), 119–30.

5. Quoted in Maurice Dreyfous, *Jules Dalou: Sa vie et son œuvre* (Paris: Librairie Renouard, 1903), 240.

6. Nicholas Penny, *The Materials of Sculpture* (New Haven, Conn., and London: Yale University Press, 1993), 123.

7. William Zorach, *Art Is My Life: The Autobiography of William Zorach* (Cleveland and New York: World Publishing, 1967), 49.

8. Ibid.

9. Zorach, *Zorach Explains Sculpture*, 191.

10. Quoted in Peter V. Moak, ed., *The Robert Laurent Memorial Exhibition, 1972–1973* (Durham, N.H.: University of New Hampshire, 1972), 21.

11. Conservator Molly O'Guinness was instrumental in determining that original surface finish of this work.

12. Zorach, *Art Is My Life*, 66. In 1916, Stieglitz exhibited Marius de Zayas' collection of African art. Zorach attended the exhibition and later bought a portfolio of Charles Sheeler's photographs of de Zayas' collection for fifty dollars.

13. Ibid.

14. Ibid.

15. Though he experimented with wood while still in Europe, Nadelman became far more prolific with the material in the years around 1920.

16. Valerie J. Fletcher, "Elie Nadelman: Art and Craft in Context," in Suzanne Ramljak et al., *Elie Nadelman: Classical Folk* (New York: American Federation of Arts, 2001), 83.

17. On Nadelman's work with these artisans, see bills in the Nadelman archives. Elie Nadelman Papers, Courtesy Cynthia Nadelman; Barbara Haskell, *Elie Nadelman: Sculptor of Modern Life* (New York: Whitney Museum of American Art, 2003), 131.

18. Fletcher, "Art and Craft in Context," 89.

19. Ibid., 88–89.

20. Haskell, *Elie Nadelman*, 131.

21. See Thayer Tolles, "'In a Class by Themselves': Polychrome Portraits by Herbert Adams," in *Perspectives on American Sculpture Before 1925*, ed. Thayer Tolles (New York: Metropolitan Museum of Art, 2003): 64–81.

22. Zorach, *Zorach Explains Sculpture*, 196.

23. Zorach, *Art Is My Life*, 82.

24. Ibid., 69.

25. Penny, *Materials of Sculpture*, 310.

26. Virginia Budny kindly shared her descriptions of these works with me, as she is preparing to publish the catalogue raisonné of Lachaise's sculpture.

27. A. E. Gallatin, *Gaston Lachaise: Sixteen Reproductions in Collotype of the Sculptor's Work* (New York: Dutton, 1924), 10.

28. Gerald Nordland, *Gaston Lachaise: The Man and His Work* (New York: George Braziller, 1974), 23.

29. Moak, *Robert Laurent Memorial Exhibition*, 19.

30. Augusta Owen Patterson, "Arts and Decoration," *Town and Country*, October 1924, 42. A warm thank-you is owed to Roberta K. Tarbell for drawing our attention to this reference (and indeed for her great scholarly generosity in sharing her expertise throughout this project).

31. Roberta K. Tarbell, *Robert Laurent and American Figurative Sculpture: Selections from the John N. Stern Collection and The David and Alfred Smart Museum of Art* (Chicago: David and Alfred Smart Museum of Art and the University of Chicago, 1994), 11; William I. H. Baur, *William Zorach* (New York: Whitney Museum of American Art, 1959), 23.

32. Zorach, *Zorach Explains Sculpture*, 226.

33. Henry R. Hope, "Robert Laurent at Indiana University," in Moak, *Robert Laurent Memorial Exhibition*, 10.

34. Marjorie Trusted, ed., *The Making of Sculpture: The Materials and Techniques of European Sculpture* (London: V&A Publications, 2007), 100–101.

35. Tarbell, *Robert Laurent and American Figurative Sculpture*, 11.

36. Zorach, *Art Is My Life*, 166.

37. Ibid., 84.

38. Laurent wrote, "What I enjoy the most is cutting direct in the material, starting generally without any preconceived idea, preferably into a block of stone, alabaster or wood having an odd shape . . . it keeps you awake, looking for something to show up." Robert Laurent Papers, Archives of American Art, Smithsonian Institution, Washington, D.C., reel N68-3, frame 16. See also Shirley Reece-Hughes' essay in this catalogue.

39. See André Salmon, "La sculpture vivante," *L'Art vivant*, no. 31 (1926): 258–60; Catherine Chevillot, "Le problème c'était Rodin," in *Oublier Rodin? La sculpture à Paris, 1905–1914*, ed. Catherine Chevillot (Paris: Musée d'Orsay, Réunion des Musées Nationaux, 2009), 17–23; and "Paris and the Birth of a New American Sculpture," in this catalogue.

40. Nordland, *Gaston Lachaise*, 7.

41. Correspondence in the object file for Lachaise, *Standing Woman*, Archives, Philadelphia Museum of Art: Carl Zigrosser to R. Sturgis Ingersoll, September 28, 1949; The Weyhe Gallery to R. Sturgis Ingersoll, October 10, 1949; R. Sturgis Ingersoll to Anne d'Harnoncourt, September 3, 1968.

42. Ibid., The Weyhe Gallery to R. Sturgis Ingersoll, October 10, 1949.

43. For a thorough discussion of Lachaise's casting process, see Julia Day et al., "Gaston Lachaise: Characteristics of His Bronze Sculpture" (Advanced-Level Training Program Completion Paper, Straus Center for Conservation and Technical Studies, Harvard Art Museums, 2012).

44. Roberta K. Tarbell, "Catalogue Raisonné of William Zorach's Carved Sculpture" (Ph.D. diss., University of Delaware, 1976), 1:154.

45. Ibid., 377–78.

46. Thanks are due to Karen Lemmey, who pointed out the connection between the bronze and *Mother and Child* during the Barnet Scholars' Weekend at the Portland Museum of Art on March 12, 2016.

47. Moak, *Robert Laurent Memorial Exhibition*, 20.

48. Penny, *Materials of Sculpture*, 255. In the nineteenth century, sculptors used aluminum for limited projects, including the capstone

of the Washington Monument and in Alfred Gilbert's *Eros* in Piccadilly Circus in London. To work in aluminum, foundries added other metals to create a stronger alloy.

49. Louise Cross, "The Sculpture for Rockefeller Center," *Parnassus* 4, no. 5 (October 1932): 3.

50. For a detailed video of the electrotyping process, see "The Electrotyping Process," The Metropolitan Museum of Art, http://www.metmuseum.org/metmedia/video/collections/esda/electrotyping-process, posted November 30, 2011.

51. Haskell, *Elie Nadelman*, 157.

Sculpting Lines on Paper

1. Elie Nadelman, preface to *Vers la beauté plastique: Thirty-Two Reproductions of Drawings* (New York: E. Weyhe, 1921), n.p.

2. Lincoln Kirstein's seminal 1973 catalogue on Nadelman provides a comprehensive examination of his stylistic evolution, including anecdotes about Guillaume Apollinaire's naming the artist "Praxitelmann" in a nod to his Greco-Roman influences, as well as the artist's formative encounter with Picasso in 1908, when Nadelman claimed Picasso poached his ideas about abstraction. Kirstein further discusses Seurat's archetypal figures and where Nadelman may have seen these drawings in Paris, in addition to Rodin's drawings for his *femmes-vases*. Lincoln Kirstein, *Elie Nadelman* (New York: Eakins Press, 1973), 168–72, 183–84. For Nadelman's interest in Fraktur and American folk arts, see Margaret K. Hofer and Roberta J. M. Olson, *Making It Modern: The Folk Art Collection of Elie and Viola Nadelman* (New York: New-York Historical Society, 2015). For an analysis of Nadelman's early drawing styles, see Athena Tacha Spear, "The Multiple Styles of Elie Nadelman: Drawings and Figure Sculptures ca. 1905–12," *Allen Memorial Art Museum Bulletin* 31, no. 1 (1973–74): 34–58.

3. Elie Nadelman, "Notes for a Catalogue," *Camera Work*, no. 32 (October 1910): 41.

4. *Vers l'unité plastique* (Toward plastic unity) was published in Paris in 1914 and included fifty facsimiles of Nadelman's early analytical drawings. It was republished in New York in 1921 as *Vers la beauté plastique* (Toward plastic beauty) with fewer reproductions. For a complete background on these early drawings, see Spear, "The Multiple Styles of Elie Nadelman."

5. Typed object file notes, with handwritten annotations, for *Study for Man in the Open Air*, The Museum of Modern Art, New York: "It has been suggested that Nadelman preserved the mould growth on the drawing as a deliberate aesthetic device."

6. E. E. Cummings, "Gaston Lachaise," *Creative Art* 3, no. 2 (August 1928): xxvi.

7. Lachaise used the term "Woman" to refer both to his wife Isabel Dutaud Nagle and to the idealized female figure he depicted in his drawings and sculpture. Gaston Lachaise, "A Comment on My Sculpture," *The Massachusetts Review* 1, no. 4 (Summer 1960): 693.

8. While Lachaise did make individualized portraits, including that of Harold Hart Crane featured in a drawing in this catalogue (**PLATE 71**), his primary focus lay in the monumental and anonymous "Woman." For his thoughts on portraiture, see ibid., 694; and Carolyn Kinder Carr and Margaret C. S. Christman, *Gaston Lachaise: Portrait Sculpture* (Washington, D.C.: National Portrait Gallery and Smithsonian Institution Press, 1985).

9. Lachaise, "A Comment on My Sculpture," 693–94.

10. Lachaise often attended burlesque performances with E. E. Cummings at the National Winter Garden Burlesque in New York City, an eight-story burlesque enterprise with two theater spaces in the East Village. John Holverson, *Gaston Lachaise: Sculpture and Drawings* (Portland, Maine: Portland Museum of Art, 1984), 32. See also Shirley Reece-Hughes' essay in this catalogue for Lachaise's relationship to contemporary dance.

11. In an effort to raise quick cash that Lachaise could send to Isabel in Maine for basic provisions such as wood or stockings, he made drawings for the sole purpose of selling privately. He wrote to his wife in October of 1930 about selling his drawings to Frank K. M. Rehn, a New York gallerist: "I try today to find some decent drawing for Rehn but . . . all out of them. I shall get to it tonight drawing hard—and find myself with 200 or more good one ready . . . tomorrow morning." In another letter to Isabel, dated November 30, 1929, Lachaise documented his continual efforts to stay financially afloat, mentioning his trip to the Weyhe Gallery in New York: "I went to sell some drawings to Weyhe in order to meet this week's expenses." Letters cited here are from the Gaston Lachaise Collection, Yale Collection of American Literature, Beinecke Rare Book and Manuscript Library, Yale University, New Haven, Connecticut, YCAL MSS 434. Transcripts and translations of letters are by Phyllis Samitz Cohen and Paula R. Hornbostel.

12. In a speech at the Barn Gallery on August 2, 1967, Laurent reflected on these drawing sessions: "In the late 20ties [i.e., 1920s] several of my friends decided to meet in our B'klyn home. Once a week—hire a model—sometimes two—draw a couple of hours in the evening. In the group we had Wood Gaylor—Stefan Hirsch—Kuniyoshi—Niles Spencer—Louis Bouché—Walt Kuhn—Gauso—Pascin—others would drop in from time to time—One day we had the great idea to auction off the drawings made during the evening—this we kept up for many months—drawings would generally start at 5 or 10 cents—reaching sometimes $2.00 or a little over—it was great fun—and a wonderful way to add to the drawings collection." Robert Laurent Papers (hereafter Laurent Papers), 1869–1973, Archives of American Art, Smithsonian Institution (hereafter AAA), reel no. 2067, frame no. 28.

13. William Zorach, *Zorach Explains Sculpture, What It Means and How It Is Made* (New York: American Artists Group, 1947), 56.

14. The aluminum sculpture *Pearl* (1932), now in a private collection, can be seen as Figure 37 in Peter V. Moak, ed., *The Robert Laurent Memorial Exhibition, 1972–1973* (Durham, N.H.: University of New Hampshire, 1972).

15. Robert Laurent, untitled speech, 1942, Laurent Papers, AAA, reel no. 2067, frame no. 46.

16. Moak, *Robert Laurent Memorial Exhibition*, 18.

17. Zorach, *Zorach Explains Sculpture*, 61.

18. Zorach wrote, "You need not make what most people call 'finished' drawings of a thing, but you should make any drawing notes of what you see in nature, so that when you model or carve, you will know something about what you are trying to express in clay, wood, or stone." Ibid., 19. He did not do his first direct carving, *Waterfall*, until 1917 at the age of twenty-eight, having previously been immersed in painting, watercolor, and printmaking.

19. Ibid., 238.

20. Zorach explained how he would use preliminary sketches to complete his *Family Group* relief panels: "I prefer to make a complete drawing or cartoon for a relief and trace it on the wood. In this way I retain my original sketch and I can carve freely and directly into the wood, feeling my way as the form develops." Ibid., 196.

21. Ibid., 238.

22. Nadelman wrote in the artist's statement for his 1915 exhibition at 291 (the Photo-Secession gallery run by Alfred Stieglitz): "Here is a wonderful force, a life that plastic art should express. Here is a life which, cultivated, enriched by art, will reach a dazzling power of expression that will stir us. It is this will of matter expressed in shapes and volume that I call plasticity. This power, this will, is not solely found imprisoned in matter itself. It is a natural force that corresponds to our own instinct." Elie Nadelman, "Elie Nadelman Exhibition at '291' (Gallery of the Photo-Secession), December Eighth, 1915, to January Eighth, 1916," reprinted in Alfred Stieglitz, "291 Exhibitions: 1914–1917," *Camera Work*, no. 48 (October 1916): 10.

Checklist of the Exhibition

COMPILED BY MOLLIE R. ARMSTRONG

Gaston Lachaise
United States, born France, 1882–1935

Robert Laurent
United States, born France, 1890–1970

Elie Nadelman
United States, born Poland, 1882–1946

William Zorach
United States, born Lithuania, 1889–1966

PLATE **1**

Robert Laurent
Acrobat, 1921
Wood, 20$\frac{1}{2}$ x 10$\frac{1}{2}$ x 8 inches
Bernard Goldberg Fine Arts LLC, New York

PLATE **2**

Gaston Lachaise
Woman Walking, modeled circa 1911, cast 1917
Bronze, 11$\frac{1}{4}$ inches (height)
Bernard Goldberg Fine Arts LLC, New York

PLATE **3**

Gaston Lachaise
Passion, modeled 1930–34, cast 1936
Bronze, 25$\frac{3}{8}$ x 12$\frac{1}{8}$ x 9 inches
Marc and Ronit Arginteanu

PLATE **4**

Gaston Lachaise
Head of Edward M. M. Warburg, 1933
Alabaster, 14$\frac{1}{2}$ x 8 x 9 inches
Courtesy Lachaise Foundation

PLATE **5**

Robert Laurent
Head (or Mask), circa 1915
Walnut on marble base, 8$\frac{1}{2}$ x 4 x 3$\frac{5}{8}$ inches
Courtesy of Conner · Rosenkranz LLC

PLATE **6**

Elie Nadelman
Head of a Woman, circa 1920
Marble, 17$\frac{1}{2}$ x 11 x 12 inches
Philip and Theresa Nadelman Collection

PLATE **7**

Elie Nadelman
Head of a Woman, circa 1916–32
Bronze, 18$\frac{3}{4}$ x 10 x 15$\frac{1}{2}$ inches
Memorial Art Gallery of the University of Rochester
Anonymous gift in honor of Gertrude Herdle Moore, 62.7

PLATE **8**

Elie Nadelman
Seated Female Nude, 1915
Bronze on onyx plinth, 17 x 7$\frac{1}{2}$ x 6 inches
The Baltimore Museum of Art
The Cone Collection, formed by Dr. Claribel Cone and Miss Etta Cone of Baltimore, Maryland, BMA1950.397

PLATE **9**

Elie Nadelman
Man in the Open Air, circa 1915
Bronze, 54$\frac{1}{2}$ x 11$\frac{3}{4}$ x 21$\frac{1}{2}$ inches
The Museum of Modern Art, New York
Gift of William S. Paley (by exchange), 259.1948

PLATE **10**

Elie Nadelman
Bust of a Woman, circa 1926–27
Galvanoplasty, 21 x 21 x 14$\frac{1}{2}$ inches
Collection of Cynthia Nadelman

PLATE 36
William Zorach
Floating Figure, 1922
Borneo mahogany, 9 x 33 1/4 x 7 inches
Collection Albright-Knox Art Gallery, Buffalo,
New York
Room of Contemporary Art Fund, 1946,
RCA1946:5

PLATE 37
William Zorach
The Dance, 1930
Bronze, 8 5/8 x 9 x 1 1/8 inches
Portland Museum of Art, Maine
Gift of Selma and Arnold Potter, 1979.143

PLATE 38
Elie Nadelman
Tango, circa 1920–24
Painted and gessoed cherry wood,
36 x 25 5/8 x 13 7/8 inches
Whitney Museum of American Art, New York
Purchase, with funds from the Mr. and Mrs.
Arthur G. Altschul Purchase Fund, the
Joan and Lester Avnet Purchase Fund, the
Edgar William and Bernice Chrysler Garbisch
Purchase Fund, the Mrs. Robert C. Graham
Purchase Fund in honor of John I. H. Baur,
the Mrs. Percy Uris Purchase Fund and the
Henry Schnakenberg Purchase Fund in honor
of Juliana Force, 88.1a-c

PLATE 39
Elie Nadelman
Chef d'Orchestre, circa 1919
Stained and gessoed cherry wood,
38 1/2 x 22 x 11 inches
Amon Carter Museum of American Art,
Fort Worth, Texas
Partial gift of the Anne Burnett and Charles
Tandy Foundation, 1988.33

PLATE 40
Elie Nadelman
The Hostess, circa 1928
Bronze, 29 7/8 x 10 1/8 x 12 7/8 inches
Colby College Museum of Art
The Lunder Collection, 2013.216

PLATE 41
Elie Nadelman
Dancer, 1918
Cherry wood and mahogany, 28 1/4 inches
(height)
Wadsworth Atheneum Museum of Art,
Hartford, Connecticut
The Philip L. Goodwin Collection, Gift of
James L. Goodwin, Henry Sage Goodwin,
and Richmond L. Brown, 1958.224

PLATE 42
William Zorach
Mother and Child, 1922
Mahogany, 31 x 12 x 12 1/2 inches
Anonymous

PLATE 43
Marguerite Zorach
Mother and Child, 1917
Butternut, 16 x 7 3/8 inches
Lent by the Estate of Dr. Samuel and
Adele Wolman

PLATE 44
William Zorach
Waterfall, 1917
Butternut, 15 3/4 x 7 1/2 inches
Lent by the Estate of Dr. Samuel and
Adele Wolman

PLATE 45
William Zorach
Bathing Girl, circa 1934
Bronze, 44 x 12 x 11 inches
Portland Museum of Art, Maine
Gift of Barridoff Galleries and
Annette and Rob Elowitch, 2002.23

PLATE 46
Robert Laurent
Reclining Figure, 1934
Mahogany, 28 1/16 x 52 x 1 3/4 inches
Portland Museum of Art, Maine
Hamilton Easter Field Art Foundation
Collection, Gift of Barn Gallery Associates,
Inc., Ogunquit, Maine, 1979.13.46

PLATE 47
Robert Laurent
Plant Form, circa 1924–28
Stained fruitwood, 32 x 5 3/4 x 5 3/4 inches
Amon Carter Museum of American Art,
Fort Worth, Texas
1989.1

PLATE 48
Robert Laurent
Head (Abstraction), 1916
Carved mahogany, 15 x 8 x 6 inches
Amon Carter Museum of American Art,
Fort Worth, Texas
1989.7

PLATE 49
William Zorach
Head of Christ, 1940
Stone, 20 5/8 x 10 1/4 x 11 5/8 inches
(including base)
The Museum of Modern Art, New York
Abby Aldrich Rockefeller Fund, 188.1942

PLATE 50
William Zorach
Dahlov (The Artist's Daughter), 1920
Terracotta, 13 1/2 x 10 5/8 x 10 1/2 inches
Smithsonian American Art Museum
Gift of International Business Machines
Corporation, 1966.27.13

PLATE 51
William Zorach
Young Boy, 1921
Mahogany, 22 x 5 x 4 3/4 inches
Private collection

PLATE 52
Robert Laurent
Nile Maiden, circa 1914
Carved wood, 25 3/16 x 11 7/16 x 1 3/16 inches
The Barnes Foundation, Philadelphia,
Pennsylvania
A428

PLATE 53
Robert Laurent
Princess, circa 1914
Carved wood, 42 15/16 x 14 x 1 3/16 inches
The Barnes Foundation, Philadelphia,
Pennsylvania
A427

PLATE 54
Gaston Lachaise
Ogunquit Torso, 1925–28
Bronze, 12 3/4 x 4 x 6 1/2 inches
Private collection, Courtesy of Gerald Peters
Gallery

PLATE 55
Robert Laurent
Kneeling Figure, modeled 1935, cast by 1938
Bronze, 23 x 10 1/2 inches
The Art Institute of Chicago
Mr. and Mrs. Frank G. Logan Purchase Prize
Fund, 1938.1272

PLATE 56
Robert Laurent
Acrobats, 1922
Mahogany, 92 x 21 1/2 inches
Anonymous

PLATE 57
William Zorach
Family Group (Mother and Child), 1925
Aluminum on mahogany panel,
17 1/16 x 7 9/16 x 1 1/16 inches
Private collection, New York

PLATE 58
Elie Nadelman
Head, Side View, 1906–7
Ink and graphite on paper mounted to
cardboard, 10 1/4 x 7 7/8 inches
Portland Museum of Art, Maine
Museum purchase with a gift from
Dr. and Mrs. Delvyn C. Case, Jr., 1982.127

PLATE 59
Elie Nadelman
Two Standing Nudes, circa 1907–8
Ink, wash, and graphite on paper,
13 5/8 x 8 5/8 inches
Amon Carter Museum of American Art,
Fort Worth, Texas
1983.172
Fort Worth and Memphis only

PLATE 60
Elie Nadelman
High Kicker, circa 1917
Pen and ink on paper, 10 x 6 3/4 inches
The Jerome Robbins Dance Division,
The New York Public Library for the
Performing Arts, Astor, Lenox and
Tilden Foundations, *MGZGA Nad E Hig 1
Portland only

PLATE 61
Elie Nadelman
Seated Figure, circa 1908–10
Ink on paper, 11 3/4 x 7 3/4 inches
Susan and Herbert Adler Collection

PLATE 62
Elie Nadelman
Study of a Female Variety Dancer, circa 1919
Pen on paper, 12 1/2 x 8 inches
The Jerome Robbins Dance Division,
The New York Public Library for the
Performing Arts, Astor, Lenox and
Tilden Foundations, *MGZGA Nad E Var 2
Memphis only

PLATE 63
Elie Nadelman
Study for "Man in the Open Air," circa 1914–15
Watercolor, ink, and pencil on paper,
10 3/4 x 7 1/8 inches
The Museum of Modern Art, New York
Aristide Maillol Fund, 267.1948

PLATE 64
Elie Nadelman
Study for "Tango," circa 1917
Pen with ink wash on paper, 9 7/8 x 7 7/8 inches
The Jerome Robbins Dance Division,
The New York Public Library for the
Performing Arts, Astor, Lenox and
Tilden Foundations, *MGZGA Nad E Tan 2
Fort Worth only

PLATE 65
Elie Nadelman
Seated Dancer, 1919
Ink on paper, 10 1/8 x 8 inches
Amon Carter Museum of American Art,
Fort Worth, Texas
Gift of Ruth Carter Stevenson, 1991.19
Fort Worth only

PLATE 66
Gaston Lachaise
Nude, circa 1924
Crayon on thin cream Japan paper,
11 15/16 x 5 9/16 inches
Worcester Art Museum, Worcester,
Massachusetts
Gift of Mrs. Helen Sagoff Slosberg, 1979.27
Portland only

PLATE 67
Gaston Lachaise
Kneeling Nude, circa 1922–32
Pencil on paper, 18 x 12 inches
Colby College Museum of Art
Museum purchase from the Jere Abbott
Acquisitions Fund, 1997.006

PLATE 68
Gaston Lachaise
Figure with Ink Splash, circa 1929–31
Graphite and ink on paper, 24 x 19 inches
Courtesy Lachaise Foundation

PLATE 69
Gaston Lachaise
Madame Lachaise, circa 1930
Pencil on paper, 17 7/8 x 11 13/16 inches
Hirshhorn Museum and Sculpture Garden,
Smithsonian Institution
Gift of the Joseph H. Hirshhorn Foundation,
1966, 66.2870

PLATE 70
Gaston Lachaise
Nude, Number 1, undated
Graphite pencil on paper, 11 x 8 1/2 inches
Whitney Museum of American Art, New York
Purchase, 32.1
Fort Worth and Memphis only

PLATE 71
Gaston Lachaise
Harold Hart Crane, circa 1923
Graphite on paper, 19 x 12 1/8 inches
National Portrait Gallery, Smithsonian
Institution
Gift of the Lachaise Foundation, NPG.91.46
Memphis and Portland only

PLATE 72
Robert Laurent
Female Torso, circa 1925
Crayon on paper, 22 x 17 inches
Courtesy of Conner · Rosenkranz LLC

PLATE 73
Robert Laurent
Woman, circa 1940
Pen, ink, and crayon on paper, 16 x 10 5/8
inches
Allen Memorial Art Museum, Oberlin College,
Oberlin, Ohio
Gift of Fay S. Stern in honor of and in memory
of John N. Stern (OC 1939), 2010.26.10
Portland only

PLATE 74
Robert Laurent
Untitled (Figure Study), first half 20th century
Ink and crayon on paper, 17 1/2 x 10 1/4 inches
Allen Memorial Art Museum, Oberlin College,
Oberlin, Ohio
Gift of Fay S. Stern in honor of and in memory
of John N. Stern (OC 1939), 2010.26.8
Fort Worth only

PLATE 75
Robert Laurent
Woman and Doe, Study for Sculpture,
first half 20th century
Crayon on paper, 21 x 11 1/4 inches
Allen Memorial Art Museum, Oberlin College,
Oberlin, Ohio
Gift of Fay S. Stern in honor of and in memory
of John N. Stern (OC 1939), 2010.26.11
Portland only

PLATE 76
Robert Laurent
Abstract Head, circa 1915
Graphite on paper, 11 1/8 x 12 3/4 inches
Bernard Goldberg Fine Arts LLC, New York
Memphis only

PLATE 77
Robert Laurent
Abstract Head, undated
Graphite on paper, 9 3/4 x 7 3/4 inches (sight)
Anonymous

PLATE 78
William Zorach
Marguerite and Tessim, undated
Pencil on paper, 10 7/8 x 8 3/8 inches
Colby College Museum of Art
Gift of the Zorach Children, 1981.026

PLATE 79
William Zorach
Nude Young Woman, 1950
Pencil on paper, 18 x 19 3/4 inches
Portland Museum of Art, Maine
Gift of the Zorach Family, Tessim Zorach,
and Dahlov Zorach Ipcar, 1971.3

PLATE 80
William Zorach
Dahlov, undated
Pencil on paper, 10 15/16 x 8 7/16 inches
Colby College Museum of Art
Gift of the Zorach Children, 1981.011

PLATE 81
William Zorach
Sketch for Plaque "The Dance"
(*Untitled—Ship Deck* on verso), undated
Pencil on paper, 13 7/8 x 9 1/2 inches
Smithsonian American Art Museum
Gift of Dahlov Ipcar and Tessim Zorach,
1968.154.111A–B
Memphis only

PLATE 82
William Zorach
Sketch of Mother and Child, 1922
Ink on wove paper, 12 7/16 x 10 1/2 inches
Portland Museum of Art, Maine
Gift of the Zorach Family, Tessim Zorach,
and Dahlov Zorach Ipcar, 1980.90

Selected Bibliography

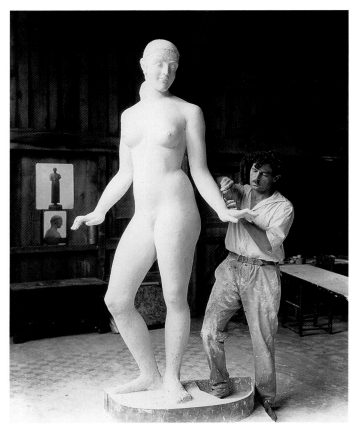

Robert Laurent in his studio with *Goose Girl*, circa 1932

Archives

Archives of American Art, Smithsonian Institution, Washington, D.C.

Gaston Lachaise Collection, Yale Collection of American Literature, Beinecke Rare Book and Manuscript Library, Yale University, New Haven, Connecticut, YCAL MSS 434

Journals

The Arts

The Dial

Camera Work

Creative Art: A Magazine of Fine and Applied Art

Published Works

Barryte, Bernard, and Roberta K. Tarbell, eds. *Rodin and America: Influence and Adaptation, 1876–1936.* Stanford, Calif.: Cantor Arts Center, 2011.

Baur, William I. H. *William Zorach.* New York: Whitney Museum of American Art, 1959.

Berman, Avis. *Rebels on Eighth Street: Juliana Force and the Whitney Museum of American Art.* New York: Athenaeum, 1990.

Biro, Yaëlle, ed. *African Art, New York, and the Avant-Garde.* Special issue no. 3 of *Tribal Magazine.* New York: Metropolitan Museum of Art, 2012.

Bolger, Doreen. "Hamilton Easter Field and His Contribution to American Modernism." *The American Art Journal* 2, no. 22 (1988): 78–107.

Budny, Virginia. "Gaston Lachaise's American Venus: The Genesis and Evolution of *Elevation.*" *The American Art Journal* 34/35 (2003/2004): 62–143.

Cahill, Holger. "Folk Art: Its Place in the American Tradition." *Parnassus* 4, no. 3 (March 1932): 1–4.

Chevillot, Catherine, ed. *Oublier Rodin? La sculpture à Paris, 1905–1914.* Paris: Musée d'Orsay, Réunion des Musées Nationaux, 2009.

Curtis, Penelope. *Sculpture 1900–1945: After Rodin.* Oxford: Oxford University Press, 1999.

Daniels, Roger. *Not Like Us: Immigrants and Minorities in America, 1890–1924.* Chicago: Ivan R. Dee, 1997.

Debakis, Melissa. *Visualizing Labor in American Sculpture.* New York: Cambridge University Press, 1999.

Field, Hamilton Easter. *The Technique of Oil Paintings and Other Essays.* Brooklyn, N.Y.: Ardsley House, 1913.

Fort, Ilene Susan, ed. *The Figure in American Sculpture: A Question of Modernity.* Los Angeles: Los Angeles County Museum of Art, 1995.

Goldwater, Robert. *Primitivism and Modern Art*. New York: Random House, 1938.

Haskell, Barbara. *Elie Nadelman: Sculptor of Modern Life*. New York: Whitney Museum of American Art, 2003.

Helfgott, Isadora Anderson. *Framing the Audience: Art and the Politics of Culture in the United States, 1929–45*. Philadelphia: Temple University Press, 2015.

Hofer, Margaret K., and Roberta J. M. Olson. *Making It Modern: The Folk Art Collection of Elie and Viola Nadelman*. New York: New-York Historical Society, 2015.

Kirstein, Lincoln. *Elie Nadelman*. New York: Eakins Press, 1973.

———. *Gaston Lachaise: Retrospective Exhibition, January 30–March 7, 1935*. New York: Museum of Modern Art, 1935.

———. *The Sculpture of Elie Nadelman*. New York: Museum of Modern Art, 1948.

Le Normand-Romain, Antoinette, ed. *Rodin en 1900, L'exposition de l'Alma*. Paris: Musée Rodin, Réunion des Musées Nationaux, 2001.

Lieberman, William S., and Alfred H. Barr, Jr. *The Masterpieces of Modern Art: The Nelson A. Rockefeller Collection*. Edited by Dorothy C. Miller. New York: Hudson Hills Press, 1981.

Marter, Joan, Roberta K. Tarbell, and J. Wechsler. *Vanguard American Sculpture, 1913–1939*. New Brunswick, N.J.: Rutgers University Art Gallery, 1979.

Moak, Peter V., ed. *The Robert Laurent Memorial Exhibition, 1972–1973*. Durham, N.H.: University of New Hampshire, 1972.

Murphy, Kevin D., ed. *Folk Art in Maine: Uncommon Treasures, 1750–1925*. Camden, Maine: Down East, The Maine Folk Art Trail, 2008.

Nadelman, Elie. *Vers la beauté plastique: Thirty-Two Reproductions of Drawings*. New York: E. Weyhe, 1921.

Nordland, Gerald. *Gaston Lachaise: The Man and His Work*. New York: George Braziller, 1974.

Passatino, Erika D., and David W. Scott, eds. *The Eye of Duncan Phillips: A Collection in the Making*. Washington, D.C.: Phillips Collection; New Haven, Conn.: Yale University Press, 1999.

Pells, Richard. *Modernist America: Art, Music, Movies, and the Globalization of American Culture*. New Haven, Conn.: Yale University Press, 2011.

Penny, Nicholas. *The Materials of Sculpture*. New Haven, Conn., and London: Yale University Press, 1993.

Pollock, Lindsay. *The Girl with the Gallery: Edith Gregor Halpert and the Making of the Modern Art Gallery*. New York: Public Affairs, 2006.

Ramljak, Suzanne, et al. *Elie Nadelman: Classical Folk*. New York: American Federation of Arts, 2001.

Rather, Susan. *Archaism, Modernism, and the Art of Paul Manship*. Austin: University of Texas Press, 1992.

Rinuy, Paul-Louis. "1907: Naissance de la sculpture moderne? Le renouveau de la taille directe en France." *Histoire de l'art* 3 (October 1988): 67–74.

Roussel, Christine. *The Art of Rockefeller Center*. New York: W. W. Norton, 2006.

Stillinger, Elizabeth. *A Kind of Archeology: Collecting American Folk Art, 1876–1976*. Amherst and Boston: University of Massachusetts Press, 2011.

Taft, Lorado. *Modern Tendencies in Sculpture*. The Scammon Lectures for 1917. Chicago: University of Chicago Press for the Art Institute of Chicago, 1921.

Tarbell, Roberta K. "Catalogue Raisonné of William Zorach's Carved Sculpture." Ph.D. diss., University of Delaware, 1976.

———. *Robert Laurent and American Figurative Sculpture: Selections from the John N. Stern Collection and The David and Alfred Smart Museum of Art*. Chicago: David and Alfred Smart Museum of Art and the University of Chicago, 1994.

Tolles, Thayer, ed. *Perspectives on American Sculpture before 1925*. New York: Metropolitan Museum of Art, 2003.

Vogel, Susan M. *Primitivism Revisited: After the End of an Idea*. New York: Sean Kelly Gallery, 2007.

Wayne, Kenneth E. *Modigliani and the Artists of Montparnasse*. Buffalo, N.Y.: Harry N. Abrams in association with the Albright-Knox Art Gallery, 2002.

Webb, Virginia-Lee. "Art as Information: The African Portfolios of Charles Sheeler and Walker Evans." *African Arts* 24 (January 1991): 56–63, 103–4.

Weber, Nicholas Fox. *Patron Saints: Five Rebels Who Opened America to a New Art, 1928–1943*. New York: Alfred A. Knopf, 1992.

Zorach, William. *Art Is My Life: The Autobiography of William Zorach*. Cleveland and New York: World Publishing Company, 1967.

———. *Zorach Explains Sculpture: What It Means and How It Is Made*. New York: American Artists Group, 1947.

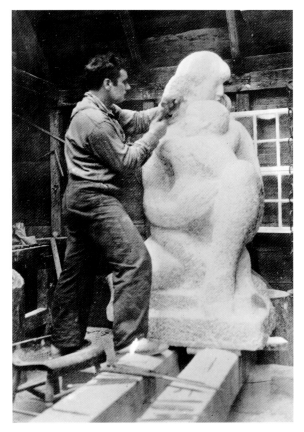

William Zorach in his studio with *Mother and Child*, circa 1928

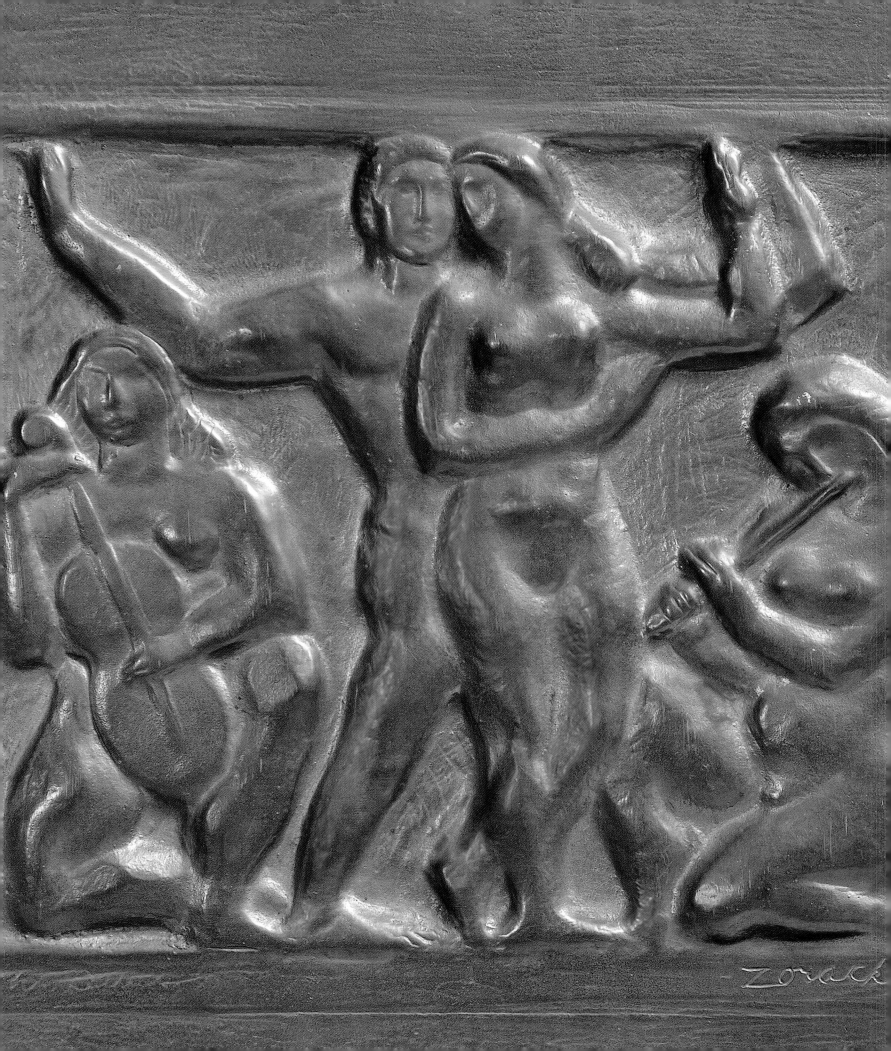

Index

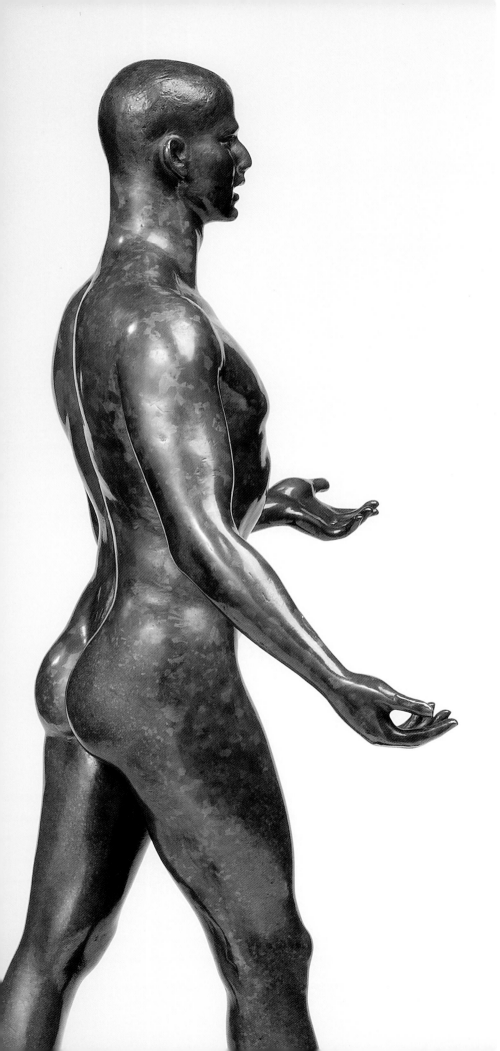

Credits

FIG. 25 Courtesy of the George Eastman Museum; © Nickolas Muray Photo Archives

FIG. 30 Courtesy of The University of Chicago Library

FIGS. 32–33, 53, PLATES 21, 24, 26, 64 Image copyright © The Metropolitan Museum of Art. Image source: Art Resource, N.Y.

FIG. 34, PLATES 9, 49, 63 Digital Image © The Museum of Modern Art / Licensed by SCALA / Art Resource, N.Y.

FIG. 36 Courtesy of the Association for Public Art, Philadelphia, Pennsylvania

FIGS. 37, 55, PLATE 16 Courtesy of the Philadelphia Museum of Art

FIG. 43 Photo by Kristen Fusselle / GSA, Courtesy of the U.S. General Services Administration, Public Buildings Services, Fine Arts Collection

FIG. 44 Photo by Carol M. Highsmith Photography, Courtesy of the U.S. General Services Administration, Public Building Service, Fine Arts Collection

FIG. 45, PLATES 12, 50, 81 Courtesy of Smithsonian American Art Museum

FIG. 46 Photo by Jerry L. Thompson / Art Resource, N.Y.

FIG. 48 Image courtesy of the National Gallery of Art, Washington, D.C.

FIG. 54 © Artists Rights Society (ARS), New York / ADAGP, Paris © Succession Brancusi– All rights reserved (ARS) 2016

PLATE 7 Courtesy of the Memorial Art Gallery of the University of Rochester, New York

PLATE 8 Photo by Mitro Hood

PAGE 84 Bain News Service, *Elie Nadelman*, December 26, 1919, Library of Congress Prints and Photographs Division, Washington, D.C., LC-DIG-ggbain-23617

PLATES 14, 18, 32, 35, 37, 42, 45, 62, 79, 82 Portland Museum of Art, Portland, Maine, Photo by Bruce Schwarz

PAGE 98 Carl Van Vechten (1880–1964), *Gaston Lachaise and his Figure of Lincoln Kirstein*, May 26, 1933, General Collection, Beinecke Rare Book and Manuscript Library, Yale University © Van Vechten Trust

PLATE 20 Collection Bruce Museum, Greenwich, Connecticut

PLATE 27 Courtesy of the Mount Holyoke College Art Museum, South Hadley, Massachusetts

PLATES 28, 39, 47–48, 59, 65 The Amon Carter Museum of American Art, Fort Worth, Texas

PLATE 29 © Courtesy of the Huntington Art Collections, San Marino, California, Photography © 2014 Fredrik Nilsen

PLATES 30–31 Courtesy of the Brooklyn Museum, Brooklyn, N.Y.

PLATES 34, 40, 67, 78, 80 Courtesy of the Colby College Museum of Art, Waterville, Maine

FIGS. 6, 29, PLATE 38 Photo by Jerry L. Thompson

PLATE 41 Photo by Allen Phillips / Wadsworth Atheneum

PLATES 52–53 Image © 2016 The Barnes Foundation

PLATE 55 Photography © The Art Institute of Chicago

PLATES 46, 58 © Portland Museum of Art, Portland, Maine, Photo by Luc Demers

PLATE 60 Jerome Robbins Dance Division, The New York Public Library for the Performing Arts, Astor, Lenox and Tilden Foundations

PLATE 66 Image © Worcester Art Museum

PLATE 69 Photo by Cathy Carver

PLATES 73–75 Courtesy of the Allen Memorial Art Museum, Oberlin College, Oberlin, Ohio

PAGE 176 Peter A. Juley & Son, *Robert Laurent in his studio at work on "Goose Girl,"* © Peter A. Juley & Son Collection, Smithsonian American Art Museum, J00018446

PAGE 177 Charles Sheeler, [*William Zorach Carving "Mother and Child"*], circa 1928, gelatin silver print, The Metropolitan Museum of Art, Gift of Tessim Zorach, 1984 (1984.1048.11), Art Resource, N.Y.

Additional Illustrations

TITLE PAGES

Gaston Lachaise, *Two Floating Nude Acrobats*, 1922 (see PLATE 25)

Elie Nadelman, *Seated Female Nude*, 1915 (see PLATE 8)

William Zorach, *Spirit of the Dance*, 1932 (see PLATE 15)

PAGE iv Robert Laurent, *The Bather*, circa 1925 (see PLATE 31)

PAGE x Elie Nadelman, *Chef d'Orchestre*, circa 1919 (detail; see PLATE 39)

PAGE xii Gaston Lachaise, *Figure with Ink Splash*, circa 1929–31 (detail; see PLATE 68)

PAGE xiii William Zorach, *Waterfall*, 1917 (detail; see PLATE 44)

PAGE 18 Elie Nadelman, *Dancer*, 1918 (detail; see PLATE 41)

PAGE 38 William Zorach, *Mother and Child*, 1922 (detail; see PLATE 42)

PAGE 58 Gaston Lachaise, *Passion*, modeled 1930–34, cast 1936 (detail; see PLATE 3)

PAGES 72–73 Robert Laurent, *Hero and Leander*, circa 1943 (detail; see PLATE 18)

PAGES 160–61 The William Zorach Studio, Maine, Courtesy of the Zorach Family, photo by Bruce Schwarz

PAGE 162 William Zorach, *Spirit of the Dance*, 1932 (detail; see PLATE 15)

PAGE 178 William Zorach, *The Dance*, 1930 (detail; see PLATE 37)

PAGE 184 Gaston Lachaise, *Man Walking (Portrait of Lincoln Kirstein)*, 1933 (detail; see PLATE 20)

This publication accompanies the exhibition

**A New American Sculpture, 1914–1945:
Lachaise, Laurent, Nadelman, and Zorach**

Organized by the Portland Museum of Art, Maine,
and the Amon Carter Museum of American Art

Exhibition curated by
Andrew J. Eschelbacher and Shirley Reece-Hughes

Exhibition Dates

Portland Museum of Art, Maine
May 26–September 8, 2017

Memphis Brooks Museum of Art, Memphis, Tennessee
October 14, 2017–January 7, 2018

Amon Carter Museum of American Art, Fort Worth, Texas
February 17–May 13, 2018

Library of Congress Control Number: 2016961001

ISBN 978-0-300-22621-8

Production by Sandra M. Klimt, Klimt Studio, Inc.
Designed by Malcolm Grear Designers
Edited by Jane E. Boyd
Proofread by Juliet Clark
Index by Frances Bowles
Separations by Martin Senn
Printed by Verona Libri, Italy

Published by the

Portland Museum of Art
Seven Congress Square
Portland, Maine 04101
PortlandMuseum.org

Amon Carter Museum of American Art
3501 Camp Bowie Boulevard
Fort Worth, Texas 76107
CarterMuseum.org

Distributed by

Yale University Press
302 Temple Street
P.O. Box 209040
New Haven, Connecticut 06520-9040
yalebooks.com/art

The Portland Museum of Art and the Amon Carter Museum of Art
gratefully acknowledge the generous support of the following
funders for the exhibition and catalogue:

Furthermore: a program of the J. M. Kaplan Fund

Henry Luce Foundation, Inc.

National Endowment for the Arts

Terra Foundation for American Art

Wyeth Foundation for American Art

Furthermore:
a program of the J. M. Kaplan Fund

HENRY LUCE FOUNDATION

ART WORKS.

National Endowment for the Arts
arts.gov

TERRA
FOUNDATION FOR AMERICAN ART